China Today

Joan Lebold Cohen and Jerome Alan Cohen With Photographs by Joan Lebold Cohen

Harry N. Abrams, Inc.

To our parents and our children

Library of Congress Cataloging in Publication Data

Cohen, Joan Lebold.

China today and her ancient treasures.

1. China—Description and travel—1949— —Views.

I. Cohen, Jerome Alan, joint author. II. Title.

DS711.C59 915.1'04'5 73-19994

ISBN 0-8109-0157-9

Library of Congress Catalogue Card Number: 73–19994 All rights reserved. No part of the contents of this book may be reproduced without the written permission of the publishers, Harry N. Abrams, Inc., New York Printed and bound in Japan

CONTENTS

Introduction • 7

The Prehistoric Period • 41

Ancient China • 53

The Founding of the Empire • 73

The Han Dynasty • 81

The Northern Wei, Sui, and T'ang Dynasties • 109

The Sung and Yüan Dynasties • 145

The Ming Dynasty • 167

The Ch'ing Dynasty • 213

The Republic of China • 227

Contemporary China • 245

The Arts in People's China • 357

Bibliography • 391

Index • 395

Chronology • 399

ACKNOWLEDGMENTS

A book of this scope, covering several thousand years of Chinese history, plainly rests upon the support of many scholars. We have benefited not only from the works cited in the bibliography but also from the personal advice of a number of colleagues and friends, including Anne Clapp, Nelson Wu, Max Loehr, Mino Yutaka, Ezra Vogel, Dwight Perkins, Donald Klein, Merle Goldman, Joseph Cheng, Nathan Sivin, Susan Bush, David Waterhouse, Michael Dalby, and Christine Kanda. A number of scholars at Harvard University's Fogg Museum have been helpful. We especially want to thank Bertha Ezell for her skillful and patient typing of the manuscript, and we pay tribute to Margaret L. Kaplan, an extraordinary editor, Nai Y. Chang, a gifted designer, and Paul Anbinder, a guiding spirit.

INTRODUCTION

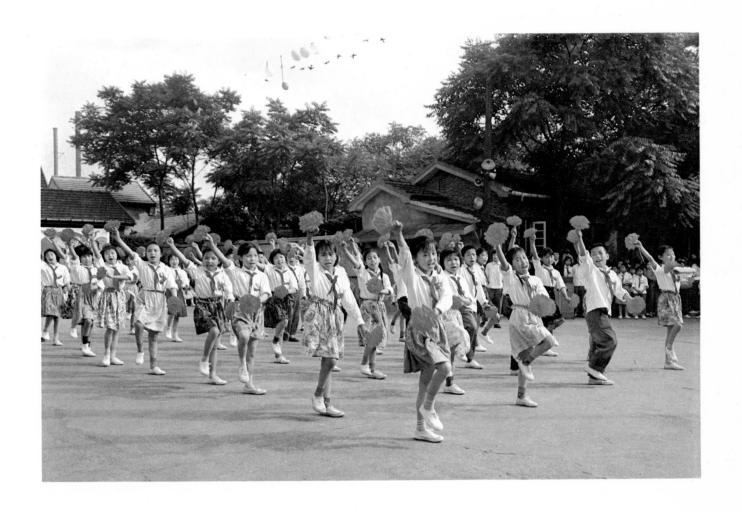

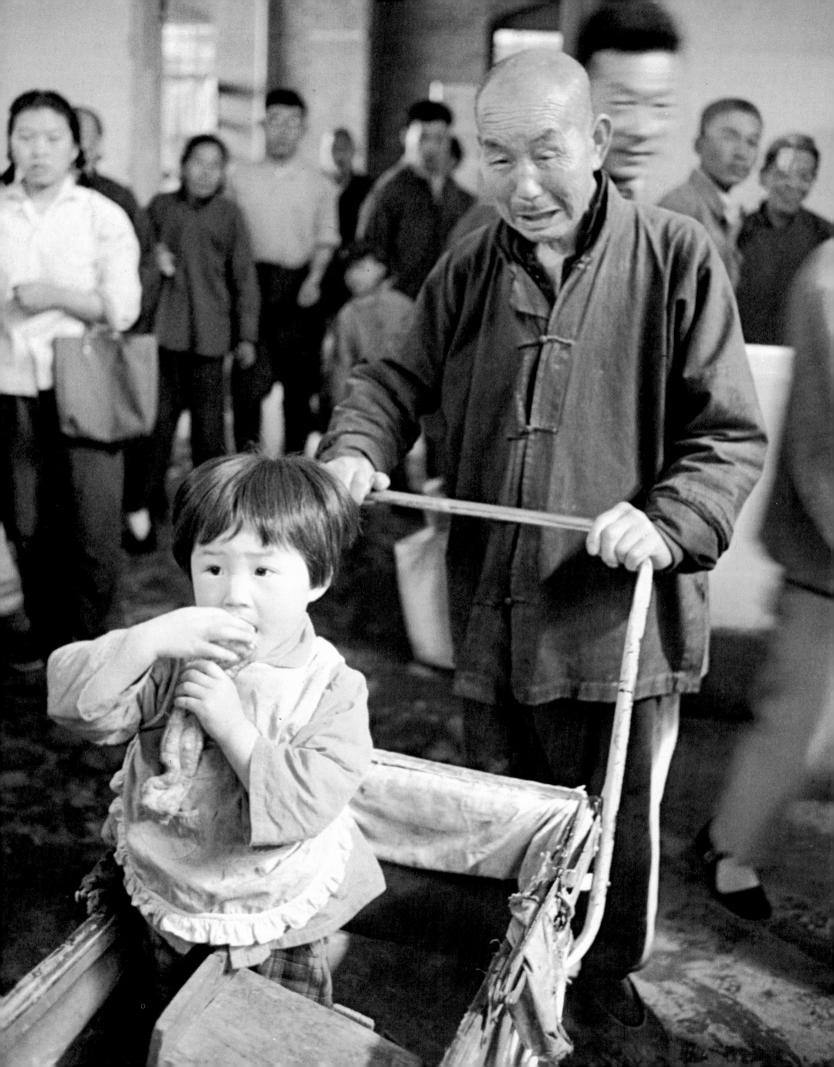

PRECEDING PAGE:

- 1. Boys and girls marching in parade formation at a "children's palace" in Shanghai. Learning to march well is a featured activity in school and in "children's palaces," which offer after-school enrichment for ideologically advanced students. The children perform frequently on national holidays and other occasions and proudly demonstrate their patriotism.
- Shopping with Grandpa in the People's Market, Peking. The government provides both day and night nurseries to ensure women full participation in the work force, but many children are cared for by their retired grandparents. The little girl here, munching on a deep-fried bun similar to a cruller, rides in a Chinese-style perambulator. The shopping bundles will be put into her carriage.

SINCE THE DAYS OF MARCO POLO, China has evoked everchanging images in the West. At present our perceptions of China are being transformed by a new Chinese imagery. The myths and symbols of the Chinese Communist revolution are being integrated into our view of China's history, and there has been a new receptivity toward China on the part of Westerners since the turmoil of the Great Proletarian Cultural Revolution of 1966-69 came to an end and China again began to present a hospitable face to the world.

Browsing in the China section of a well-stocked library, amid the thousands upon thousands of books that have been published in the last hundred years, can be as enlightening about our shifting vision of China as it is about Chinese history itself. Period pieces from the nineteenth century conjure up the "mysterious Orient": In Forbidden China; The Mystic Flowering; and Foreign Devils in a Flowery Kingdom, for example. The chaotic conditions of early twentieth-century China are suggested by China in Crisis and What's Wrong with China? From the same period, Kind-Hearted Tiger illustrates the sentimental view of a China innately good although politically impotent. Somewhat later, Westernized Chinese writers show nationalistic fervor in titles such as China, My China and My Country, My People. After World War II, jubilant Communist titles such as The East Is Red elicit Cold War responses, including Secret Diary from Red China.

Today, which is the "true" view of China? In a sense, China remains what she has been-mysterious, troubled, kindhearted, patriotic, militant, and antilibertarian. Yet none of these adjectives does justice to the image of China that has been emerging in the United States since the historic Ping-Pong matches of April, 1971, initiated a Sino-American reconciliation. Once again, political developments have produced a new vision.

This vision, of course, is one that has been meticulously fostered by the government of the People's Republic of China (PRC). Although hundreds of thousands of Americans have applied for visas since "Ping-Pong diplomacy" opened the door a crack, only a few thousand have met with success, and these have been very carefully selected. This is not to say that the Chinese have limited their invitations to ideologically pure Maoists whose rose-tinted glasses reveal only the many accomplishments of new China. Chairman Mao Tse-tung, Premier Chou En-lai, and their colleagues are far too shrewd for that. They have invited a careful mixture of businessmen, journalists, scholars, students, scientists, congressmen, workers, farmers, ministers, athletes, movie stars, housewives, and others of various political persuasions, ages, and racial, religious, and ethnic backgrounds. By and large, however, the chosen few have had two discernible characteristics in common. First, they have convinced Chinese officialdom that they are prepared to be open-minded about revolutionary China, despite a quarter century of hostile American propaganda that sought to depict the People's Republic as aggressive abroad and tyrannous at home. Second, and more important, they are people whom the Chinese believe to be useful, perhaps because of the knowledge or trade they can bring to China, perhaps because of their efforts to invite Chinese to the United States, but almost always because they are in a position to spread the new vision of China to an important segment of our pluralistic society.

"Vision" is an appropriate term, for the predominant impressions with which the visitor to China returns home are apt to be visually derived. The printed word is of limited use in understanding the China of today. To be sure, bookstores feature the works of Chairman Mao and earlier stars of the international Communist firmament, as well as topical political tracts. A few scientific and archaeological studies and some novels and collections of short stories have also appeared in recent years. But other books are scarce, although the extreme intellectual drought that began with the Cultural Revolution seems to be ending.

Chinese newspapers serve largely didactic and propagandistic functions and contain relatively little solid information. Moreover, foreigners are not permitted to obtain any except the *People's Daily*, the nationally circulated ideological vehicle

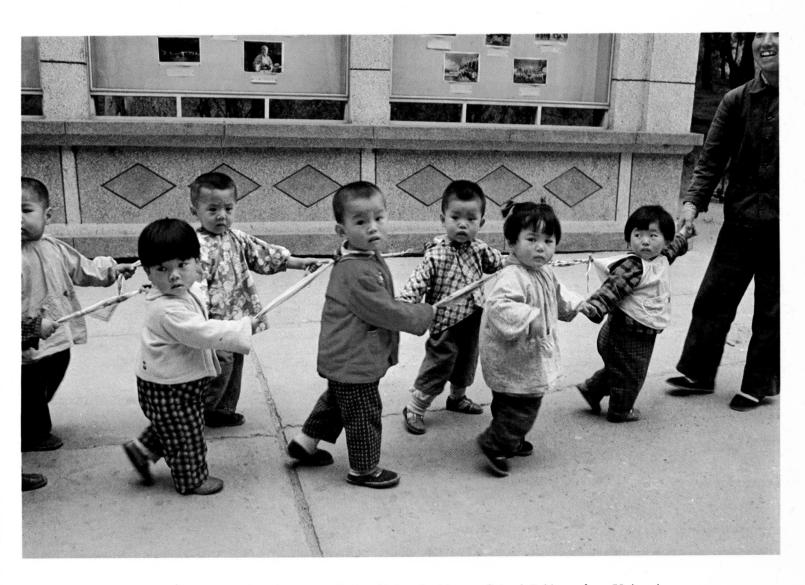

3. Line of nursery-school children at the Peking University Nursery School, Peking, where University employees can leave their children in good hands during work hours. Each toddler keeps in line behind the teacher by holding onto a handkerchief tied to the child ahead.

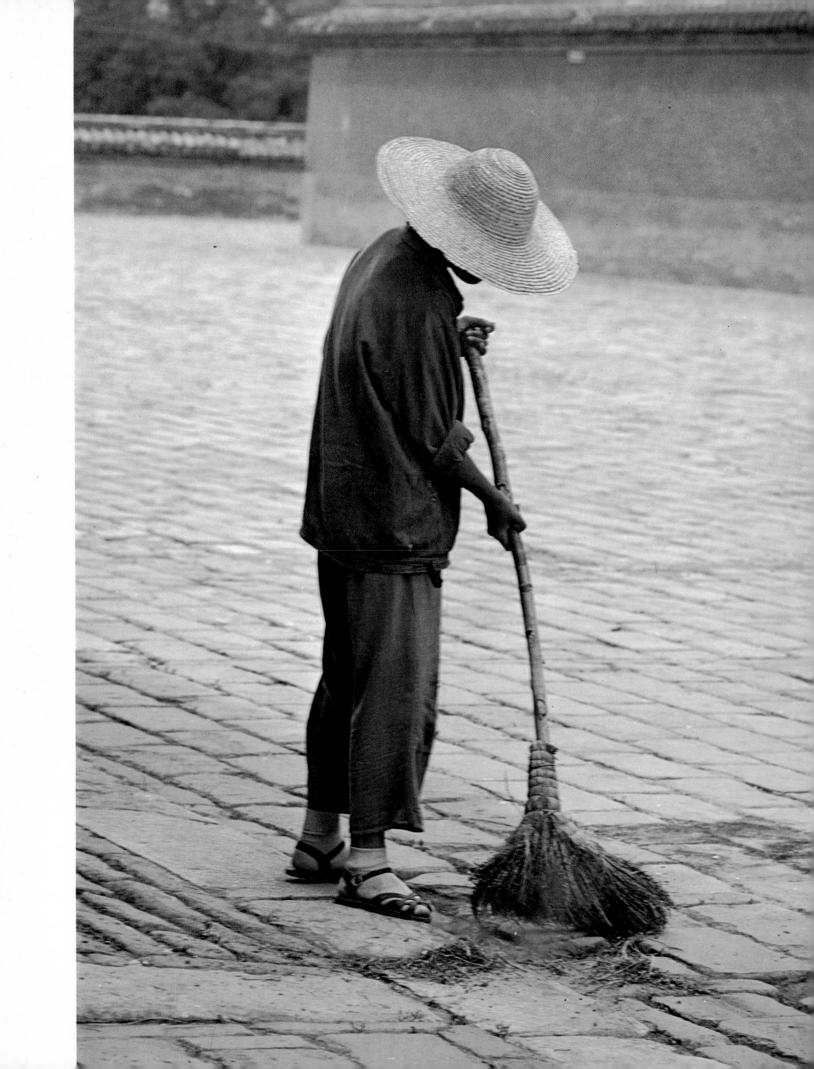

◀4. Sweeping a courtyard in the Imperial Palace, Peking.

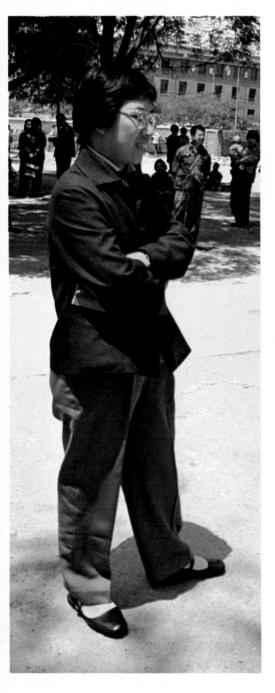

5. Female cadre in Peking.

of the Chinese Communist Party, and two or three others. The Chinese are well aware that other nations' intelligence agencies eagerly collect all the local newspapers they can in their efforts to scrutinize the inscrutable. Thus, the visitor to a Chinese city who wants to read its local newspapers must do so while standing conspicuously in front of one of the bulletin boards in various central locations where they are posted, an awkward exercise at best. And even if he does so, he finds that the most striking difference between the local papers and the *People's Daily* is that the former offer the local weather report, television guide, and movie schedule.

For a variety of reasons oral communication also is a limited and sometimes unreliable source of information. Although workers, peasants, and soldiers are proclaimed to be the backbone of new China, it is difficult even for the visitor who speaks Chinese to exchange ideas with them in an unstructured setting. The people whom the visitor usually comes to know are the cadres (plate 5)—officials who serve as escorts, guides, and interpreters and who run the farms, factories, schools, hospitals, and other units that he visits. Of course, the cadres who are exposed to foreigners are generally those in whose discretion the regime has confidence. To the extent that they impart information, they generally present a bland version of reality that often evokes skepticism even in the visitor who is not a "China-watcher."

Since reading and talking offer limited possibilities for insight, seeing becomes correspondingly more important to the traveler. Unfortunately, large portions of the country are out of bounds to foreigners. If only occasionally the mountain fastnesses of Yunnan province or the fabled Yangtze River gorges in Szechwan yield to a favored visitor, the same is even more true of Tibet or Sinkiang, for example. Cities such as Nanchang, capital of Kiangsi province, have been open to Americans in December and closed the following May. Even within the cities to which one has access, a number of things are off limits. Sight-seeing in Peking will be somewhat less arduous than it used to be so long as a number of major museums, libraries, parks, and other places of interest are "closed for repairs"—a frequently heard euphemism that seems to include ideological as well as physical repairs.

Yet the People's Republic is no "Potemkin village," no false facade designed to delude the visitor. Its achievements are real and many, and, having decided to admit foreigners, its leaders have been wise enough to permit them enough mo-

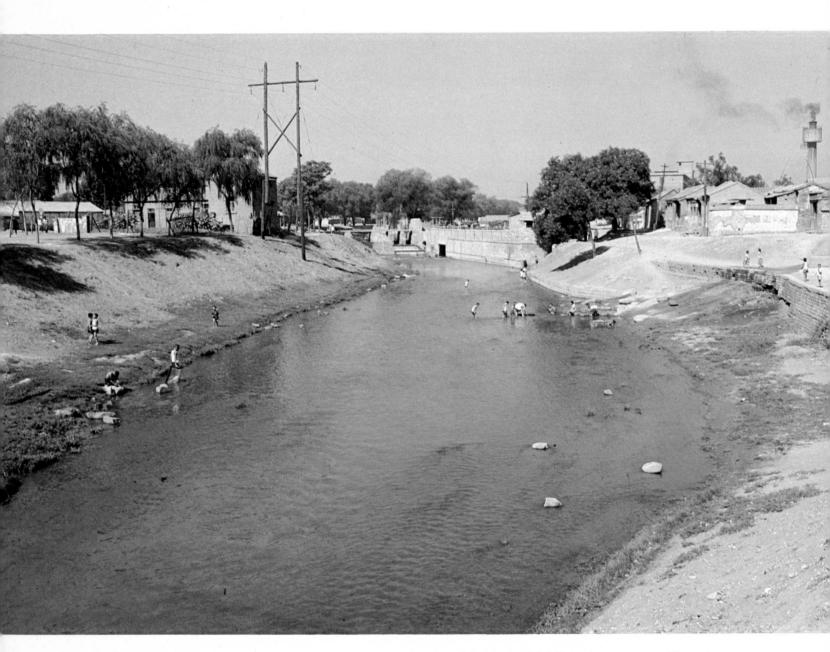

6. Comrades bathing in the river along the northern border of Peking's old Ming city near an old northwest gate (Te-sheng-men).

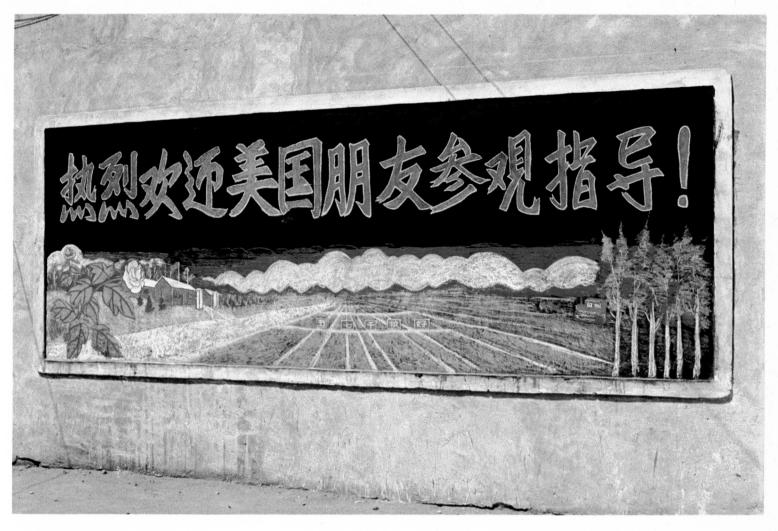

7. Blackboard at a "May 7th Cadre School" northeast of Peking. The idyllic farm scene drawn in colored chalks includes trees and flowers, a tractor, green fields studded with slogans, school buildings, and a long white cloud. Above, in red characters outlined with yellow, it says: "We enthusiastically welcome the visit and guidance of American friends" (a recent Chinese Communist Party line toward the United States).

bility to appreciate what China has done. The Chinese are self-confident and sufficiently sophisticated to allow visitors to roam rather freely and without escort in those areas to which they are admitted.

Of course, contemporary China is a highly dynamic society. From 1971 through 1973 things changed in the direction of facilitating communication. Not only did books reappear on bookstore shelves; people became more receptive to contact with foreigners, and areas of the country formerly off limits gradually opened.

Indeed, the year 1972–73 brought a marked change in both official and popular Chinese attitudes toward Americans. In 1972 most ordinary Chinese thought American visitors were European and showed no particular warmth when they learned their nationality. A year later, however, many people would inquire whether a visitor was American and,

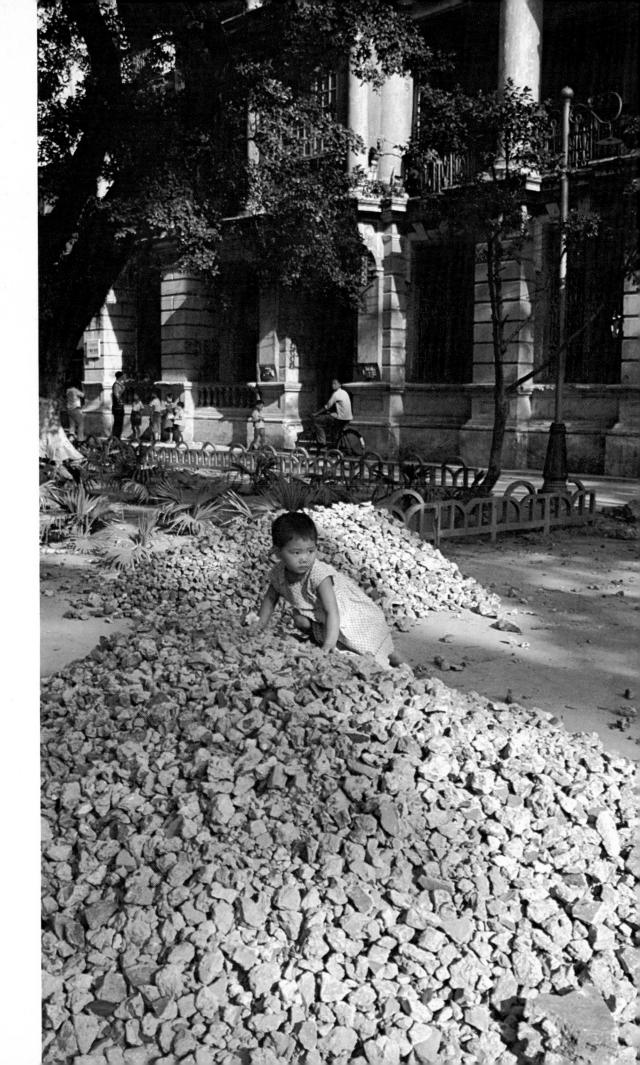

8. Little girl climbing on pebbles on Sha-mien Island, Canton (Kwangchow)

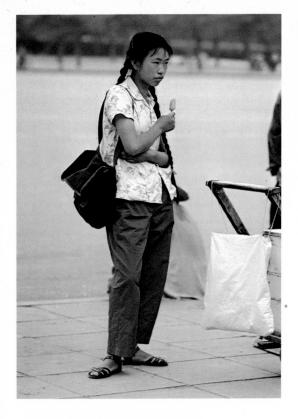

9. Student with a popsicle, Peking.

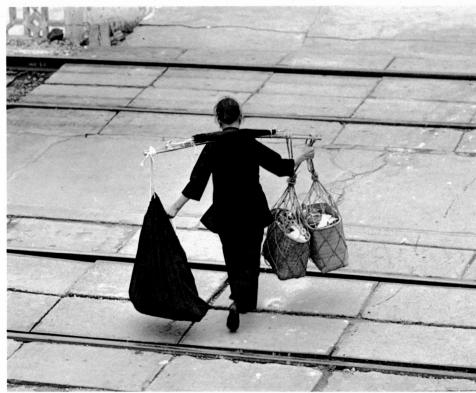

10. Old woman carrying bundles on a yoke at Shunchün, Kwangtung province, at the border to Hong Kong. She wears what used to be the "uniform" for mature women in traditional China.

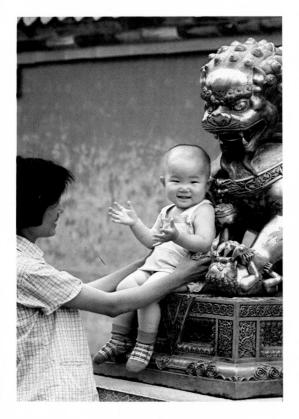

11. Playing pat-a-cake on a bronze lion in the Imperial Palace, Peking.

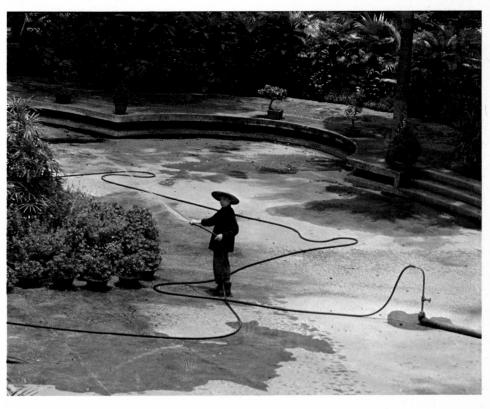

12. Gardener watering potted plants in the garden of the Kwangtung Province State Guest House, Canton (Kwangchow).

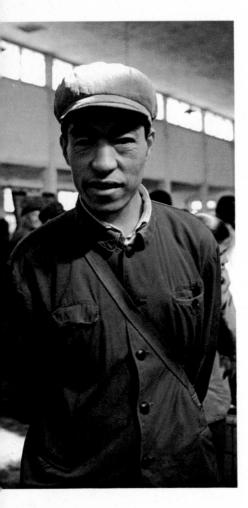

13. Blue-jacketed worker in a green hat stares while shopping at the People's Market, Peking.

upon confirmation, be sincerely friendly. This change in popular attitude plainly had official blessing. In 1973 there were still signs that exhorted the masses to "defeat the American imperialists and their running dogs," but these were balanced by others that pointedly read: "We want to be friends with all the peoples of the world, including the American people."

In 1973 one could spend an entire evening talking with young interpreters about some of their experiences as Red Guards, the high-school and university students whom Chairman Mao mobilized to struggle against Party and government bureaucrats in the early stages of the Cultural Revolution. They might relate how their studies at the Institute of Foreign Languages in Peking had been interrupted in 1966 and how they had spent months traveling through China with bands of fellow Red Guards. They might talk with pride of having walked with a group from Peking to Wuhan, engaging in "revolutionary activities" along the roughly six-hundredmile route. Such hikes were designed to give youth a taste of the famous Long March of 1934-35, when Chairman Mao led thousands of Communist guerrillas on a harrowing 6,000mile trek from southeastern China to new revolutionary bases in the mountains of the northwest.

By spring, 1974, however, the situation seemed to be changing once again. Foreigners began to encounter new restrictions upon both travel and interpersonal communication as a consequence of the revival of the Cultural Revolution spirit. At present the world and the Chinese people wait anxiously to see how far this newest swing of the pendulum will go.

A few observations about the cultural adjustments that a Westerner visiting China today must be prepared to make may prove helpful to those fortunate enough to secure a visa.

Those who visit China for the first time tend to be under certain psychological pressures. Most have waited years for the opportunity. Many have come at considerable financial sacrifice. Some feel the strain of being cut off from the world in a strange land whose language they do not understand and whose political system they have been taught to fear. Whether excited or apprehensive, virtually all are determined to get as much out of the brief trip as possible. If, as is usual, they are members of a heterogeneous group, the attempt to reconcile divergent interests within the group prior to proposing an itinerary to the hosts often drains individual energies and good humor. Moreover, some people arrive in China tired from a long journey or so eager not to miss anything that they spurn such time-honored Chinese practices as napping after lunch and going to

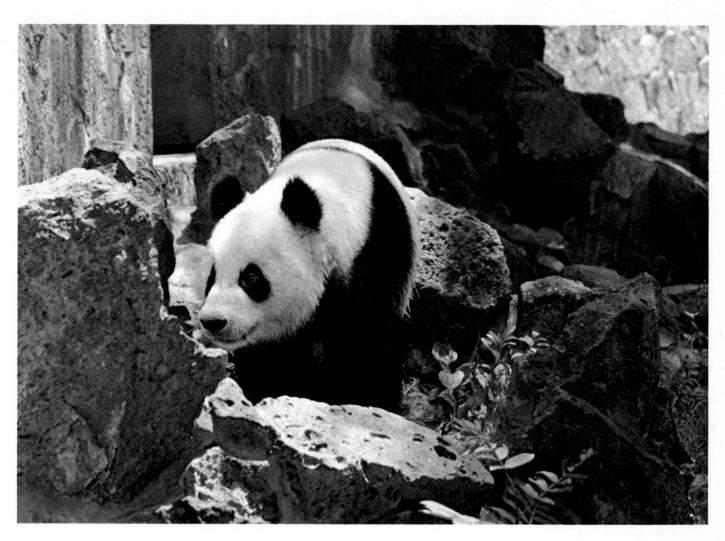

14. Giant panda in the rocks at the Shanghai Zoo. The rarest large mammals in the world, pandas are found only in the mountains of Szechwan province and Tibet. Gifts of these animals to the United States and other nations have come to symbolize Chinese international friendship.

bed early, so that they court exhaustion and often fall ill. The fierce extremes of summer or winter and an occasional all-night train ride or long transportation delay may also contribute to the discomfort of visitors. Whatever the reasons, for-eigners frequently seem to be more than usually tense, irritable, and high-strung while in China. In these circumstances they sometimes are inordinately sensitive to experiences that more detached observers would dismiss as unworthy of notice. Occasionally their reactions to these experiences are unfortunate and complicate cultural contacts.

In the United States conspicuous foreign visitors are often stared at, especially once they leave our big cities, and Americans abroad are accustomed to being scrutinized by the local population. In China staring at visitors is something else again (plate 13). Relatively few foreigners are seen there, and

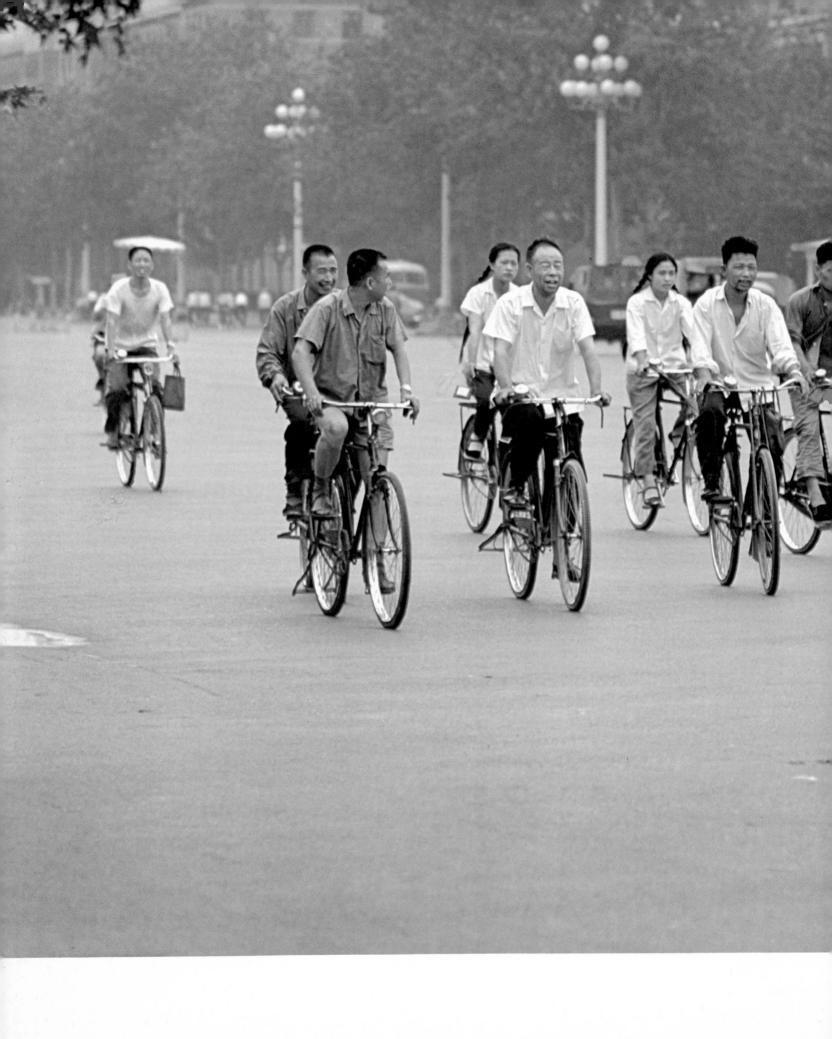

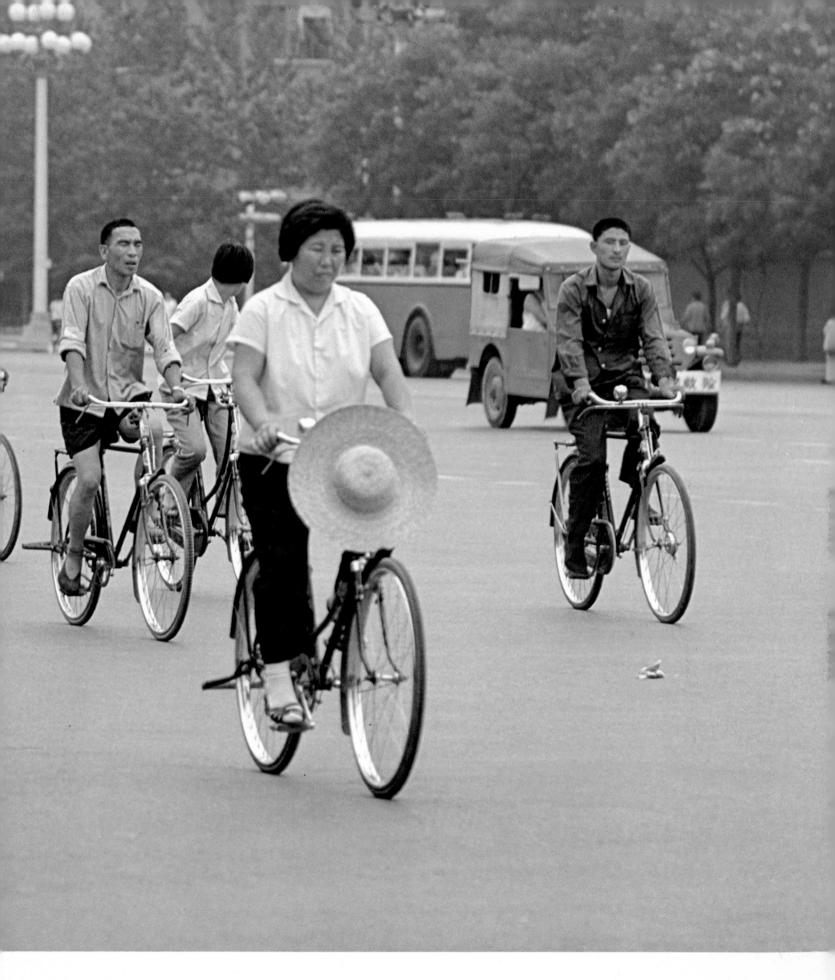

15. Bicycle traffic on a main boulevard, Peking. Bicycles are the principal means of transportation for the masses of China. Cycling is considered practical, economical, and health-building.

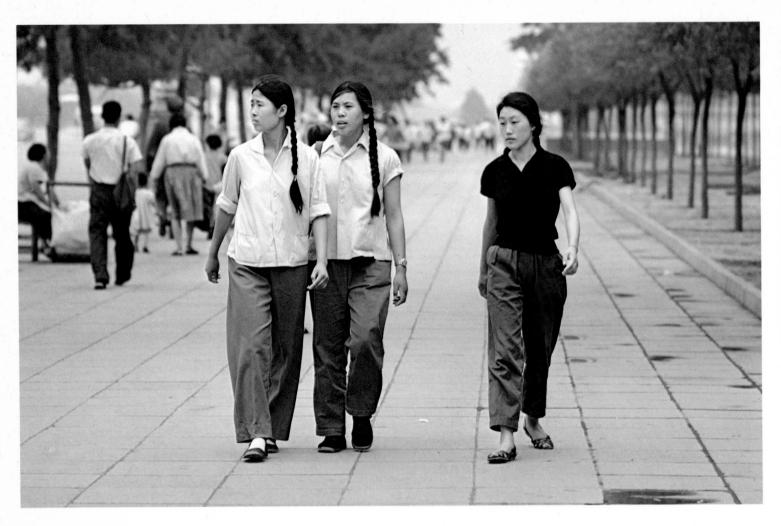

16. Peking strollers.

staring at them seems to be a national pastime. The Chinese do not hide their immense curiosity about non-Chinese. They stare with forthright intensity and at as close a range as possible, up to three inches—even in the urban centers that are standard sight-seeing stops. One often sees groups of Chinese assembled outside the leading hotels waiting to catch a glimpse of the exotic foreigners, and at the excellent zoos of Peking, Shanghai, and Canton the people stare at foreigners while the foreigners stare at the animals (plate 14). Eventually one comes to know what it must feel like to be a giant panda. There is no point in trying to look baggy-panted in an effort to melt into the crowd. Foreigners, and especially women, will be stared at no matter what they wear. However, it is well to know that the Chinese are offended by décolleté necklines on women and that sleeveless shirts have only recently become accepted as appropriate attire.

At any rate, the authorities are aware of the discomfort too

17. Transporting tables by horse and wagon, Peking. (Photograph by Peter Lebold Cohen.)

much attention can cause visitors and do their best to minimize it. The ever-watchful plainclothes public-security officers always seem to materialize when needed, discreetly rerouting the crowd.

Not all official efforts to accommodate their guests are such an unmixed blessing. Some visitors find it difficult to get used to the consistent differentiation among guests according to status. The Chinese insist that the leading members of every foreign delegation be ranked in hierarchical order, diplomatic style. The hosts then respect this order every day in every way. The head of a delegation is usually expected to ride in a big, black "Red Flag" limousine, the deputy head in a more compact "Shanghai" sedan, and the number-three person in a slightly more battered "Shanghai." Similar protocol is followed in arranging places at banquets, allocating hotel rooms, making introductions, and reporting in the press. The Chinese defend this policy on grounds of politeness and explain that it

18. Pomegranates in the Imperial Palace, Peking.

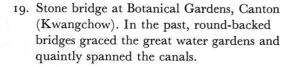

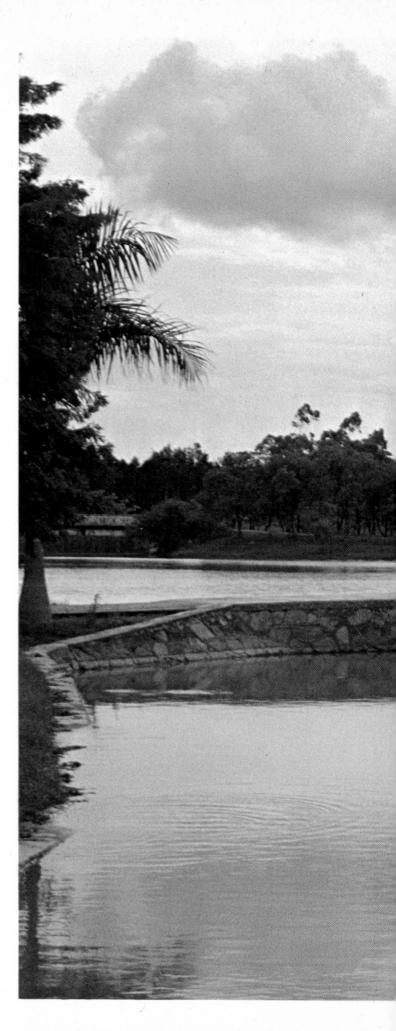

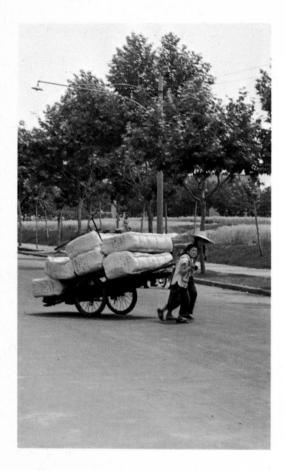

20. Boy and girl pulling a handcart full of bales, Loyang, Honan province. Trucks transport some Chinese goods, but handcarts are still a primary mode of conveyance.

avoids confusion and facilitates efficient arrangements. Surely this is true, but the extremes to which they carry the practice disconcert many visitors unused to diplomatic protocol.

Another startling factor is the way the Chinese handle the automobile. Wildly honking cars bearing foreign guests unceremoniously shunt aside cyclists and pedestrians. Cars are in very short supply in China, and none are privately owned. Although buses and trucks assume a good deal of the burden of local transportation, great numbers of people rely on their bicycles or walk (plates 15, 16). Perhaps because of the scarcity of motor vehicles, Chinese cyclists and pedestrians appear to be among the most undisciplined in the world, a surprising fact in a country that is governed so rigorously. Thus, a certain amount of horn blowing is required by those who seek to navigate the sometimes chaotic urban streets. But in China it seems that the gas pedal and the horn are linked, so that one cannot move an inch without mindless honking, preferably while driving at a relatively high speed that sends pedestrians scurrying for safety. It is interesting to note that a similar phenomenon occurred in Tokyo in the years just after World War II, before the automobile became commonplace. Whatever the explanation, so irksome is the experience that an occasional visitor will refuse to continue riding in cars, to the puzzlement and discomfort of his escorts, who find crowded buses and hot hikes far more annoying than the excesses of the characteristic Chinese chauffeur.

Other examples of privileged treatment for foreigners abound: clearing people away from a museum exhibition they were enjoying so that foreigners can quickly gain an unobstructed view; providing special restaurants or private dining rooms for foreigners; ushering foreigners into special lounges during intermissions at the theater; and so forth. These arrangements may be frustrating for visitors who would like to narrow the inevitable gap between themselves and the Chinese people. It should be borne in mind, however, that they are intended as gestures of consideration and that such privileged treatment, which in prerevolutionary days was a hated symbol of foreign domination, is now granted through China's free choice, a decision proudly made by the host as a courtesy to guests.

The visitor to China is offered many conveniences. Activities are thoughtfully and efficiently arranged, enabling him to make maximum use of his time. The guests are consulted by the host organization, which does its best to meet the varied

21. Tiled roof, Loyang, Honan province.

interests of the members of each group. And the Chinese patiently tolerate the foibles of foreign group dynamics as the guests struggle among themselves to order their priorities.

Yet, when all is said and done, the Chinese expect us to concentrate upon the China they perceive and want others to understand. Ordinarily this poses little problem, for most visitors enjoy the variety of the usual tour to selected factories, schools, communes, medical facilities, and cultural monuments. But the foreigner who comes as a specialist, with the hope of concentrating on what China has done in his particular area of expertise, may become frustrated. If, as would be natural in most countries, he seeks to meet Chinese who pursue the same line of work, he may be disappointed. Artists, art historians, writers, law professors, judges, and sociologists were among those who were unavailable to visitors from the beginning of the Cultural Revolution until recently, and they are only now beginning to surface to a limited extent. Scientists, engineers, doctors, journalists, local officials, and others have been more accessible. Yet, even if one is fortunate enough to meet his professional opposite number, it is often in circumstances that do

■22. Cadres cook at a "May 7th Cadre School" northeast of Peking. The Communist Party and government officials who staff the Chinese bureaucracy are called "cadres." The "May 7th Cadre Schools" were established during the Cultural Revolution so that cadres could engage in intensive ideological indoctrination and in physical labor.

■23. Banquet at the Kwangtung Province State Guest House. The first course of cold meats, seafood, vegetables, and peanuts has been served. At least ten courses of hot food will follow, including meat, fish, vegetables, and several soups. A foreign visitor is flanked by a cadre and an interpreter. not lend themselves to sustained substantive conversations. Most meetings take place in groups and under the watchful eyes of the cadres. Moreover, because of the desire to show visiting experts the overall transformation of new China within which developments in individual fields must be understood, the demands of the schedule usually ration opportunities for exchanging experiences with experts.

Most guests simply accept the fact that, at least on their first trip to China, there will be limits upon the pursuit of specialized interests. Once in a while, however, a human explosion occurs and disturbs the good feeling which generally prevails. Such unattractive incidents strain Sino-American relations, and the lesson to be learned is that if you are not prepared to do it the Chinese way, don't go to China.

Gifts are a problem that occasionally arouses sensitivities. Visitors usually want to express their appreciation to the cadres who accompany them during their stay, and they often want to take something to the organization that has invited them and to the institutions that receive them. Gifts such as clothing, household objects, or personal trinkets that might be appropriate in the Western world are out of the question for cadres. The People's Republic has done much to eliminate the endemic corruption of previous Chinese governments, and it is especially concerned about officials succumbing to what the Party calls "the silver-coated bullets of the bourgeoisie."

Books might seem an appropriate present, especially from academic or professional guests. Yet one must tread cautiously here. Books approved for Chinese reading must be carefully screened to make certain that they contain no "counterrevolutionary" ideas, and Americans who proffer books sometimes meet with unanticipated rebuffs. Before journeying to China, one woman spent a week selecting the very best American children's books to present to a Shanghai "children's palace," where ideologically advanced youngsters enjoy an after-school enrichment program in the arts, sciences, and sports. No one, however, was willing to accept the books, so that an embarrassing situation was created.

One excellent solution is to take along a Polaroid camera, so that one can give instant mementos to people who are particularly kind. Escorts also appreciate photographs mailed to them after the visitor returns home.

No impressionistic account of adjusting to Chinese society could be complete without some reference to what may well be the world's best cuisine. Several aspects are noteworthy.

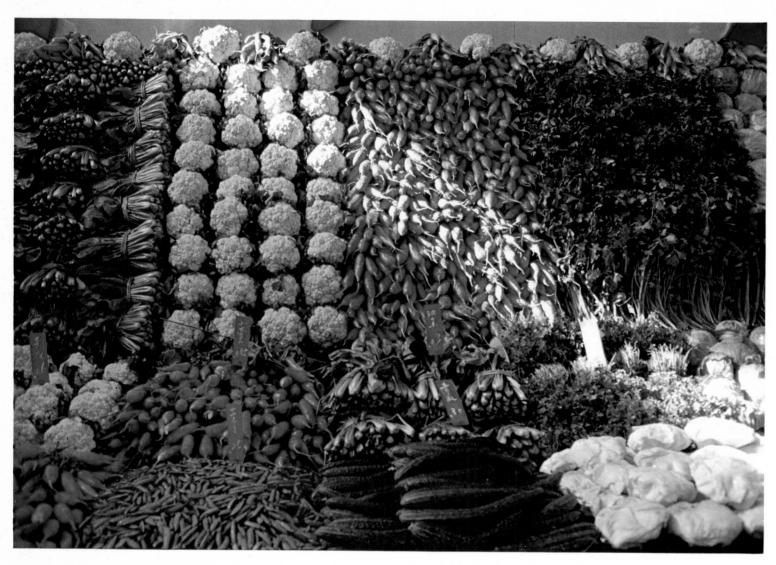

24. Vegetables in the People's Market, Peking. The state-run market is generously stocked with varied and beautiful produce. There are virtually no waiting lines, and prices are low in relation to earning power.

At one end of the social spectrum are the workers' restaurants. The differences between the food served there and that to which visitors are usually exposed are noticeable. Rice, for example, tends to be somewhat harder, smaller grained, and grayer than that served visitors, but still quite edible even for Westerners. The meat is rather fatty, for this is traditional Chinese preference, but the workers' meals as a whole are tasty. At the other end of the spectrum, the interesting culinary feature of state banquets in the Great Hall of the People is the predominance of soft, easily digestible dishes and soups, a menu suited to the needs of China's aging leadership.

Apart from the occasional ceremonial banquet (plate 23), meals are generally taken in hotel dining rooms. Hotel cooking in China is excellent, but after a few nights in succession

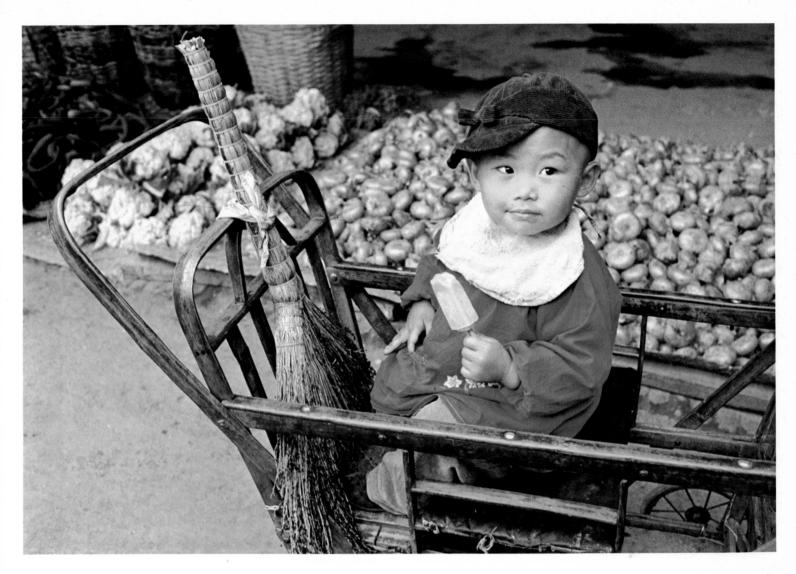

25. A little boy with a popsicle waits in a Chinese-style perambulator at a market in Loyang, Honan province.

in the same dining room, many Americans become eager to try somewhere else. Hosts to official parties sometimes seem reluctant to let their charges go on their own to some of the fine restaurants of Peking, as businessmen and others are free to do. The dialogue may go something like this: "Don't you like the hotel's food?" "It's fine, but we'd like to sample some other restaurants." "They're very crowded, and it will be inconvenient if you have to wait for a table." "That's all right. It will give us a chance to see how Chinese people dine out." "Oh. You just want to look at the people? Then why not eat dinner in the hotel first and then we can walk through a restaurant and see the people." The reason for this reluctance is unclear. Could it be that official groups are booked into hotels on the "American plan"? A more likely explanation is that the

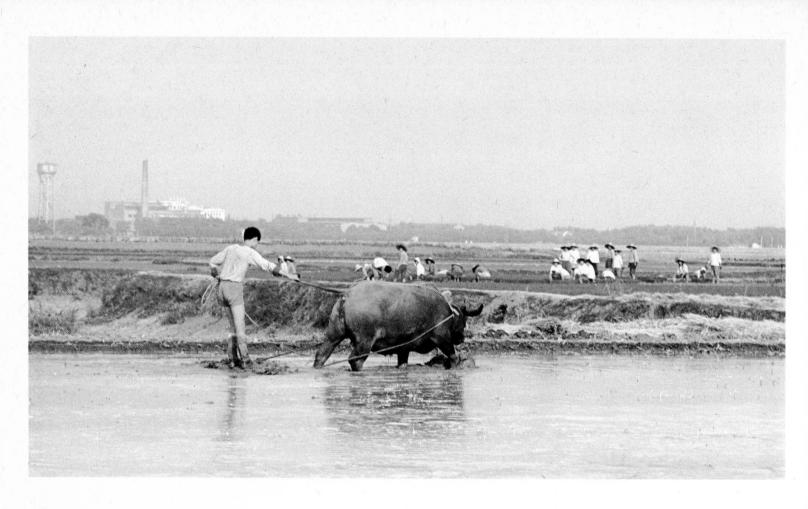

26. Plowing a flooded rice paddy in a commune near Shanghai. The young man rides a plow while holding the tail of a water buffalo.

27. Rice paddies of Kwangtung province. Some paddies are flooded in preparation for planting, others are green with young plants. hosts must accompany their guests, and eating in a different restaurant every night would make their already long days even longer. Being an official guest is in many ways easier, but it is sometimes more confining than seeing China in a less exalted capacity.

One area in which the government allowed visitors great freedom in 1972–73 was in the taking of photographs, and the requirement that all film be developed prior to departure from China was abolished. Photographs from airplanes were forbidden for security reasons, as were shots of the Peking subway occasionally, because of its importance to the capital's vast underground network of air-raid shelters. Virtually everything else in sight was fair game for the lens, although a surprising number of people were reluctant to be photographed—almost as though they were afraid that the camera's "evil eye" would possess their souls. The Chinese guides did not insist that their guests photograph tractors instead of water buffalo (plate 26), workers instead of peasants, or handsomely dressed children instead of traditional-looking older people in an attempt to make their country seem more "modern" than it actually is.

The camera thus could capture much, if not all, of the reality of China: naturally lush southern rice fields and arid central plains that have become fertile through heroic feats of irrigation; huge factories and the ubiquitous small workshops; various means for transporting agricultural commodities and manufactured products-man, beast, bicycle, boat, wheelbarrow, and truck; central markets and neighborhood stalls; run-down city courtyards and recently built workers' apartments; peasant houses and dim cave dwellings; nursery schools and universities; neighborhood clinics and city hospitals; churches transformed into warehouses and Confucian temples turned into revolutionary museums; families picnicking at the Great Wall, the emperor's Summer Palace, or the many parks; children swimming in the moat of the Imperial Palace, playing basketball within the former Forbidden City (plate 29), or singing as they hike to the fields to help with the harvest; revolutionary movies, ballets, concerts, operas, and parades; national and international athletic events; chic but ineffectual traffic policemen and baggy but lionized soldiers; ever-present images of Chairman Mao immortalized in statues, paintings, photographs, and lapel buttons, and inescapable selections from the Chairman's writings (known as his "Thought") carried by billboards, banners, broadcasts, and books (plates 31, 32).

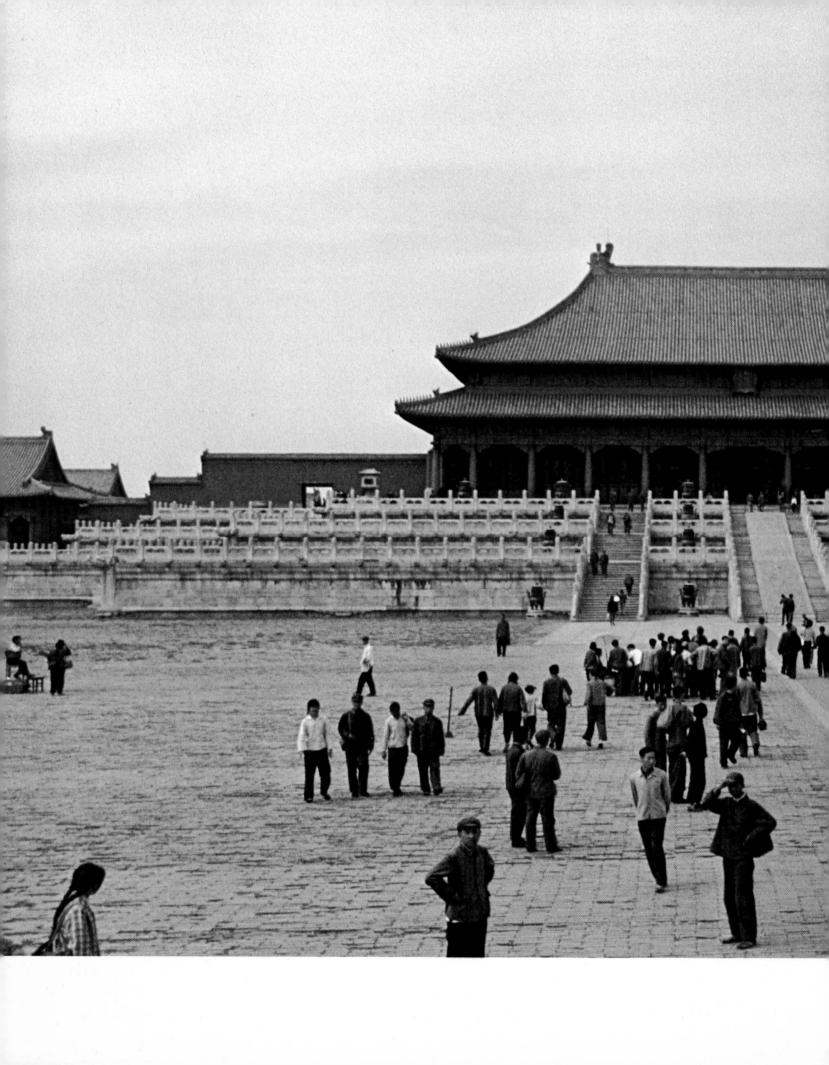

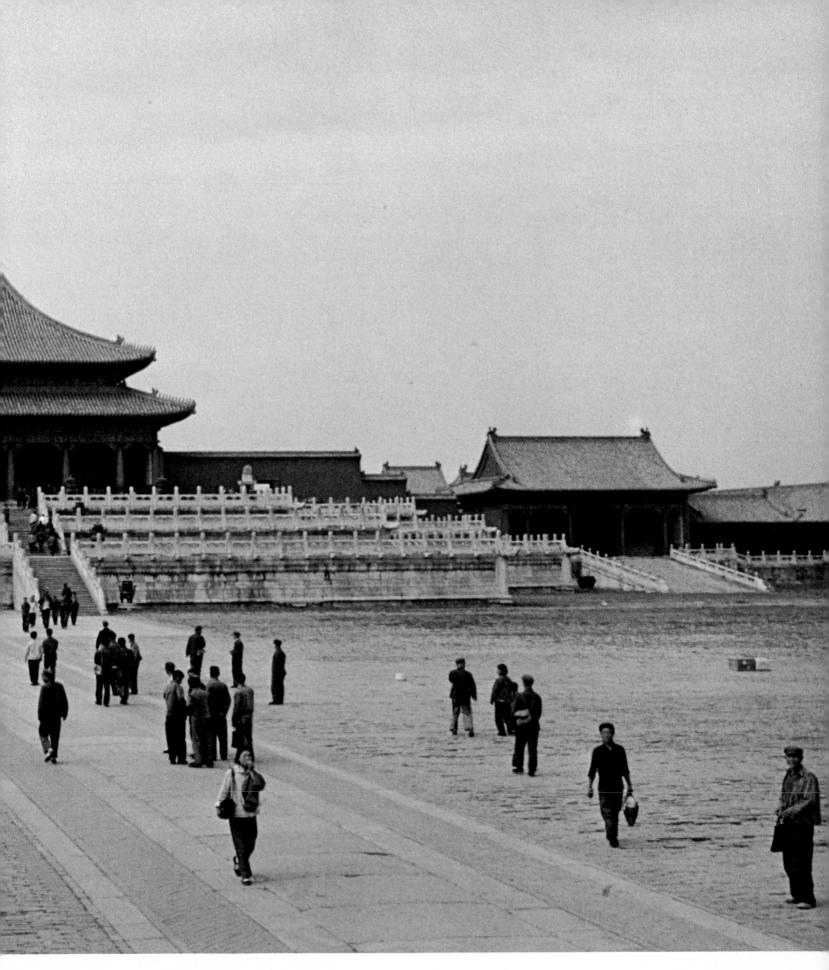

28. Hall of Supreme Harmony (T'ai-ho-tien), Imperial Palace, Peking. Ming dynasty (1368–1644), with renovations of the Ch'ing dynasty, the Republic, and the People's Republic. Height of hall 87 feet, length 210 feet, width 115 feet.

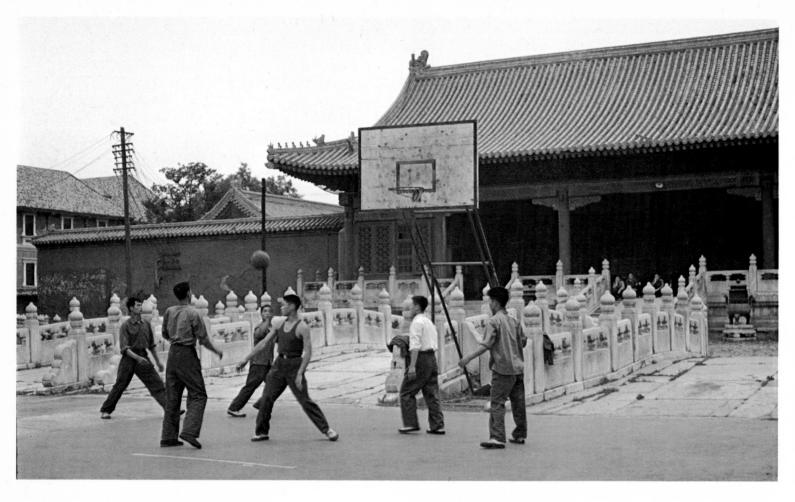

29. Playing basketball in the Imperial Palace, Peking. In the setting is the Gate of Military Prowess (Wu-ying-men), southwestern section of the Imperial Palace. Ming dynasty (1368–1644), with renovations of the Ch'ing dynasty and the People's Republic.

30. Girls of Middle School No. 26, Peking, perform a dance from the revolutionary opera *On the Docks*.

The northern scene:

A thousand leagues locked in ice,

A myriad leagues of fluttering snow.

On either side of the Great Wall

Only one vastness to be seen.

Up and down this broad river

Torrents flatten and stiffen.

The mountains are dancing silver serpents

And hills, like waxen elephants, plod on the plain,

Challenging heaven with their heights.

A sunny day is needed

For seeing them, with added elegance,

In red and white.

Such is the beauty of these mountains and rivers
That has been admired by unnumbered heroes—
The great emperors of Ch'in and Han
Lacking literary brilliance,
Those of T'ang and Sung
Having but few romantic inclinations,
And the prodigious Gengis Khan
owing only how to bend his bow and shoot at vultur

Knowing only how to bend his bow and shoot at vultures.

All are past and gone!

For men of vision

We must seek among the present generation.

(Trans. Michael Bullock and Jerome Ch'en in Jerome

Ch'en, Mao and the Chinese Revolution.)

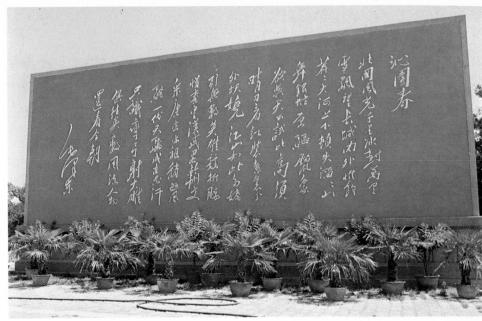

31. Billboard with the poem "Snow" by Mao Tse-tung, reproduced in his own calligraphy, in the Temple of Heaven complex (T'ien T'an), Peking. The poem, probably the best-known of Mao's output, was written in the years preceding the establishment of the People's Republic in 1949.

32. Chairman Mao in the Yü Yüan, a mandarin garden, Shanghai. Gilt sculpture, People's Republic. Hall, 1537 (Ming dynasty), restored 1956.

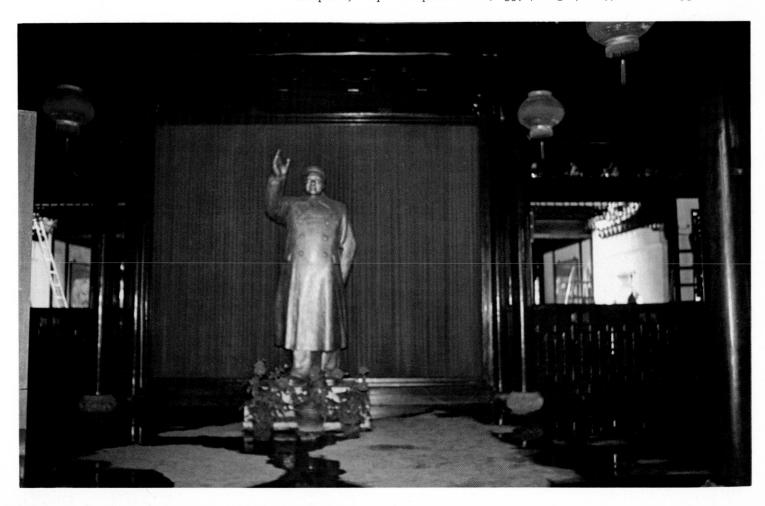

34. Orchid Garden, Canton (Kwangchow).

This kaleidoscope of contemporary China fails to suggest the continuing prominence that the architectural monuments and art objects of traditional China enjoy today, not only for foreign tourists but also for the Chinese themselves. In line with the current Party slogan, "Make the past serve the present," the masses can now enjoy some of the previously inaccessible preserves of the emperors. Indeed, one of the happier reminders of the vast changes that have been wrought in China in this century is the sight of peasants sipping tea in one of the gardens of the Forbidden City or workers napping on the railings of the Summer Palace. But China's artistic heritage serves the present in broader ways than by demonstrating the egalitarianism of contemporary society. It is an important factor in fueling the sense of national pride, which in turn sustains the spirit of nationalism that has spurred China's progress and made over two decades of sacrifice endurable for the masses. It is also, at least in the hands of skilled archaeologists, historians, museum curators, and propagandists, an important vehicle for educating the masses about both the evils and the

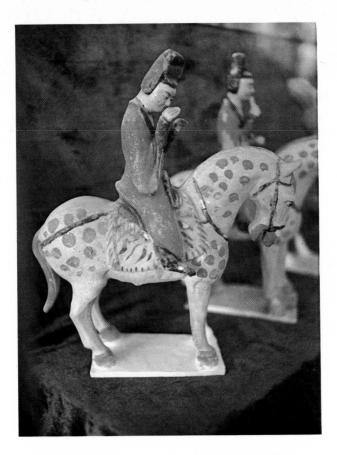

35. Tomb figure of an equestrian musician. T'ang dynasty (618–907). Pottery with yellowish glaze, painted with red and black cold pigments.

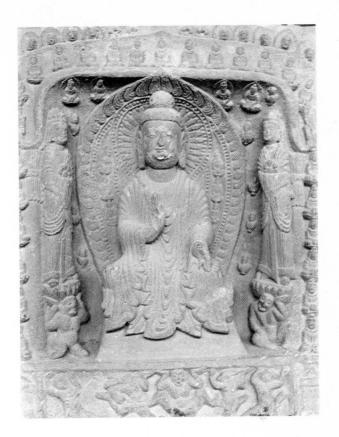

36. Stele with Buddhas from Ch'ang-an, Shensi province. 501 (Northern Wei dynasty). Sandstone, 23 5/8 × 22 inches. Shown at the Historical Museum, Sian, Shensi province.

accomplishments of the old society, the enormous social and economic price paid for aesthetic attainments, and the unfolding of the class struggle throughout China's history. And it is a peerless instrument for winning the admiration and respect of the outside world, as demonstrated by the response to the great traveling exhibition, Treasures of Chinese Art, which began its tour in Paris in 1973.

For these reasons, revolutionary China has allocated substantial resources to preserving, restoring, rediscovering, and displaying the artistic achievements of the past. The excesses of the Cultural Revolution resulted in damage to some cultural artifacts and historic buildings, but vigorous measures by Chou En-lai and various other leaders limited the destruction, and in recent years a considerable effort has been made to repair the damage. The People's Republic has also gone to great lengths to exhibit the many priceless treasures that were unearthed during the Cultural Revolution, in order to cast a more positive light on that difficult period both at home and abroad.

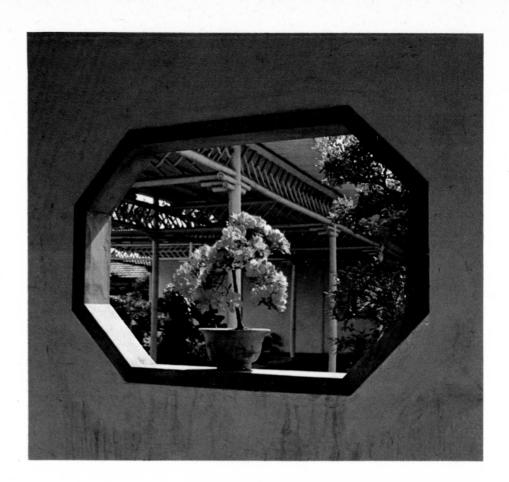

37. Hexagonal window with a rare azalea plant in the covered gallery of a Shanghai nursery. People's Republic.

As a result, foreign visitors can rejoice in some of the glories of ancient Chinese civilization in addition to witnessing the social and economic progress of the past quarter century. Indeed, itineraries have come to reflect an easy counterpoint between tradition and transformation. In Peking one may see the Children's Hospital in the morning and the Temple of Heaven in the afternoon. In Shanghai a long trek through the massive Industrial Palace may precede a leisurely appreciation of the sixteenth-century garden of the Yü Yüan. And in Loyang a tour of the magnificent Buddhist sculptures in the Lung-men caves is balanced by an inspection of the country's largest tractor factory.

The aim of this book is to achieve a similar balance between past and present. The photographs and commentary reflect impressions gained during several recent visits to China and attempt to show the magnificent artistic heritage of the Chinese people in the context of their society today.

THE PREHISTORIC PERIOD

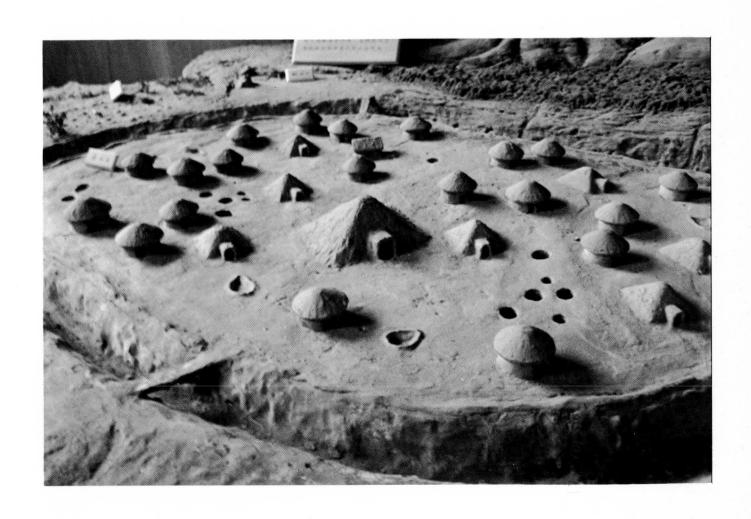

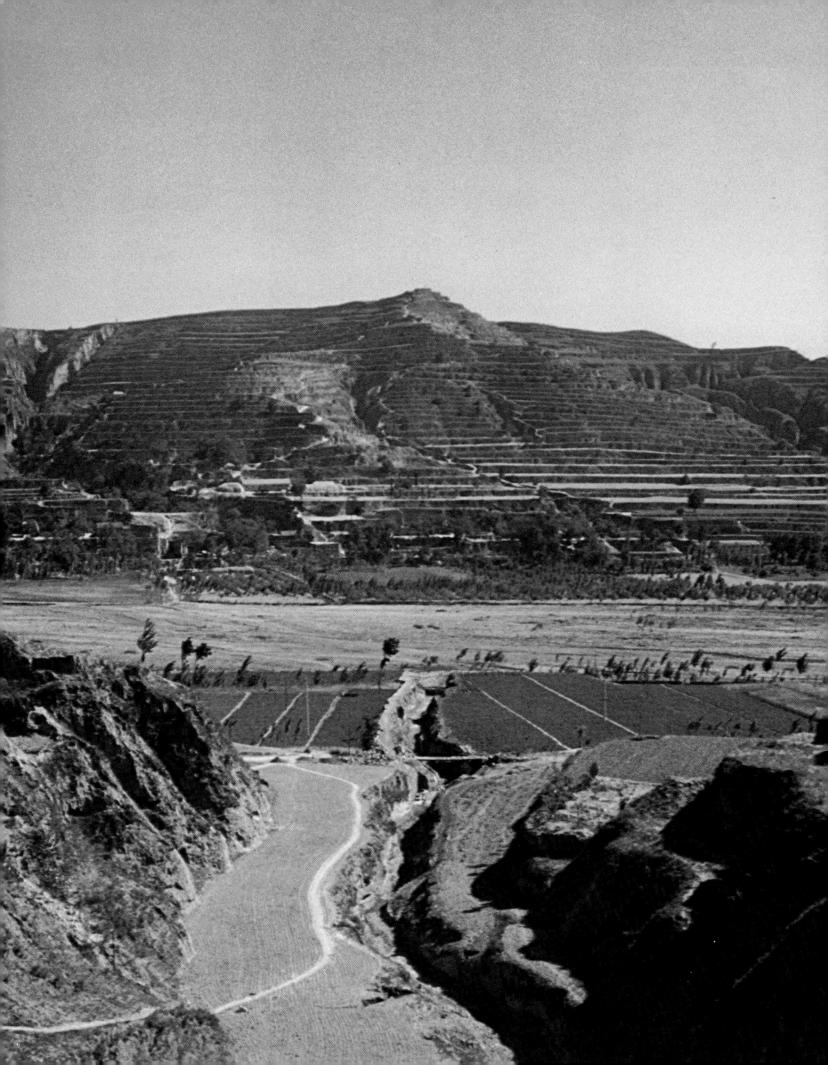

PRECEDING PAGE:

38. Model for Pan-p'o, a Neolithic village of about 4000 B.C. Shown at the Pan-p'o Museum. This modern reconstruction is based on foundations excavated near Sian, Shensi province. About one-fifth of the total area of the village has been excavated. The circular and quadrangular housing and pits were surrounded by a ditch.

39. Landscape east of Sian, Shensi province. The loess beds of north-central China near the Yellow River have been cultivated since prehistoric times, but now the mountainsides have been terraced to expand agricultural production.

The prehistory of China is a fascinating puzzle of archaeological and geographical facts, engaging myths, and vast numbers of unanswered questions. According to the Confucian Classics, Chinese civilization stretches back to the third millennium B.C. They tell of sage kings who showed the great Yellow River the way to the sea and taught their people how to drain the marshes and burn the forests for planting, how to carry on agriculture and spinning, and how to cast bronze. They tell of three successive glorious dynasties—the Hsia, Shang, and Chou—founded by kings who through their virtue and humility were granted the "mandate of heaven" to rule as temporal monarchs. Each of the three dynasties eventually came under the rule of tyrannical kings lacking in virtue and humility, who thereby lost the "mandate of heaven" and caused their dynasties to fall.

The Chinese, who have always been proud of and consumingly interested in their long history, accepted these mythic stories as fact until the early twentieth century, when a new breed of Chinese scholar began to question the antiquity of Chinese civilization. These skeptics viewed the "history" in the Classics as mythology. They proved that the larger part of the Classics was written no earlier than the sixth century B.C. and pointed out that there was no archaeological evidence of Chinese civilization before the Chou dynasty (?1027–256 B.C.). Li Chi, a distinguished archaeologist born in 1896, poignantly recalls his encounter with this new intellectual atmosphere. As a schoolboy before the revolution of 1911 (which marked the end of the Ch'ing dynasty and the beginning of the Republican era), Li Chi had learned that there were five thousand years of history; now this impressive time span was

being considerably shortened for lack of evidence. In subsequent years, Li Chi and others devoted themselves to reconstructing China's ancient history with evidence solid enough to meet the skeptics' standards.

At the beginning of the twentieth century, archaeology had not yet been scientifically applied to the study of China's past. There are a number of reasons why this was so. Modern archaeology is itself a relatively new discipline among the time-honored classical academic pursuits. Furthermore, the heart of archaeological work is digging in the earth to find buried relics of the past. The traditional Chinese considered disturbing the earth inauspicious; to dig wantonly would upset the precarious balance of forces between heaven and earth. And it was entirely taboo to dig up grave sites and disturb the spirits of the ancestors.

Bronze vessels presumed to be from the period of the Shang dynasty (?1523-?1027 B.C.) and coveted by connoisseurs and antiquarians had been looted surreptitiously from tombs by generations of grave robbers. But these bronzes appeared mysteriously on the market, without records of provenance or archaeological context that might prove their antiquity. Thus the existence of both the Shang dynasty and, by extension, the earlier Hsia, which had been written about in the Classics, was questioned. Beyond that no prehistoric Chinese materials had been excavated. Some scholars assumed that human habitation in China was relatively new compared to the Near East and Europe.

Several dramatic archaeological discoveries in the 1920s and 1930s renewed China's confidence in the antiquity of its civilization. While making a survey in north-central China in 1921, J. G. Andersson, a Swedish geologist who became a great archaeologist, uncovered Yang-shao, a Neolithic site (third millennium B.C.) which gave its name to one of the principal cultures of the "cradle of China." Andersson also made repeated visits to the Chou-k'ou-tien cave site, roughly thirty miles southwest of Peking. This site was extensively excavated from 1927 to 1929. Vast numbers of late Stone Age fossils were found there, but of greatest importance were the skull, teeth, and bones of Peking man, who flourished 500,000 years ago. When these remains were eventually analyzed, they served as conclusive proof of the antiquity of Chinese habitation.

In the late 1920s the ancient city of Anyang, the last Shang capital (flourished ?1300-?1027 B.C.), became the third im-

portant discovery and the subject thereafter of large-scale excavations. However, although Neolithic remains near Anyang showed that the area had been settled for an undetermined period prior to its occupation by the Shang, the Hsia dynasty mentioned in the Classics has yet to be positively identified and therefore still remains in the realm of mythology so far as archaeologists are concerned.

The excavation of Anyang was the first Chinese-government-sponsored archaeological dig. Conservative officials had effectively opposed previous plans in the 1920s, but a group of Chinese archaeologists gained the support and protection of Chiang Kai-shek and uncovered a sophisticated, ordered urban center of impressive proportions.

This period was the heyday of foreign collectors of Chinese antiquities. Ancient bronzes, jades, and ceramics could easily be bought in the curio shops of Peking, Shanghai, and Canton. Although Chinese law proclaimed all objects found in the earth to be the property of the Chinese government, the law was ignored and some officials even received a share of the profits from illicit sales. It was then that the great collections of Chinese art in Japan, Europe, and America were formed.

Today, while the treasures of India and other Asian countries continue to be pillaged for the benefit of the international collector, China and Japan have effectively stopped the cultural drain. The techniques of control are different in those two countries: Japan has designated and listed national treasures and important cultural properties which may not be exported. The Chinese government has simply taken over all museums, temples, collections, and art stores, and sells only what it considers unimportant to the national heritage.

Chinese archaeology changed greatly after 1949. Although it is hardly a first priority in a nation concerned primarily with advancing its industrialization and agriculture, emphasis has been placed upon increasing the knowledge of ancient China through a number of excavations that recognize the role of archaeology in glorifying the great tradition of Chinese civilization both at home and abroad.

Most Chinese archaeological sites have been found accidentally, including the Neolithic village of Pan-p'o, which was uncovered when foundations for a factory were being excavated. Rarely has the archaeologist in China gone to the plains with the Classics in hand to locate a lost city, as has happened in the Mediterranean areas with the Bible or Homer as guide. Some Chinese excavations have, however, been plotted out in

advance, like that of the tomb mound of Ming dynasty Emperor Wan-li (r. 1573–1620).

Communist Chinese literature explains that when archaeological sites are discovered by chance, they are reported to the regional archaeological committee, which in turn informs the national organization for archaeology. Excavations are organized by archaeological teams who may call on the army and on local peasants and workers for help. A dig is often carried out with extraordinary speed, judging by Western standards. A few months have sufficed to complete some major excavations that in the West would take years. While it is true that loss and breakage may occur when digging by untrained manpower proceeds with such speed, the Chinese have certainly exhibited and published information about many remarkable treasures found since 1949.

The village of Pan-p'o (c. 4000 B.C.), four miles northeast of Sian, was excavated during the period 1953–57, a time span which does not reflect the inordinate speed of other digs. One-fifth of the total village was excavated and roofed over for preservation; adjoining the site, a museum was built to display a number of objects accompanied by extensive explanatory labels.

The people of Pan-p'o were part of the Yang-shao Neolithic culture, which had settlements on the terraces of fine-grained, wind-blown soil called loess, in north-central China near the Yellow River and in northwest China. They are identified by a fine ceramic ware ranging in color between buff and red and decorated with black and red geometric patterns. This same Yang-shao culture also produced a coarse sandy ware often decorated with impressions made by pressing cord or wovengrass matting against the wet clay. Remains of another Neolithic culture, called Lung-shan, which produced a black ware, have also been uncovered in north-central China and in the eastern provinces. Relative dating of these two cultures is under debate, although it is known that Yang-shao was the earlier—lasting from about 4000 to 2000 B.C.—and that Lungshan thrived from about 2000 B.C. until the beginning of the Shang dynasty, with pockets remaining during the Shang and continuing into the Chou period. But recent finds have brought to light fresh material which may serve to reorganize all scholarship on prehistoric China.

There is a wealth of information on the village of Pan-p'o, which is typical of many hundreds of other Neolithic settlements. It is situated near a tributary of the Wei River, itself a

o. Bowl in the style of Miao-ti-kou, Honan province. Yang-shao culture, c. 3500 B.C. Buff earthenware decorated with reddish slip and black pigment. Shown at the Imperial Palace, Peking.

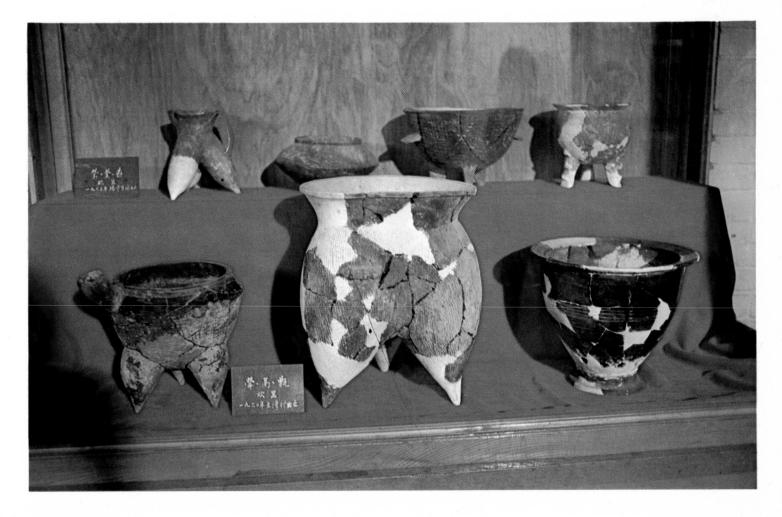

tributary of the great Yellow River. The community was basically sedentary, with agriculture providing the primary food source. Hunting, fishing, and gathering supplemented the diet. Because of the number of prehistoric communities clustered near the southern reaches of the Yellow River, the area has been called the "cradle of China." But there are great differences between the "cradle of China" and the "cradle of civilization" communities which grew up along the banks of the Tigris and Euphrates rivers and the Nile. The Chinese settlements were located some distance from the river, presumably to avoid the great seasonal floods. Mesopotamian and ancient Egyptian agricultural communities contemporaneous with Neolithic China utilized the annual inundation for fertilization of the soil and the trapped waters for irrigation. The ancient Chinese did not use irrigation but depended on the small annual rainfall to grow millet and sorghum.

The settlement of Pan-p'o itself was quite large, covering roughly 70,000 square meters. The foundations of forty-six houses, over two hundred storage pits, and remains of thousands of tools and pieces of ceramic have been unearthed. It has been estimated that as many as two hundred families could have lived in this village at any one time. A ditch surrounded the housing area, which covered roughly 30,000 square meters. Chinese archaeologists called this a "defense" ditch, but it was more likely used for drainage and to keep dogs and pigs from wandering away into the fields. All indications point to a peaceful existence.

Two kinds of houses were built at Pan-p'o; most were round, but some were quadrangular. Similar building techniques were used for both styles. The floors of the buildings were sometimes sunken and sometimes at ground level. The floors and wattle-and-daub walls were plastered with clay. Grasses collected from the plain were soaked in mud to provide a cohesive thatch roofing material, and the roof was supported by wooden pillars made of hewn logs driven into claylined holes in the earth. The entrances of all the houses faced south, to avoid the bitter north wind of winter. Interior areas for eating and sleeping appear to have been defined by pounded-earth platforms. Woven-grass matting and animal skins were probably used as bedding and decoration. A central fire pit served for cooking and heating. Warm clothing was sewn by the women, who used bone needles.

The larger quadrangular houses had roughly twenty square meters of space, which was enough for a family of four, ac-

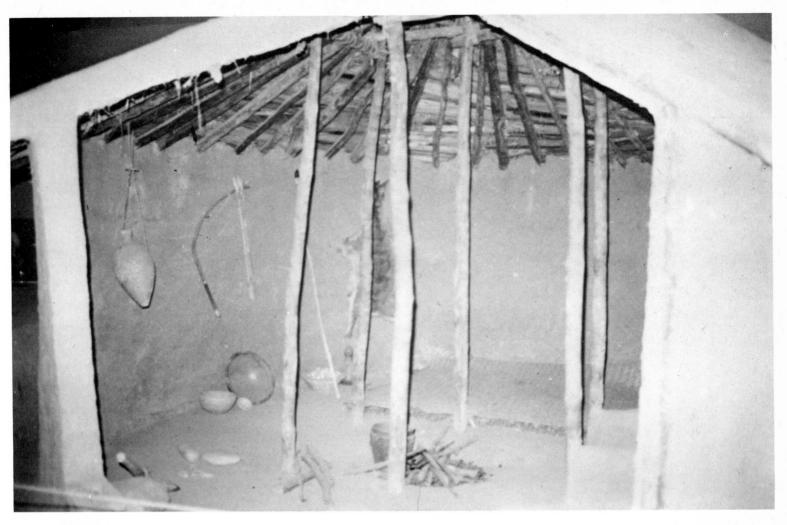

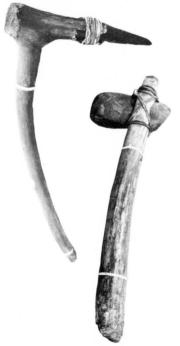

43, 44. Stone-and-wood ax and dibble from Pan-p'o. Shown at the Pan-p'o Museum.

42. Speculative reconstruction of a circular house at Pan-p'o, made of wattle and daub with a thatched roof. The Pan-p'o excavations have been roofed over for protection.

cording to Dr. Judith Treistman (The Prehistory of China, p. 44).

The skillful craftsmanship of the Pan-p'o inhabitants is shown by their agricultural tools, such as axes, adzes, and dibbles (used to make holes in which to plant seeds), and gear for hunting and fishing, such as arrowheads, fish hooks, and net sinkers. The tools are designed with elegant simplicity and have a direct appeal, a rustic aesthetic which delights eyes weary of overdesigned machine-age tools.

It is the pottery, however, that best exhibits the exuberance and skill of the Yang-shao people. It is of high quality, varied in shape and design, and appears to share some characteristics with ceramics contemporaneously made in the Near East and notably in Central Asia. No one has yet established a defi-

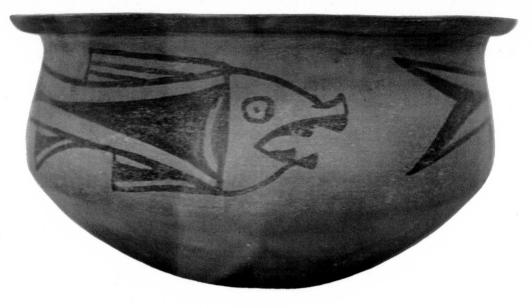

45. Buff earthenware bowl from Pan-p'o, decorated with black paint. Shown at the Pan-p'o Museum. The potter who decorated this bowl captured the essential quality of the fish with great skill and economy of means.

nite link between these cultures at that time, although later intercourse between China and these areas is well documented. Most scholars maintain that Chinese civilization grew up independently, but some suggest borrowings from other cultures. It may yet be proved that these views are not irreconcilable. If, indeed, the prehistoric Chinese society grew up independently, it may still have been enriched by contacts with Near Eastern or Central Asian prehistoric cultures.

The vast majority of Yang-shao pots are decorated with rhythmic abstract designs of straight lines, diagonals, cross-hatching, zigzags, circles, loops, open-ended ovoids, waves, and swirls. These designs are usually executed in black paint, enhancing the form of the pots and harmoniously uniting the flat patterns with the swelling volumes. They make a fit beginning for a culture that was to produce the greatest ceramics tradition in the world.

An outstanding piece of ceramic ware found at Pan-p'o differs from the later Yang-shao ware decorated with abstract designs. Its design borrows from the natural world, with marvelous fish swimming around the outside. One fish on the exterior wall is open-mouthed, with black teeth and a nose that resembles a pig's snout. Its body is defined by long curving lines containing two black triangles, one to accent the body, the other the tail. Three triangular fins finish the form, and the gill is indicated by an unpainted crescent within the black body triangle.

6. Buff earthenware water vessel with cord-marked design, from Pan-p'o. Shown at the Pan-p'o Museum. In the speculative reconstruction of the circular house (plate 42), this vessel is shown suspended by cords passed through the handles. It may have been used in this way, or it may have been sunk into soft earth—perhaps both storage methods were used.

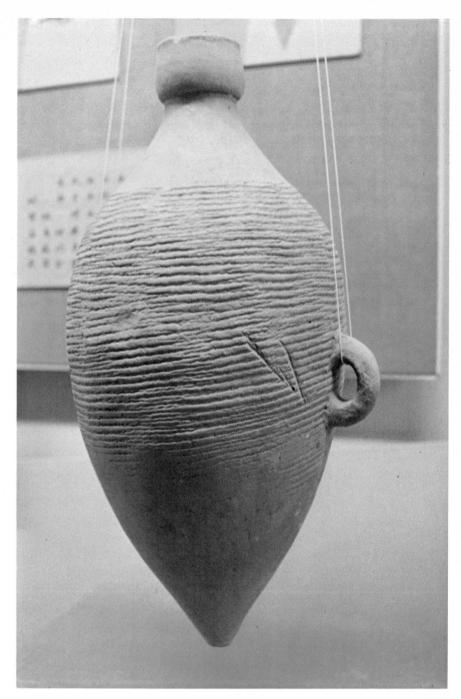

This pot reflects an intimacy with aquatic life acquired through sustained observation. It is a joyful recording of the natural world by people who were able to communicate its wonders through schematic visual forms.

Another kind of vessel found at Pan-p'o is a coarse, cordmarked, small-necked amphora with a pointed base, an eloquent example of rustic simplicity. Its pointed bottom suggests that the vessel may have been placed in the ground to keep its contents cool, but in the Pan-p'o reconstruction of a circular house, the amphora is hung on a wall by cording threaded through the earlike holes at the middle of the vessel. To make the decoration, a cord was rolled over the wet surface. Other examples of this kind of ware were decorated by pressing matting onto the surface or simply by "combing" (incising) the surface with a shell or stick. The pieces were fired in the community kiln located to the east of the dwelling area.

The function of pottery extended beyond the everyday cooking, serving, and storage of foods and liquids. Pots were also buried with the dead. In the graveyard, which lies beyond the enclosing ditch north of the housing cluster, most adults were buried with at least a pot or two at their feet. This rite suggests the beginnings of the ritual offerings for the afterlife, a custom which was to become ever more important in the later historic periods of Chinese civilization. Children were buried in pots near the houses, presumably to stay near their parents.

Chinese Communist historians have striven to fit the archaeological material into a Marxian periodization of Chinese history. They claim that for tens of thousands of years prior to the Shang dynasty a form of social organization prevailed in China that was a type of "primitive, utopian Communism," so named because people lived in clan communes. The members of each commune, it is said, were all related and elected their own leader. They held land, domestic animals, and tools in common, tilled the soil collectively, and shared the fruits of their labor equally. According to this view, because there was no such thing as private ownership of land or other means of production, society was not divided into classes and there was no economic exploitation of one group by another. Some Communist historians maintain that this primitive society was matriarchal, with women developing and practicing the techniques of agriculture while men hunted and fished. This may be true. At least this interpretation accords well with the present attitude, which seeks to glorify the role of the Chinese woman. Articles in Party organs constantly report female feats of strength, courage, and initiative in jobs formerly thought to be men's work, such as the drilling of wells and the building of bridges and dams. The Pan-p'o finds are seen as confirmation of women's basic right to work shoulder to shoulder with their husbands, brothers, and comrades.

ANCIENT CHINA

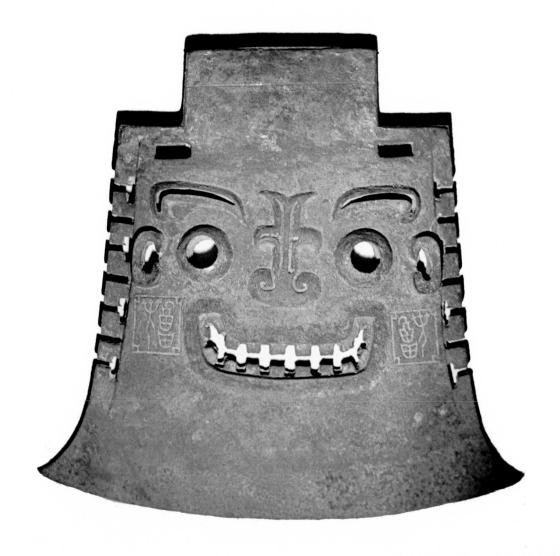

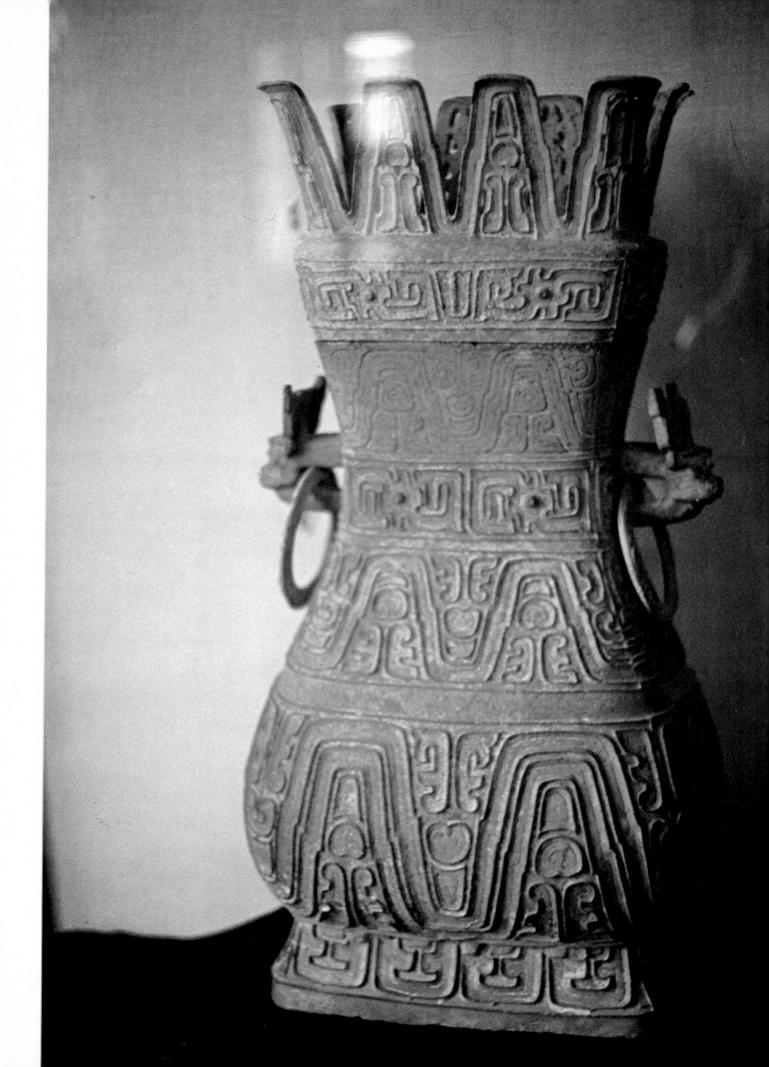

PRECEDING PAGE:

- 47. Ax head. Late Shang dynasty (?1300-?1027 B.C.). Bronze, $12 3/4 \times 13 1/2$ inches. Shown at the Imperial Palace, Peking. Found in the tomb of an important personage in Shang society, this ritual ax may have been used to decapitate victims chosen to accompany the deceased. The face has the round eyes and toothy grin of a skull, yet the nose, eyebrows, ears, and side hair, all features of the living, are included in stiffly curled forms. The strange combination of elements in this monster face is characteristic of Shang design.
- 48. Bronze vessel ("Wai-shu") from Ch'i-shan, Shensi province. Western Chou dynasty (?1027-770 B.C.). Height 35 inches. Shown at the Historical Museum, Sian. This large vessel (ting) was used to hold sacrificial food for ancestors and for the "Great Spirit Who Resides in Heaven." The body and legs of the vessel bear banded relief decorations combining a swirling scroll design with monster faces. The eyes of the profile monsters are small nobs, and their bodies curl ambiguously into birdlike or aquatic forms intertwined with the abstract scrolls.

THE ARCHAEOLOGICAL AND HISTORICAL EXPLANATIONS of ancient China that one receives in China today reflect a point of view quite different from that of either traditional Chinese or Western-influenced scholarship. Communist historians view ancient China proudly, while at the same time discrediting it as a viable model of society. Its achievements have been put under glass as a sanitized display stripped of ideological authority yet maintained in order to satisfy curiosity and foster national pride.

According to the Marxist interpretation of history, which is derived from Western experience, societies evolve in stages from primitive communism through slavery, feudalism, and capitalism to socialism, and eventually reach the paradise of Communism. Chinese Communist scholars have had many problems fitting their country's millennial heritage into the Marxist mold. They have found it particularly difficult to arrive at a consensus about the periodization of ancient history.

At present the dominant opinion seems to be that of Kuo Mo-jo, president of the Academy of Sciences and contemporary China's best-known intellectual. Kuo, who revised his own views considerably after first publishing a study of the question in 1930, now maintains that the advent of the Shang dynasty (?1523-?1027 B.C.) marked the end of primitive communism and the rise of the "Slave Society." This new stage in the Marxists' "inevitable" unfolding of history is said to have developed because gradual improvements in agricultural production techniques had brought about an increasing division of labor, the accumulation of large production surpluses, and the creation of a wealthy aristocratic class capable of owning and exploiting slaves. As a result of these changes, a monarchical form of government emerged, in which the king, the biggest slave owner and chief of the nobility, owned all the land but permitted its use by nobles, ministers, and other high officials.

According to Kuo and his followers, "Slave Society" lasted through the early part of the Chou dynasty, usually called the Western Chou (?1027-770 B.C.). Roughly midway during the latter part of the dynasty, called the Eastern Chou (770-256 B.C.), they claim, "Slave Society" gave way to "Feudal Society" because the slave economy had developed into a more complex landlord economy, in which exploitation of serf labor became the dominant form of agriculture and private ownership of land came to be recognized. The Communists use the term "feudal" in a much broader, less technical way than do non-Marxist scholars, bringing within its ambit various types of landlord economy rather than solely that type in which land is held by enfeoffment, as it was in medieval Europe. Thus, in their view, "Feudal Society" lasted for over two millenniums until the Opium War of 1839-42 initiated the process of turning China into what they call "a semi-colonial, semi-feudal" country.

The great philosopher-statesman Confucius (551–479 B.C.) and his disciples, who for over two thousand years exercised the most profound influence over Chinese society, lived during a chaotic transitional era. Confucius maintained that the early Shang period and, even more, the early Chou had been "golden ages" when the world had been ruled by virtue and all had been peace and order. He urged the aristocratic rulers of the Chinese states that were contending for power under the nominal reign of the Chou monarchy to emulate those supposedly model governments of ancient China. During subsequent millenniums, right-thinking Chinese rulers and their bureaucracies adopted the Confucian view of ancient China.

Communist historians, by branding the Shang dynasty and the early Chou as the era of "Slave Society" and by revealing and condemning what they believe to be its true nature, have sought to discredit the "golden age" in the minds of the Chinese people. In recent years they have also sought to discredit Confucius, calling him a descendant of the declining slave-owning aristocracy who preached an ideology that idealized the traditional virtues in order to uphold the old system and frustrate the slaves' efforts to end their oppression. Indeed, Communist Party propaganda organs have mounted a nationwide campaign against the Sage that has presented China-watchers with their most perplexing enigma as they seek to puzzle out who among the leadership is using history to attack whom.

Although art objects of the "Slave Society" are commended

for their beauty, Communist authorities emphasize that Chinese craftsmen were exploited by the ruling class. As Chairman Mao has said of traditional China: "The peasants and the handicraft workers were the basic classes which created the wealth and culture of this society." According to the Chairman, the resources expended to make the objects should have been spent for the welfare of the people, not for the delight of a few.

During the Shang and the early Chou, human sacrifices were made to appease troublesome cosmic spirits or to provide company for the dead in the afterlife. As one learns the details of these sacrifices, the term "Slave Society" takes on a more profound meaning even for those who do not necessarily subscribe to the Marxian analysis of history. Ritual bronze daggers and axes reveal that the victim was often killed with weapons decorated with spiral-relief designs similar to those found on bronze vessels (plate 47). Sometimes they show the holloweyed, toothy grin of a skull. Probably some of the people who were killed to accompany the dead were decapitated with these axes. Some excavations reveal that their severed heads were stored in one part of the tomb, their bodies in another. In other burial situations metal clamps held down other victims, who were incarcerated live in the tombs. The Chinese display the clamps along with photographs from the site showing the exact positions of the skeletons around the central chamber. In yet a third burial type victims were drugged or poisoned and then sealed into the tomb.

The "Slave Society" provides Communist historians with archaeological evidence that communicates a poignant object lesson to the masses, a lesson driven home through explanations, photographs in the exhibitions, and publications, lest the new Maoist man become too enamored of the glories of China's past. But while vocal in denouncing the horrors of the ancient elite and their exploitation of the skilled craftsmen and the masses at large, the People's Republic nevertheless preserves and celebrates the remarkable antiquity, continuity, and genius of Chinese civilization.

Shang culture reveals the early stage at which both the arts and sociopolitical institutions developed in China. Writing was an outstanding achievement of this period. The ancient characters have been preserved for us mainly on oracle bones, which were used for divination, and on some early bronzes bearing single-character inscriptions. When the Communist

historian assesses the value of these oracle bones, he disparages

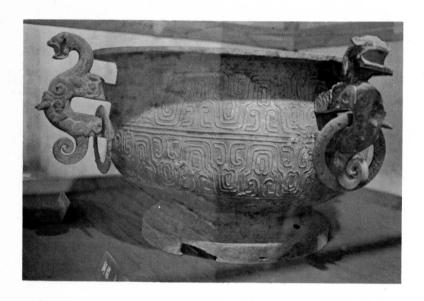

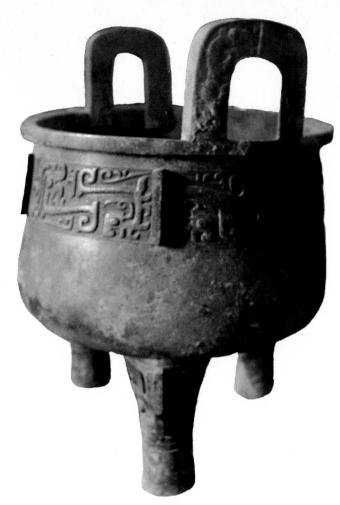

49. Bronze vessel found near Loyang, Honan province. Eastern Chou 770–256 B.C.). Height 17 inches, diameter 28 3/4 inches. Shown at the museum in Wang-ch'eng Park, Loyang. This large kuei was also used to hold ritual offerings. Monster faces are absent, but the handles are in the shape of demons, recognizable in this case as a cross between a seahorse and a dragon.

their use as superstition but extols the antiquity of the Chinese language. The written language has developed continuously for at least thirty-five hundred years and has served as a singular unifying factor within the immense diversity that is China.

From the Western viewpoint, it may seem strange that Communist historians even today feel the need to discredit the superstitions surrounding oracle bones. One must remember, however, that less than a century ago these bones were still being used in China because of their supposed magical powers and that related superstitions have continued to prevail among the peasants in the Communist era. In the practice of nineteenth-century Chinese medicine, "dragon bones," as they were called, were ground up and used in compounds dispensed as cures for a variety of ills, and the owners of medicine shops would buy them from peasants who found them in their fields. These traditional Chinese practices may be more properly viewed within the perspective of the vast popularity that astrology, palmistry, and the occult enjoy in the West of today.

jo. Bronze vessel ("Tsengcheng Yu-fu'') from Ching-shan, Hupei province. Western Chou dynasty (?1027-770 B.C.). Height 33 7/8 inches. Shown at the Imperial Palace, Peking. Like the ting, this fang-hu was one of many bronze vessels used for ritual purposes. Found during the excavation of the tomb of a Chou nobleman in 1966, the buried bronze had interacted with its environment to produce the handsome patina. The banded scroll design of the earlier ting (plate 48), with its powerful swirls, contrasts with the relaxed linear scrolls of the fang-hu. The ribbon-like scroll design has lost its intensity, yet the surface design as a whole has a marvelously lively quality.

In the last years of the nineteenth century, a Chinese scholar recognized that many oracle bones were inscribed with ancient forms of Chinese characters and began to collect them for study. These bones, some of which are 3,500 years old, from the shoulders of cattle (sometimes also from the shells of tortoises), were inscribed with questions addressed to the spirits of heaven and earth, such as the following: "Is it the proper time to sacrifice to deities? Is the weather right for plowing or planting? Will the next ten-day period be auspicious for hunting, for making war, for a journey?" When a hot stick was applied to a bone by a shaman, the heat caused the bone to crack; then the shaman "read" the crackles, telling the questioner how the spirits had responded. Sometimes the names of the questioners were recorded on the bones along with the oracular response and the subsequent outcome. Thus, these bones reveal to us not only the earliest known forms of the written language and a magical rite performed in the attempt to understand unseen forces but also the foremost concerns of ancient society.

Most Chinese believed that there was a universal harmony between man and nature, as exemplified by the endless cycle of the seasons. To assure the success of all things, they sought to keep this harmony in balance. Thus, by questioning the divine spirits as to the advisability of action, they hoped to avoid creating a disharmony which might trigger a natural or man-made disaster.

Bronze vessels are the quintessential image of ancient Chinese cultural achievement, communicating the aesthetic and technical sophistication of the Shang and Chou craftsmen (plates 48–50). Marvelous decoration enhances the power of the vessel forms, creating a perfect artistic unity. Whether the decoration represented magical figures to the supplicants who offered sacrifices in these vessels is still a matter of debate. Certainly the knob-eyed beings and fanciful hybrid birds and beasts within the sinuous relief swirls possess a powerful artistic magic for us today. And we must acknowledge the technological ingenuity of the ancient Chinese, who cast the vessels in intricately carved piece molds (composed of a number of sections).

The zenith of their achievement came during the late Shang (from about 1300 B.C.) and Western Chou (to 770 B.C.) periods. Thus, these bronze vessels serve as a bridge to the past, telling us about the highly developed rituals of an ancient so-

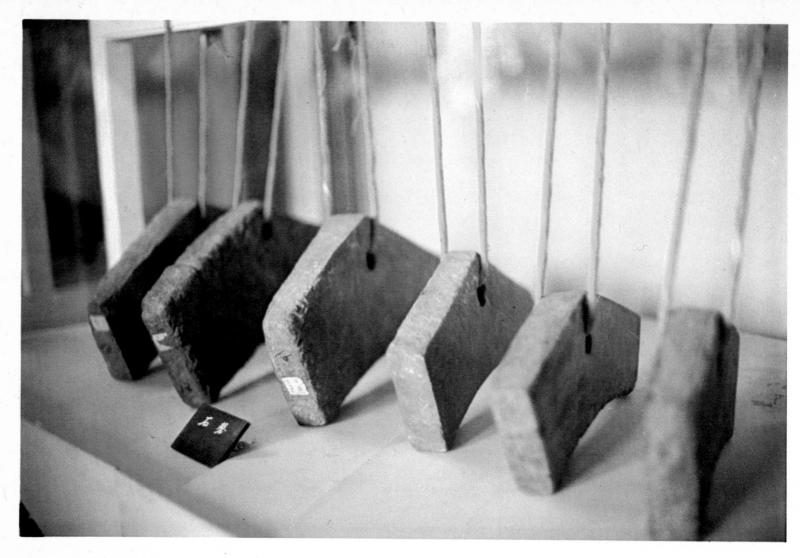

51, 52. Stone chimes, above, and bronze bells, opposite page. Eastern Chou dynasty (770–256 B.C.). Shown at the Imperial Palace, Peking. Both were hung and played by striking.

ciety. They were made for the presentation of food and drink to the primordial ancestor (the "Great Spirit Who Resides in Heaven"), all the ancestors of the ruling dynasty, and the ancestors of aristocratic families who participated in sacrifices. The spirits of wind, water, mountains, and various crops may also have been cajoled and honored by offerings, as they were in later times.

Details of the ceremony for the dead may be found in a legend usually ascribed to the third century B.C., the story of a late Chou king whose favorite concubine died. She had accompanied the king on a hunting trip and had caught cold in the damp marsh. A description of this lady's funeral appears in The Freer Chinese Bronzes (John A. Pope et al, p. 8). However, the translators warn that the date of the legend is unsure and may be as late as the first century A.D. If the story was written in the first century, the funerary practices it describes may vary somewhat from those of the Chou, yet they are surely worth recalling here:

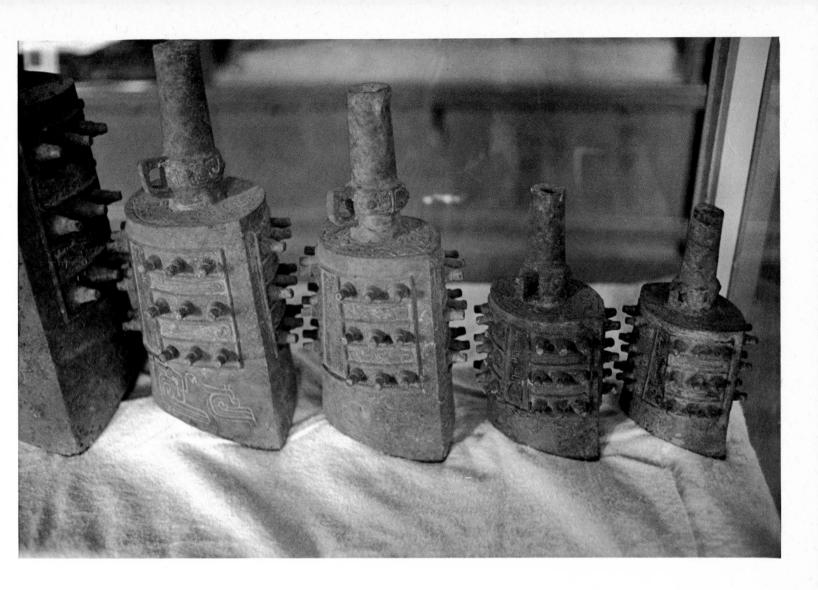

53. Jade disk (huan). Eastern Chou dynasty (770–256 B.C.). Shown at the Imperial Palace, Peking. Court officials wore jade disks as badges of rank. Numbers of these disks have been found in some coffins; they were placed beside the head, arms, and feet of noblemen.

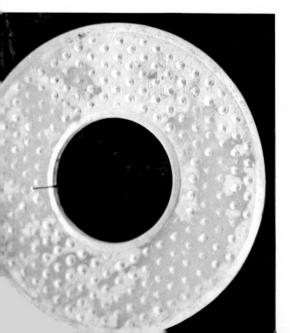

The sacrificial officer was in charge of the sacrificial tables on which he spread offerings such as meat soup, raw meat, dry meat, minced meat, dates, millet gruel, cold porridge, dry fish, scallions, and a hundred other things. There were twelve tsu of raw meat and raw fish and ninety tou of cooked meat and forty ting, tun, hu, and tsun of hot food and wine [tsu means platter; tou, ting, tun, hu, and tsun are different kinds of bronze vessels]. . . .

The sacrificial officer began offering the sacrifices by presenting the soup and wine to the chief mourner . . . who received them with a bow and presented them to the spirit of the dead. The ladies also presented their offerings to the chief lady mourner . . . who performed the ceremonies [as the male mourner had]. The sacrificial officer then gave some of the wine to the court musicians.

Music was a vital part of ancient offering rites. Drums, bells, chimes, pipes, and stringed instruments were all used in early Chinese music. Ancient literature tells of elaborate ceremonies

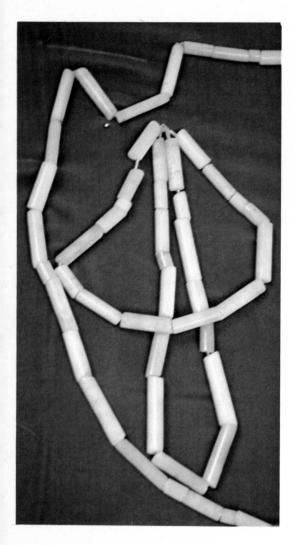

54. Jade beads. Shang dynasty (?1523–1027 B.C.). Shown at the Imperial Palace, Peking. These beads from Hunan province were found inside a bronze vessel along with other jade objects. The smallest has a diameter of about 1/2 inch.

in which music and delicious, pungent foods in bronze vessels were offered not only to the spirits of heaven and of the ancestors but also to celebrate seasons, rains, and military victories. Liturgical chanting and dancing were part of the musical offering. Clothed in appropriate colors, the dancers and musicians sought to convey the mood of the season. Sometimes the dance-mime, using stylized rhythms and gestures, evoked warlike imagery, or the coming of the rains, or honor to the dead.

Because of the fragmentary nature of the archaeological and textual evidence, experts have found it impossible to reconstruct completely the nature of ancient music and dance. Yet some musical instruments have been recovered from tombs, where they were probably put to serenade the deceased with everlasting harmonies.

Two of the most durable types of instrument were stone chimes and bronze bells (plates 51, 52). Both were hung in series from a rectangular wooden frame by silk cords or leather thongs and were played with a striking stick. Although their visual qualities afford aesthetic satisfaction, not to hear them played is like being deaf at the seashore.

The ancient texts tell us that on the battlefield the sound of the stone chimes was a call to arms that would make a man willing to give up his life. If he heard the chimes at home, he would think of heroes who had died in the service of the king. Stone chimes also accompanied dances to invoke rain. Both music and dance imitated the sounds and patterns of wind, rain, and thunder.

Sets of bronze bells, like the stone chimes, varied in size and produced a variety of notes probably often organized in a pentatonic scale. Because no scores have survived (if, indeed, they existed), it is hard to know whether the traditional Chinese music heard today bears much relationship to ancient music.

Bronze bells were cast by the same piece-mold technique used to make bronze vessels. One characteristic pattern of the later Chou period is that of high-relief, decorative bosses which cover the surface area and stand out from it like the quills of an angered porcupine. This design, compared with the lower, integrated relief patterns of the earlier vessels, is almost aggressively virile. Within this design the craftsmen seem to have expressed the functional duty of the bells, which, like the stone chimes, were struck to send out a call to arms and to stir the hearts of soldiers in battle.

Music in ancient China was bound into prescribed ritual,

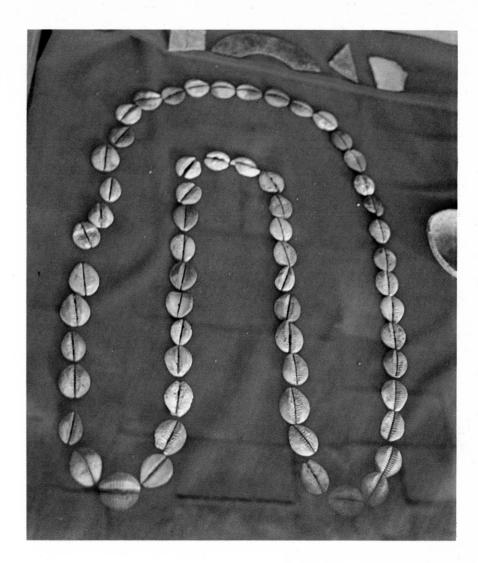

55. String of cowrie shells. Shang—Chou dynasties. Shown at the museum in Wang-ch'eng Park, Loyang, Honan province. The Chinese, like many other ancient and primitive civilizations, treasured cowrie shells for their beauty and provocatively female shapes.

and contemporary Chinese commentators are quick to point out that art and music in ancient China fed the superstitions which the elite manipulated to enslave the people. They maintain that the new forms of art, music, and literature "serve the people." Although the magical powers of ritual music have been repudiated, music nevertheless constitutes part of the catalogue of ancient achievements presented to bolster national pride, so that the political orientation of Chinese Communist music seems more understandable.

Carved jade has been a favorite medium for ritual and decorative objects since ancient times. Ancient jade is, in fact, nephrite, which may have been mined in China. It comes in a variety of subdued colors ranging from creamy whites and pale greens to red-browns. It was treasured for its uncompromising hardness, for its translucent beauty that hides no flaws, and for the pure tone it produces when struck. These qualities are all

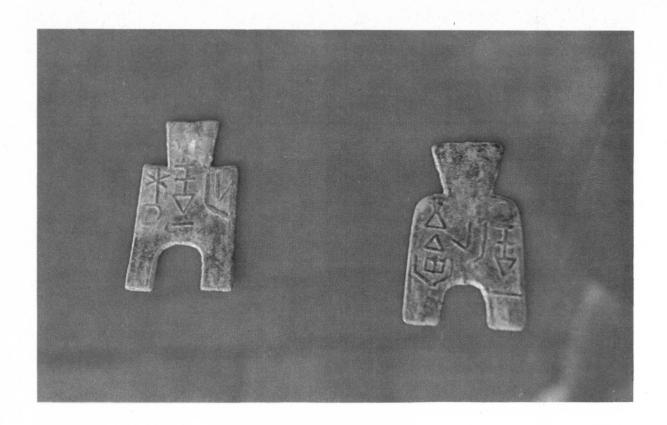

associated with virtue. The hardness of jade makes it extremely difficult to carve, even for the modern craftsman who uses power-driven abrasives. Thus, the patience and skill of the ancient craftsmen are especially remarkable.

Jade objects that were buried with the dead, like other funerary accouterments, tell much about the treasured things of ancient life. Mysterious long, rectangular objects enclosing a cylindrical void are thought to be objects of earth worship; other pieces, circular disks with three notches on the outer rim, may have been astronomical instruments. Necklaces of jade beads (plate 54) and small carved plaques of jade sewn on garments enhanced the beauty and dignity of ritual costumes. A circle of jade was worn as a badge of rank in the service of the king. Jade knives and scepters were fashioned for ceremonial use. In Eastern Chou, jade pieces were placed in the openings of the bodies of the dead, and jade disks were sometimes placed at the head, feet, legs, and arms of the corpse (plate 53). And later, in the Han period (206 B.C.-A.D. 220), pieces of jade were sewn together to make complete funerary garments (plates 69, 82, 83).

Current Chinese burial practices outside the People's Republic continue the tradition of providing for the needs of the deceased in the afterlife. During 1,500 years of assimilation in

56. Bronze coins. Late Eastern Chou dynasty (403–256 B.C.). Shown at the museum in Wang-ch'eng Park, Loyang, Honan province. These spade-shaped coins, minted by the State of Wei, replaced real spades as a medium of exchange.

China, the Buddhist establishment took over the ancient Chinese practice of outfitting and honoring the dead. It is still possible to visit Buddhist temples in Macao, Hong Kong, Singapore, and Taiwan where elaborate funerary sets are offered. Small-scale houses, cars, food, clothing, and money are fashioned out of paper. These things are burned with the expectation that the rising smoke will deliver the objects to the dead. In watching the preparation and performance of these rituals, one cannot help being impressed by the outstanding quality of the paper fabrications—products of a long tradition of fine craftsmanship—and the thoroughness with which the dead person's possessions are re-created.

The funerary practice of offering money to the dead is not a new phenomenon. Money is commonly found in the tombs of the ancients. Strings of cowrie shells, worn as decorations and kept as magical charms, were also the earliest medium of exchange (plate 55). This kind of shell may have come to China from as far away as the south Indian waters, but cowries, with their provocative female shapes, were used as money in many ancient cultures of the world.

The Chou people, when they came from western China and conquered the Shang about 1027 B.C., not only carried on the sedentary agricultural practices developed in Neolithic times but also absorbed and assimilated Shang culture. Some of the distinguishing Shang characteristics assumed by the Chou, in addition to the mastery of bronze casting for sacrificial vessels and weapons, were a highly developed writing system; a complicated and efficient political and military organization, including the use of chariots; a theocratic state dominated by ancestor worship; underground burials in chambers; an advanced ceramics industry; the development of a sophisticated architecture and decorative arts; the cultivation of silkworms and the technology of silk weaving.

In Chou times the prosperity of China increased along with a developing mercantile economy. Bolts of silk, ingots of precious metals, and cast-bronze objects such as knives and spades were used as mediums of exchange. In the last stages of the Chou, called the period of the "Warring States" (403–221 B.C.), these were supplemented by copper currency. The earliest metal money was cast into miniature replicas of knives and spades (plate 56). Then circular copper coins with square openings at the center came into use. The open centers allowed the coins to be strung together with a cord to make a

"string of cash" (plate 143). This distinctive type of coin, containing the symbolic shapes of heaven (round) and earth (square), along with metal ingots and silk bolts, continued to be an accepted medium of exchange in China into the twentieth century.

Traditional Chinese scholars held that the virtue of the kings was inextricably related to the rise and fall of each ruling house. The character of the monarch ultimately determined the gain, and then the loss, of the "mandate of heaven." In theory, one who was not the hereditary heir could be awarded the ruling mandate because of his flawless virtue. Each new dynasty was supposedly founded by a humble, pious, dutybound, humanitarian paragon whose conduct served as an example to his people. The Classics tell of the inevitable decline in virtue of the succeeding monarchs, until debauchery and tyranny resulted in the loss of the "mandate of heaven" to a new dynasty. Monarchs who lost the mandate were said to be proud, impious, and unwilling to fulfill their duties. They gave no thought to the welfare of their people and made unreasonable demands upon them, imposing back-breaking taxes and forced labor in order to build unnecessary palaces, wear extravagant clothes, and engage in excesses of wine and women. The death knell of a dynasty was signaled by earthquakes, floods, droughts, eclipses of the sun, rebellions, and invasions.

The histories of Shang and Chou set forth in the Confucian Classics established the pattern of traditional Chinese historical interpretation. Long after the Chou conquest of the Shang, when the story was already several hundred years old, it was written that the last Shang tyrant had been replaced by a glowingly virtuous Chou king. To strengthen the case for Chou legitimacy, the histories relate that the first king was descended from a mythical sage-king. It was said that the favorite concubine of this mythical progenitor went into the fields one day and saw the footprint of a giant. Delighted with what she saw, she put her own foot inside it. As she did so, she became pregnant, and later gave birth to the first of the Chou.

In the last quarter of the eleventh century B.C. the first Chou king established his capital on the Wei River near Sian in Shensi province. An early Chou pleasure palace was built at the foot of Black Horse Hill, thirty-five miles east of Sian. This spot, now called Hua-ch'ing-kung (plates 57, 58), was selected not only for its stately beauty but also for its natural hot springs, and many Chinese rulers have floated in its regenera-

57. Pavilions, walkways, and moon gates at Hua-ch'ing-kung, Shensi province. This twentieth-century resort, built in the traditional Chinese palace style, freely borrows picturesque elements from the imperial architecture of past millenniums.

58. Hua-ch'ing-kung, the hot springs resort near Sian, Shensi province, built in the twentieth century. Black Horse Hill rises in the distance.

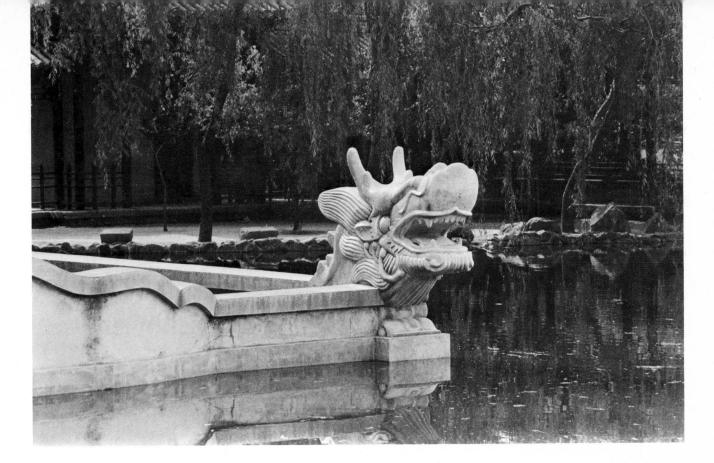

59. Dragon head, detail of marble boat at Hua-ch'ing-kung, Shensi province (see plate 58).

Traditional Chinese stories tell of dragons who reside in clouds, waterfalls, rivers, and the ocean. It was thought that dragons controlled the rains and floods. Elaborate rituals were performed to cajole dragons into bringing rain at times of drought or to stop the water in times of flood.

tive waters. It whispers tales of kings, concubines, courtesans, and generals from the Chou dynasty to modern times.

The Chinese tell a colorful story of the intemperate Chou monarch whose folly led to the loss of the western part of his kingdom some twenty-eight hundred years ago. Although his favorite concubine was a rare beauty, the king was not completely pleased with her because she rarely laughed. To no avail he imported magicians and acrobats and tried everything to make her gay. One day he hit upon the idea of lighting the signal fire on top of Black Horse Hill, which was an emergency call for help from his vassals. The vassals rushed to the palace to aid the king, only to discover that a joke had been played on them. The concubine, amused to see the king's men embarrassed, laughed out loud. So pleased was the king to see his usually sullen favorite amused that he replayed the joke several times. Inevitably, there came a time of real danger, when the king lighted his signal fire and his angry vassals did not come. The Chou capital was invaded and sacked, and the king was forced to flee to the east, where he established a new capital at Loyang for his sadly truncated kingdom.

When the capital was reestablished in the area of Sian during the Sui (581–618) and T'ang (618–907) dynasties, monarchs once again built palaces and gardens at the foot of Black Horse Hill so that they could enjoy the soothing waters of the

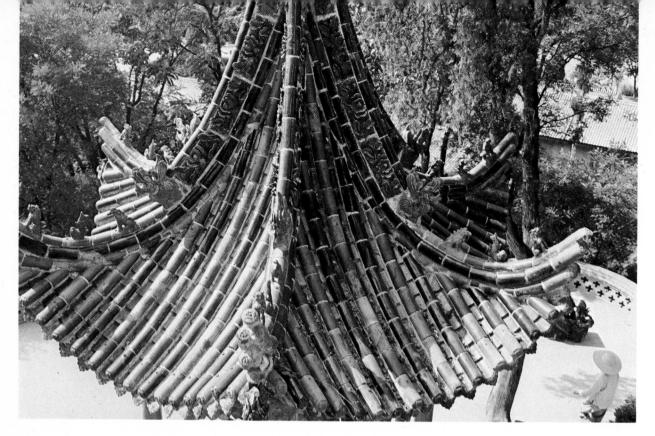

60. Tiled roof of a gazebo at Huach'ing-kung, Shensi province.

The parade of guardians on the spines of the roof were positioned to ward off evil spirits. The tiny pavilion provides a perfect spot for moon viewing, solitary contemplation, or intimate conversation.

hot springs. Although nothing of the Sui or T'ang palaces remains, a white marble tub shaped like a tiered lotus flower and inlaid with colorful designs is claimed to be the pool in which Yang Kuei-fei, the famous T'ang imperial consort, bathed. After the T'ang period some Taoist temples were built on the site, and the pools were periodically renovated. In the Republican period (1912–49), a full-scale resort was built.

In December, 1936, a major event in modern Chinese history occurred at the hot springs. Generalissimo Chiang Kaishek, faced with both Communist revolution and Japanese invasion, went to Sian to confer with his ally the warlord Chang Hsüeh-liang. Chiang Kai-shek wanted the so-called "Young Marshal" to carry out a policy of "pacification first, then resistance," which meant that an all-out effort to destroy the Chinese Communist armies was to precede any struggle against the Japanese invaders. However, the Communists had convinced the Young Marshal that all Chinese brothers should unite against the Japanese. They also suggested that the Generalissimo's motive in ordering the Young Marshal's forces to fight the Communists instead of the Japanese was to destroy both rival Chinese armies, thus wiping out all internal opposition to his control of China.

During his stay at the hot springs, Chiang Kai-shek rejected the Young Marshal's proposals for a united front against the Japanese. When the forces of the Young Marshal sought to shoot their way into Chiang's room to take him prisoner,

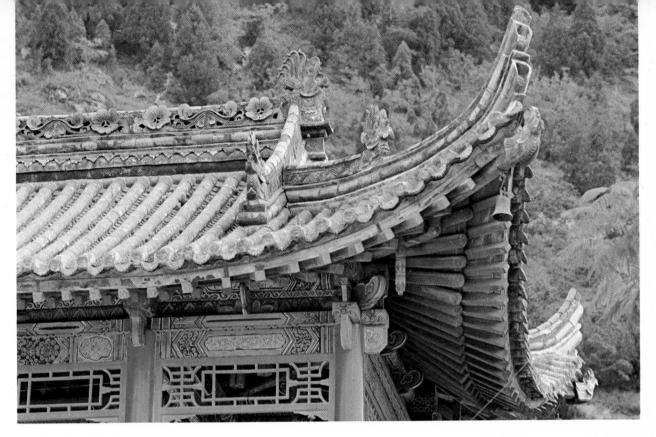

61. Detail of roof bracketing at Hua-ch'ing-kung, Shensi province. This modern roof line includes elaborate brackets and rooftop course designs. On ancient Chinese buildings such decorative elements were functional. Originally the brackets helped to bear the weight of the roof and the courses worked as weights to hold down the thatch.

Chiang tried to escape in the predawn gloom by climbing out of the window of his ground-floor room and scrambling up Black Horse Hill. After showing visitors his room and the place where he was caught, Chinese guides tell with some relish that Chiang had been in such a hurry that he lost his false teeth and was captured in his nightshirt.

After almost two weeks of bargaining with Communist leaders, including Chou En-lai, the Generalissimo agreed orally to some of the demands, and the scene was set for the ensuing united-front resistance against the Japanese.

Today, the architecture at the hot-springs resort is an elaborate twentieth-century version of the palaces of the past (plates 57-62). The most basic building forms can be traced back to Shang prototypes, such as rectangular halls with wooden columns. The walls are simply protective and decorative screens; they do not bear the weight of the roof. The painted brackets under the roof lines were real supporting members in former times; now they are merely decorative adjuncts (plate 61). The curving "dragon-back" roofs are a parvenu feature, having been used in Chinese architecture for little more than a thousand years. Tile roofs had replaced thatched ones on royal buildings as early as the Chou dynasty, but the tile roof lines continued to recall the original thatch shapes. Today the functions of gable ends as well as those of brackets have been forgotten, and the form is simply decorative—or, as eighteenthcentury Europeans called it, "picturesque." It is likely that

62. Lotus pond at Hua-ch'ing-kung, Shensi province. A citizen tries to catch frogs.

the original thatched roofs were topped with wooden logs and that gable ends were bound in spots in order to form a wind baffle weighing down the grass-and-mud mixture. In the tile version the wind baffle is simply copied, even though it has become technologically obsolete, and the old form is incorporated as a decorative element. Thus the rooftop courses, elaborated with bands and crowned with sinuous flowers, are transformed versions of the ancient log wind baffle. The roof guardians may have grown out of the knoblike weights that held down the ridges of the gable ends.

Circular pavilions with humorously curved roofs function as gazebos from which to view the moon and stars (plate 60). Moon gates, curving walls, and latticed screening are all elements of traditional Chinese architecture (plate 61). They have been brought together here in a nostalgic recollection of imperial grandeur that emphasizes the conservative nature of traditional Chinese society, exemplified in the enduring architectural forms.

Water has always been an integral part of palace-garden design. At the hot springs, three formal rectangular halls overlook a small free-form lake (plate 58). Set against the modest mountain with its wrinkled yellow-earth gorge, the lake reflects graceful willow trees, a stone bridge with a pavilion for viewing, an abundant growth of elephant-ear lotus leaves, and a "marble boat." The "marble boat" is, in fact, a pavilion built out into the lake. Two horned dragons pose openmouthed at the front of the "boat," as if they had just emerged from the watery depths to carry the vessel across the water, aided by a marble paddle wheel (plate 59). This fantasy is a reproduction of the famous nineteenth-century one at the Summer Palace near Peking. In both, the pleasures of the water can be enjoyed without suffering the inconvenience of a real boat.

THE FOUNDING OF THE EMPIRE

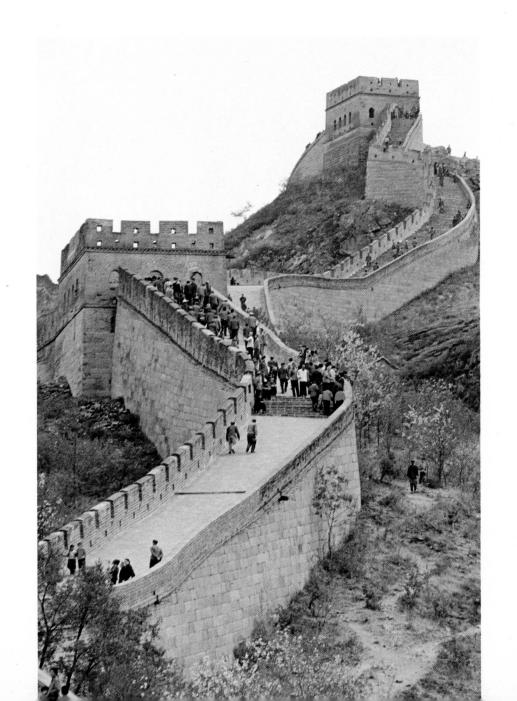

PRECEDING PAGE:

- 63. A section of the Great Wall,
 Hopei province. Built in the
 third century B.C. and rebuilt
 in succeeding periods. The portion
 shown here is a modern
 reconstruction. The Great Wall
 extends from the Gulf of Pohai
 to the Central Asian Desert in
 Kansu province.
- 64. Sightseers relax on the Great Wall. Most people climb the wall at an easy pace, for the steep grades are tiring. Visiting with friends and eating picnics are all part of the outing.

No monument is a more potent symbol of the power, glory, struggle, breadth, and antiquity of the Chinese empire than the Great Wall. Several centuries before Christ construction began on this massive rampart, which threads its way from the Gulf of Pohai on the east coast, around mountains, through forests and steppe lands, and deep into the deserts of northwestern Kansu.

The Wall, which separated agricultural, sedentary China from the nomadic, pastoral northern peoples, was built because north China has no natural barrier to stop invaders. To the east and southeast there is the ocean. The dense jungle on the southern borders joins the almost impassable mountains of the southwest. In the far west, the great Central Asian desert forms a natural barrier. North China provides the only easy avenues for entry. Yet the Great Wall, like other permanent lines of defense such as the extensive Roman walls or the Maginot Line, has never been entirely effective in keeping out invaders. The nomadic peoples who roamed the steppe lands continued to sweep down upon China in wave after wave. Even today the old fear of invasion from the north persists—the Soviet Union is now the country the Chinese fear most.

Nevertheless, the Wall has continued to serve as a tangible reminder of the enduring and cohesive nature of Chinese civilization. It is truly overwhelming, a serpentine miracle of engineering that extends for roughly 2,500 miles. Rebuilt and expanded by many rulers of China at different times, it averages 24 feet in height, 21 feet in thickness at the base, and 18 feet in width at the top. It is made of earth and gravel, and was faced with stone until the fourteenth century, when the Ming covered it with brick.

Although the Wall is an amazing construction, it is not forbidding. It seems to blend into the mountains, making it perfect for hiking and picnics, and it has become a favorite spot for Chinese families and friends to spend their days of leisure (plate 64).

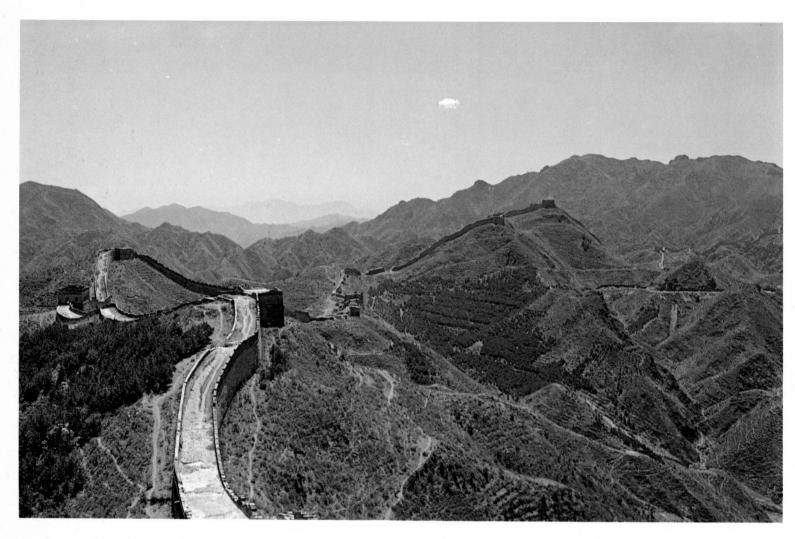

65. Distant view of the Great Wall, Hopei province. A miracle of engineering, the wall threads over mountains and through forests, valleys, and deserts. Only a few sections have been repaired; most of it is in ruins. The Ming were the last to rebuild it as a defensive fortification.

One can stroll on it for over a mile near Peking, following the sinuous, precipitous path of its restored sections and luxuriating in vistas of its unbroken thread vanishing into endless mountains. One can climb the lookout towers and stand there as defenders stood for two millenniums under the burning summer sun, where the winds from the desert inflame the crusty earth with gusts of hot air that soar to 130 degrees.

The Wall's powerful configuration does not divulge the suffering, isolation, and death of those who built it, nor does it whisper grandiloquent stories of battles fought on it. It is difficult to imagine the generations of Chinese soldiers who huddled around winter fires or scanned the horizon for marauding hordes. In many places it is so precipitous that one wonders how it could have fulfilled its secondary function of serving as a northern highway for communication and supplies. It seems impossible that couriers, army cavalry riding five abreast, and horse-drawn chariots could, as was reported, have raced from post to post along its top.

The idea of building the Great Wall was conceived and realized by Ch'in Shih Huang-ti, unifier of China and self-proclaimed "First Emperor" of the Ch'in dynasty, which was established in 221 B.C. In ancient China, as in medieval Europe, cities had been made secure from their enemies by building walls around them. Some states, in the fifth and fourth centuries B.C., had extended this military concept by building walls at the edges of their domains to prevent invasion by aggressive neighbors. After the king of Ch'in conquered the other states contending for power in the later stages of the Chou dynasty and formed the empire, he decided to link the walls of the various states and expanded these ramparts into the longest fortification the world has known. Unlike the kings of Chou, who had presided over a system of princely vassal states, the First Emperor developed a centralized, bureaucratic military government that gave him far greater control over the entire populace. He mustered a forced-labor crew of 300, ooo men, who worked on the Wall over a ten-year period. In addition, he tried to solve the problem of internal communication with the expanding empire by building roads and canals and standardized not only weights and measures (plate 66) but also the axle lengths of wagons. This last achievement made wagon travel easier by enabling vehicles to travel in the same ruts on the pounded-earth roads.

According to Confucian historians, since the First Emperor was a tyrant—unforgivable in the Confucian judgment—his

66. Carved ivory ruler. Han dynasty (206 B.C.-A.D. 220). Shown at the museum in Wang-ch'eng Park, Loyang, Honan province. The emperor fixed the measurements at the outset of dynastic rule.

achievements could never outweigh his oppressive methods. Generations of Chinese mourned those who perished while building the Wall and other state projects that consumed the energy and wealth of the country and added to the misery of the peasants. Yet in recent years Communist writers have praised the First Emperor for his work in unifying China and establishing a centralized imperial government that assured the development of what they call "Feudal Society" (fifth century B.C. to nineteenth century A.D.). In his day, they maintain, the First Emperor was "progressive" and served as a landmark on the path of historical inevitability, completing the transition from the earlier "Slave Society."

The First Emperor alienated the educated class by burning most books except such "useful" texts as those on agriculture, medicine, and divination. Many of the semisacred books of history, songs and prayers, manuals on rites, and philosophical works were cast into great bonfires in an attempt to wipe out memories and records of the past and to stifle contending philosophies which might imply criticism of his methods of government and his legitimacy. He even went to the extreme of doing away with more than 460 scholars as well as their books. These actions of Ch'in Shih Huang-ti were not the last of their kind in Chinese history, and they suggest an interesting analogy to China today, where few books are permitted, intellectuals are suppressed, and dissent is not tolerated. In defending the First Emperor, the Communists point out that he did not seek to do away with all books but only those in certain fields, and that he did so in an effort to unify thinking. Similarly, they maintain, he buried scholars alive "not to kill all scholars, but to punish the opposition faction, which stood for restoring the old rules." The lesson is undoubtedly not lost on those who might oppose Chairman Mao.

The Chinese see the Wall as a symbol of their heritage. Therefore it is not surprising that China exports Great Wall Cigars, Great Wall Mandarin Oranges, Great Wall Vodka, and a host of other Great Wall items. China's trade officials have applied Chairman Mao's slogan: "Make the past serve the present." Great Wall products are extensions of China. They are marketing China's vision of herself.

An American businessman at the semiannual Chinese Export Commodities Fair, popularly known as the Canton Fair, was eager to buy canned mandarin oranges, but he wanted the Chinese to put his own company's label on the product. The Chinese spent days explaining why they would not

LEFT:

67. A soldier from the People's Liberation Army (PLA) peers down from the Great Wall. Perhaps he wonders what difficulties and hardships his predecessors had to endure in defense of the motherland.

BELOW:

68. Profile view of the Great Wall, Hopei province. The wall's powerful image evokes national pride and recalls the long history and the solidarity of the nation. It also reminds the people that almost all their enemies and conquerors have invaded China from the north.

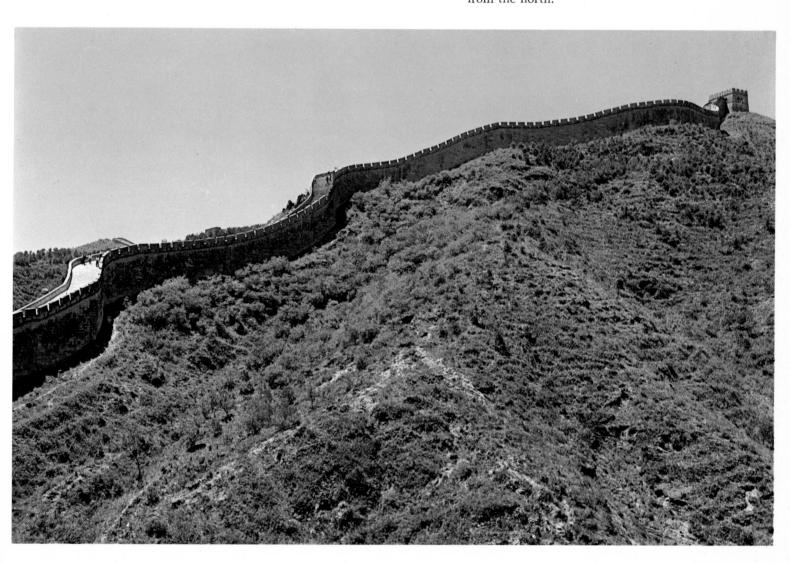

abandon the Great Wall label. Unable to persuade them, the American went home empty-handed, and the Chinese lost a substantial export order.

Why should the Great Wall name be so important? The Chinese are interested in selling to foreign markets, but they want the world to know that what it is getting is Chinese. Given the generally high quality of their products, the Chinese see no reason why "Great Wall" should not eventually become as famous as any other brand name in the world, evoking memories of a long and glorious past which has been fused into a new image of modern China.

THE HAN DYNASTY

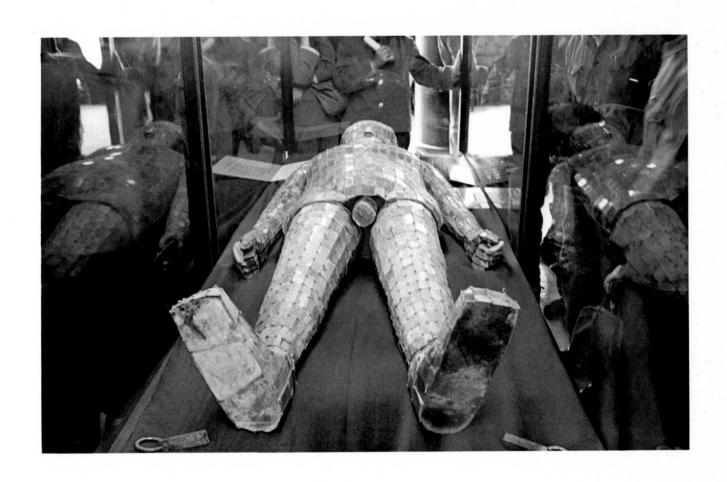

70. Painted tile in a tomb in Wang-ch'eng Park, Loyang, Honan province. 48–7 B.C. (Western Han dynasty). Ink and colors on a clay surface. The tile shows a detail of Hsiang Yü's banquet for Liu Pang. At the left two men watch the banquet, while a third appears from the side to perform a sword dance. Mountains are outlined in the background.

PRECEDING PAGE:

69. Funerary suit of Liu Sheng, from his tomb in Man-ch'eng, Hopei province. Second century B.C. (Western Han dynasty).

Jade with gold thread, length 74 inches. Shown at the Imperial Palace, Peking. When Liu Sheng died, in 113 B.C., his body was encased in this suit. The 2,498 pieces of jade were sewed together with about 1,110 grams of gold thread. The silk binding is a reconstruction.

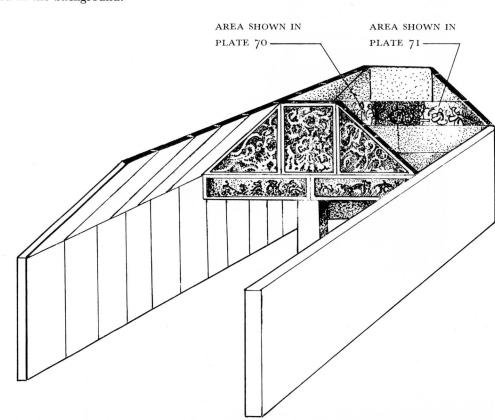

71. Painted tile in a tomb in Wang-ch'eng Park, Loyang, Honan province. 48–7 B.C. (Western Han dynasty). Ink and colors on a clay surface. The tile shows another detail of Hsiang Yü's banquet (see plate 70). A man cooks meat over a small brazier while a companion and a horse watch.

A REBELLION ended the rule of the Ch'in dynasty just a few years after Ch'in Shih Huang-ti died (210 B.C.). The insurgent armies were composed of an alliance of oppressed peasants and dispossessed hereditary nobles. The peasants were exhausted and impoverished from the unreasonable tax and labor demands of the Ch'in, and the aristocratic families wanted to restore their power and regain their fiefdoms. In 206 B.C., the second Ch'in emperor was captured and the Ch'in capital at Ch'ang-an was burned and looted. (Ch'ang-an means "eternal peace," and that city is now called Sian). Although this marked the end of the dynasty, it was only the beginning of a struggle for succession which reached its climax in 202 B.C., when Liu Pang, who became Emperor Kao Tsu, founded a new dynasty—the Han.

The story of the struggle for power between the wily peasant, Liu Pang, and the suave aristocrat, Hsiang Yü, the acknowledged leader of the rebellion, lends romance and excitement to histories of the Han. A painted tile depicting this story is shown visitors to a Han tomb in Loyang built sometime between 48 and 7 B.C. (plates 70, 71). Dr. A. Bulling has inter-

preted this tile and another from the same tomb as scenes from two different plays which were probably performed during the mourning period for the deceased. She suggests that the reason neither literary accounts nor scripts from Han theater have survived may be that the theater, an amusement for women and the illiterate, was considered an unworthy subject for scholars, even though it was an accepted theme for tomb decoration ("Historical Plays in the Art of the Han Period," *Archives of Asian Art*, XXI, pp. 21–37).

Whether the painting represents a theatrical performance or is simply a narrative painting depicting historical events is still a matter of scholarly debate. It does, in any case, tell the story of the struggle for the throne as recounted by the two great Han historians, Ssu-ma Ch'ien and Pan Ku.

The rectangular hollow tile, which looks like a ceramic imitation of a hewn wooden beam, is set into the rear wall of the long central chamber of the tomb. Its surface was covered with white paint as a background for water-based mineral pigments. It shows the confrontation of the contenders for the Han throne at a banquet given by Hsiang Yü in the mountains near Ch'ang-an after Liu Pang's armies had conquered the Ch'in capital and taken the Ch'in emperor prisoner.

While awaiting the arrival of Hsiang Yü, Liu Pang had sealed off the palaces, treasuries, and courts and had forbidden looting. According to the Han histories, Liu Pang had also occupied the critical pass to the capital. When Hsiang Yü approached, he learned of the conquest of Ch'ang-an and the occupation of the pass. He was warned that Liu Pang, formerly greedy and lustful, had touched neither money nor women in Ch'ang-an—an indication that he was planning to seize power and declare himself emperor. Worst of all, the peasant general was said to have the aura of a dragon hovering about him, a sure sign of the "mandate of heaven." Convinced of Liu Pang's treachery, Hsiang Yü, who was a fine general and had an army at least twice as large as Liu Pang's, decided to attack him. Liu Pang learned of the plan and sent a message of apology and explanation. He assured Hsiang Yü that he meant no disloyalty and had, indeed, not only crushed Ch'in resistance for his leader but also had saved the loot for him and his troops; his occupation of the pass was designed only to protect it from bandits (plate 72). The next day Liu Pang came in person to offer his regrets and good will, which Hsiang Yü accepted, inviting him to a banquet.

At the banquet a canny follower of Hsiang Yü began to do

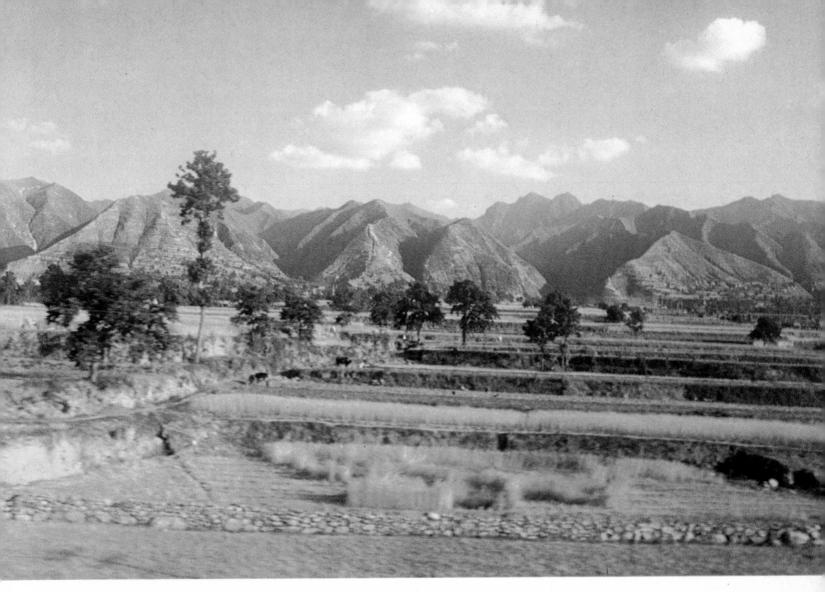

72. Mountains in south-central Shensi province, east of Sian (ancient Ch'angan). In 206 B.C., Hsiang Yü gave a conciliatory banquet for Liu Pang in the mountain pass east of Ch'ang-an.

a sword dance, during which he intended to kill Liu Pang, but the latter's companion joined the dance and shielded his master's body with his own. When Liu Pang went out to relieve himself, he and several followers secretly fled the encampment. For more than four years afterward Liu Pang fought Hsiang Yü for control of China.

In the scene on one of the painted tiles, the figures of the two protagonists in the center are almost obliterated. However, one can easily make out other figures at the sides, such as a purple-robed man with a curled mustache and pointed beard who is cooking meat over a flaming brazier while a horse and a companion stand by (plate 71). At the other end of the tile, two long-robed figures outlined against a mountainscape observe the scene, their hands tucked into their long, billowing sleeves (plate 70). Next to them, left hand on hip, a buck-toothed, popeyed sword dancer makes an entrance from the side, sword in hand.

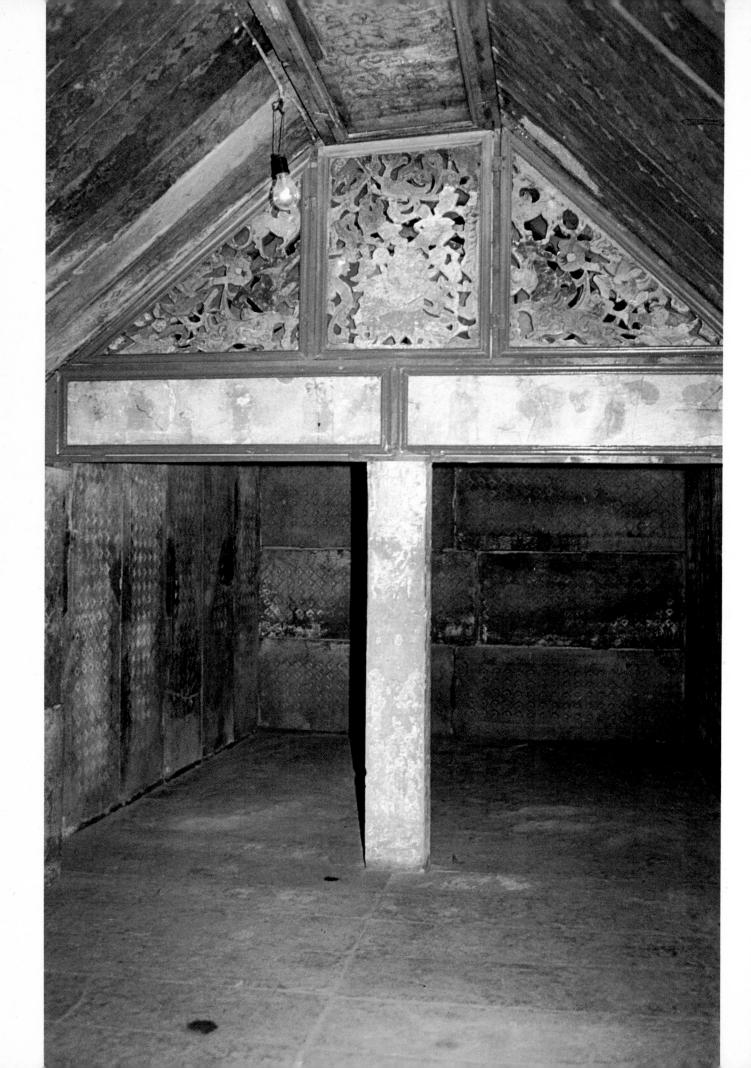

73. Painted tile on the gabled partition of the central chamber in a tomb in Wang-ch'eng Park, Loyang, Honan province.
48-7 B.C. (Western Han dynasty). Ink and colors on a clay surface. The tile shows the story called "Killing Three Knights with Two Peaches." The cutout partition above is painted with swirling bodies of men and wild animals.

The tiles of the Loyang tomb are among the earliest Chinese paintings to survive, yet their facile brushwork and clearly organized composition show that this is not a primitive painting experiment but part of a long, highly developed tradition.

The central tomb chamber is divided into sections by a gabled partition: the post, beam, and gable construction is a translation of wooden building and carving techniques into tile, a more enduring material (plate 73). The central lintel beam, like the one on the rear wall, is a hollow tile with a painting of another historical anecdote. The tile story was identified by Kuo Mo-jo, president of the Chinese Academy of Sciences, as being "Killing Three Knights with Two Peaches," a Confucian parable. Above the lintel swirling bodies of men and wild animals in the mountains appear on the cutout, painted partition. The roof gable is decorated with symbols of the firmament—sun, moon, and stars—which played an important role in the Han religion. Parts of another painted tile remain over the entrance to the tomb, with a beguiling angel flying in the firmament. The embellishment of the rest of the tomb, including the side chambers, consists of patterns stamped into tiles or pressed into bricks. The casket and generous provisions were placed on the floor.

As we have seen, some preimperial funerals included human sacrifices and actual objects, but miniature images made of clay, bronze, or wood were gradually substituted for living people, real musical instruments, and a host of other items. This change was not only humanitarian; it was also a more economical use of resources. And because of it, the poverty of literary sources concerning theatrical entertainment prior to the Sung dynasty (A.D. 960–1279) is somewhat compensated for by wall decorations and small sculptural substitute figures placed on the floors of tombs. Many miniature musicians and performers who were meant to serenade and amuse the dead

have been recovered and now delight us.

One of the most remarkable of the much-heralded new archaeological finds, made in 1969, during the Cultural Revolution, is a clay model of a musical performance that features dancers and acrobats (plate 74). Standing on a rectangular base, the show takes place between two groups of large-scaled observers. At one end, next to a large drum on a post, three solemn men, basically cylindrical in shape, with flat hats and black robes trimmed with red, stand in a row, hands in sleeves. Their mouths are pursed into circles, as if they were chanting. At the opposite end of the scene, four men sit watch-

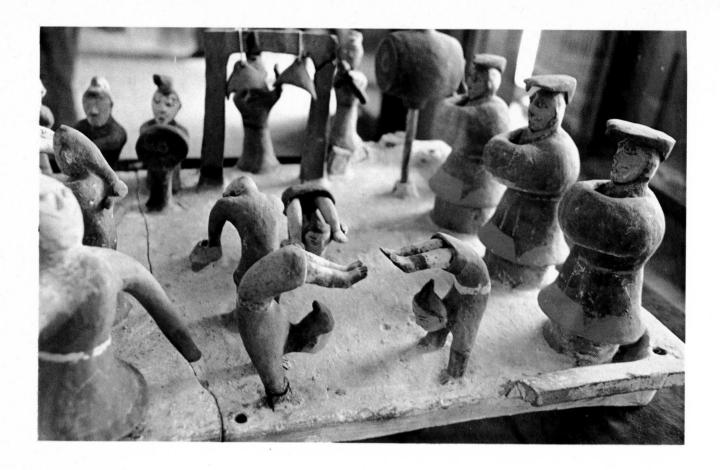

ing, also with hands in sleeves. Two wear tan robes, two wear white robes, and all have white hats crowned with circles that look like doughnuts set on end. Perhaps these figures, larger than the performers, were court officials or ceremonial mourners. While it seems likely that this performance served mourning purposes, it probably was the format for official entertainments as well.

The clay model is also a catalogue of musical instruments. Two players blow a kind of mouth organ (sheng), a set of reed pipes attached to a single base; another plays a kind of zither; and three musicians strike percussion instruments. One of these percussion instruments stands on a stemlike base with a circular top; a second, called pien ch'ing, consists of two stone triangles that hang from a wooden frame; the third is a great drum, probably made of hide and wood, mounted on a post. The musicians play their instruments intently, while two female sleeve dancers and four male acrobats perform with graceful agility. At the front of the stage, a larger man in long sleeves seems to act as master of ceremonies. In this lively document of the performing arts, the genius of the Chinese craftsman is displayed through his ability to transform the clay into

74. Acrobats, dancers, and musicians, from Tsinan, Shantung province. Western Han dynasty (206 B.C.—A.D. 8). Painted clay; length of scene 26 3/8 inches, width 18 1/4 inches. Shown at the Imperial Palace, Peking. Originally there were twenty-two figures, but one has been lost. This lively group displays an ancient integrated production of performing arts combining music, dance, acrobatics, and singing.

completely believable, exuberant beings. He has infused his material with the torsion and balance of the acrobats and the rhythmic sway of the dancers.

The new Han materials represent some of the most interesting recent archaeological finds in China and enrich our vision of the Han empire. Liu Pang abandoned many of the more unpopular measures of the first Ch'in emperor, reducing taxes, the terms of corvée labor, and punishments, while at the same time retaining many of the Ch'in innovations regarding central control of the government. His peasant background made him sensitive to the needs and desires of the people, and he adopted the Confucian teaching of "government for the good of the people." Despite a legendary distaste for the pretensions of the literati, he established a precedent for imperial consultation with learned ministers. This consultation was gradually institutionalized into an elaborate civil service. His flair for leadership and his colorful peasant ways make for some of the liveliest reading in Chinese history. In a day before the Chinese had chairs, he squatted—a position assumed by peasants, not nobles—and he used the vernacular language in a most unrestrained way. A biographer writes that one day he grabbed the hat from a scholar's head and urinated in it to express his contempt for the studied affectations of scholars.

As Emperor Kao Tsu, Liu Pang established a firm government, expanded the empire to include more states in all directions, and restored relative peace to the countryside. One of his major problems was the troublesome nomadic people who plagued the northern borders near the Great Wall. He tried to buy peace from the Hsiung-nu, known in the West as the Huns, by sending a Chinese princess to marry their leader and by offering them annual tribute. After Kao Tsu's death (195 B.C.) and a succession of short-lived monarchs, Emperor Wu Ti (r. 140–87 B.C.) consolidated the Han empire and resumed military campaigns against the Hsiung-nu.

Wu Ti, which means "Martial Emperor," decided to make an alliance with some old Han enemies, the Yüeh-chih, no-mads who shared the Chinese hostility to the Hsiung-nu because they had been defeated by them. The Yüeh-chih no-mads having been chased west by the Hsiung-nu, Wu Ti sent a general to find them. The general was captured by the Hsiung-nu and imprisoned for several years. When he finally escaped, he resumed his quest, and, pushing farther and farther west, eventually discovered the hoped-for allies, now settled in present-day Afghanistan. By this time, however, the Yüeh-

chih were no longer interested in revenge against the Hsiungnu.

This was only one of a number of attempts Wu Ti made to find allies. He sent out expeditions which conquered many oasis cities in the Central Asian desert, initiating what came to be known as the Silk Road. This route extended as far as the shores of the Mediterranean, skirting the Tarim River basin in Central Asia and moving across the Near East through Afghanistan. Roman women eagerly adorned themselves in gossamer Chinese silks. Roman glass and gold were sent in exchange to China, but the Romans bought more than they sold, creating a serious drain of gold from the Roman treasury.

The Han search for allies broadened China's knowledge and control of Central Asia. Among the things encountered on such expeditions were the "blood-sweating horses of Ferghana." These marvelous horses—thought to be foaled by heavenly forebears—were reputed to be able to travel a thousand li (over 300 miles) in a day. They were said to be 15 feet high, were heartier than Chinese ponies, had what looked like a double spine similar to a tiger's, and were able to tread on stones without breaking their hooves. Their sweat was red foam. Modern scientists explain that "blood sweating" is caused by parasites which create lesions in the skin. Blood from the lesions mixes with sweat, causing the red foam. When Wu Ti, whose armies were ever in need of horses, heard about these magnificent creatures, he sent an envoy with a gift of a thousand catties of gold and a horse cast in gold to ask the king of Ferghana for some of his fine steeds. But the king was not willing to part with his precious animals. Instead, he slew the Chinese envoy and kept the gold. Wu Ti sent a second expedition against Ferghana, this time with a military force of more than a hundred thousand men. After four years of fighting, the king of Ferghana was killed and the Chinese took three thousand of his horses.

One of the recently discovered Han treasures is a bronze horse (plates 75, 76). Three legs are unsupported, while a single leg is set lightly on the back of a flying swallow. Although this galloping horse was buried as part of a large equestrian funerary entourage between the first and third centuries A.D.—more than a century after Wu Ti received his "gift" from the people of Ferghana—the model was surely meant to represent the "blood-sweating" import from across the desert. Its physical beauty and qualities of speed and motion were so magnificently captured by the skill of the bronze caster that

it is easy to believe in the myth of the heavenly descent of the "blood-sweating horses." No ordinary horse could leap through space with such effortless grace.

This horse was one of a large number of bronze objects, including thirty-eight other horses, fourteen chariots (plate 78), and more than twenty military attendants, that have been found in Wu-wei, Kansu, the western area of Han China that served as a gateway to the Central Asian Silk Road.

Despite the fact that clay, wood, or metal figures were substituted for real people in the tombs of Han royal and aristocratic families, real horses and chariots were still sometimes offered. This was true in what is perhaps the most spectacular of the recent archaeological finds—the tombs of the Han royal prince Liu Sheng and his wife, Tou Wan, in Man-ch'eng, Hopei province. Among the 2,800 objects in the two tombs was a gilt-bronze spotted dragon, inlaid with turquoise, that probably functioned as a chariot fitting for one of the several chariots and dozen horses found with it (plate 77). Bronze vessels for cooking and storing food and drink, hundreds of ceramic and many lacquer vessels, and sets of figurines were carefully arranged in the enormous tombs, which are referred to by the Chinese as "underground palaces." Both tombs were cut into a rock cliff and entered from the east through underground passages. The vastness of Liu Sheng's tomb is best told through its dimensions: 170 feet long, 120 feet wide, and 23 feet high. Tou Wan's tomb is slightly larger. The plans of the two tombs are similar. Each has a central chamber, with side chambers on the north, west, and south. The west chamber, at the rear of each tomb, held the coffin and the most precious furnishings.

Incense was an essential part of traditional ritual offerings and was also used regularly to perfume the air. Beginning with the Han period, many censers were made in the shape of miniature mountains. When conceiving this shape, Chinese craftsmen apparently intended an association between the vaporous qualities of incense and mountain mists. The ingenious design allows the small-scaled jutting peak to be shrouded in everchanging rising clouds as long as the incense is burning.

Buried with Prince Liu Sheng was one of the most exquisite examples of all incense burners (plate 79), made of bronze and delicately inlaid with gold. Its protruding forms may represent waves or clouds or strangely shaped rocks. People and beasts appear within the surging "waves." Like similarly formed censers, it is called *po-shan-lu*, which means "Mount

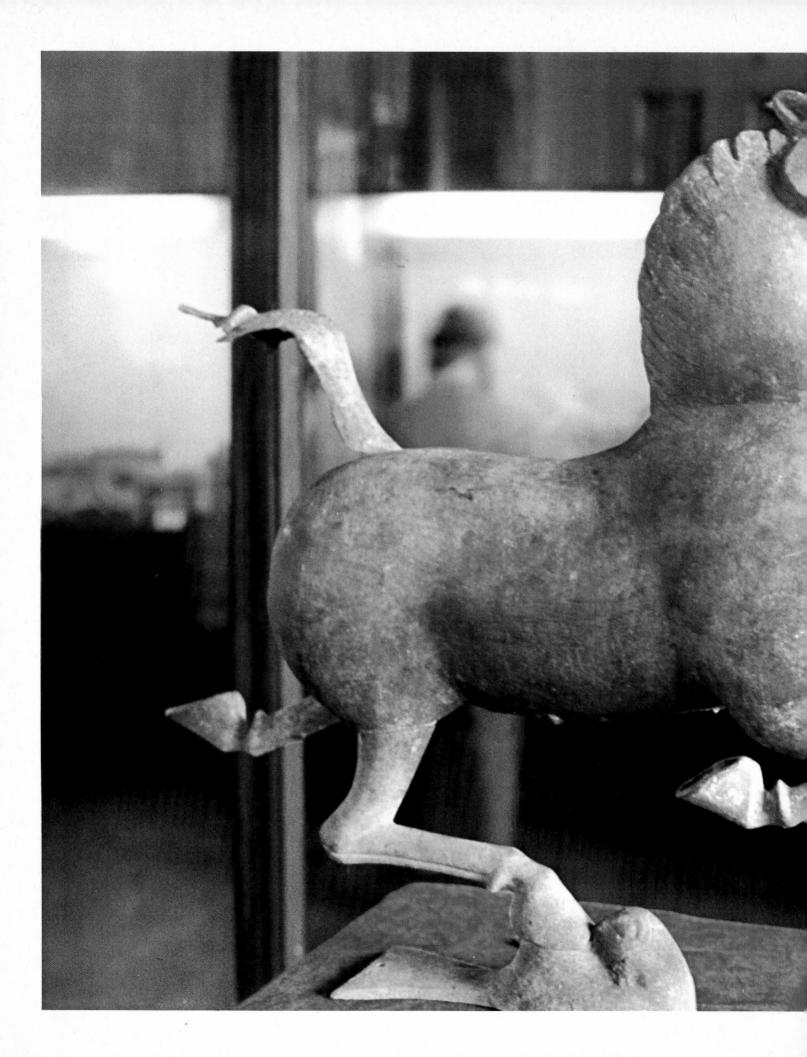

75, 76. Flying horse from Wu-wei, Kansu province. Western Han dynasty (206 B.C.-A.D. 8). Bronze; height 13 1/2 inches, length 17 3/4 inches. Shown at the Imperial Palace, Peking. Transoxianian horses (known to the West as Arabian horses) were imported from Ferghana (Afghanistan) during the Han period. One of those magnificent steeds served as a model for this brilliantly fashioned bronze horse. The sculptor suggests the mythically divine attributes of the horse with one hoof resting lightly on a flying swallow as the horse gallops freely through the air.

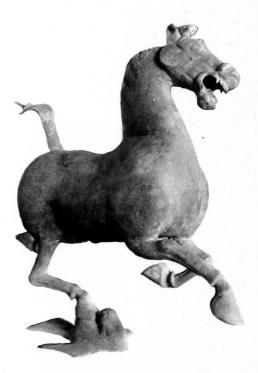

Po censer." According to the authors of Arts of China: Neolithic Cultures to T'ang Dynasty (Akiyama Terukaza et al, p. 69), the name comes from a hill in Shantung province, the birthplace of a famous maker of incense burners. The mountainous Shantung peninsula, which extends into the Yellow Sea, is the site of several sacred mountains where sacrifices were performed and where Taoists, and later Buddhists, established temples. During the reign of Wu Ti, who was a younger brother of Liu Sheng, Shantung was the home of a number of magicians and the source of many Taoist legends. Possibly Liu Sheng's incense burner represents the legendary Taoist "Islands of the Immortals," which Wu Ti and many others strove to find; perhaps it simply represents a mountain on which royalty enjoyed hunting.

One of the most beautiful objects found in Tou Wan's tomb was a gilt-bronze serving girl holding a lamp (plate 80). Her regular features show a balanced perfection; her wide-sleeved robe covers her body with graceful, easy rhythm. Both she and the galloping horse illustrated earlier demonstrate a new phase of the Chinese mastery of bronze casting quite different from that revealed in the ritual vessels of Shang and Chou. As if by the hand of a magician, the material is convincingly transformed into effortlessly naturalistic renditions of breathing beings. The lamp which the girl holds has an adjustable opening to allow either more or less light, and her sleeve acts as a vent to remove smoke and soot.

Another remarkable object from Tou Wan's tomb is a small bronze leopard, one of a group thought to have been used as sleeve weights (plate 81). The inlay workmanship is superb and so are the realistically feline form and position. Although many things were made specifically for interment, it seems likely that these leopards were buried after a lifetime of use.

Among the many spectacular treasures found in the tombs of Liu Sheng and his wife, the objects which elicit the most enthusiastic popular response are the two jade funerary suits in which the Han royal couple were buried (plates 69, 82, 83). Jade was not only considered to be beautiful and to symbolize virtue but was also thought to prevent decay of the human body. The ancient Chinese must have hoped that by clothing the body completely in jade they could ensure its eternal preservation. The suits, which include masks, gloves, and shoes, were made of wafers of jade, mostly oblong in shape, sewn with gold thread. The polished jade shimmers in the light and

Dragon-head chariot fitting from the tomb of Liu Sheng (d. 113 B.C.), in Man-ch'eng, Hopei province. Second century B.C. (Western Han dynasty). Gilt-bronze inlaid with turquoise, length 8 inches. Shown at the Imperial Palace, Peking. Exquisite fittings for twelve chariots were found in this tomb. Liu Sheng was the brother of the Han emperor Wu Ti (r. 141–87 B.C.).

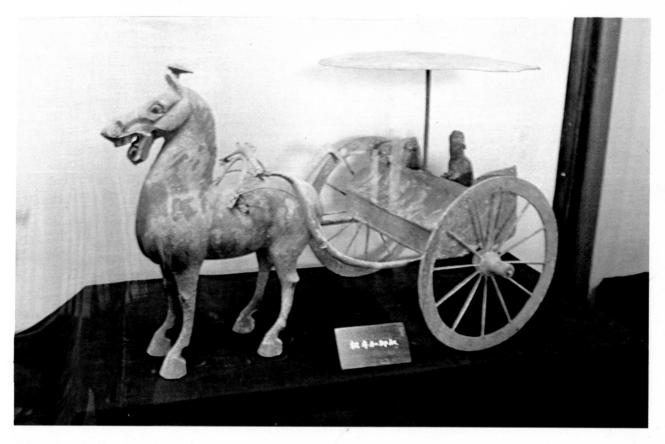

78. Horse-drawn chariot from Wu-wei, Kansu province. Western Han dynasty (206 B.C.-A.D. 8). Bronze, approximate height of horse 18 inches. Shown at the Imperial Palace, Peking. This chariot was one of 220 funerary objects made of lacquer, gold, bronze, iron, jade, bone, and stone found in the tomb that also contained the flying horse.

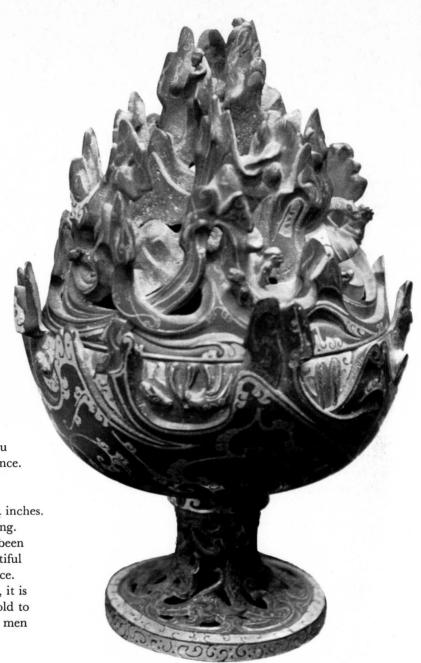

79. Incense burner from the tomb of Liu Sheng, in Man-ch'eng, Hopei province. Second century B.C. (Western Han dynasty). Bronze inlaid with gold; height 10 1/4 inches, diameter 3 3/4 inches. Shown at the Imperial Palace, Peking. Many hill censers (po-shan-lu) have been found in the past, but none so beautiful in design and conception as this piece. Perfectly cast into a mountain form, it is brilliantly inlaid with hairlines of gold to accent its undulating peaks and the men and beasts who inhabit the scene.

looks as though it were a Chinese version of chain-mail armor.

A total of 2,498 pieces of jade and 1,110 grams of gold thread were used to enshroud Liu Sheng, as compared with smaller-sized Tou Wan, who needed only 2,156 pieces of jade and 703 grams of gold thread. It must have taken numbers of master jade workers years to carve the pieces. Among their most amazing technological feats is the drilling of the four small holes in the corners of each piece, roughly one-eighth inch away from the edge, through which the gold thread was sewn to hold the jade pieces together.

Official records of the period note that princes of the blood were entitled to be buried in jade sewn with gold thread; no-

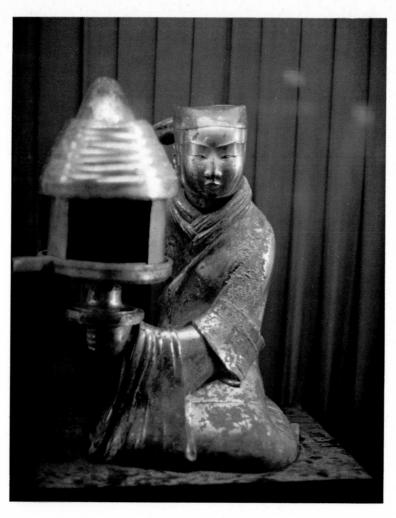

81. Leopard sleeve weight, from the tomb of Tou Wan, in Man-ch'eng, Hopei province. Second century B.C. (Western Han dynasty). Bronze inlaid with gold and stones; height 1 3/8 inches, length 2 3/8 inches. Shown at the Imperial Palace, Peking.

80. Lamp from the tomb of Tou
Wan, in Man-ch'eng, Hopei
province. Second century B.C.
(Western Han dynasty).
Gilt-bronze; overall height 18 7/8
inches, figure height 17 1/2 inches.
Shown at the Imperial Palace,
Peking. A serving girl holds the
lamp in her right hand, her arm
functioning as the flue. The
lamp has an adjustable
opening to vary the amount of light.

bles of the rank below prince could have jade suits sewn with silver thread; the lowest of the high-ranking nobles could have jade suits sewn with copper thread. Jade wafers had previously been found scattered in some tombs, but these isolated pieces were incomplete and their exact use had not been ascertained. The discovery of the tombs of Liu Sheng and his consort, together with all the other elements of the find, make it comparable in importance to the discovery of Tutankhamen's tomb in Egypt.

Today in China the significance of this find is expressed in terms of class struggle. In the publication New Archaeological Finds in China Ku Yen-wen (pp. 18–19) states:

The archaeological work has mercilessly exposed their [the elite's] evils and extravagance as well as their brutal exploitation and oppression of the labouring people. . . . [It] has once again brought to light a great many precious cultural objects . . . which the labouring people created with their own hands and which in turn demonstrate the craftsmanship of their creators. . . . [Archaeological work] is not

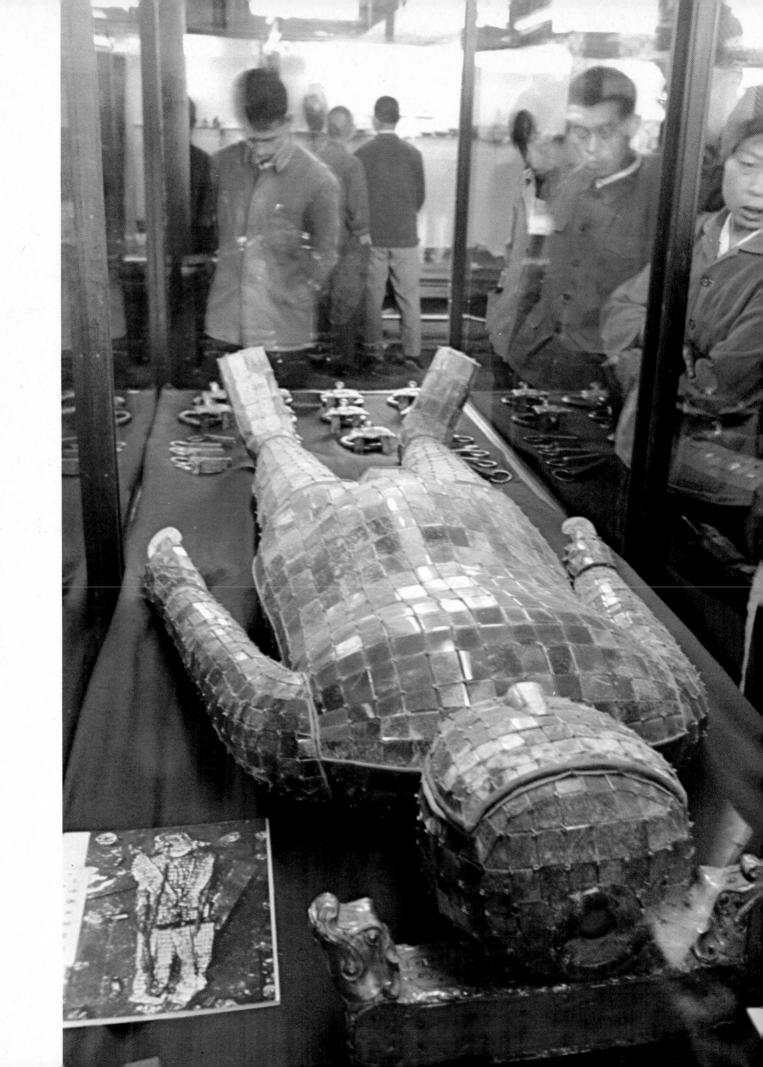

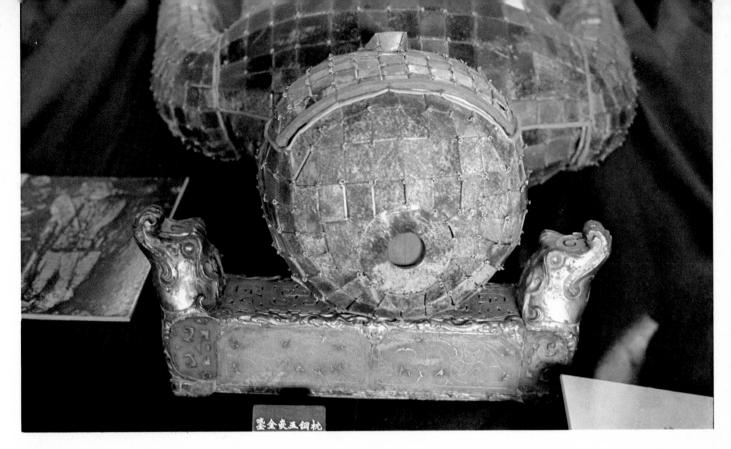

82, 83. Both Liu Sheng and his wife,
Tou Wan, were buried in
gold-sewed jade funerary suits
(see plate 69). The
privilege of being buried in
such an elaborate shroud was
accorded only to the royal
family. Above, detail
showing the top of the head
and the pillow. The jade
pillow was enhanced with
gilt.

only highly conducive to the study of the history of ancient Chinese society but also provides rich, vivid historical data for widespread, popular education in ideology, politics and class struggle.

In addition to their jade suits, Liu Sheng and Tou Wan had brick-shaped jade pillows on which to rest their heads eternally (the Chinese favored hard pillows, often brick-shaped, for two thousand years; plate 83). Two jade dragon heads, embellished with gilt, peer up at each end of Liu Sheng's pillow. Its surface is covered with low-relief carving which features animal combat, the bodies of animals intertwined with undulating serpentine forms.

At the time of burial, the jade-shrouded bodies were encased in wooden coffins. Although no trace of the wood remains, the gilt-bronze coffin handles have survived (plate 85). Each handle is made in two pieces, with a fastening plaque in the shape of a monster face. Double lines above the eyes curl down into the monster's nose, and curling hair or feathers decorate his brow, which is crowned by triangular ears and a small tiara-like medallion in the center. The handle ring hangs from a snout, but the lower jaw is absent. The absent lower jaw is characteristic of the ancient monster faces found on Shang and Chou bronze vessels, and this full-blown Han motif is a descendant of that zoomorphic tradition.

84. Detail of a fish carved on the stone lintel over the entrance doorway of a tomb in Wang-ch'eng Park, Loyang, Honan province. Eastern Han dynasty (A.D. 25–220).

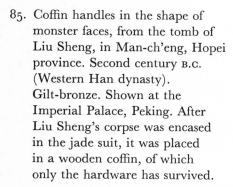

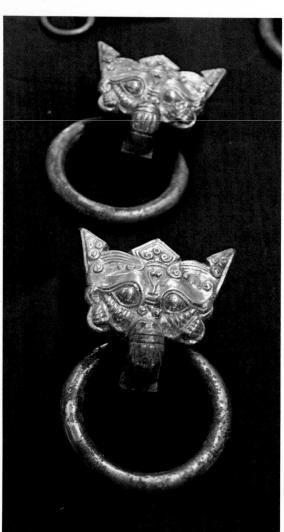

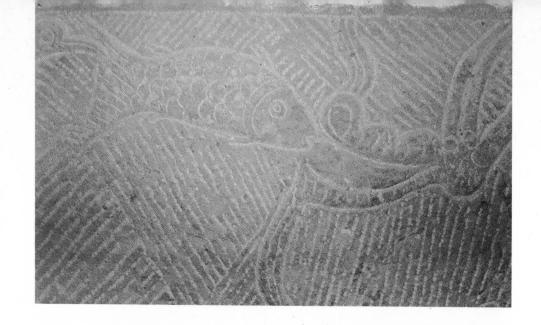

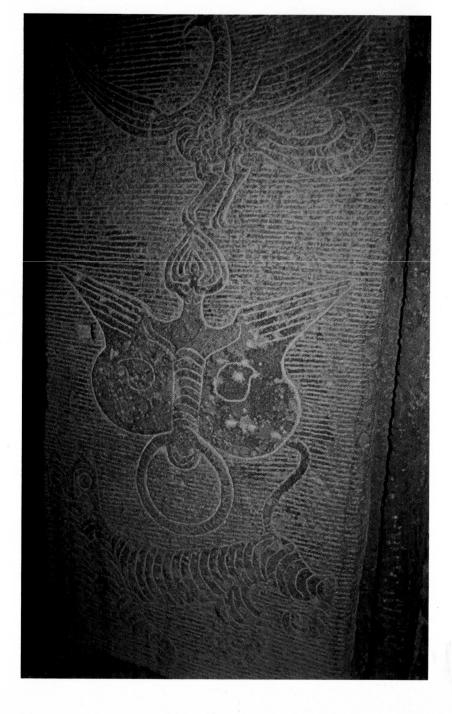

86. Detail of stone carving on the entrance doorway of a tomb in Wang-ch'eng Park, Loyang, Honan province. Eastern Han dynasty (A.D. 25–220). The door is incised with a handle design suspended by a phoenix.

It would appear that monster-face handles were frequently used in Han times. In a tomb dating from the Eastern Han dynasty (A.D. 25–220) that was uncovered at Loyang, the capital during that period, the exterior of the stone doors was incised with monster-face handles (plate 86). Since the tomb was meant to be shut for eternity once the deceased was entombed, the handles had no functional purpose, and the designer of the tomb conceived the relief carving simply as a decorative door symbol. The lintel over the doorway was also carved in low relief; it features a realistically rendered fish within an ornamental motif that includes other aquatic forms (plate 84). The crescent-scaled fish, which traditionally symbolizes fertility and prosperity, swims in lightly carved, angled stripes of water.

The interior of this Loyang tomb is quite similar to the earlier painted Han tomb. The long, rectangular central chamber is divided into two rooms by three posts supporting a lintel surmounted by a carved gable. Two smaller chambers with lower ceilings extend on either side of the central one. Symbols of the zodiac adorn the carved gable, and the center post, looking somewhat like a totem pole, has a smiling carnivore with bared teeth. Bricks impressed with a herringbone design have replaced the pressed-tile wall designs found in the earlier Han tomb.

One side chamber is still lined with ceramic vessels which held provisions for the dead; this chamber also contained a miniature clay pigpen containing a single fat sow (plate 87). The pig was one of the first animals to be domesticated, and pork has always been a favorite at Chinese banquets. Even today, Chinese pigs enjoy the finest care in meticulously kept quarters at communes (plate 88).

Some funerary furnishings found in later Han tombs offer a glimpse of household essentials and accouterments. While these things lack the glamour of the furnishings of Liu Sheng's tomb, they fill out parts of the picture of everyday life (plates 89–93). Two hens peep out of a half-rounded chicken coop shaped like a tiny Quonset hut, and a thick-legged rooster poses grandly under his curling cockscomb. Banquet food is set out waiting to be cooked on a rectangular stove; two turtles, some fish, and other culinary delights are seen near a knife and a deep bowl for soup. Even more basic than banquet offerings are the circular and square ceramic wells ready to quench an eternal thirst and a little house that will mill grain endlessly to replenish the storage jars provided.

88. Piglets at a commune near Shanghai. Domesticated in the prehistoric period, pigs continue to be favorite animals today.

Some of these ceramic pieces are unglazed, some are partially painted, and others are covered with a pale-green lead glaze. During the time that the objects remained buried, the glaze underwent a chemical change that produced a softly iridescent patina similar to the look of ancient Roman glass that was also buried for centuries.

Not all later Han objects were mundane; a bronze unicorn assures us that whimsical beasts continued to enliven the Han imagination (plate 95). This particular creature is depicted with such earnest realism that it seems as natural as the bronze horses from Kansu. A remarkable wooden unicorn shown in the 1973–74 traveling exhibition, Treasures of Chinese Art, is similar to its bronze brother. Both have their single-horned heads lowered menacingly, as if ready to charge; they are, no doubt, examples of the legendary flesh-eating unicorn.

Another glamorous later Han treasure recently unearthed is a gilt-bronze, turquoise-inlaid case holding an inkstone (plate 94). It is shaped like a four-legged, horned, toadlike beast and was buried in a nobleman's grave sometime between A.D. 117 and 145. Very likely this inkstone, like Princess Tou Wan's leopards, was a favorite object used in his lifetime by the deceased. The elegance of the inkstone case reveals the esteemed place occupied by Chinese calligraphy. Calligraphy was an essential part of the education of the elite, and members of the small class of literate people aspired to form characters with a fluent, rhythmic style. Poor handwriting was taken to be a sign of bad character. One can imagine that this brilliantly crafted inkstone case inspired its owner to paint in a perfect calligraphic style.

A stone was vital to the preparation of Chinese ink because ink came in a dried stick and had to be ground and mixed with water prior to each use. The use of ink can be documented to the third century B.C. Although its origins are obscure,

87. A small chamber to the left of the central chamber in a tomb in Wang-ch'eng Park, Loyang, Honan province. Eastern Han dynasty (A.D. 25–220). Ceramic vessels hold offerings of food and drink. A miniature ceramic pigpen with a single sow stands in the rear on the right side of the chamber.

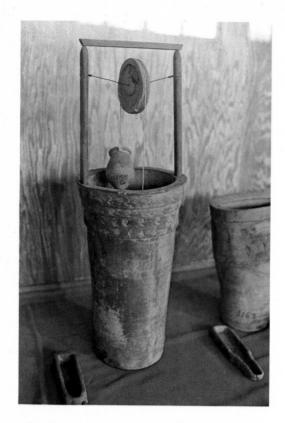

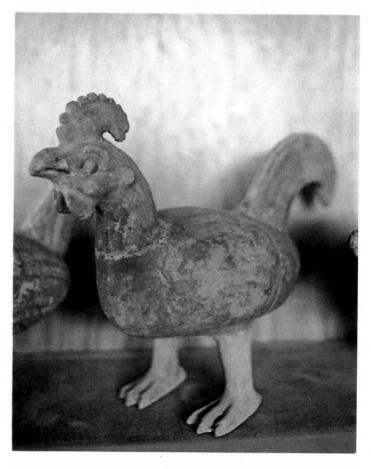

9-93. Clay funerary objects. Eastern Han dynasty (A.D. 25–220). All shown at the museum in Wangch'eng Park, Loyang, Honan province. Han tombs were often filled with these small models of the essential items of daily life. Recent finds include not only barnyard animals but also wells for drawing water and facilities for cooking and pounding grain into flour.

it may go back as far as the second millennium. It was made from lampblack; the carbon residue was collected, mixed with glue as a binding medium, and then dried in a mold to produce a stick. When the user ground the stick, he had to take care to grind it evenly, for a crookedly ground stick was interpreted to mean a flawed personality.

A most economical development of the funerary vase appeared later, in the fourth century, during the Six Dynasties period; it has almost everything imaginable piled onto its cover (plate 96). Relief plaques of mountain goats and monsterface handles are studded around the middle of the vase; the top is crowned with a house and walled garden, birds, groups of people, and large vessels with offerings for the dead. This combination house-entourage offering may have spared the family of the deceased the high cost of a large set of funerary objects. The green glaze of the vase is called protoceladon and is a forerunner of the fully vitrified celadon, Yüeh ware, which was developed in succeeding centuries.

Today's Chinese still refer to themselves as "the Han people," and most of the substantial Han territorial conquests are now regarded as part of China proper. Starting out from the "cradle of China," the area around the Yellow River, military action and subsequent settlement expanded the Han empire to include the southeastern coastal provinces of Fukien and Kwangtung, the southwestern provinces of Kwangsi, Kweichow, and Szechwan, and the northeastern province of the region formerly called Manchuria. The most distant reaches of the Han empire included what today we know as North Vietnam, North Korea, much of Mongolia, and many of the oasis cities along the Silk Road in Central Asia. Han rule lasted about four hundred years—from 206 B.C. to A.D. 220, except for a brief period of usurpation (A.D. 9-23)—and its influence in East Asia has been compared by some scholars to the influence in Europe of the partly contemporaneous (27 B.C.-A.D. 395) Roman empire. Most of the vast empire the Han established has endured for the two succeeding millenniums. The Han conquests gave the expanding Chinese population new lands to settle, and as they moved below the Yangtze into the warm, humid south, they developed an intensive rice culture. This great expansion made it necessary for communications to be improved, so that the capital could control distant provinces and goods could be moved from one part of China to another. Even today, internal transportation continues to be a

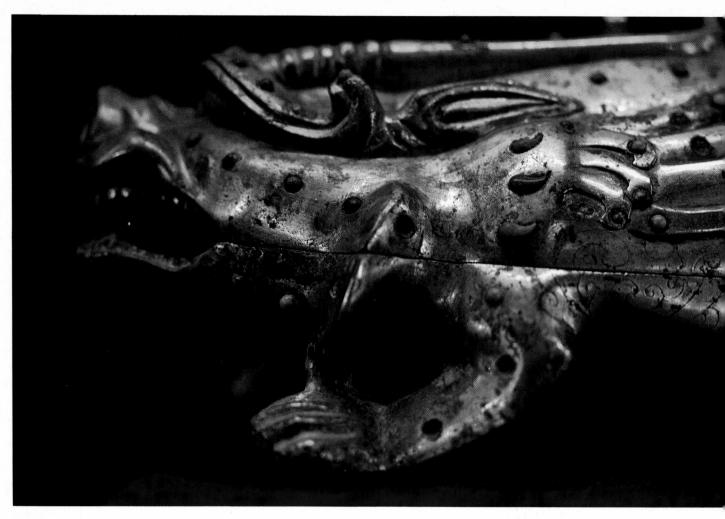

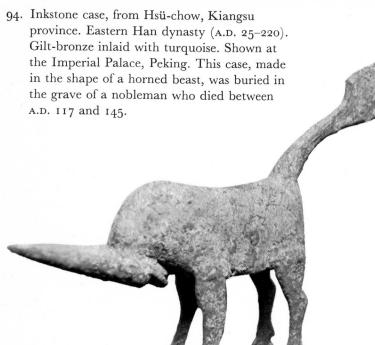

95. Bronze unicorn. Eastern Han dynasty (A.D. 25–220). Shown at the Imperial Palace, Peking.

96. Ceramic funerary urn with Yüeh-type celadon glaze. Fourth century (early Six Dynasties). Shown at the Imperial Palace, Peking. A house, people, birds, and offering vessels crowd the lid.

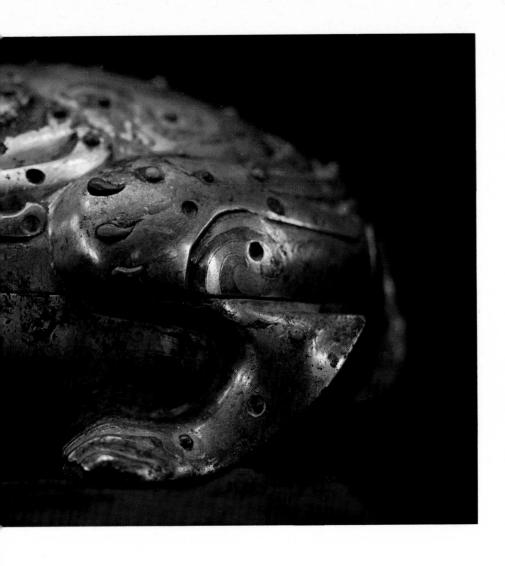

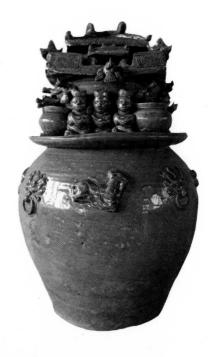

major problem for the Chinese. To supply the population of the east coast, it appears to be more economical for the People's Republic to import wheat from abroad than to transport it from the remote west.

The great rivers of China became major routes of transport, and they were supplemented by a network of canals built and maintained by the imperial government. A clay boat from the first or second century A.D., unearthed in Canton, was made as part of a funerary set. It is startling to see how similar the design of many Chinese boats in use today is to this ancient prototype (plates 97, 98).

Professor Joseph Needham, in his monumental study Science and Civilization in China (vol. 4, pp. 650-51), points to this model boat to prove that the first-century Chinese used the axial rudder, a sophisticated steering device not developed for

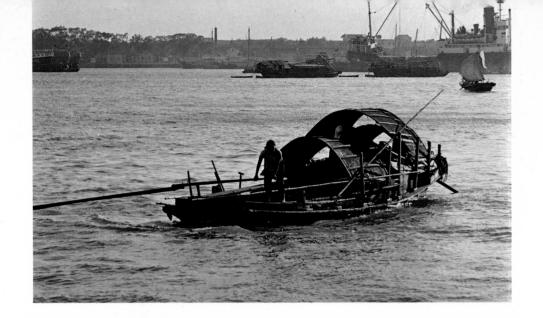

97. Boat on the Pearl River, Canton (Kwangchow). On the rivers of China today one still sees many traditionally styled boats. This marine design goes back at least two millenniums.

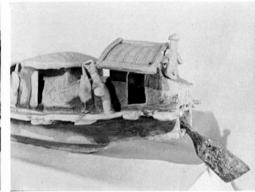

98. Gray pottery boat from Canton (Kwangchow). First century (Eastern Han dynasty). Length, just under 22 inches. Shown at the Historical Museum, Canton (Kwangchow). This boat was found in the tomb of a man who was probably a shipowning merchant of Han Canton.

another thousand years in the West. He also speculates that the boat was made for a wealthy merchant-venturer and shipowner of Han Canton.

The boat model provides us with precise detail. A small cabin at the stern serves to shelter the helmsman. Several deckhouses with barrel roofs, probably made of woven matting, serve as cabins or storage space for cargo. The anchor hangs over the projecting bow. Along the sides of the boat there are narrow outboard galleries from which the crew poled. These galleries are broken on both sides near the bow. Needham suggests that this was probably the place for the sail, and that the missing mast would have been placed in the center of the deck in front of the cabins.

Some seagoing vessels sailed beyond the shores of China to Japan and Southeast Asia during the Han period, but the great development of ocean travel came later, in the T'ang period (618–907).

THE NORTHERN WEI, SUI, AND TANG DYNASTIES

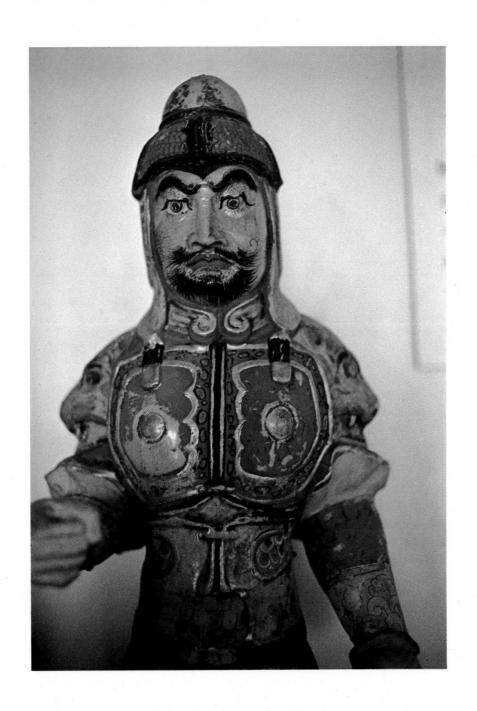

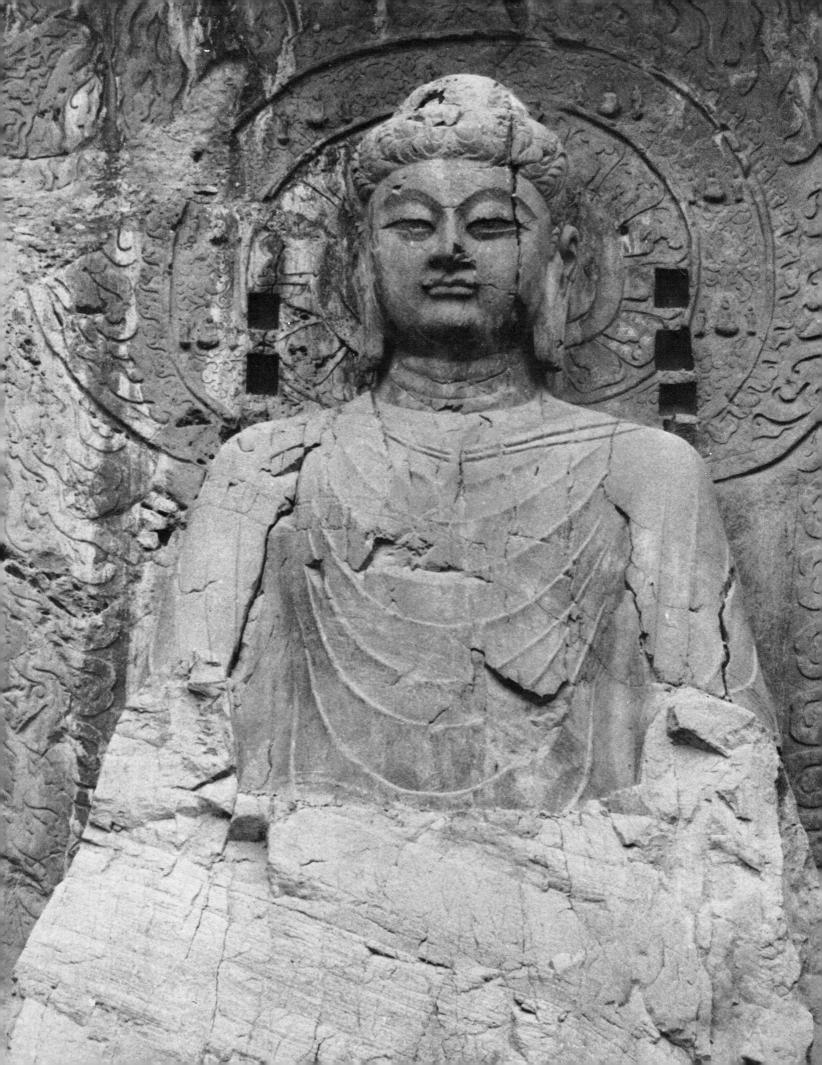

PRECEDING PAGE:

- 99. Tomb figure of a warrior, from Li-chüan-hsien, Shensi province. Last half of the seventh century (T'ang dynasty). Pottery painted with color and gold. Shown at the Historical Museum, Sian, Shensi province. The features of this T'ang warrior's face suggest that he was descended at least partially from Central Asian forebears.
- oo. The Buddha Vairocana. Feng-hsien Temple (Feng-hsien-ssu), Lung-men, Honan province. The inscription on the base is equivalent to a dating of 672-75 (T'ang dynasty). Vairocana is the personification of the original spirit and all-pervasive nature of Buddhist law and the universe. Vairocana sits on a thousand-petaled lotus; each petal represents a universe containing a myriad worlds, each with a Buddha. The cave is about 100 feet square; the height of the figure, including the base, is about 56 feet.

The disintegration of the Han empire—in process for more than a hundred years—was formally acknowledged in A.D. 220 by the fall of the ruling house. For the next four hundred years, north China was overrun by various groups of nomads, and many wealthy and powerful Chinese families moved to the mountains or paddy lands of the south, beyond the reach of the equestrian invaders. Those who stayed in the north to protect their estates had to cooperate with and pay tribute to the barbarians. This was a period of incessant warfare, with a succession of generals proclaiming a series of short-lived dynasties that controlled small segments of what was then China.

The city of Loyang had been the capital of the Eastern Chou (770–256 B.C.), the later Han (A.D. 25–220), and two brief dynasties in the third and fourth centuries. Under the Han, Loyang had been an elegant walled city with lavish palaces, abundant gardens, and an imperial university with an enrollment of more than 30,000 students from all over the empire. When the Han fled from Loyang to escape advancing enemy troops, seven thousand chariots were not enough to move all the books. The vast majority of both official and private books and records perished when the city was sacked and burned by the conquerors of the Han and successive invaders. These fires did more to destroy the written records of ancient China than Ch'in Shih Huang-ti's organized book burning had done in the late third century B.C.

In modern Loyang, virtually nothing remains of the ancient city save the foundations of ramparts and palaces, and Wang-ch'eng (Royal Town) Park, which occupies the site of the Eastern Chou capital. The city walls were torn down in 1939, and the oldest section of the present city goes back no further than the twelfth century. Some narrow lanes lined with handsome old wooden houses roofed with gray tiles evoke the past, but none reveals the imperial grandeur of the old capital city. Some modest tangible proof of once imposing architecture is to be found in rubbings made from decorative

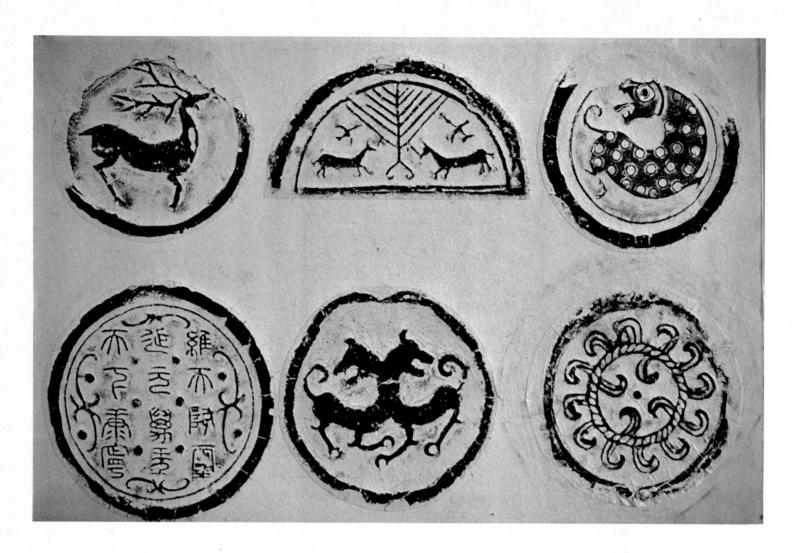

roof tiles (plate 101); these are displayed at the archaeological museum in the Park.

The glory of Loyang did not end with the Han and its immediate successors; the city served again as capital during the last forty-one years of the Northern Wei (386–534) and as a secondary capital during the T'ang (618–907). (The primary capital was Sian, then called Ch'ang-an.) Although no city structures from these eras remain, Lung-men, one of the most impressive Buddhist cave sites in China—indeed, in the Buddhist world—can still be seen about nine miles south of Loyang on the Yi River. The carving of the cave sculptures was begun by the Northern Wei dynasty at the end of the fifth century and continued for another three hundred years.

The Indian religion of Buddhism had been brought to China by foreign missionaries, merchants, and returning Chinese pilgrims over a period of at least five hundred years before the caves at Lung-men were begun. During the troubled times of the later Han dynasty and the succeeding period, o1. Rubbings of decorative roof tiles. Han dynasty (206 B.C.—A.D. 220). Shown at the museum in Wang-ch'eng Park, Loyang, Honan province. Stamped roof tile ends have been found from Chou dynasty buildings, and traditionally styled roofs are still being decorated in a similar manner today. The motifs include mythical beasts, birds, and animals, characters written in the ancient oracle-bone style of writing, and a circle of rope with curls.

the Chinese, faced with constant warfare and no leadership, searched for reassurance and salvation as they saw their world and ideals shattered. These conditions may help to explain why Buddhism was successful in China, despite the fact that its teachings were so different from traditional Chinese ancestor worship and Confucian ideals of filial piety and man's perfectibility.

In the Indian Buddhist view, the life of a being is one small moment in the endless stream of rebirth, and all of life is suffering. In the fifth century B.C., the historical Gautama Buddha had preached that to eliminate suffering one must detach oneself from all cares and desires, including material comforts and beloved family, be celibate, and follow the eightfold path of virtuous living, steering between the excesses of self-mortification and self-indulgence. Through meditation one may become "enlightened," which implies a detachment from all passion and liberation from the cycle of rebirth.

At the beginning of our era Indian Buddhism was five hundred years old and had already developed an alternative course called Mahayana, which means "the greater vehicle." Pious followers were helped to overcome their attachments and passions by devoting themselves in prayer to grace-giving Bodhisattvas and by practicing good works and charity. A compassionate Bodhisattva was an enlightened being who deferred his own entry into Nirvana, or final peace, until all other sentient beings had achieved theirs.

It was Mahayana Buddhism that met with success in China. The main route of transmission was through Central Asia. Upon arrival, it underwent changes which made it understandable and acceptable to the Chinese, and the syncretism of Buddhist and Chinese beliefs is vividly reflected in Chinese Buddhist art forms.

The Northern Wei, who promoted Buddhism as a state religion, were originally the T'o-pa Tartars. They had been invading nomads who pacified north China by A.D. 386, took the Chinese name Wei, and established their first capital, Ta-t'ung, on the northern border near the Great Wall, close to their former pastureland home. They believed that the Northern Wei king was the incarnation of the "Enlightened One." They expressed their piety by carving a huge Buddhist cave complex out of the rocks at Yün-kang, near Ta-t'ung. During more than a century, the T'o-pa Tartars gradually lost their "barbarian" qualities. In the process of assimilating Chinese culture they learned to use Chinese as the official court lan-

guage, wore Chinese dress, adopted Chinese customs and family names, intermarried with Chinese, and finally moved their capital from the northern edge of the state to Loyang, in the traditional heartland of China.

After the Northern Wei established their new capital at Loyang in 493, they again sought to express their piety at an appropriate nearby site. They chose a defile where the dense, gray, rocky cliffs rise abruptly from the banks of the Yi River. This came to be known as Lung-men, which means "dragon gate," where more than a thousand caves and a hundred thousand Buddhas evidence in tangible form the teachings of the Buddhist religion and the devotion of the Chinese.

The Chinese Communist Constitution of 1954 guaranteed freedom of religion to the people. However, Marxian theory postulates that religion, like other superstitions, will disappear when Socialism removes its causes, and in practice the Communist Party inhibited the free exercise of religion and sought to convert the populace to belief in Mao and the new Chinese state. The government took over the resources of the Buddhist Church and controlled its functions through a carefully monitored Buddhist association. Although Buddhist education was unavailable to the youth of the country, there was a small ongoing Buddhist establishment, which was enough to convince the international community that the Chinese had not abolished Buddhism. In 1963, the Party initiated a policy that regarded Buddhism as a vestigial poison whose roots must be pulled out and destroyed. This policy reached its climax during the Cultural Revolution (1966–69), when the remaining Buddhist establishments that had previously been allowed to perform ceremonies were shut down. In the general relaxation of the post-Cultural Revolution period, the government appears to have returned to its pre-1966 line. A few temples have been reopened and a few monks are again permitted to perform services and to meet specially interested foreigners. As Holmes Welch, a leading authority on the subject, suggests (Far Eastern Economic Review, July 16, 1973, pp. 26–30), even this very limited practice of Buddhism may be allowed to die a natural death when the present old and middle-aged priests have gone. In China there is freedom "not to believe," and the assumption is that younger Chinese will make that choice. As for Buddhist imagery, it is safely categorized within the larger body of historical relics, admired for its craftsmanship but stripped of its religious power.

Chinese guides at Lung-men show that they are sensitive

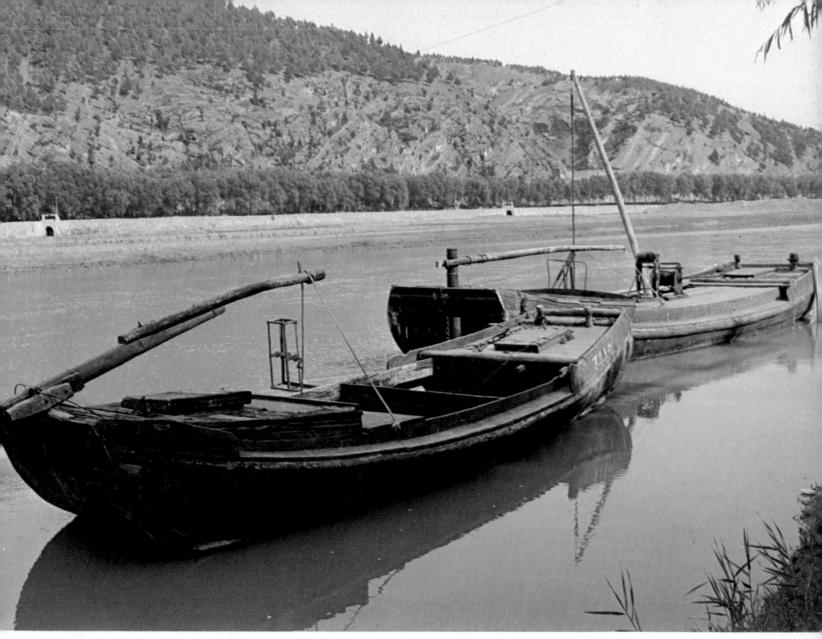

the eastern cliffs, Lung-men, Honan province. Lung-men is about nine miles south of Loyang, and means "dragon gate." This was where the Northern Wei began to carve Buddhist caves at the end of the fifth century.

about the pillaging of sculptures for the foreign market before 1949. As visitors tour the caves, they are shown empty places where sculptures that now enhance major foreign museums originally stood. The guides often show great tact, however, in sparing visitors affiliated with a specific institution the embarrassment of seeing where their own museum's piece was hacked out of the stone wall.

Prior to the establishment of the People's Republic, no favorable Chinese interest had been shown in these caves for a thousand years, and the effects of weather, neglect, and wanton destruction by the Chinese themselves during several periods of severe anti-Buddhist persecutions have doubtless been far more damaging than twentieth-century pillaging for profit. After the T'ang, Chinese cognoscenti did not value Buddhist sculpture as having any religious or aesthetic im-

103. The western cliff face at Lung-men, Honan province, showing a honeycomb of cave openings and niches and a pomegranate tree in bloom.

portance. That China's later emperors showed no interest in ancient Buddhist sculpture is demonstrated by its scarcity in the former Peking Palace Collection, now in Taiwan, most of whose treasures, accumulated over a thousand years, were taken from the mainland by the government of Chiang Kaishek in 1949. Foreign buyers of Lung-men's statuary had no feelings of guilt, because sales were openly transacted and the pieces were sold by Chinese. In addition, collectors felt they could properly care for objects that were being neglected at Lung-men, and that they could transmit the marvels of Chinese Buddhist art to the world beyond China.

The majority of the Lung-men caves and niches were carved on the western shore of the Yi River; during the T'ang dynasty, comparatively few were carved in the eastern hills (plate 102). As time went on and more niches and caves were fashioned out of the rock, the face of Lung-men came to look like a honeycomb (plate 103). Because Chinese Buddhist art styles evolved over the centuries in which the caves and sculptures were carved, Lung-men serves not only as a type site for Northern Wei Buddhist art but also as a catalogue of Six Dynasties and T'ang styles.

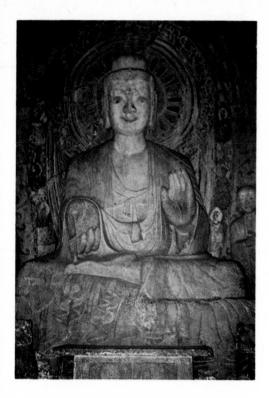

104. Seated Buddha in the Pin-yang cave, Lung-men, Honan province. Carved 502–23 (Northern Wei dynasty). This Buddha, located in the center of the rear (west) wall, is the principal image in the cave.

The process of sinicization of the foreign Buddha image involved transforming the facial features—the Buddha developed Chinese eyes and a small nose—as well as hiding the body behind voluminous layers of drapery. The contours of the body, revealed by diaphanous robes on the foreign image, disappear in the Chinese style in a formal cascade of folds in lowrelief linear patterns. In the Pin-yang cave, probably carved for royal patrons between A.D. 500 and 523, there are brilliant examples of the new Chinese synthesis, which occurred toward the end of Northern Wei rule. The main Buddha (plate 104) is seated cross-legged at the central point in the rear of the cave directly opposite the doorway. His slight smile is often compared to smiles seen on archaic Greek statues of the sixth century B.C. Symbolic of his power, his oversize hands stand out from the fluid ripples of the robe, radiating magical reassurance.

There is a group (plate 105) on either side wall of the Pinyang cave, each consisting of a standing Buddha flanked by smaller attendant Bodhisattvas. Behind the head of each Buddha a circular flaming halo is shallowly carved in low relief, and the whole figure stands within a huge, elaborately carved body halo called a mandorla. The artistic source of halos, in both Buddhist and Christian iconography, is thought to be the Persian gods of light, who were shown encircled by an aura.

The Pin-yang cave was carved over a period of twenty-three years. It has a well-organized plan for all the decorations, including the high- and low-relief sculpture and painting. This is distinctive, because many of the other caves have sections carved by different patrons at different times, resulting in haphazard organization. The dedicatory inscriptions at Lung-men tell us that its patrons included royal, aristocratic, and literati families; monks and nuns (plate 106) who lived at Lung-men and elsewhere; and religious societies that included the common people. Perhaps one of Buddhism's most beneficial effects on Wei and T'ang society was its cohesive force. It offered salvation to all segments of society.

Kenneth Ch'en's *Buddhism in China* (pp. 174–76) summarizes dedications made by the ruling class in honor of the emperor, in memory of ancestors, for the prosperity of the dynasty, for the longevity of the clan, and for the well-being of all the people. The dedicatory purposes of the religious societies reflected the concerns of the masses: to be reborn in a Buddhist paradise, to attain enlightenment, to thank the Buddha for boons granted, to obtain benefits such as material wealth,

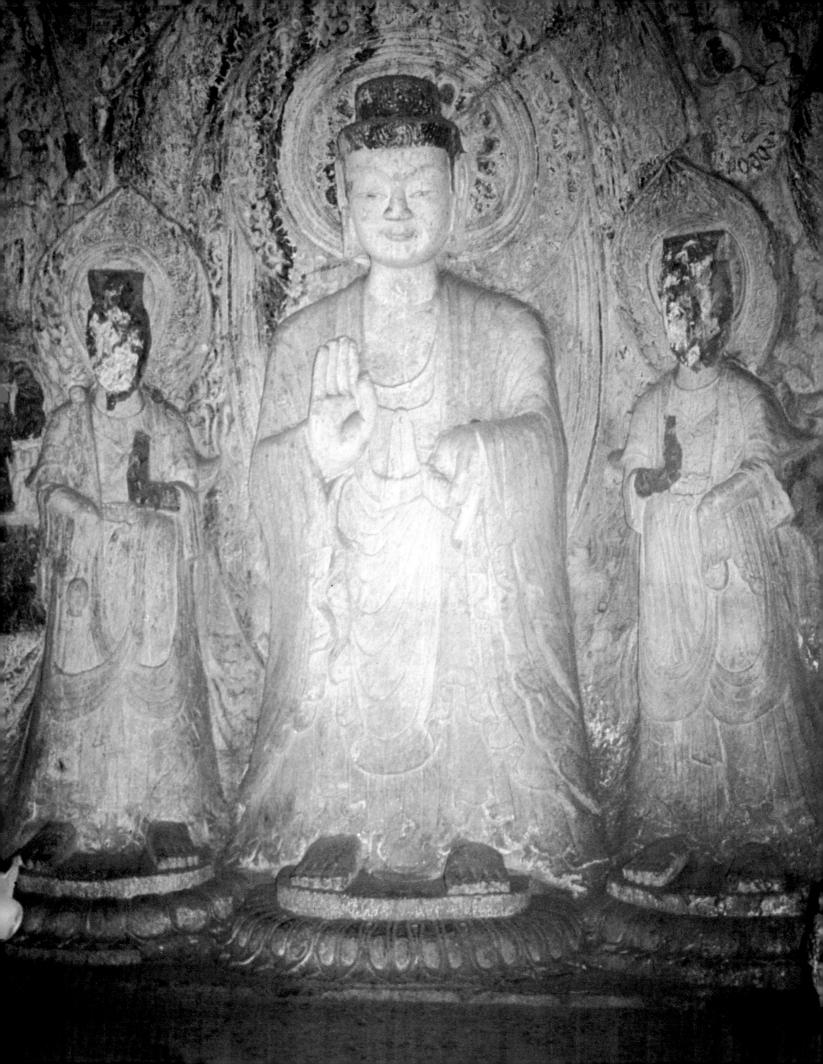

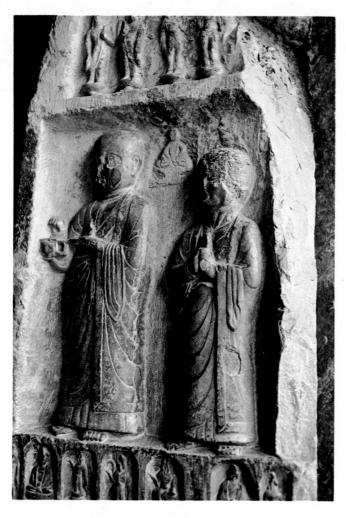

107. North wall of a cave carved with Buddhas in niches, Ku-yang (or Lao-chün) cave, Lung-men, Honan province. Cave carved 495–524 (Northern Wei dynasty). The cave is about 42 1/2 feet long, 22 feet wide, and 36 feet high. Below the Buddha niches is a canopy shape including Buddhas, Bodhisattvas, and swagged jewels emanating from monster mouths and floral designs.

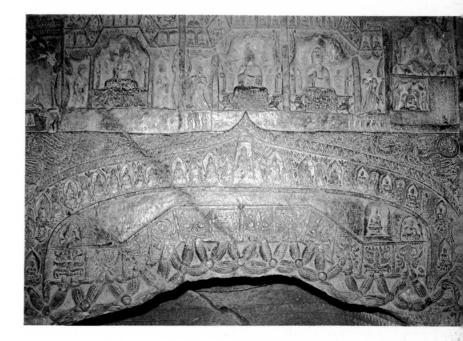

106. Worshiping monks. Lung-men, Honan province. T'ang dynasty (618–907). One small niche among the thousands carved with adoring supplicants.

5. Buddha flanked by Bodhisattvas in the Pin-yang cave. Carved 502–23 (Northern Wei dynasty). This is one of two identical sculptured triads, one on the north wall and one on the south wall of the cave.

official position, and long life, to express gratitude for recovering good health, and to assure military success in a campaign.

A religious society with only limited financial resources might carve a single niche or part of a wall. Many walls are covered with such unintegrated dedications. A typical example of this kind of wall (plate 107), carved in the Northern Wei style, shows a series of Buddhas cloaked in cascades of drapery, seated on lion thrones in a throne room swagged with curtains, and flanked by disciples and grace-giving Bodhisattvas. Various Buddhas are represented: Prabhūtaratna, the Buddha who presided in a past eon of time and was predecessor to the historical Buddha; Shākyamuni, the historical Buddha born in India in the sixth century B.C.; Maitreya, a Bodhisattva who will become the next Buddha (in other words, a messiah); Amitābha, the Buddha of Infinite Light, who presides over the Western Paradise. Avalokiteshvara (Kuan-yin),

108. Flying musicians at Lung-men, Honan province. T'ang dynasty (618–907). Behind a Buddha's head, a circle of celestial flames was carved in low relief. Heavenly musicians play accompaniment within the halo.

a compassionate Bodhisattva who offers grace to all and assists the worshiper to the Western Paradise of Amitābha, is also shown. There are thousands of representations of paradise enriched with silk swags and jewels, and tens of thousands of smaller Buddhas who float on lotus flowers encircled by radiant mandorlas, attended by a seemingly endless cast of Bodhisattvas. Fastened to what appears to be the proscenium arch of the paradise scene, strings of beaded jewels emerge from the mouths of monsters and from floral designs. Heavenly godlings, called Apsarases (plate 108), are depicted in crisp linear patterns flying about within a flourish of long flowing scarves.

The lotus flower was a favorite Buddhist symbol. In one cave (plate 109) a huge lotus was carved out of the ceiling in the Northern Wei period. Lotus grows wild in Asia; it flourishes in the swamps and marshes without cultivation, attaining its clean and perfect form unscathed by its impure environment. Thus it symbolized the Buddha's beauty and purity.

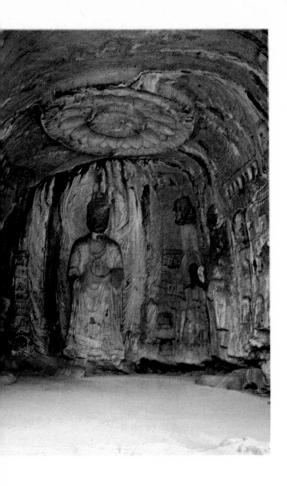

Lotus Flower Cave (Lien-hua-tung), Lung-men, Honan province. The cave is named for the giant lotus flower carved in the ceiling. Most of the carving was done 518–22, with the smaller niches being carved c. 525–75. The cave is about 20 feet wide and 32 feet deep. The height of the standing Buddha is about 20 feet.

He, too, was uncorrupted by the tainted world about him, by the temptations of life.

In A.D. 534, racked by internal struggles, Northern Weirule collapsed. North China was again divided. Splinters of the ruling house, Eastern and Western Wei, were briefly established, and they in turn were succeeded by two more short-lived dynasties during the second half of the sixth century. During this chaotic time, less carving was done at Lung-men, and the level of activity dropped off almost completely after the second dynastic switch in mid-century. It was only modestly resumed when China was reunited under the Sui dynasty in 581. Although the Sui too was short-lived (581-618), it achieved what its predecessors had been unable to do for more than three hundred years—it created a strong central government with effective military control over much of what had been the heart of Han China. The Sui unification of China set the stage for the long and glorious rule of the T'ang dynasty (618-907), just as the Ch'in unification (221-206 B.C.) had set the stage for Han rule (206 B.C.-A.D. 220).

The establishment of the T'ang ushered China into a golden age of domestic peace and prosperity and one of the periods of greatest imperial expansion in her history. For a brief time in the eighth century, T'ang control of western China extended beyond the Pamir mountains into the Oxus Valley, today part of Afghanistan and the USSR. The T'ang imperial family was of mixed blood resulting from Turkic-Chinese intermarriage. The name of the great Emperor T'ai Tsung (r. 626-49), which means "Grand Ancestor," reflects the unselfconscious cosmopolitan mixture of the imperial blood. This was to be a sign of the broad tolerance enjoyed in T'ang China by all kinds of foreign people, ideas, images, and goods. The capital cities of Ch'ang-an (Sian) and Loyang and the trade city of Canton had areas reserved for foreign traders, officials, and missionaries. Although Buddhism was by far the most widely practiced religion of foreign origin, it had been transformed into a Chinese religion, and many of its ideas were absorbed into the texture of Chinese thought. However, it was but one among a group of religions introduced to China from outside. Others were Zoroastrianism, Manichaeism, Nestorian Christianity, Judaism, and Mohammedanism.

The Buddhist imagery of the T'ang reflects the new cosmopolitan qualities of T'ang thought. It loses much of the specifically Chinese linear stylization that marks the images of the Northern Wei period. Buddhist craftsmen of the T'ang

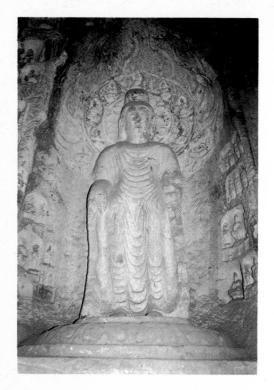

110. Buddha, east wall of Cave II,Lung-men, Honan province.Sui or T'ang dynasty.

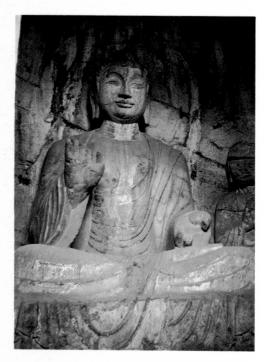

(Ch'ien-ch'i-ssu), Lung-men, Honan province. First half of the seventh century (T'ang dynasty). This awesome Buddha reflects the early T'ang stylistic shift.

examined freshly imported, full-bodied Indian Buddha images and carved new ones in a new Chinese style (plates 110, 111). The change was partly due to continuing foreign influence, but there was also an indigenous Chinese stylistic development away from the abstract, disembodied Wei ideal and toward an image more closely related to human anatomy. Faces lose the exaggerated elongation characteristic of the Wei style, and the bodies of the deities in the pantheon begin to be defined under their robes. The trend toward a kind of sensual "realism" climaxes during the eighth and ninth centuries, when the facial expressions and revealed torsos of some of the Buddhist images take on a decidedly earthly look, as if they were modeled after T'ang courtiers.

This change is amply reflected at Lung-men. The Cave of Ten Thousand Buddhas, called Wan-fo-tung (plates 112–114), was completed in A.D. 680. Following the general organization of the earlier caves, the central Buddha sits crosslegged on a lotus throne, flanked by disciples and Bodhisattvas. An example of the early T'ang style, this Buddha has an overall rounded feeling quite different from his angular Pinyang counterpart; his face is heavy, his chin sharply defined, and his lips are unsmiling; the torso is clearly suggested under the robe. The cave walls and sculptures were painted at the time they were dedicated, and some were repainted in later pious acts of refurbishing. In the Cave of Ten Thousand Buddhas, the red-painted halos and red-and-white-painted lotus on the ceiling (plate 112) have survived remarkably well.

The name of the cave comes from the thousands of tiny Buddhas that are carved in relief on its side walls. In the Pure Land sect, a major school of Chinese Buddhism in which Amitābha presided over the Western Paradise, rebirth in this heaven was offered as a reward for the practice of "good works" such as repetition of the Buddha's name and repeated creation of the Buddha image. The invention of printing in T'ang China facilitated mass reproduction of Buddha images on paper, but this cave illustrates the pious act in a more durable form.

Close examination of these thousands of Buddhas (plate 113) reveals that the majority of their minuscule heads—no larger than half an inch—have been broken off. It seems unlikely that this vandalism was the work of thieves, for the head fragments would be no more than unrecognizable pebbles. These heads were probably smashed in iconoclastic campaigns against Buddhism. There were three major Buddhist persecutions in

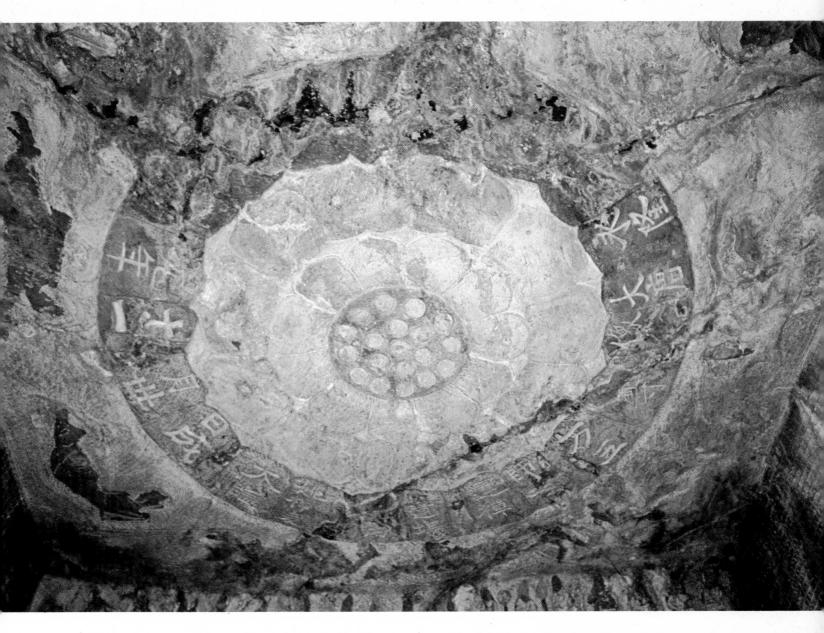

112. The ceiling of the Cave of Ten Thousand Buddhas is engraved and painted with a lotus-flower design.

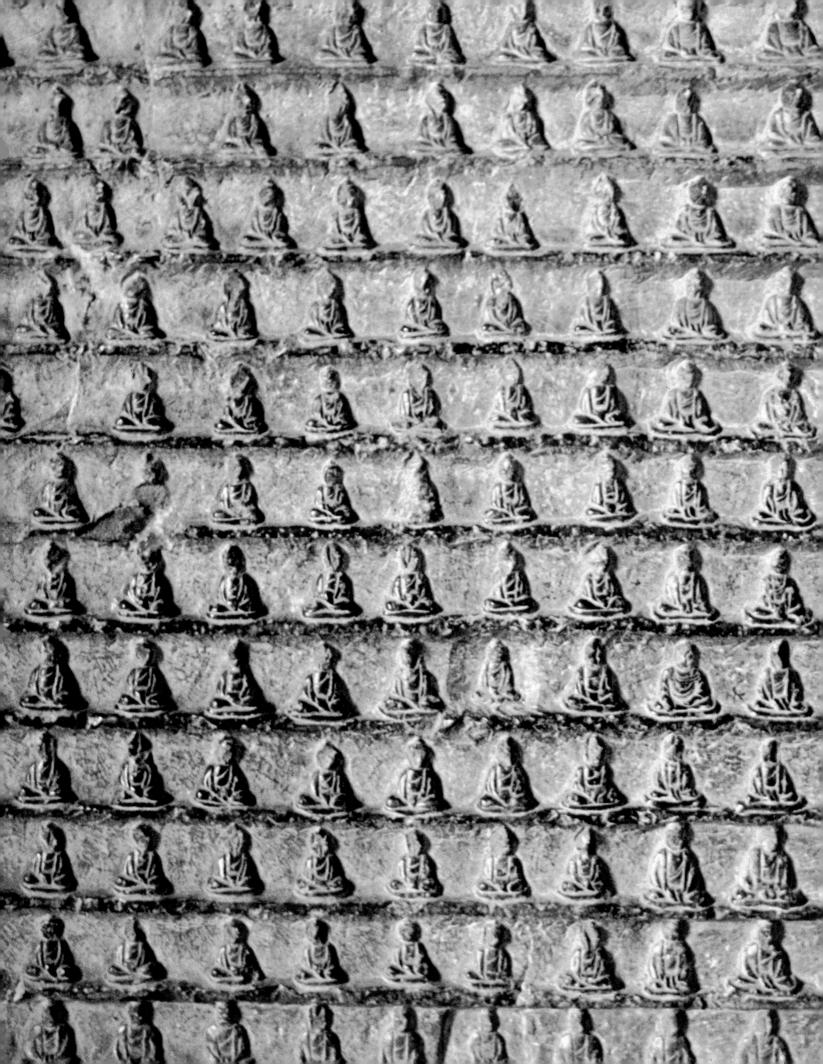

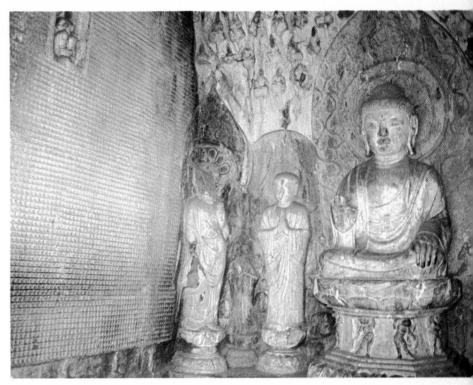

Yung-lung-tung), Lung-men, Honan province.
Completed in 680 (T'ang dynasty). Carved and painted stone. The cave is about 19 feet wide and 22 feet deep. The Buddha is flanked by two disciples and two Bodhisattvas (one of each shown here) and a host of smaller attendants. The side wall is carved with thousands of tiny Buddhas (detail at left). Wan-fo-tung means Cave of Ten Thousand Buddhas; the other cave name comes from the title of the period of years beginning in 680 (Yung-lung).

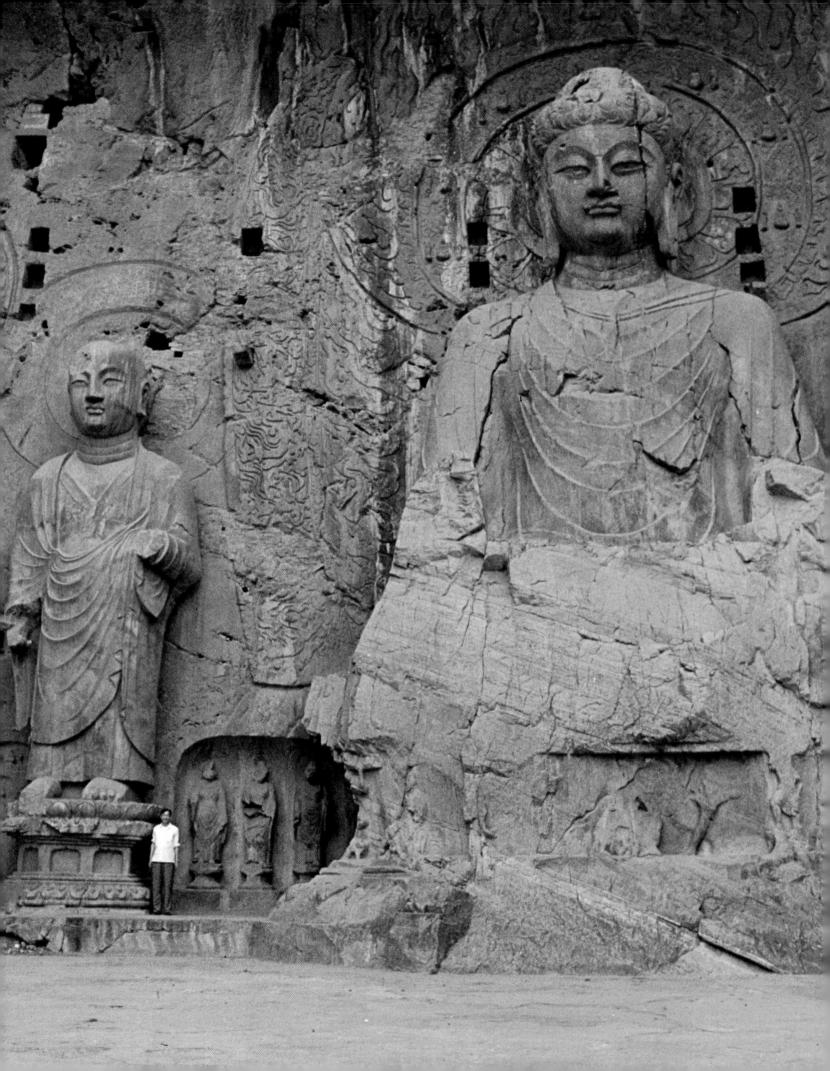

Itis. The Buddha Vairocana and a disciple (lohan), Feng-hsien Temple (Feng-hsien-ssu), Lung-men, Honan province. Statue, 672–75. Vairocana has some of the magical marks that identify Buddhas, such as the cranial protuberance, and the disciple shares other characteristics of the Buddha, such as three folds of flesh at the neck and elongated ear lobes. The size of the colossal statue can be comprehended by comparing it to the height of the man to the right of the disciple.

Chinese history. The most devastating one occurred in 845, only 165 years after the completion of this cave.

The pinnacle of glory reached by Buddhism at the height of its influence—before the crippling persecutions and its displacement as the imperial religion—can be seen in the largest cave at Lung-men, called Feng-hsien Temple (plates 100, 115-118). It is roughly 100 feet square and is called a temple because, unlike the other caves, no natural roof remained when the giant cavity was hollowed out of the hillside. In its day, the temple was covered with a wooden roof. An inscription reveals that the central Buddha was begun in 672 and completed in 675. This colossal figure, measuring 56 feet including its pedestal, has been identified as Vairocana, a newly introduced member of the Chinese Buddhist pantheon who is different from both the historical Buddha and the Savior, Lord of the Western Paradise. Laurence Sickman describes Vairocana in Sickman and Soper, The Art and Architecture of China (p. 71), as a personification of "a philosophical concept of the original creative spirit that embraces the Buddhist Law and the cosmos." According to the scriptures, Vairocana Buddha sits on a thousand-petaled lotus; each petal represents a universe containing myriad worlds, each with a Buddha. Vairocana has some of the magical marks which identify Buddhas, such as the cranial protuberance called ushnisha, the reputed location of his special knowledge, and three folds of flesh on his neck. He has a peaceful, introspective expression and in both size and looks fits the awesome cosmic prescription for such a universal spirit. Behind the giant Vairocana Buddha, floating within his flaming nimbus, are many small Buddhas seated on lotus flowers.

The entourage of two flanking disciples and two Bodhisattvas seen in many other Lung-men caves is also carved in gigantic high relief. The principal disciples of the Buddha, Ananda (plate 117) and Kashyapa, appear, although the latter has now been almost completely obliterated. They both had shaved heads and simple monastic robes. The Bodhisattvas wear the crown, jewels, and double-draped skirt (dhoti) of an Indian prince. After all sentient beings become enlightened and reach Buddhahood, the Bodhisattvas, having finished their work, will also become Buddhas and will take off their finery as a symbolic act of renunciation. Their relaxed posture, standing with one hip slightly extended, is an adaptation of the Indian *tribhanga* pose. It contrasts vividly with the stiffly frontal Bodhisattvas in the Northern Wei style. Of the original

- 116. Two guardian kings in the southern section of Feng-hsien Temple. The one on the left, pagoda in hand, is stamping on a dwarf. The other, by far the fiercer looking of the two, with bulging muscles and eyes, is scantily dressed in jewels, scarves, and a short skirt. Most of the caves have more modestly scaled door guardians of similar appearance.
- 117. The Buddha Vairocana, a disciple, a Bodhisattva, and fragments of a guardian king in the northwest section of Feng-hsien Temple (Feng-hsien-ssu), Lung-men, Honan province. Originally Vairocana had eight colossal attendant figures, four on each side. Flanking Vairocana were two disciples, beside them two Bodhisattvas, and beside these two pairs of guardian kings.

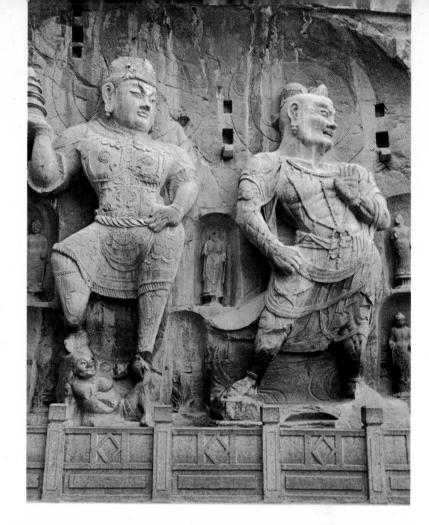

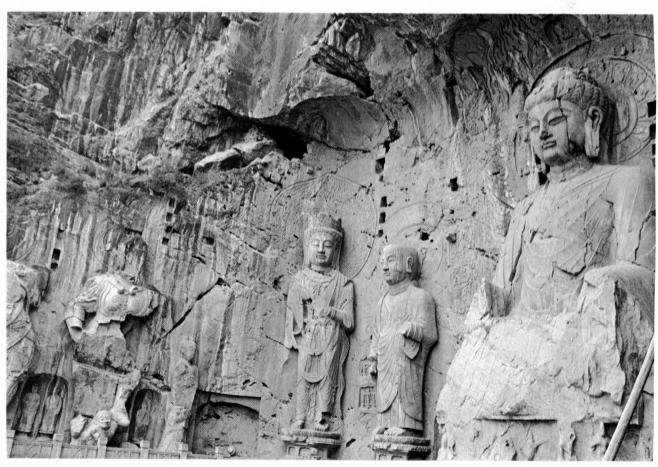

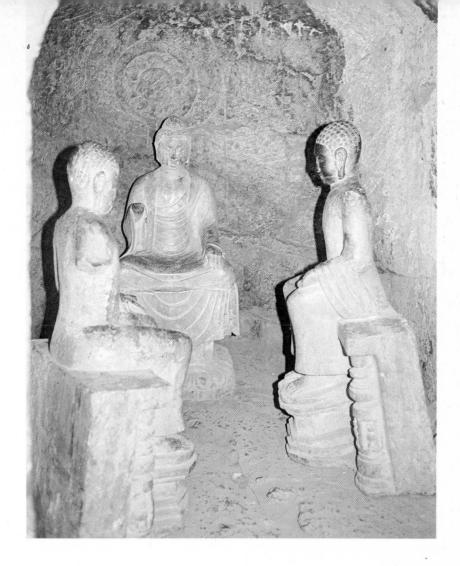

118. Three seated Buddhas. Lung-men, Honan province. T'ang dynasty (618-907). These figures present a problem in dating and location because they were probably moved from another Lung-men site.

four guardians only one set of two remains intact on the north side (plate 116).

More caves were carved at Lung-men between 640 and 720 than at any other time. Activity later dropped off, especially after the great Buddhist persecution of 845, although some carving continued through the last years of the T'ang dynasty and into the Sung (960–1279). Under the T'ang, the Buddhist establishment grew rich and powerful. The Buddhist Church became a major landholder through imperial and private land grants. It had hundreds of thousands of adherents who took monastic vows; their motivation was not always pious, for doing so made it possible to avoid taxes, corvée labor, and military duties. The fanatical Taoist emperor who engineered the anti-Buddhist repression and confiscation of 845 did so not only for religious reasons. He also feared that his wealth and the strength of his empire would be drained off by the taxexempt Buddhist properties and the unproductiveness of those who took refuge in monastic life. Records from that period catalogue the destruction of 4,600 monasteries and 40,000

119. Pagoda carved into the wall of the western cliff face at Lung-men, Honan province. T'ang dynasty (618–907). OPPOSITE PAGE:

120. Great Gander Pagoda (Ta-yen-t'a), Sian, Shensi province. Originally built in 652, it was rebuilt with two more stories in the eighth century and restored in 1580 and recently. This pagoda was built as a depository for the Buddhist scriptures brought to China from India by the famous monk Hsüan-tsang in the seventh century.

shrines, and the return of 260,000 monks and nuns and their 150,000 servants to the tax registers.

By the late T'ang, Chinese Buddhism had lost its inner vitality and never really recovered. Although Confucian scholarship was carried on during the T'ang, some of the ablest leaders of Chinese society studied Buddhist law. In the subsequent Sung dynasty, the elite lost interest in Buddhism, hoping for careers in government. They studied ancient Chinese history and literature, for the civil-service examinations tested a man's mastery of the Confucian Classics. Yet some aspects of Buddhist thought remained within the fabric of Chinese learning, and, although diminished in power, prestige, and wealth, a major Buddhist establishment survived in China into modern times.

Buddhist art left marks on the Chinese landscape, just as many Buddhist ideas became absorbed into Chinese thought. The pagoda—the Chinese equivalent of the Indian stupa, or relic mound—is the most obvious enduring form seen by travelers in China today. In India the stupa was a hemispherical burial mound in which the sacred remains of the Buddha or his disciples were enshrined. In the transmission of Buddhism to China, the repository for such relics took the form of a storied tower. Some scholars trace the origins of the pagoda to the traditional Chinese watch towers built in Han China. Not only were the stupas and pagodas sanctified structures themselves because they housed sacred objects, but their shapes—stupa in Indian Buddhist art and pagoda in Chinese Buddhist art—were also carved or painted on walls in sacred places and were worshiped just as were images of the Buddha.

There are at least thirty-nine small, carved representations of pagodas on the walls of the Lung-men caves (plate 119). The one illustrated here, square-shaped and with five stories, looks as though it has undergone some terrible natural disaster or the ruinous hacksaw of an anti-Buddhist. This style of pagoda was popular in the T'ang period. The Great Gander Pagoda (Ta-yen-t'a; plate 120) in Ch'ang-an looked very much like this Lung-men carved pagoda when it was first built in the seventh century for Hsüan-tsang, the most famous of Chinese pilgrims. He had traveled to India between A.D. 629 and 645 in search of understanding and the true scriptures and had kept a careful account of where he had been and whom he had met. His informative Record of the Western Regions is an invaluable document of Indian history, especially because the great body of Indian literature is philosophical in

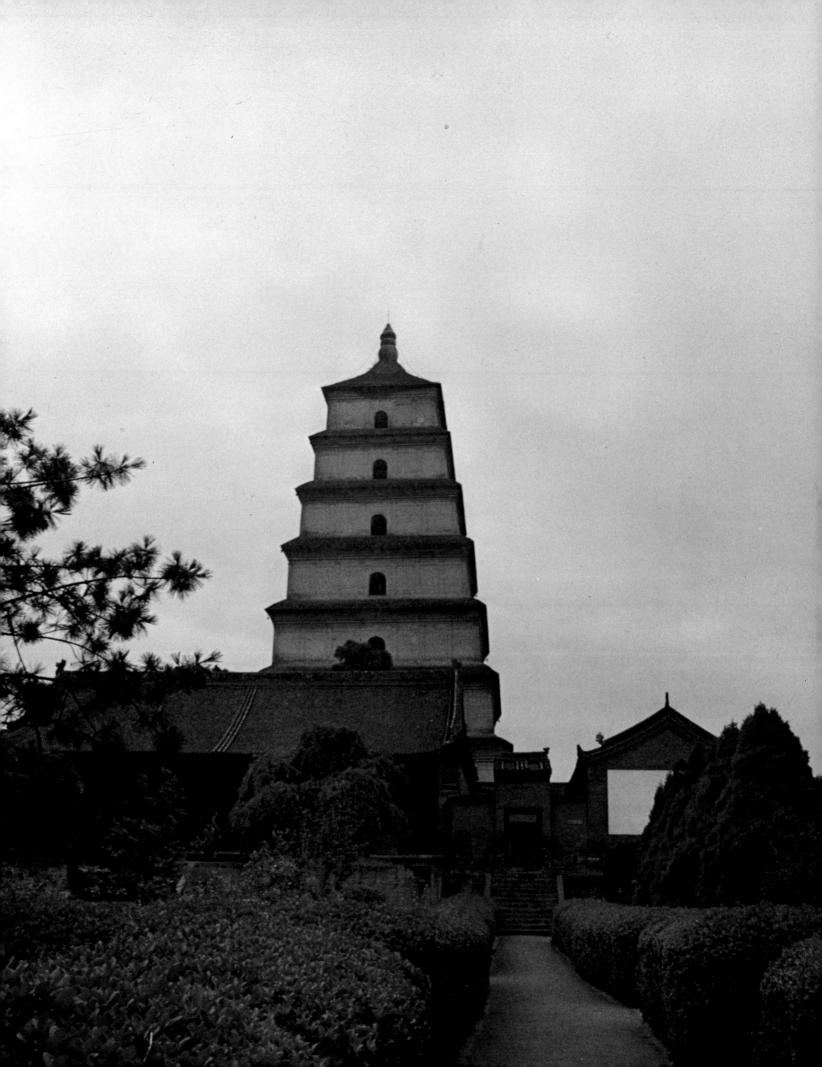

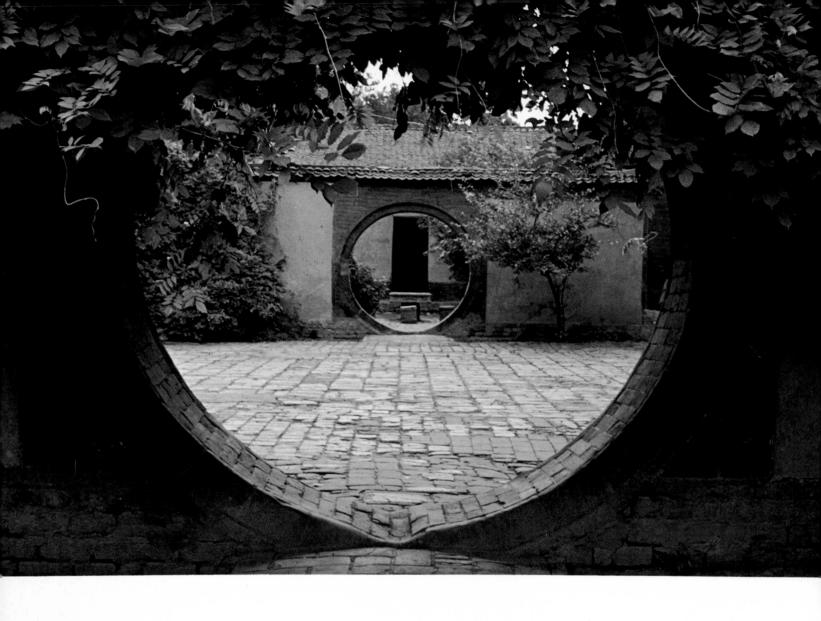

content and does not include the mundane dates and events from which history is reconstructed.

After Hsüan-tsang returned from India to Ch'ang-an via Khotan on the newly opened "southern route" over the Central Asian desert, he was celebrated not only for his adventurous travel, which stirred the Chinese romantic imagination for generations, but also for his great learning. He translated some of the scriptures he brought back from India, and these served as basic documents for some important schools of Buddhism which subsequently flourished in China and Japan. He asked the emperor to build an appropriate repository for this sacred literature. Most Buddhist temple architecture, including pagodas, was built of wood, the form of religious buildings following the models of palace architecture, which were also made of wood. Hsüan-tsang wanted a pagoda made of stone, the more enduring material he had seen used in the great stupas of India. In a very Chinese compromise, the Great

121. Temple of Great Good Will (Tz'uen-ssu), located at the base of the Great Gander Pagoda, Sian, Shensi province. Originally built in 647, it was rebuilt in 1850 and recently. Moon gates and wisteria evoke poetic images of China's past. Gander Pagoda was built in five stories of brick. However, soon after the monument for Hsüan-tsang's precious texts was built, it cracked and had to be restored. When it was repaired in the early eighth century, two more stories were added. Although the Great Gander Pagoda was built within the walls of the T'ang city of Ch'ang-an, the setting was then, as it remains now, far from the hustle and crowding of the central city. T'ang aristocrats built pleasure pavilions close by, and twice a year the local populace was allowed to come to picnic, enjoy the country air, and climb the pagoda to look at the spectacular view of the environs and glimpse the mountains of Szechwan at the edge of the north China plateau. The pagoda and adjoining temple burned in the eleventh and twelfth centuries and were restored in the sixteenth century and then again by the People's Republic. The temple complex of rectangular halls, drum towers, and courtyards (plate 121) has been rebuilt in a traditional style.

Funerary ceramics attest to the continuing popularity of the T'ang rectangular pagoda style. Among recent archaeological finds are a ninth-century stoneware ewer (plate 122) decorated with a curving-roofed T'ang pagoda design in relief and covered with a celadon glaze, and a late tenth-century three-colored, seven-story funerary pagoda (plate 123). A companion piece to the latter is a pottery box for preserving Buddhist relics. Its highly unusual shape is a cross between a box with metal edging and a one-story mausoleum. If it is reproducing an architectural form, it is of a vaguely foreign type. A creamy yellow crown of medallions is set around the roof line at the base of the hipped roof, which is flat on top. Under the roof-line decor, the cubic building form is outlined horizontally by green studded beams and by green vertical posts framing the corners (perhaps simply the box's protective edging). White high-relief lions guard the corners, and creamcolored anthropomorphic guardians stand beside the door. Brown, circular medallions with starred centers decorate the walls.

Much foreign artistic influence was absorbed into Chinese forms during the T'ang, reflecting the receptive climate for non-Chinese exotica. The visitor to China today still finds some tangible evidence of this early foreign influence—mosques in various cities, for example, and, of course, early Buddhist temples. In Kwangchow (Canton), a fine pagoda was originally built in 537 as part of a temple complex which came to be known as the Temple of the Six Banyan Trees (plate

122. Ewer from Changsha, Hunan province. Ninth century (T'ang dynasty). Stoneware with celadon glaze. Shown at the Imperial Palace, Peking.

123. Miniature funerary pagoda and Buddhist relic box, from Mi-hsien, Honan province.

Last quarter of the tenth century (Sung dynasty). Stoneware with three-color glazes. Shown at the Imperial Palace, Peking.

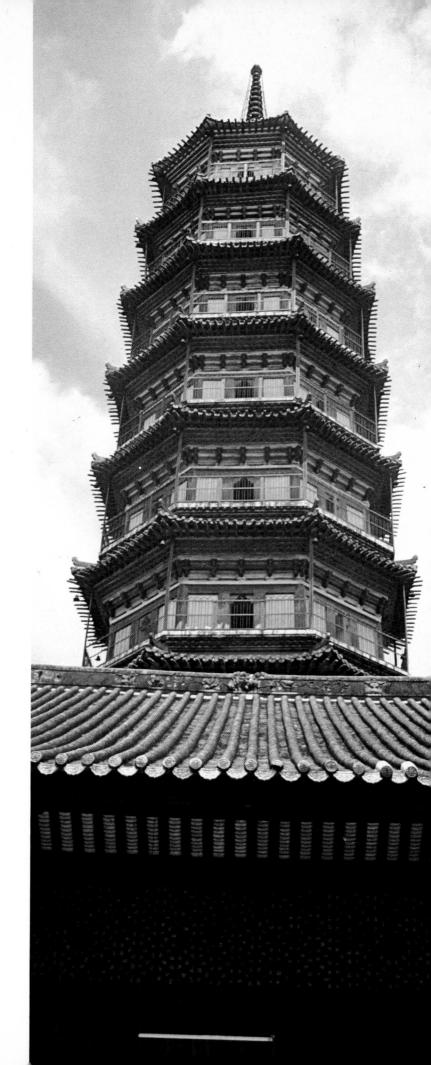

of the Temple of the Six Banyan Trees (Liu-jung-ssu), Canton (Kwangchow), Kwangtung province. The temple was founded in 479. Buddhist scriptures recount that the Buddha sat beneath this kind of tree at Bodhgaya when he became enlightened. Seedlings from that sacred tree were carried all over the Buddhist world to be planted and worshiped.

Temple of the Six Banyan
Trees (Liu-jung-ssu), Canton
(Kwangchow), Kwangtung
province. First built in 537, it
was rebuilt in 1098 in Sung
pagoda style. Height 180 feet.
The polygonal Sung pagoda
style is a sophisticated elaboration
of the T'ang pagoda.

124). When the pagoda was restored in 1098 after a fire, it was rebuilt in the mode characteristic of Sung dynasty pagodas. A faceted tower rises from an octagonal base, an elaboration on the square T'ang models. The Temple of the Six Banyan Trees includes yet another exotic import, two bodhi (pipal) trees (plate 125); the Buddha purportedly was seated under a bodhi tree at the moment of his Enlightenment. Although the Buddha's sacred tree in Bodhgaya, India, died, seedlings from it were carried to many places, along with Buddhism, its scriptures, and its imagery. Trees from the seedlings still flourish today at Anaradhapura in Ceylon and Borobudur in Java, for example, and it is quite likely that the great bodhi trees in the Canton temple grew from seedlings taken to China by pious Buddhists.

During the T'ang, the largest foreign community in China was in Ch'ang-an, where the imperial court resided. From the seventh to the ninth centuries, this was the seat of power of the largest empire in the world, as well as the world's most populous city, having over two million inhabitants. Ch'ang-an was the richest, most cosmopolitan, most carefully planned metrop-

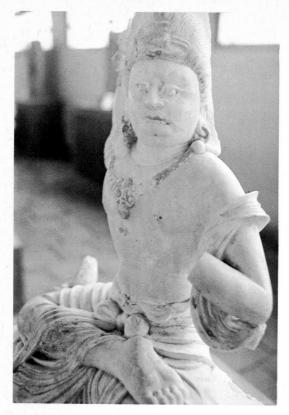

126. A Radiant King. T'ang dynasty (618–907). Marble. Shown at the Historical Museum, Sian, Shensi province.

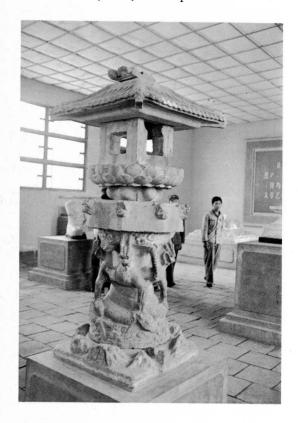

127. Lantern with a coiled-dragon base. T'ang dynasty (618–907). Stone. Shown at the Historical Museum, Sian, Shensi province The watery habitat of the many-headed, coiled dragon is suggested by waves at the base.

olis in the world and expressed the highest achievements of organization, technology, and art of that period.

The visitor to Sian today can see little of T'ang splendor save two pagodas. The T'ang city fell into ruins after the dissolution of the dynasty. What remains of old Sian was built during the Ming (1368-1644) and Ch'ing (1644-1912) dynasties, and its walls (plate 128) enclose a city area one-sixth the size of T'ang Ch'ang-an. Still, even if modestly, the scale of these walls and of their great fortified gateways evokes some sense of the ancient imperial presence. The Ch'ing city is a miniature version of the great T'ang city, arranged in a gridiron pattern with wide boulevards. For a lover of ruins, old city walls, weathered and unrepaired, possess romance (plate 129). If no palaces remain, there still are little alleys lined with thatch-roofed houses made of whitewashed, pounded earth mixed with clay, the kind of dwelling built by common folk for at least two millenniums. The lanes of Sian are lined with walls which enclose courtyard dwellings (plate 130). A peep through the occasional open gate reveals scenes of housekeeping-water storing, washing, cooking, and kitchen gardening —not so different from those seen in Han funerary sets.

One must go to the museum to find traces of the glory that was T'ang Ch'ang-an. Among many items of high quality are some voluptuous, vigorously carved, white marble Buddhist sculptures (plate 126) from the wealthy Buddhist temples of Ch'ang-an. A marvelously carved lantern (plate 127) held up by a coiled, dragon-like being is probably from a temple and is but a single example from perhaps thousands of elaborate fixtures that once illuminated that city. Ch'ang-an was famous for night-time diversions ranging from Buddhist feasts, dances, and dramatic performances to amusements offered in the gay quarters by beguiling courtesans skilled in musical arts and flattering conversation and by ordinary prostitutes. There were taverns and teahouses offering rare foods and wines not only from China but also from the many foreign countries represented in the local population.

In his brilliant book *The Golden Peaches of Samarkand*, Edward Schafer draws a vivid picture of the foreigners whose ways enriched the texture of Chinese life with what he calls "T'ang exoticism." Li Po, a famous T'ang poet, commemorated one such exotic T'ang creature, a lithe, fair-haired, green-eyed beauty called a "western houri," who seduced the poet and other guests with her intoxicating charms. As translated by Schafer (p. 21), Li Po's poem touches us directly:

128. City wall and gates in Sian, Shensi province, built during the Ming dynasty (1368–1644). Fields of tomato plants can be seen in the foreground.

As the modern city of Sian flourishes, old walls fall into ruin or are pulled down.

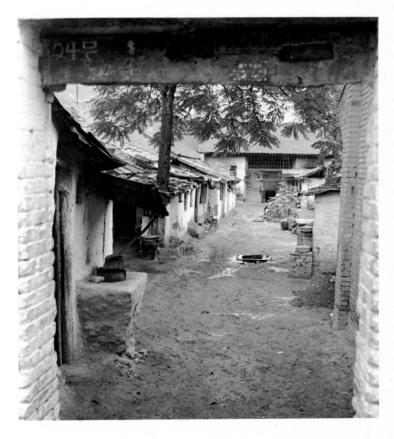

130. Courtyard housing in Sian, Shensi province. From a small lane, a brick gateway leads to a courtyard shared by a group of traditional-style houses.

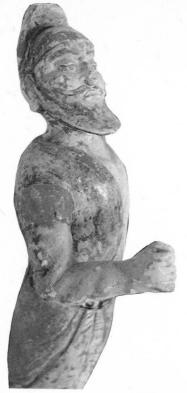

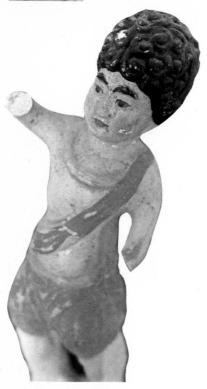

131, 132. Tomb figures of a merchant from the Middle East, top, and of a foreign youth who served as a groom. Eighth century (T'ang dynasty). Pottery painted with cold pigments. Shown at the museum in Wang-ch'eng Park, Loyang, Honan province.

The zither plays . . .

The lovely wine, in its pot of jade, is as clear as the sky . . . our faces begin to redden

That western houri with features like a flower—

She stands by the wine-warmer, and laughs with the breath of spring

Laughs with the breath of spring

Dances in a dress of gauze!

Once again, it is the sets of funerary figures that show us a glimpse of local color. Hook-nosed, bearded traders from the Near East, both Aryan and Semitic, often appear in the timeless entourages (plate 131). These merchants supplied the Chinese nobleman with prized foreign products during his lifetime, and it was presumed that they would continue to do so after his death. Some conquered peoples of Central Asia were brought to Ch'ang-an to serve as slaves for the imperial family and for noblemen, while other foreigners came by choice to trade with or serve the Chinese. Among the funerary figures are a number of fair-skinned youths with black, curly hair, who served as grooms (plate 132). The youth depicted here wears only a single length of cloth, wrapped around his legs and torso below the waist in the form of slightly ballooning shorts. The end of the material crosses over his chest and goes around his neck, although the neck material has been left unpainted. His dark, bushy eyebrows, painted with exuberance, harmonize with his marvelously thick, curling hair, molded in high relief. His dark mane and small red lips are a foil for his fair complexion.

Most of the Central Asian peoples who came to Ch'ang-an—Turks, Uighurs, Tocharians, and Sogdians—traveled to China overland, following the Silk Road. By contrast, their South Asian counterparts—the Chams, Khmers, Javanese, and Sinhalese—came by sea and mainly congregated in Canton. Both international settlements had large groups of Arabs, Persians, and Indians who came to China by both land and sea routes.

The two-humped Bactrian camel (plate 133) made it possible to journey by land around long stretches of desert—the most difficult part of the route. The Chinese obtained these camels through tribute, war booty, and purchase from various Turkic tribes. Bactrian camels were prized as mounts as well as beasts of burden; their fleet gait often sped emergency messages to remote frontier posts. But their most important role in T'ang China was to carry men and goods along the Silk

Tomb figures of a Bactrian camel and a groom, from Loyang, Honan province. Eighth century (T'ang dynasty). Pottery with three-color glazes; height of camel 34 inches. Shown at the Imperial Palace, Peking. The Silk Road was difficult, skirting the dry wastes of the Central Asian Desert. The unusual capacities of the Bactrian camel made the trip possible.

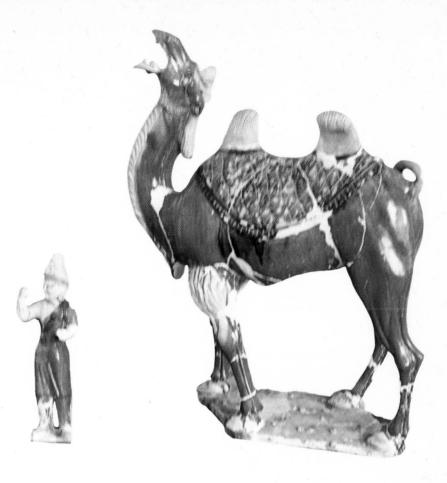

Road. Schafer points out (pp. 13–14) that the roads would have been impassable were it not for "the peculiar virtues of the Bactrian camel, which could sniff out subterranean springs for thirsty merchants, and also predict deadly sand storms." He translates an ancient account: "When such a wind is about to arrive, only the old camels have advance knowledge of it, and they immediately stand snarling together, and bury their mouths in the sand." Men in the caravans observed the camels and covered themselves completely for protection against these perilous sand-laden winds and the imminent death they threatened.

Models of these noble desert beasts were often fashioned of clay and included in a funerary entourage. T'ang Bactrian camels and horses like the "blood-sweating horses of Ferghana" were among the most appealing Chinese art objects collected by foreigners in the late nineteenth and the twentieth centuries. Hardly any museum in the West is without a T'ang camel or horse, or at least a good imitation, because eager buyers outnumbered the authentic products and clever forgers could realize high profits.

The brown, green, and creamy yellow glazing seen on the haughty, bellowing Bactrian camel is typical of T'ang funerary ceramics. It is called "three-color ware." T'ang potters

134, 135. Tomb figures of T'ang dynasty court ladies. Pottery with three-color glazes; unglazed heads painted with cold pigments. Shown at the Historical Museum, Sian, Shensi province.

did not know the secret of keeping the colors separate, and the glazes dripped beyond the specified areas, despite the use of relief patterns to hold the glazes in place. However, the potters used the dripped blobs of glaze to marvelous advantage, which is part of the charm of T'ang ware. The hollow clay figures were made in a series of molds, with a large opening under the belly of the creature to allow the gases to escape during the firing.

Among the most engaging burial figurines are some lively lady companions, full of self-composed elegance and charm. They wear the modish dresses of the period, when fashions were greatly influenced by various Central Asian styles of dress, coiffure, and makeup. The styles were brought to Ch'ang-an by musicians, entertainers, and courtesans. The voluminous, flowing robes and long sleeves worn in Wei and Han times were replaced by a tight-fitting bodice with equally tight-fitting sleeves, worn over a full skirt (plate 134). The older feminine hair style—parted and combed to the neck—was replaced by a new look featuring a flamboyantly upswept coiffure with one or two knots of hair worn on top of the head. The slim beauties of the seventh century were replaced by robust eighth-century ladies (plate 135) reflecting the economic well-being of the time. Jane Gaston Mahler, in The Westerners Among the Figurines of the T'ang Dynasty of China (p. 114), suggests that these ladies must have eaten heartily at banquets of more than fifty courses, which included unusual items such as "longevity gruel . . . dragon brain, unborn phoenix . . . fairy meat . . . broiled dragon whiskers, purple dragon dumplings, and elephant tusk dumplings." Evidently these double-chinned ladies enjoyed the banqueting and modified the noble dress to flow loosely over their well-fed bodies. Soft sleeves and a loose torso replaced the tight-fitting bodice so popular in the seventh century. A gossamer scarf fell from the shoulders under the arm and around the undefined waist.

Yang Kuei-fei was the reigning beauty and style setter of the mid-eighth century. She was the favorite of Emperor Ming Huang (r. 712–56). Her flawless complexion, moon face, and ample matronly figure, as well as the love and attention the emperor showered on her, have been celebrated by T'ang poets. There are many tales of how she and Ming Huang enjoyed cavorting in the hot springs at the foot of Black Horse Hill near Ch'ang-an. But the part of her story that has assured Yang Kuei-fei's place in history revolves around the great friendship she and the emperor lavished on An Lu-shan,

136. Tomb figure of a scholar-official, from Li-chüan-hsien, Shensi province. Last half of the seventh century (T'ang dynasty). Pottery painted with color and gold. Shown at the Historical Museum, Sian, Shensi province.

a general of partly Sogdian origin who was a powerful military governor of a northeastern T'ang province in the area of modern Peking. Consort Yang and the general may have had an intimate relationship; if so, it was a shocking indiscretion for an imperial consort. In any event, An Lu-shan became the enemy of Yang Kuei-fei's brother, the chief minister, who dominated court politics in the early 750s. Angered by Minister Yang, An Lu-shan revolted in 756, captured Ch'ang-an, and forced the emperor and his followers to flee. The unhappy imperial soldiers blamed the disaster on Yang Kuei-fei and her brother and demanded their lives. The old emperor sacrificed the great love of his life, the exquisite Yang Kuei-fei, and quit the capital, traveling southwest through the lofty mountains of modern Szechwan. Generations of Chinese have retold the sad story of Yang Kuei-fei and Ming Huang in painting, poetry, prose, and drama.

One can imagine that the imperial horses which accompanied Ming Huang's hapless entourage had decorations of gold and silver on their armor; that An Lu-shan, the rebellious general, wore brilliantly colored red-and-green armor edged in gold (plate 99); and that Yang Kuei-fei's brother, as an important court official, wore a long-sleeved robe enriched with brilliant brocade panels and a black hat (plate 136).

In 1970, archaeologists in China added a fascinating appendix to this story by finding two large ceramic jars that contained more than a thousand objects of extraordinary beauty. The jars were discovered in the suburbs of the present city of Sian, on the site of the mansion of the Prince of Pin, Li Shouli, a cousin of the Emperor Ming Huang. The Chinese archaeologist Hsia Nai writes in *New Archaeological Finds in China* (p. 4) that this treasure hoard had probably been buried by someone in the princely household of Li Shou-li's son before the nobles fled with the imperial party.

The number of objects in this cache is modest compared to the extensive inventories of the Shōsōin treasure house in Nara, Japan, which contains a wide range of T'ang pieces that had been acquired by Japan's Emperor Shōmu. During the seventh and eighth centuries the Japanese, vastly impressed by the rich and powerful T'ang civilization, engaged in large-scale borrowing of the trappings of the sophisticated mainland culture—its Buddhist religion, its theory of government, its city planning, and its styles of art—including a taste for the foreign goods imported into China. The prince's precious hoard has some items that are similar to those in the Shōsōin

137-39. Treasures found in the hoard of the Prince of Pin, at Ho'chia-ts'un, Sian, Shensi province. First half of the eighth century (T'ang dynasty). Shown at the Imperial Palace, Peking. 137: Silver censer, diameter 1 3/4 inches. 138: Gold dragons, height 1 inch. 139: Silver dish with amethyst crystals.

collection, having been made in the same time period. One such example is a handsome small glass bowl decorated with relief circles (plate 141). Bowls of this kind were made in Sassanian Persia and brought to China over the Silk Road.

Another imported treasure of incredible beauty found in the cache of the Prince of Pin was an onyx rhyton, a goldtipped drinking vessel carved in the shape of a ram's head (plate 142). The smooth curve of the magnificent drinking horn is artfully complemented by the graceful reverse curve of the great ram's twisted horns.

Other banquet accounterments were found in the large pottery jars containing the hoard: over two hundred gold and silver vessels, many of which were silver bowls decorated with gold repoussé designs. Some were round, while others were fashioned into graceful leaf or double-leaf shapes. Decoration includes animal motifs, some native to China—such as the revered tortoise, symbol of longevity—and some Sassanian-inspired animals, such as a fluffy-tailed fox with a long nose like that of an anteater (plate 140).

A tiny spherical incense burner (plate 137), similar to one in the Shōsōin repository at Nara, Japan, is one of the smallest and most engaging objects found in the prince's hoard. It is hung from a chain and cleverly designed so that it can never spill, for within a delicately carved openwork silver case, a tiny bowl to contain burning incense is mounted on concentric rings. No doubt it was worn to ensure a perfumed aura, and it may also have been placed among pillows or bedding to scent the environment.

A set of minuscule dragons made of gold (plate 138) was also among the tiny treasures from the hoard. Although it is not clear exactly how these decorative beasts were used, they are made in the form of the primordial Chinese ancestor, the Dragon King. All through Chinese dynastic art the dragon was an imperial symbol. It was believed that dragons were the presiding spirits of the waters and that they dwelt in rivers, oceans, pools, and clouds. Unlike dragons in the West, which are cast as incarnate evil, Chinese dragons personify creative, life-giving forces as well as the destructive powers of flooding.

The Chinese, perhaps more than other peoples, had a consuming interest in seeking the elixir of immortality. The study and search for the animals, minerals, and herbs which might supply this magical elixir was pioneered by amateurs, many of them initiates into esoteric Taoism, who engaged in alchemy as well as in the preparation of herbal medicines. The Prince

140–42. More treasures from the hoard of the Prince of Pin. 140: Double leaf-shaped dish with repoussé fox designs, silver with gold, diameter 8 7/8 inches. Mid-eighth century (T'ang dynasty). 141: Glass bowl from Sassanian Persia, diameter at mouth 5 5/8 inches. Seventh to eighth century. 142: Onyx and gold rhyton (drinking horn) from Central Asia, length 6 1/8 inches. Mid-eighth century (T'ang dynasty).

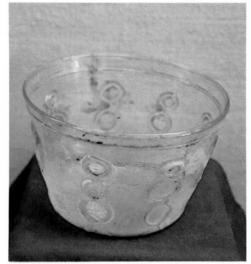

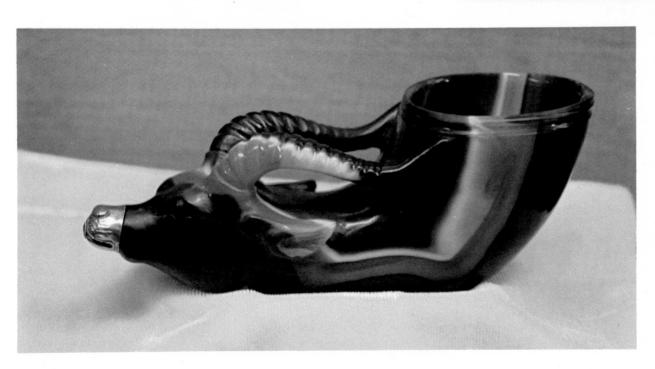

143, 144. Silver coins threaded as a string of cash, below, and a silver disk, right, found in the hoard of the Prince of Pin, at Ho-chia-ts'un, Sian, Shensi province. All T'ang dynasty. Shown at the Imperial Palace, Peking.

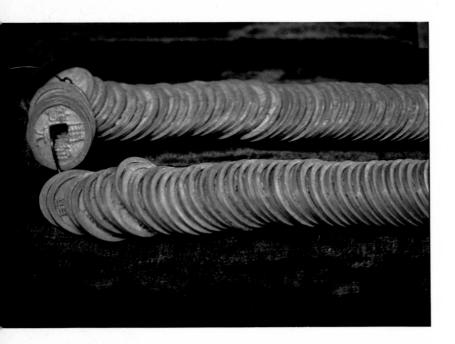

of Pin, like other nobles and many emperors, engaged the services of a variety of alchemists, magicians, and priests to produce not only the elixir of immortality and substances that might make flight to the heavens possible, but also medicines. Cinnabar, stalactite, amethyst (plate 139), quartz, and litharge were among the medicinal items deposited in the prince's hoard. Chemically treated ground cinnabar, taken by mouth, was thought to be the sure vehicle to immortality.

No true treasure trove would be complete without cash, and, indeed, the Prince of Pin's was well supplied. There were bars of metal, gold and silver Chinese coins (plate 143), inscribed silver disks bearing a date equivalent to 731 (plate 144), gold dust, a Sassanian silver coin (Chosroes II, A.D. 590–627), a Byzantine gold coin (Heraclius, A.D. 610–41), and five Japanese silver coins minted in 708. This international coinage further confirms the cosmopolitan picture of T'ang Ch'ang-an.

The significance of the find is enormous. In Communist terms, Hsia Nai in New Archaeological Finds in China (p. 5) says: "This group of precious objects created by the working people finally returned to their hands after 1,200 years." For others, the hoard is a kind of eighth-century time capsule—a magnificent heritage for archaeologist, historian, and art lover alike.

THE SUNG AND YÜAN DYNASTIES

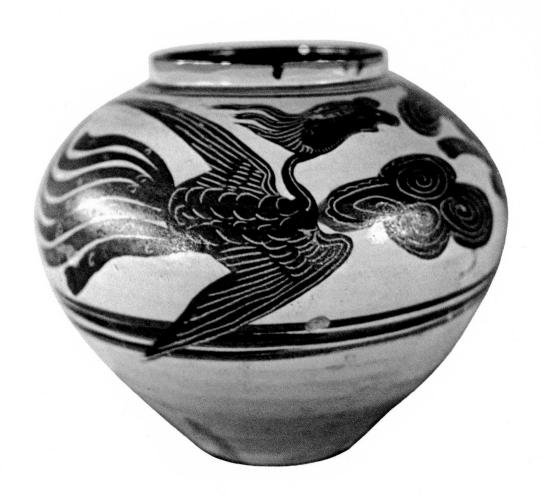

Sung Dynasty

- PRECEDING PAGE:
 45. Tz'u-chou jar. Thirteenth century (Yüan dynasty). Stoneware.
 Shown at the Ceramic Exhibition, Imperial Palace, Peking. The amply rounded upper zone of this vessel is delineated by rapidly drawn brown lines. With a spirited naturalness, the potter allowed the phoenix wing to break out of this zone and refrained from smoothing the ridges of the vessel wall.
- 46. "The Forest of Steles." Han dynasty (206 B.C.—A.D. 220) through Ch'ing dynasty (1644—1912). Stone. Historical Museum, Sian, Shensi province. The Chinese have inscribed stone tablets for commemorative purposes for several millenniums. Although most of these steles have Confucian inscriptions, some are Buddhist and there is a single Nestorian Christian inscription.

The T'ang dynasty showed signs of disintegration at least 150 years before its actual collapse in 907. Indeed, the distant reaches of the empire had begun to detach themselves from central control soon after their conquest in the seventh and eighth centuries. Regional generals established themselves as de facto rulers and passed their rule on to their descendants rather than to officials designated by the capital. Increasingly the directives of the T'ang court were ignored, and within a few generations of the great expansion the loyalty of some of the recently acquired territories could not be relied on.

Beset by financial difficulties, the imperial house imposed new taxes in the eighth century, but these were not enough to offset the extravagances of the court. Neither was there enough land available both to make estate grants—the expected imperial reward to loyal officials—and to redistribute land among the burgeoning peasant population. Ordinary peasant farmers, caught in an intolerable economic squeeze, resorted to uprisings and banditry in their quest for survival.

Although the T'ang dynasty collapsed, China endured only fifty years of disunity before the successor dynasty, the Sung (960–1279), reestablished patterns of centralized rule developed under the T'ang. During the T'ang period, the literati officials had won administrative control, taking power from the old nobility through an institutionalized bureaucracy. This shift of power toward the upwardly mobile scholarly class was even more fully developed during the Sung.

Under the Sung, the ruling house no longer embraced Buddhism as a state religion, and bright young men did not spend their energies studying Buddhist law. There was a potent revival and reshaping of Chinese values and a turning inward that closed the Chinese mind to foreign ideas. The Chinese saw no reason to accommodate to outsiders. From China, which means the "Central Realm," they were able to deal with the world at large on their own terms until the Opium War of 1839–42. Their intellectual, technological, and economic

147, 148. Unknown artist. Scenes from The Ch'ing-ming Festival on the River. Copy after Chang Tse-tuan (active c. 1120). Probably Ming dynasty (1368-1644). Hand scroll, ink and color on silk. Shown at the Imperial Palace, Palace of Peace and Longevity (Ning-shou-kung), Peking. Above, street hawkers offer food, drink, and fans to the crowd on a Kaifeng street. The buildings in the background are, from left: a tea shop, an antique store with bronze and ceramic vessels and scroll paintings, and the entryway to a temple guarded by stone lions. Right, shops around a residential courtyard and three scholars debating. The bustle of the city shops seems removed from this peaceful courtyard scene. The stylish Ming red-lacquered railings in the courtyard show the Chinese fretwork design so admired

by Western adapters.

growth under the Sung served as a model for subsequent dynasties, and their pattern of government was also sustained.

In giving a new look to Confucianism, Sung scholars revived classical thought. The new form, Neo-Confucianism, reemphasized humane values and personal relationships and offered explanations enriched by Buddhist and Taoist ideas concerning the nature of the universe. Neo-Confucianism not only emphasized the need for proper relationships of authority and obedience within the family—between father and son, husband and wife, elder brother and younger—but it also took the family as a model for the relationship of the emperor to his subjects and created a comprehensive public and private code of ethics and philosophy for the Chinese elite.

Confucian scholarship had been carried on throughout the period of Buddhist domination. In Sian, at the Historical Museum, there is a remarkable group of over a thousand large stone tablets (plate 146), many of which are inscribed with the words of the ancient Classics. Among these steles there are many examples of the pre-Sung Confucian tradition, the most important being a group of 114 made during the T'ang for teaching purposes at the imperial college. They are inscribed with 560,000 characters, which comprise the texts of the twelve Classics. In 1090 they were brought to their present site, "The Forest of Steles." The Sian collection also has many Buddhist steles and a Nestorian Christian one that records the arrival of a priest and the founding of a Christian chapel in the T'ang city of Ch'ang-an (Sian) in 781.

Neo-Confucianism was only one element in the intellectual

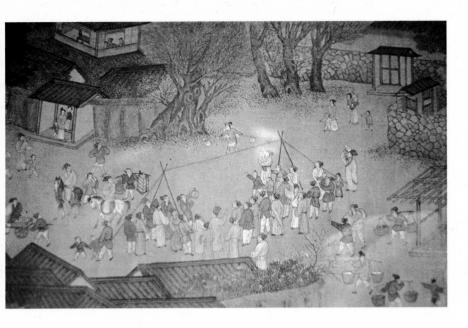

149, 150. Above, scene from The Ch'ing-ming Festival on the River (see plates 147, 148). Among the many city entertainments shown on this scroll, a tightrope walker performs before a fascinated crowd. Right, a modern tightrope walker from Kaifeng performs in Loyang. A number of cities in the People's Republic officially support acrobatic troupes which perform in their own cities and nearby regions.

flowering of Sung society. Alongside the revival of classical thought there was intensified interest in history and the arts of painting and poetry. As part of his learning, any cultivated man was expected to be accomplished in calligraphy, the vehicle for expressing his higher thoughts in words. Moreover, the Chinese traditionally categorized painting as an extension of calligraphy, and the ability to paint was generally expected of a literatus.

Sung art served as an ideal and a frame of reference for future generations of artists. Its influence, which continued throughout the imperial period, closely parallels that of the patterns of government and forms of thought which prevailed into the twentieth century. Because the political, social, and spiritual institutions of China remained relatively static from the tenth century to the twentieth, John K. Fairbank, Edwin O. Reischauer, and Albert M. Craig call the Sung "early modern China" (East Asia: Tradition and Transformation, p. 151). They point to "the uniquely stable and traditionalist society . . . which changed so little, in comparison with Europe," in spite of two foreign conquests—by the Mongols (the Yüan dynasty of 1279-1368) and the Manchus (the Ch'ing dynasty of 1644-1912). During these conquests, neither the ideas nor the images of the conquerors or of other foreigners penetrated the Chinese artistic consciousness in a revolutionary way, as Buddhism and its imagery had done.

The way in which Sung visual art served as the basic reference point for what was to follow can be seen in a painting that probably depicts the annual spring festival called Ch'ing-

151. North-central China, between Loyang and Sian. Clear air, broad, dry plains, and looming mountains characterize much of the northern Chinese landscape.

ming (plates 147–149). It was painted by an anonymous artist of the Ming dynasty (1368–1644), who seems to have used as a model a Sung painting by Chang Tse-tuan, who was active in the Imperial Academy about 1120. Chang Tse-tuan's painting portrayed the Ch'ing-ming festival at Kaifeng, the capital city of the Northern Sung dynasty, and at least thirty-five adaptations of it exist. Our Ming painting, a very long hand scroll, is not a line-for-line copy of the Sung version but, in the manner of post-Sung thematic and inspirational borrowings, is a paraphrase of the older work painted in the current Ming style.

Ch'ing-ming is still celebrated today by Chinese in Hong Kong, Taiwan, and Singapore, though its importance has diminished on the mainland. When the willows first come into leaf, branches are cut to sweep the ancestral graves. It is a joyous time, when people put on their best clothes and enjoy banquets and other entertainments. This event, depicted in the prosperous city of Kaifeng, offers a fascinating view of urban domestic and commercial life along the canals, through the streets, and over the bridges. While coolies carry goods and artisans build houses, some merchants sell silk from shops stocked with great bolts, others deal in antiquities and paint-

152. South China coast, Kwangtung province. Warm, wet mists often enshroud much of the humid temperate to subtropical southern Chinese landscape.

ings (plate 147). In the streets, hawkers offer fans and cooked tidbits of food to the monks, officials, and workers who hurry by. In a house built around a courtyard shielded from the teeming humanity outside, scholars carry on an animated discussion (plate 148). The painting clearly documents that wooden houses with tiled roofs continued to be the standard form for elegant living—as they had been for hundreds of years before the Ming.

A ship with a sail made of woven reeds tries to negotiate the narrow waterway, while in the background a team of coolies pulls a barge farther downstream. A tightrope artist performs to the accompaniment of a drum (plate 149). Another scene shows an inn by the river, with a group of men sipping wine and eating delicacies.

Landscape painting was one of the loftiest achievements of the Sung. Two types evolved, roughly corresponding to the two major periods and geographic centers of the dynasty: Northern Sung (960–1127) and Southern Sung (1127–1279). They share a basic vocabulary and artistic harmony, yet they reflect both the physical differences in the landscapes of north and south China (plates 151, 152) and the psychological differences in the Sung mind during the two periods. The

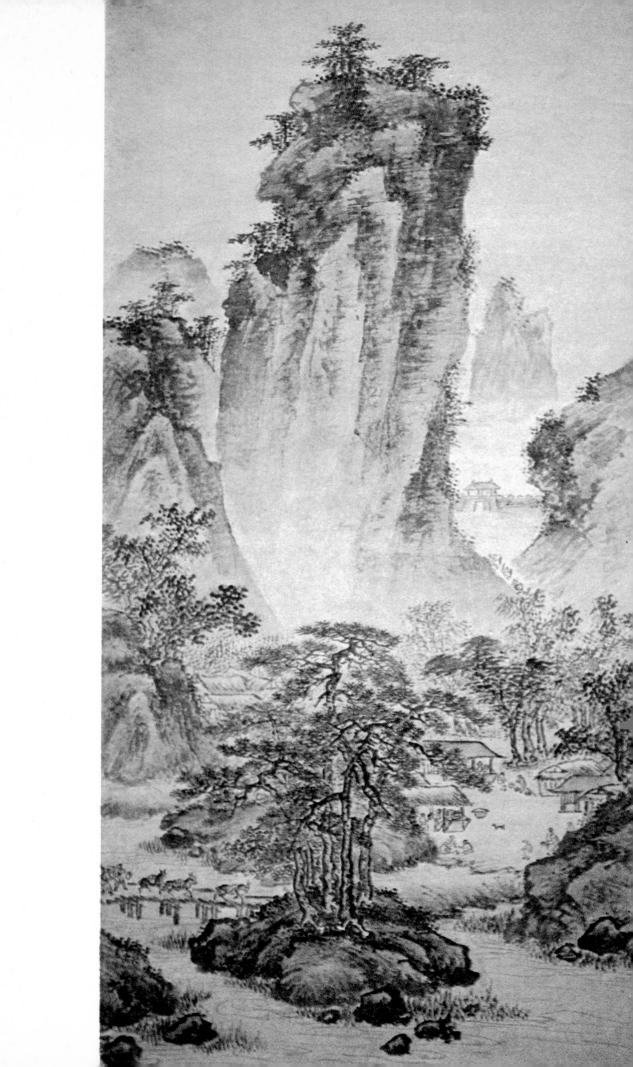

monumental landscapes associated with the Northern Sung school are awesome, as austere and uncompromising as are the northern mountains themselves. They are painted with a self-confidence that comes from technical mastery combined with a sureness of perception, in which truth and beauty are merged into a unified artistic expression.

When the Sung were invaded by the aggressive northern hordes called Jurchen, they were forced to evacuate the capital at Kaifeng and flee to the south. In 1127, remnants of the Sung court set up a "temporary" capital at Hangchow, from which they ruled south China for the next century and a half.

Landscape painting in the south continued to be practiced in the reestablished Imperial Academy. A Southern Sung style evolved in which the painted landscapes, often cloaked in enveloping mists, loom smaller on the silk ground and express a softer, more intimately personal vision than that of the Northern Sung landscape style. Their qualities reflect a new Chinese introspection infused with a kind of lyricism which is absent from the Northern Sung forerunners.

Highly esteemed Sung landscapes served as a model for subsequent landscape painting. Chinese art historians point to Tai Chin, active during the second quarter of the fifteenth century in the Ming Imperial Academy, as an example of a later painter in whose work this extended influence can be seen. The chauvinistic Ming court, eager to blot out the memory of the foreign Mongols, encouraged Tai Chin to revive the Southern Sung style of painting at the Imperial Academy, and he became the founder of the Che school, whose name derived from the fact that he lived in Chekiang. Although his expression has a decidedly Ming look to it, he strove to re-create the Southern Sung ideals. In his Mountain Landscape (plate 153) in Peking's Palace Collection, the foreground has clumps of trees painted with lively vigor, while small rustic pavilions and a few people are painted in an inconspicuous, unaccented way. Just above the tree line, the middle distance is ambiguously disembodied in a subtle band of haze. Towering cliffs accented by inky dots and crowned with clumps of trees dominate the background. Misty profiles of the cliffs beyond linger in the remotest reaches of the painting. The mountain "wrinkles" of the sheerly rising cliffs are mainly defined by "ax-cut" brushstrokes, so called because the ink formation takes on the appearance of an ax mark on wood. All these elements may be traced back to Sung painting, although the Ming master has elaborated on the earlier models. In its more complicated form, the Ming painting does not reveal the striving for subtle harmonies of light

53. Tai Chin (active second quarter of the fifteenth century). Mountain Landscape. Ming dynasty (1368-1644). Hanging scroll, ink on paper. Shown at the Imperial Palace, Palace of Peace and Longevity (Ning-shou-kung), Peking. The awesome scale and grandeur of nature, in relation to the tiny people who inhabit it, is a favorite Chinese landscape theme. The individual artistic expression is marked by the artist's conception and technique in presenting his own variation of the usual components, such as mountains, mists, water, rocks, and trees.

and mist, the suggestively incomplete rendering of detail, or the openness of composition manifested in large blank areas so characteristic of Southern Sung painting. Tai Chin's style is relatively dehumidified, quite complete in filling the paper, and assertive in its descriptive precision.

Although Sung painters and poets idealized nature, most of them lived in the cities and only occasionally ventured into the mountains. They were urban dwellers with a romantic vision of unsullied nature somewhat akin to that of Jean-Jacques Rousseau. One of the great masters of Northern Sung painting, Kuo Hsi (c. 1021–c. 1090), wrote An Essay on Landscape Painting which has guided generations of Chinese artists. In a translation by Shio Sakanashi (pp. 32–33) we can learn something of Kuo Hsi's thoughts and goals:

Why does a virtuous man take delight in landscapes? It is for these reasons: that in a rustic retreat he may nourish his nature; that amid the carefree play of rocks and streams, he may take delight. . . . The din of the dusty world and the locked-in-ness of human habitation are what human nature habitually abhors; while, on the contrary, haze, mist, and haunting spirits of the mountains are what human nature seeks, and yet can rarely find. When, however, . . . the minds, both of a man's sovereign and of his parents, are full of high expectations of his services, should he stand aloof, neglecting the responsibilities of honor and righteousness? In the face of such duties the benevolent man cannot seclude himself and shun the world. . . . Having no access to the landscapes, the lover of forest and stream, the friend of mist and haze, enjoys them only in his dreams. How delightful then to have a landscape painted by a skilled hand! Without leaving the room, at once, he finds himself among the streams and ravines; the cries of the birds and monkeys are faintly audible to his senses; light on the hills and reflection on the water, glittering, dazzle his eyes. Does not such a scene satisfy his mind and captivate his heart?

It is hard to imagine that any urban dweller today would fail to be moved by this eloquent statement, yet the Chinese Communists regard Kuo Hsi's ideals as quite unacceptable for Chinese art today, considering them to be a hedonistic appreciation of the countryside that is not only elitist but also an incomplete artistic expression of love of the motherland. In the Communist view, a painting must reflect proletarian class consciousness and have revolutionary content, expressing the struggle, progress, and victory of the Communist cause. Moreover, the

(Tower Which Bestrides the Road, also known as the "Cloud Terrace"), at Chü-yung-kuan Pass, Hopei province. Inscribed with date corresponding to 1345 (Yüan dynasty).

Yüan Dynasty whole concept of the "locked-in-ness of human habitation" being "what human nature habitually abhors" runs counter to Chairman Mao's vision of the ideal state, in which the individual seeks to serve his country wherever the Party sends him and feels no selfish desire to be elsewhere.

During the first half of the thirteenth century the Golden Horde of the great Genghis Khan swept down from Mongolia to gain control of north China. By 1279 Kublai Khan, the grandson of Genghis, and his fabulous cavalry completed the occupation of south and southwest China, subjecting the country to the most extensive foreign conquest it had known. The Great Khan, as he was known, and his relatives controlled an empire larger than any other the world has experienced. It stretched from China, Korea, and the northern parts of Vietnam and Burma across Eurasia to Persia and the Black Sea and as far as Hungary and Moscow. The success of the well-

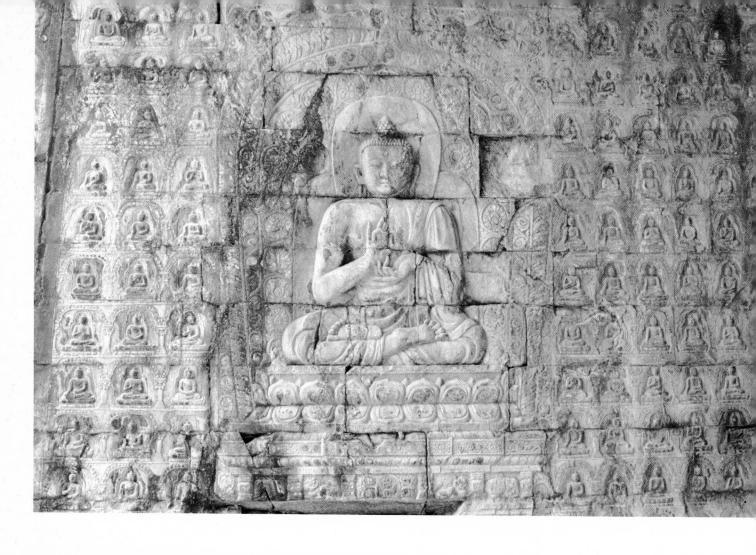

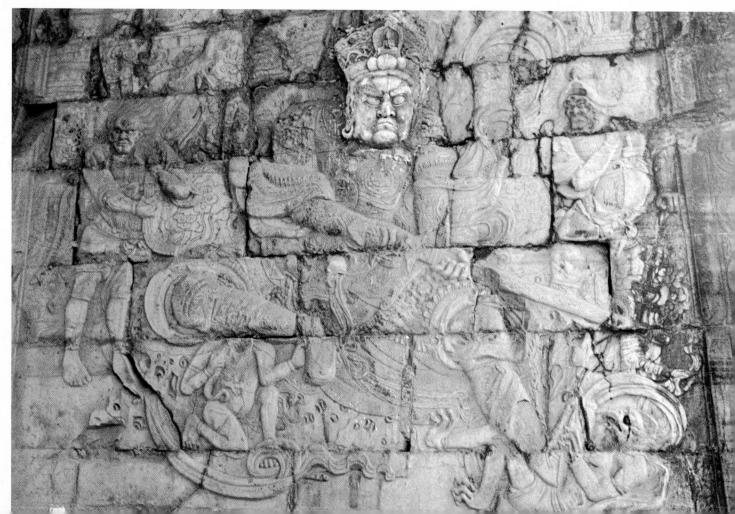

- 5. Detail of the gateway at Chüyung-kuan Pass (plate 154),
 showing carving of Buddhas in
 the passage under the terrace.
 Travelers to and from the Yüan
 capital must have been reassured
 by seeing the carvings of so many
 Buddhas, and by the inscriptions
 of Buddhist charms on the
 gateway, written in the many
 languages of the people who passed
 through.
- 6. Detail of the gateway at Chüyung-kuan Pass (plate 154), showing stone carving of a celestial guardian. This is one of four guardians, all carved with great animation, who protectively preside over this gateway.

trained Mongol forces was due not only to their ferocity and brilliant strategy but also to their reputation. Hair-raising tales were told of the horrors that were in store for those who resisted the Mongols, while those who surrendered without a fight were promised leniency and consideration. In addition, the Mongols received ill-considered Chinese cooperation at certain points, especially in defeating the Jurchen barbarians, who had defeated the Sung in 1127 and established themselves in the north as the Chin dynasty (1115–1234). Once the Mongols defeated the Chin, there was no buffer state between the Chinese and the Mongols, and this simplified the completion of the Mongol conquest.

Following the pattern of other barbarian rulers before them, the Mongols took a Chinese dynastic name, Yüan. They used the Chinese bureaucracy to maintain order and collect taxes from the local population, but often placed Mongols or other foreigners in key positions in an effort to control established Chinese patterns of government.

The victorious Yüan leaders extended the despotic power of the central government, which was reinforced by their great military strength, and they supervised the Chinese bureaucrats, who performed for them as though the Yüan emperor were a native Chinese emperor. According to Marco Polo, this system worked extremely well. His tales include accounts of the rich and handsome city of Hangchow, previously the Southern Sung capital, which continued to flourish as a great center of commerce and the arts, and the newly founded Yüan winter capital of Ta-tu (Peking).

The recent uncovering of parts of Ta-tu has somewhat increased the small number of architectural remains from that period. Only a few pieces of molded ornamental yellow and green tile have been exhibited, however, and they tell us little about the sculptural achievements of the Yüan. A most interesting monument seen by visitors en route to the Great Wall is a gate carved at Chü-yung-kuan (plate 154) bearing a date corresponding to 1342-45. It is referred to by Sherman Lee as the "Cloud Terrace" (Chinese Art Under the Mongols, p. 6), and is regarded as a key monument for stylistic attribution and dating of Yüan works. Its Chinese name, Kuo-chieh-t'a, translates as "Tower Which Bestrides the Road." The terrace was probably meant to have been topped with a stupa tower. As it is, the marble platform has a commanding view of the countryside and mountains northwest of Peking. The old road to the Yüan capital passed under the carved archway, and, once one had passed the Great Wall, this was the last gateway before the capital.

The walls of the passage are covered with relief carvings of Buddhas (plate 155), celestial guardian kings (plate 156), and inscriptions in six languages. The gesturing Buddha in a flame-edged mandorla decorated with lotus flowers peacefully communicates his intense introspection. His face, body, robe, and snail-curl hair design have an overall schematic harmony and a spirit quite different from that of the angular, disembodied Northern Wei Buddhas or the full-bodied T'ang Buddhas at Lung-men. Hundreds of smaller Buddhas sit within arcades of niches hung with beaded ornaments. One of the guardian kings destroys the enemies of the Buddha with a single pass of the sword. His crown, elegant armor, and flying scarves do not detract from his menacing posture and bulging-eyed ferocity. The inscriptions on the "Cloud Terrace," which are Buddhist prayers or magical charm formulas, spotlight the cosmopolitan mixture of languages within the Mongol empire: Chinese, Tibetan, Mongolian, Uighur Turkish, Tangut, and Sanskrit. Of these scripts, only Sanskrit was not a vernacular tongue; it was the classical language of Buddhism, in which the charms had originally been written.

Many Mongols practiced Tibetan Buddhism, called Lamaism, which emphasizes ritual formulas and secret magical practices. Kublai Khan protected Confucian temples and exempted Confucian scholars from taxation, but he extended the same tolerance to other religious establishments as well. This displeased the educated Chinese, who were also alienated by the Yüan practice of entrusting key administrative positions to foreigners from all over the vast Mongol empire.

After the fall of the Yüan, Ming historians refused to concede that the Mongols had contributed any innovation or achievement. They presented the Mongols as unclean savages interested only in destruction and orgies, and this judgment became the cliché of subsequent Chinese historians. The great painters of the period were not condemned, however, for they were native Chinese. The Mongols had no tradition of pictorial art.

Ceramics: T'ang to Ming

Ceramics, like landscape painting, achieved supreme perfection in the expression of Sung aesthetics. Just as Sung painting served as a classic prototype for subsequent paintings, so Sung ceramic shapes, glazes, and decoration served as models

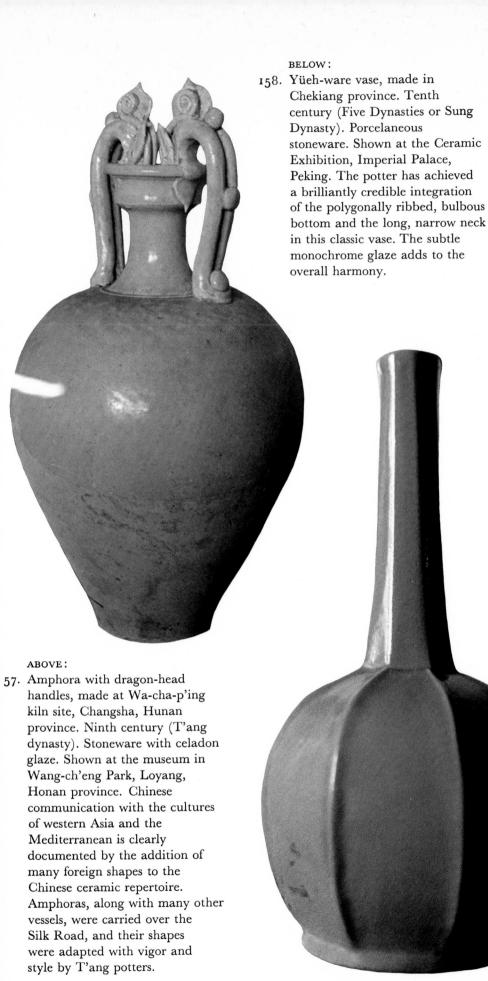

ABOVE:

159. Bird-headed ewer, made in Sian, Shensi province. Eighth century (T'ang dynasty). Porcelaneous stoneware with Northern Celadon glaze. Shown at the Ceramic Exhibition, Imperial Palace, Peking. When some Sassanian Persian metal ewers were unearthed in Russia, it was suggested that the Chinese vessels were modeled after these prototypes. This kind of ewer was popular in T'ang China and certainly reflects a foreign influence.

in Chekiang province. Tenth century (Five Dynasties or Sung dynasty). Porcelaneous stoneware with Yüeh-type celadon glaze. Shown at the Ceramic Exhibition, Imperial Palace, Peking. The lotus petal and four-line wave patterns incised on the surface, and the spouts, which seem to grow out of the vessel's body, have a lively charm. The sculptured, lotiform crown holds a cutout pomegranate.

for potters throughout the imperial period. After the T'ang, no more foreign shapes were added to the vocabulary of ceramic forms, as the round-bodied, long-necked amphora (plate 157) and the bird-headed ewer (plate 159), both of which were inspired by Persian prototypes, had been. Moreover, the T'ang shapes, foreign and Chinese alike, were modified into a more integrated form. The long-necked, blue-green Yüehware vase of the tenth century (plate 158) is a model of the kind of synthesis of forms that occurred in Sung. Between the swollen polygonal bottom and the tall neck which unites the two sections there is the subtlest kind of harmony. The T'ang vessels do not possess such an overall unity; there is a distinct differentiation between the amphora's swollen bottom and its small neck. Yet, compared to the quieter grace of Sung wares, T'ang wares have a lively, robust quality, as though bursting with energy.

Of the many Chinese inventions, perhaps the one that has been most universally appreciated is porcelain. Porcelain can be defined in many ways, but in the Chinese context it means a broad range of high-fired, hard-bodied, nonporous ceramics which ring when struck. When Chinese porcelains began to be exported in large quantities to Europe in the seventeenth century, the principal items were blue-and-white or thin, white, shining, translucent china, painted with overglaze enamel. Thus, Westerners came to think that porcelain was limited to these wares. The body and glaze of porcelain are fused during an intensely hot firing, at about 1,440 degrees Centigrade. In the course of this process, called vitrification, a chemical change transforms the clay body of kaolin and feldspar and the silica glaze into a new, totally nonporous molecular arrangement. Technically, porcelain is a kind of stoneware, which is a broader category of ceramics fired at high temperatures and includes a greater variety of clay body combinations.

The making of porcelain in China dates from at least the Six Dynasties (A.D. 222–589). One probable reason for its development was the desire to utilize fully the space in a Chinese type of kiln. These kilns were built into a hillside and had up to twenty chambers spaced progressively away from the firebox. The chamber closest to the firebox got the most heat, while the ones farther away were suitable only for wares that could be fired at lower temperatures. In *Chinese Art* (vol. 2, pp. 402–11), William Willetts explains that the economical Chinese potters conducted extended experiments in order to find a clay and glaze which could withstand the intense heat nearest the fire. The result was porcelain, treasured not only in the imperial

61. Bowl made at You-chou kiln, Shensi province. Eleventh to twelfth century (Sung dynasty). Northern Celadon porcelain. Shown at the Ceramic Exhibition, Imperial Palace, Peking.

162. Chün-ware dish. Twelfth century (Sung dynasty). Porcelaneous stoneware. Shown at the Ceramic Exhibition, Imperial Palace, Peking.

court but also in Africa, Europe, and America. Ceramics, along with silk, were long among China's most important export items. As indisputable evidence of this, T'ang pots have been found in a number of places in the Near East, and ceramics dating from the Sung on have been found in quantities in the Philippines, Indonesia, and the Indo-Chinese peninsula. This distribution occurred long before the Portuguese arrived in China in the sixteenth century and began to whet European appetites for Chinese porcelains, thereby causing a revolution in Western ceramics industries.

An admiring foreign public calls one of the famous groups of Sung porcelaneous wares "celadon." This label brings to mind pots glazed not only in sea-foam green but also in a range of other greens that include tones of gray, olive, brown, and blue. Although there are still many scholarly questions to be answered concerning identifications and classifications within the vast group of green wares, various types of celadons are identified by certain characteristics and by the site of manufacture. For example, the type of celadon called Yüeh ware was manufactured in Chekiang and appeared in a variety of colors, shapes, and designs. A lotus-petal design was in-

- 163. Ting-ware pillow in the form of a reclining baby. Eleventh to twelfth century (Sung dynasty). Porcelain. Shown at the Ceramic Exhibition, Imperial Palace, Peking. The Chinese have traditionally favored hard pillows. They were made in a variety of shapes and often decorated.
- 164. Tz'u-chou pillow. Thirteenth to fourteenth century (Yüan dynasty). Stoneware with three-color glazes. Shown at the museum in Wang-ch'eng Park, Loyang, Honan province.

cised into the body of a multispouted covered jar (plate 160), which is grandly bathed in a soft gray-green glaze. A long-necked bottle without carved decoration and covered in a soft blue-green glaze is another example (plate 158). Potters in the north made their own versions of Yüeh ware, called Northern Celadon. Gray and olive tones are characteristic of this kind of ware (plate 161), which frequently has intricate patterns carved into the clay body.

Although these celadons were highly prized, they were not among the official wares made for use at the Sung court. One of the imperial wares, called Chün (plate 162), was made at Yü hsien in Honan province during the Sung. Its haunting turquoise glaze is often spotted with splashes of purple. Some modern connoisseurs particularly prize the purple effects, yet the Chinese called the reddish-purple by scornful terms such as "mules' liver" and "horses' lung."

Much about Chinese firing techniques is still mysterious, so that it is difficult to explain exactly how these spots and other subtleties were achieved. We do know that they varied with the metallic contents of glazes (iron, copper, manganese, and cobalt were among the metals used) and the intensity of heat and amounts of oxygen in the kiln. But the precise color and effects were determined by the uneven nature of the wood employed as fuel, the purity of the metals, atmospheric conditions on firing days, and a host of other variables.

A probably apocryphal story about the spots on Chün ware relates that they were first produced when a pig accidentally wandered into the kiln and was burned. This supposedly created a great deal of smoke, which reduced the amount of oxygen in relation to carbon dioxide and produced the purple spots. When the emperor saw this "mistake," he was delighted and ordered more of the same. The hapless potter, having no more pigs and knowing no other way to re-create the effect, sacrificed his daughter in the kiln in an effort to please the emperor.

White Ting ware was also made for official court use. Among the Ting ware shown in the Imperial Palace ceramics exhibition is a porcelain pillow in the shape of a reclining baby (plate 163), formed with such convincing realism that one almost believes a bright-eyed baby could assume such a convoluted posture. Another pillow of great charm (plate 164), in a slightly curving brick shape, shows within its incised lines a child ambiguously either swimming in a green lotus pond or flying above it. Although its greens and mustard yellows are reminiscent of T'ang three-color ware, it was made during the

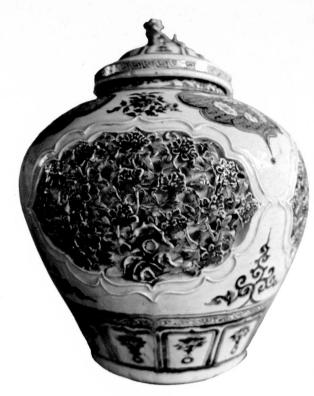

165. Jar. Hsüan-te (1426–1435, Ming dynasty). Blue-and-white porcelain. Shown at the Ceramic Exhibition, Imperial Palace, Peking.

166. Jar with cover, made at Paoting, Hopei province. Fourteenth century (Yüan dynasty). Porcelain with blue and red underglaze. Shown at the Ceramic Exhibition, Imperial Palace, Peking.

late Sung dynasty (twelfth and thirteenth centuries) and is a type of Tz'u-chou ware.

Tz'u-chou is a handsome stoneware which characteristically has lively brown or black designs on a white body. Some of the finest examples were made in north China during the Sung and Yüan periods. A superb Yüan specimen shown in the Imperial Palace exhibition pictures a dark brown phoenix flying around a richly swelling jar (plate 145). The clouds and the mythical bird, which is often used to symbolize the empress, are elaborated within their brown fields by scratches which lay bare the white surface underneath.

The story of blue-and-white ware is one part of the history of ceramics which has greatly benefited from the reassessment of Mongol contributions. Perhaps no kind of Chinese ware can compete with blue-and-white for enduring popularity in the West. Since the seventeenth century, it, along with enamel wares, has been imported in vast quantities and copied by almost every European kiln, including Meissen, Delft, and a host of English potteries. Because only a limited amount of Ming (1368–1644) ware had been sent to the West, the blue-

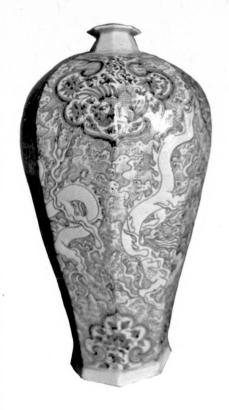

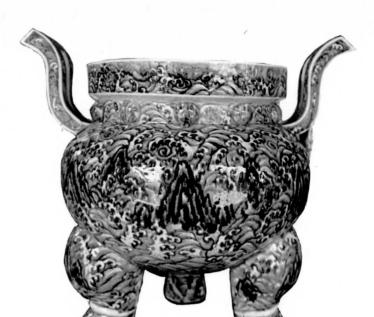

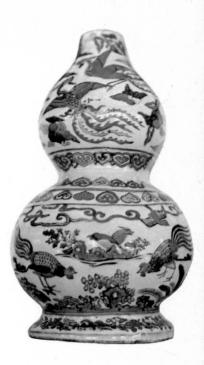

67. Jar. Fourteenth century (Yüan dynasty).
Blue-and-white porcelain. Shown at
the Ceramic Exhibition, Imperial
Palace, Peking.

168. Incense burner in the shape of a bronze vessel. Wan-li (r. 1573–1620, Ming dynasty). Blue-and-white porcelain. Shown at the Ceramic Exhibition, Imperial Palace, Peking.

169. Gourd-shaped vase. Wan-li (r. 1573–1620, Ming dynasty). Porcelain with enamel glazes. Shown at the Ceramic Exhibition, Imperial Palace, Peking.

and-white designs best known in Europe were creations of the Ch'ing dynasty (1644–1912), and these were the models and inspiration for the voguish chinoiserie ceramics of the eighteenth century.

Until recently, few Yüan dynasty blue-and-white pieces had been identified, even though the first manufacture of this ware had been traced to the Yüan. It was assumed that the technology for controlling the colors so that they would not drip or spread beyond their assigned areas had been learned from Persian potters. After all, the cobalt with which to produce the blue had been imported from the Near East during the Yüan and in subsequent periods. For lack of evidence, Yüan blue-and-white was not seriously studied, while Ming examples were celebrated. But more recent scholarship has shown that highly sophisticated blue-and-white pots and bowls were produced under the Yüan. Moreover, some scholars suggest that the technology for separating colors in glazes may well have developed independently in China, concurrent with the Near Eastern achievement.

Two remarkable jars from the Yuan period on display at the

Imperial Palace are shown here. Their rich decorations reveal a flamboyant taste quite different from the earlier classical wares. Dragons swim with a kind of electric energy through churning waves, while lobed medallions form a counterpoint design around the collar (plate 167). The underglaze design is painted with the same facility and commitment that Yüan artists displayed when working with brush and ink on paper or silk. The bulbous covered jar (plate 166) has an even more ornate design, utilizing both underglaze blue and red, within an openwork panel carved into a bed of peonies and contained within an undulating medallion. This jar is one of four of its kind known to exist; its twin made financial history in 1971, when it was reputedly sold by a London dealer for half a million dollars.

Ming blue-and-white from the late fourteenth and fifteenth centuries shows a far more restrained use of pattern, at once delicate and forceful (plate 165). It is curvaceous, yet, compared to Yuan designs, austere. It is these early Ming wares, with intertwined chrysanthemums and peonies in a deep blue against a white ground, that the majority of Western collectors have most cherished. Over the almost three-hundred-year Ming rule and in different regions of China, there was great variation in the forms and designs of blue-and-white wares. In addition, the tones range from sky blue to blue-black, depending on the purity of the cobalt used in the glaze. An imposing dark-blue-and-white incense burner (plate 168) from the time of Wan-li (r. 1573–1620) is made in the shape of an ancient bronze sacrificial vessel. Many ceramics were designed not only to follow the Sung repertoire of shapes but also to imitate ancient bronze shapes; these serve as yet another example of the reassertion of the traditional bonds of Chinese culture.

The Ming had fully developed the technique for decorating china with bright, jewel-like colors, as seen in the fine double-gourd-shaped bottle covered with red, yellow, blue, and green overglaze designs (plate 169). The white high-fired porcelain was painted with lead-based glazes and fired a second time at a lower temperature. Overglazing enjoyed great popularity in the late Ming and Ch'ing times. Another innovation can be seen in a nascent form on the lower half of the double-gourd bottle. The birds here are shown in a landscape of curling, stringlike clouds. The rich, glossy quality of the shining white background and the brilliant, opaque colors distinguish this piece from pre-Ming decorated wares.

THE MING DYNASTY

PRECEDING PAGE:

- o. Kneeling elephant. Ming dynasty (1368–1644). "Sacred Way" to the Imperial Ming Tombs, northwest of Peking. There are four elephants among "Sacred Way" animals; two stand and two kneel. They appear both to guard and to pay homage to the imperial descendants who come to make offerings.
- of T'ien-an-men Gate, Peking.

 Ming dynasty (1368–1644).

 Marble. A cloud pierces the shaft of this column carved with an encircling dragon—symbols of heaven. The column represents the bestowal of heavenly power on the dynasty the "mandate of heaven" to govern the "Central Realm."

Temür, grandson of Kublai Khan and the last strong Mongol emperor, died in 1307. Although the dynasty lingered until 1368, his successors were unable to exercise effective control over China. Once again, the warning signals of dynastic downfall that had been mentioned in the Confucian Classics occurred in the form of floods and famine accompanied by popular uprisings. A series of contenders emerged from the Chinese rebel forces to claim the "mandate of heaven," and one of them, Chu Yüan-chang, born a commoner like Liu Pang, founder of the Han dynasty, managed to expel the despised barbarians and establish himself as the first Ming emperor. He is generally referred to as Hung-wu ("Vast Military Power"), the name he gave his reigning years (1368–1398). The practice of referring to the emperor by the name he chose for his reign years was perpetuated in the Ming and Ch'ing dynasties.

The Ming followed the general governmental pattern established in T'ang and Sung times, but included the Yüan innovation of personal imperial control over government organs. One inherited imperial institution that reached new heights of influence under the Ming was the Board of Censors, whose function was to serve as the "eyes and ears of the emperor," inspecting the operation of government at all levels and reporting directly to him. Hung-wu, famous for his bad temper and cruelty, set himself up as a virtual despot in Nanking, which he made the capital. When he died in 1398, his grandson inherited the throne briefly but was removed after a devastating civil war which an uncle, the fourth son of the late emperor, waged against the heir. The victorious uncle became known as Emperor Yung-lo (r. 1403–1424).

Like his father, Yung-lo continued to expand the empire and to keep the northern barbarians divided and therefore militarily impotent. He moved the capital back to Peking and began to build his own palace—the Forbidden City—which was to house China's rulers until the end of the imperial period in 1912. He selected a site for a tomb northwest of Peking

(plate 172) after the conventional consultation with diviners about an auspicious spot. The emperor wanted to be assured that in death he would not be plagued by hungry ghosts or other malevolent spirits.

Later Ming emperors continued the ancient practice of building tombs for themselves near the capital. Twelve of Yung-lo's successors were buried in the same beautiful valley that he chose, which the Chinese now call the Valley of the Thirteen Tombs. It is roughly an hour's drive by car from Peking, but it must have been almost a day's ride on horseback. During the Ming, the large valley, which stretches three miles north and south and two miles east and west, was sealed off by guards to keep people from cultivating the soil, cutting trees, or taking stones. No one, not even the emperor himself, was allowed to enter the sanctified precincts on horseback.

172. Valley of the Imperial Ming
Tombs, northwest of Peking.
Ming dynasty (1368–1644).
Roofs of the tomb complex of
Emperor Yung-lo (r. 1403–
1424), from right to left: gateway,
offering hall, and stele tower. The
tomb itself is buried within the
hemispherical wooded mound at
the extreme left.

Everyone who came to make offerings walked through several great marble gateways, past an inscribed stele once protected by a roofed pavilion, and down a long avenue lined on both sides with impressive but engaging stone animals and human figures. The avenue (plate 173) is usually called the "Sacred Way" in English, but a more accurate translation of the Chinese name (shen-tao) is the "Way of the Spirit." Twelve pairs of animals overlook the initial part of the avenue, which was recently paved with blacktop. The road turns slightly after one passes the last of the animals, and twelve human figures line the rest of the avenue. There are four generals (plate 175), four officials, and four retired officials.

In building this avenue, the Ming rulers were perpetuating the traditional formula for imperial tombs, for Han and T'ang tombs also had fine stone animals lining their approaches. Examples of this earlier monumental carving may be seen in the Historical Museum in Sian, and compared to them the Ming animals, marvelous though they are, have a certain stiffness and formality. The Ming lion (plate 173) looks decorative, smug, and stony in contrast to the leopard-like Han feline, whose tense, screeching form looks ready to pounce (plate 174).

Like Confucian ideals and the institutions of the past, artistic formulas were accepted as revealed truth and simply adapted and reused. In monumental sculpture and imperial architecture, what was lost in vigor and spirit was made up for

in formality and decorative elaboration.

The tomb of Yung-lo was built at the end of the great avenue. It is a large, impressive area which has been carefully repainted and tended by the current regime. One enters through a triple-arched gateway into a courtyard, and through a second great gateway which leads to another, larger courtyard measuring 500 feet in length. The central pathway leads to a mammoth building (plate 177) with a carved marble stairway. This structure is the Hall of Eminent Favors (Ling-entien), which is 220 feet long and 105 feet wide. The colossal hall has a double roof covered with yellow-orange tiles and supported by tremendous red wooden pillars. It was here that the descendants of Yung-lo brought sumptuous offerings to a stele on a central altar. The ceilings (plate 176) are elaborately painted in gold and intense gemlike hues. The central motif features the imperial golden dragons within square coffers and on crossbeams.

Beyond the offering hall one passes straight on through an-

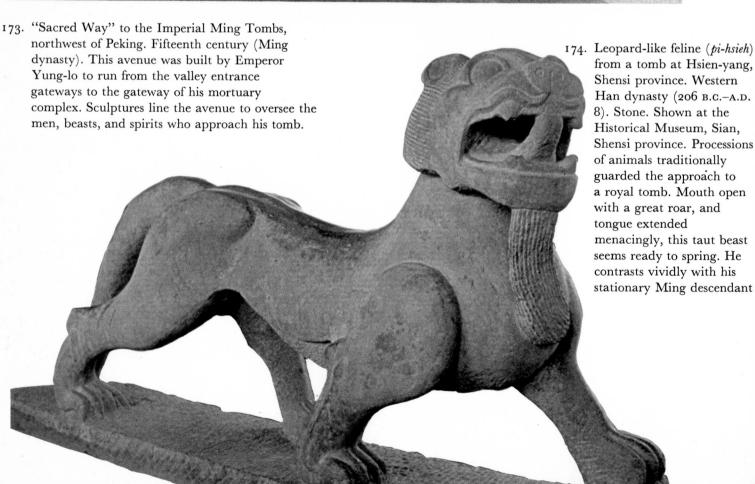

175. General, detail of head and torso.
Ming dynasty (1368–1644). Stone.
"Sacred Way" to the Imperial
Ming Tombs, northwest of
Peking. The avenue is lined by
statues of twenty-four animals
and twelve human figures,
among them four generals in
elaborate armor.

other great gateway and then a smaller one to a marble altar (plate 178) set with five marble ritual vessels. Just beyond the altar is a massive tower which has a crenellated stone base and is crowned by a double roof. This 70-foot tower contains a 7-foot stone stele inscribed with the emperor's name. From the tower one can enjoy a commanding view of the mountains and of the wooded valley, dotted by distant roofs belonging to funerary buildings of the subsequent Ming emperors. Behind the tower lies a great forested mound in which the tomb itself was built. It has not yet been excavated.

When the Chinese do open the tomb of Emperor Yung-lo, they are apt to find a great number of treasures similar to the ones already excavated from the tomb of Emperor Wan-li (r. 1573–1620). That long-tenured sovereign, who ruled about 150 years after Yung-lo, is not remembered for any of the Confucian virtues. All Chinese historians, including the current Communist ones, tell of Wan-li's awesome extravagances and his irresponsibility about his governmental duties.

In "Opening an Imperial Tomb" (China Reconstructs, March, 1959, p. 16), archaeologist Hsia Nai told how the tomb of Wan-li was excavated. He described the objects discovered and set forth the facts in a straightforward way, not mentioning class struggle, exploitation, or other object lessons of Communist history. He noted that the tomb chambers were being repaired and that there would be an underground museum. He also mentioned that the tomb, which took six years to build, cost eight million ounces of silver and that Ming historians recorded the fact that Wan-li ordered an "entertainment" in his funeral chamber upon its completion.

The apolitical tone of Hsia's 1959 article contrasts with that in his article in the 1972 volume New Archaeological Finds in China, which combines archaeological revelations with ideological object lessons about the evil exploitation of the laboring classes during the "Feudal Period." Nor are such lessons lacking in the completed underground museum in Wan-li's tomb. Visual and written explanatory materials on the walls present a vivid image of peasant suffering and glorify peasant uprisings during the Ming period. The educational messages detail how many bushels of rice would have been available to feed how many hungry people for how many years if the capital and labor lavished on the tomb building and its treasure had been used for the people instead.

Among the array of jeweled and ceramic vessels, lamps, lacquered coffins, silks, and ornaments, a supreme treasure 176, 177. Offering hall and detail of ceiling,
Hall of Eminent Favors (Ling-entien), Tomb of Yung-lo (r. 1403—
1424). First quarter of the fifteenth century (Ming dynasty), recently renovated. Courtyard length 500 feet, hall length 220 feet, width 105 feet.
This immense building is one of the largest wooden halls in Asia. The wooden ceiling, like those in the Imperial Palace, is coffered and brightly painted with colors and gold. Golden dragons writhe within the coffers and on the cross beams.

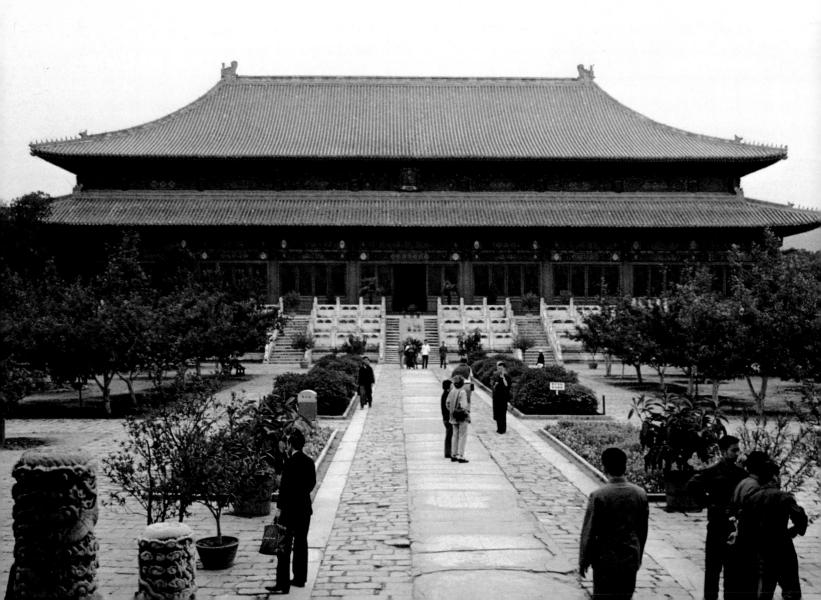

178. Altar in front of stele tower,
Tomb of Yung-lo (r. 1403–1424).
First quarter of the fifteenth
century (Ming dynasty). Marble.
Offering vessels were usually made
of lacquer, metal, or ceramic, but
here they have been fashioned for
posterity out of marble. The
central vessel simulates a censer
in a ting tripod shape. The
sculptor has formalized the
vaporous emissions, like a great
conical hat. A dragon resides in
this cloud.

found in Wan-li's tomb belonged to one of the two empresses who were buried with him. It was probably a bridal headdress and is called a phoenix hat (plate 179) because the female imperial symbol dominates the top of the pearl-encrusted, gemstudded crown. Outlined in gold, the marvelous blue phoenix looks as if made of enamel, although some authorities say it is made of kingfishers' feathers. Three small golden dragons ride on the crest of the hat. The dragons on each side hold strings of pearls in their mouths. The strings are intermittently punctuated with gold star-studded medallions.

An interesting contrast in style may be seen by comparing this Ming tomb with the 1957 tomb (plate 180) commemorating the Communist martyrs who were killed by Chiang Kaishek's forces in what today is called the Canton Commune Rising of 1927. The latter contains the remains of 5,000 victims in a huge hemispherical mound, encircled by a marble wall. It is designated by characters carved into the wall and is guarded by traditionally conceived lions that sit atop the

179. Phoenix hat, from the tomb of Wan-li (r. 1573–1620) and his consorts. Reproduction(?). Last quarter of the sixteenth or first quarter of the seventeenth century (Ming dynasty). Gold, gems, pearls, and blue enamel or kingfisher feathers. Shown at the Imperial Palace, Peking. This was probably worn by one of Wan-li's empresses as a bridal headdress.

wall. Potted plants grouped in front of the inscription serve to honor and decorate the monument. In their search for a Chinese Communist style, the designers consciously departed from the imperial Ming prototype and created a distinctive monumental form. Bronze doors in the marble wall bear an unmistakable international Communist red-star symbol.

Areas near Peking have been the site of human habitation since at least 500,000 B.C., as the discovery of the bones of Peking man proved. The remains of early settlements and references to it in ancient literature have revealed something of Peking's long history. Yung-lo made it the Ming capital in 1421 and built his palace over areas where the ruined Mongol palace and city had been. He laid out a new, enlarged city which excluded some of the northern sections of the older city and extended south beyond the old Yüan walls. The city walls erected by the Ming enclosed Peking until recently, when the Communist authorities pulled them down in the course of modernization. Unfortunately, this has deprived the city of much of its distinctive atmosphere, although the old gates still stand. Peking now sprawls in the same way that Western cities do, to the dismay of its admirers.

The Ming city, virtually unchanged by the Ch'ing, was constructed in the shape of two adjoining rectangles, one north of the other, and planned on axes governed by the four cardinal points—north, south, east, and west. The northern rectangle was built over much of the old Mongol city and includes the Imperial Palace, parks, and drum and bell towers. The southern rectangle was somewhat wider, extending slightly east and west beyond the walls of the northern part, but was shorter in length than the northern section. Buildings for imperial worship, such as the Temple of Agriculture and the Temple of Heaven, were built within the southern part of Ming Peking.

The Temple of Heaven complex (T'ien T'an), built in 1530–40, restored in 1749 and again recently, is several miles long. It is in the southernmost part of the Ming city and lies east of the central north-south avenue that bisects that part of the city. Here, at the time of the winter solstice, the emperor used to address Heaven and offer sacrifices.

Let us approach the main ceremonial axis from the south and proceed north, as the emperor did on ceremonial occasions. A vast walled square area encloses the southern section. We enter through a triple gate, proceeding north to a circular wall and through another triple gate. In the center of the

180. Tumulus in the Park of the Martyrs of the Canton Commune Uprising, Canton (Kwangchow). Built in 1957. Marble wall and lions. The mound holds the remains of the 5,000 victims killed when the Kuomintang crushed the Communist commune in Canton in 1927.

round courtyard there is a marble platform—the Altar of Heaven (plate 181). Open to the sky, this is the altar from which the emperor's signed declaration was read to the "Great Spirit Who Resides in Heaven." The marble altar is a flat-topped circular platform rising up in three tiers, with stairways located in the four cardinal directions. Its only embellishments are the carved marble balustrades. It is a marvelously simple construction which reflects the crisp formulation of the traditional Chinese symbols of Heaven (round) and Earth (square), using architecture to invoke the ideal harmony of the two. Multiplication of elements grouped in nines recurs frequently; the number nine is the symbol of the sky and the emperor.

Proceeding northward from the altar, we go through two more sets of marble gates, the northern openings of the circular and square walls. Those walls, like the altar itself, have four gates or stairway approaches, one in each cardinal direction. The stone walls are painted red and roofed with deepazure tiles, the color of the innermost recesses of the vaulted

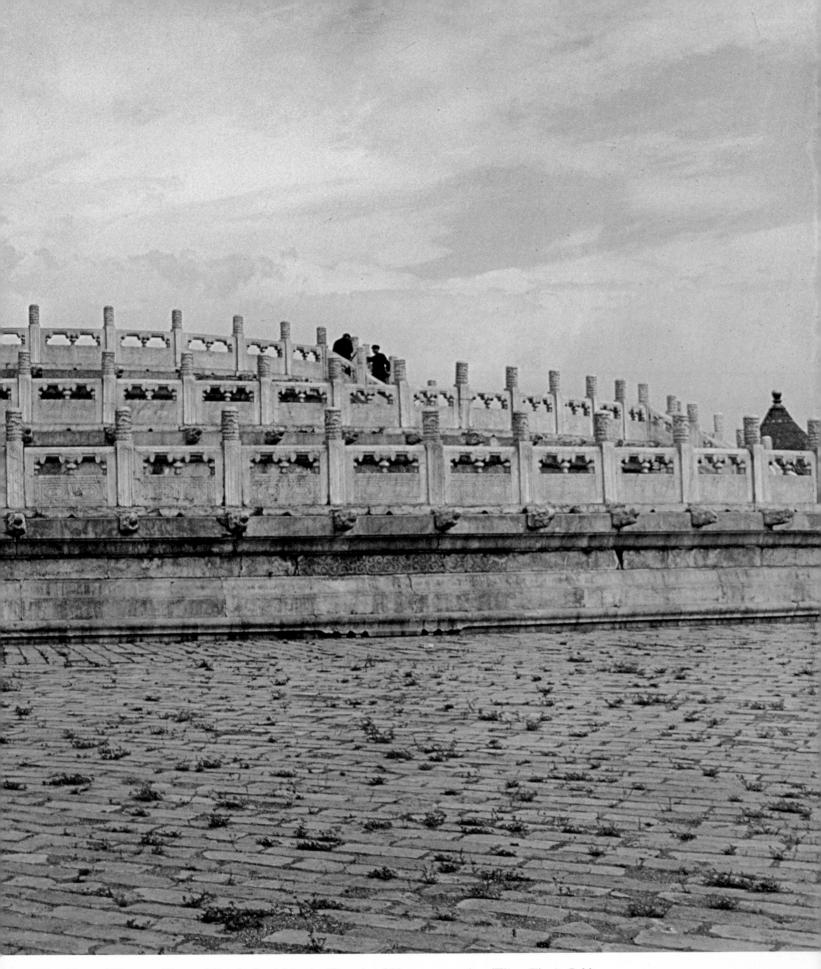

181. The Altar of Heaven (Yüan-ch'iu-t'an) within the Temple of Heaven complex (T'ien T'an), Peking. Built in 1530 (Ming dynasty), enlarged in 1749. Marble. During the Ming and Ch'ing dynasties, each year at the time of the winter solstice, the emperor offered prayers on this altar to the "Great Spirit Who Resides in Heaven."

182. Walls and gateways between the Altar of Heaven (Yüan-ch'iu-t'an) and the Imperial Heavenly Vault (Huang-ch'iung-yü) in the Temple of Heaven complex (T'ien T'an), Peking. Ming dynasty (1368–1644), rebuilt in 1749. The Altar of Heaven is surrounded by a circular wall and a square wall, each with three gateways in the four cardinal directions. This view looks north from the altar through gateways of both walls.

heavens. As on most traditional roofs, the ends of the circular and semicircular tiles are decorated with relief designs. For this imperial monument, the tile ends are stamped with five-clawed dragons flying in clouds (plate 183), symbols of Heaven. Larger, rounded tile heads of makaras (mythical water demons) emerge from the tops of the spines of the tile roofs near where the roofs end at the marble gateposts. The most distinctive features of the post-and-lintel gates (plate 182), besides their obvious translation from wooden construction into stone, are the flat carved-stone clouds which pierce through the tops of the posts. It is an extraordinary image which reminds the visitor that he is not treading on mundane soil, but walking within the Chinese conception of Heaven.

Professor Nelson Wu brilliantly interprets the Temple of Heaven complex in *Chinese and Indian Architecture* (pp. 41–45). He suggests that the round Altar of Heaven set within the square courtyard (Earth) is the earthly base for this monument, and that the other gateways and buildings along the main northern axis were conceived in the Chinese mind as ascending at each stage and stretching up toward the heavens. In other words, the next building, the Imperial Heavenly Vault, a single-storied wooden structure with a dazzling blue-tiled roof, was to be understood as being above the Altar of Heaven. And beyond it, the circular, triple-roofed Hall of Prayer for Good Harvests (commonly referred to as the Temple of Heaven) was mentally conceived to be directly above the Imperial Heavenly Vault, brushing the clouds in the heavens.

As we leave the Altar of Heaven and proceed north, which we now understand to be up, we enter the gate, courtyard, and then round pavilion of the Imperial Heavenly Vault (plate 185). Within this building, stone tablets were placed on the altar, and sacrifices were performed before them. One can still see the carved marble altar (plate 184) with stairs and the wooden case which once held the stele that rests atop the altar. The tile roof is supported by great wooden pillars which were covered with elaborately decorated relief designs in a gesso-like material (plate 186). The surface design of these pillars has flaked away over the years, and since the Imperial Heavenly Vault has not yet been as fully restored as the Hall of Prayer for Good Harvests, one can see just how the decoration was applied in layers.

We continue our northward journey to a half-rounded wall—the gate through the dome of heaven—and proceed on a mile-long marble avenue to the gateway of the Hall of Prayer

183. Detail of roof tiles on wall (plate 182).

for Good Harvests. The enormous circular triple-roofed building (plate 188) rests on a huge circular base within a vast rectangular courtyard. This climactic building lies at the north end of the complex; the encompassing wall of the whole complex is rectangular (Earth) at the south end but rounded (Heaven) at the north end, which further bolsters Professor Wu's vertical theory. The temple has been repainted quite recently with gold and the rainbow colors. The crossbeams and domed vault are embellished with designs which include dragons, phoenixes, clouds, and medallions (plate 187). Great pillars, decorated with gilded flowers and leaf designs, support the dome. The wooden pillars were made from giant trees from Yunnan. All this decoration creates an extraordinarily rich and elaborate vision of the heavens.

The restoration gives the monument quite a different appearance from the way it looked during the Cultural Revolu-

184. Altar in the Imperial Heavenly Vault (plate 185). Altar, marble; stele box, carved screen, and pillars, wood.

During the Ming and Ch'ing, tablets honoring gods and royal ancestors were worshiped on this altar.

OPPOSITE PAGE:

185. The Imperial Heavenly Vault (Huang-ch'iung-yü) in the Temple of Heaven complex (T'ien T'an), Peking. Built in 1530 (Ming dynasty), restored in 1752. Temple diameter 51 feet, height 63 feet. The imperial entourage traveled north from the Altar of Heaven through two sets of gateways (plate 182) and then through the covered gateways of the encircling wall of the Imperial Heavenly Vault.

tion (1966–69). During that period, the imperial decoration was eclipsed by giant pictures of Chairman Mao hung both outside and inside. By 1972, however, the only ideological reminders within the Temple of Heaven complex were a discreet bulletin board at the western approach that exhibited photos of friendly delegations visiting China, and a large red billboard on the mile-long marble roadway. The billboard, which looks much like those used in the West for outdoor advertising, artfully reproduces Chairman Mao's poem "Snow" in his own calligraphy (plate 31). The poem extols the awesome grandeur of the winter landscape in the highlands of Shensi and Shansi provinces, which has been so admired by Chinese leaders of the past. Mao uses the poem to remind his followers that the present generation must produce its own leaders—men of vision.

The Temple of Heaven complex provides an example of how an old monument is put to new use following the Chairman's directive to "let the old serve the new." During the Ming and Ch'ing, only the emperor and his entourage could enter its sacred precincts. After the collapse of the empire in 1912, it was opened to the public, and some festivals were held and offerings made there during the earliest years of the Republic. Now the notions of Heaven's power and of sacrifice to spirits have been derided as superstition, and the complex serves sightseers and strollers, showing the masses the "glorious achievements of the craftsmen of the past." Only a single billboard is needed to remind them that universal power no longer resides in the heavens but within Chairman Mao's Chinese Communist Party. Sacrifices, once made in the form of cooked offerings, must be understood as self-sacrifice to be made in everyday service to the state. Ultimate truth, once thought to be found in the Confucian Classics or imperial edicts, now resides in the "Thought" of Chairman Mao.

Just north of the center of the old city of Peking is perhaps the best-known Ming monument, the Imperial Palace (now called Ku-kung, which means "old palace"), also called the Forbidden City. It was called the Forbidden City (Tzu-chin-ch'eng) because, during the centuries of Ming and Ch'ing rule, entrance into its vast confines was strictly forbidden to all except the emperor and his entourage of concubines, eunuchs, officials, guards, palace staff, and craftsmen. It is hard to conjure up a vision of this exclusiveness today, when thousands of visitors from all over China and from abroad stream through the palace daily. In good weather one can see children and

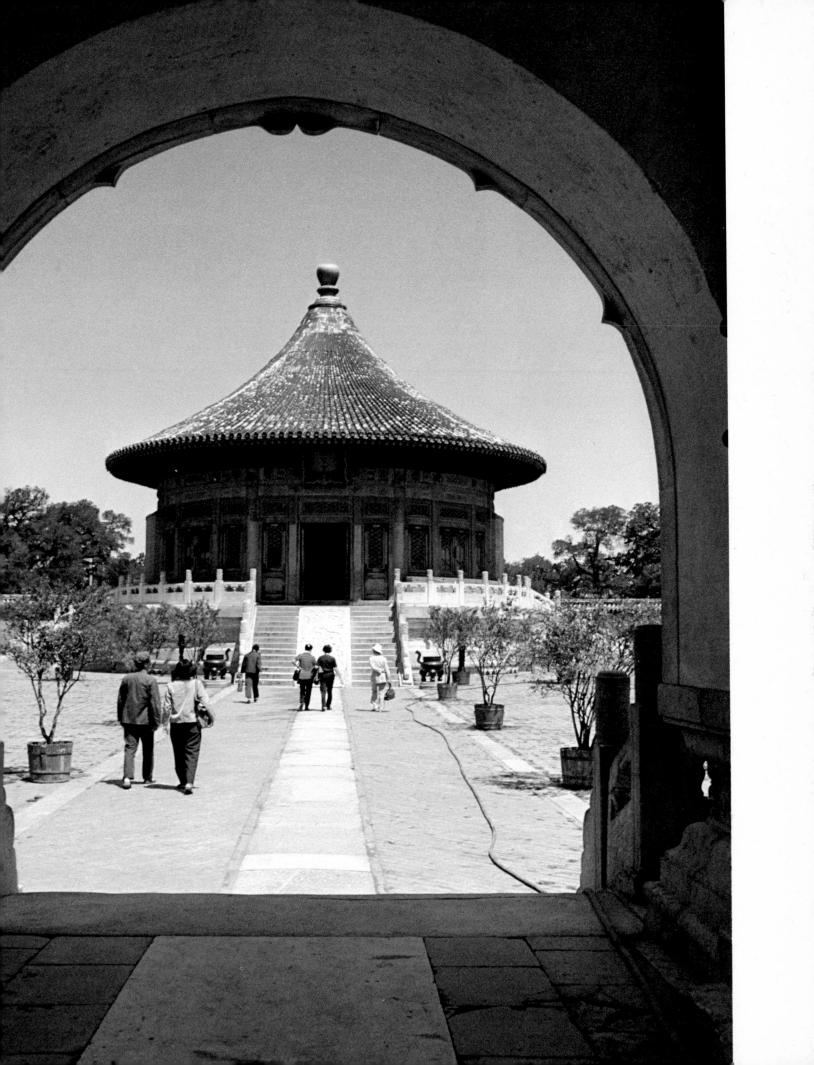

186, 187. Below, pillar in the Imperial Heavenly Vault (plate 185). Wood with layers of gesso. In contrast with the brightly painted pillars of the Hall of Prayer for Good Harvests at right, the aging pillars in this building reveal how the relief decoration was applied to the wood surface.

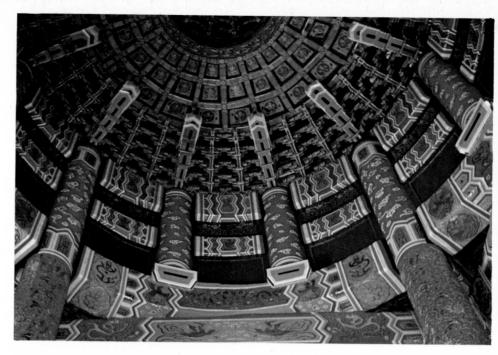

adults posing for photographs on the great ornamental sculptures, a game of basketball being played in the outer precincts of the palace, and swimmers diving into the moat surrounding its walls.

Let us approach the Forbidden City from T'ien-an-men Square (plate 328). "T'ien-an-men" means "Gate of Heavenly Peace," and the square takes its name from the old imperial gate located at its north end (plate 357). It is in the center of the capital and is considered to be the heart of the People's Republic of China. T'ien-an-men is the ceremonial center where the major demonstrations and parades take place. The area was formerly much smaller, but the Communists cleared away enough buildings to create a 98-acre space. It is estimated that the square can hold a million people. When great parades are held, officials watch from a reviewing platform on T'ien-an-men's gateway. The current government has built two enormous structures on the east and west sides of the square—the Museum of History and the Revolution and the Great Hall of the People. In the middle of the square there is a huge monument to the People's Heroes.

During the Ming and Ch'ing, the emperor passed through T'ien-an-men when he went to make sacrifices at the Temple of Heaven, and imperial edicts were handed down from the top of the gateway. The edicts were placed in the mouth of a golden, phoenix-shaped box and lowered to a kneeling official, who had them copied and distributed throughout the empire.

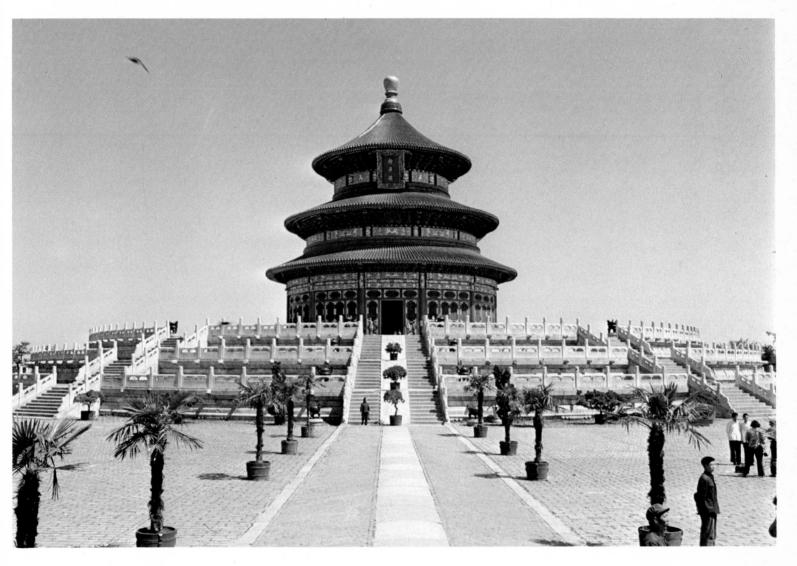

188. Hall of Prayer for Good Harvests (Ch'i-nien-tien), Temple of Heaven complex (T'ien T'an), Peking. Originally built in 1420 (Ming dynasty), restored in 1751, burned in 1889, rebuilt in the 1890s, restored recently. Terrace height 36 feet, diameter at broadest point 195 feet. Hall overall height 123 feet, diameter 96 feet. This nineteenth-century reconstruction is perhaps the best-known building in the Temple of Heaven complex. Its distinctive profile, with a triple roof, is often used as a logo on Chinese printed materials.

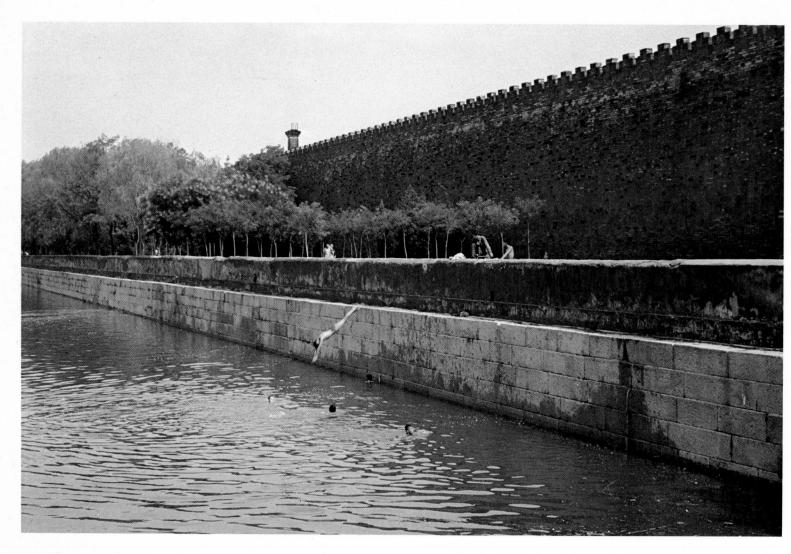

189. Swimming in the moat surrounding the Imperial Palace, Peking. Moat, Ming dynasty (1368–1644). The masses of China come in great numbers to visit monuments of the past, and the new generation as well as the supervising cadres exhibit a certain lack of awe of the once forbidden precincts.

When the present government cleared the space, pairs of huge imperial sculptures which had lined the approach to the T'ien-an-men gate were moved north closer to the gate to permit construction of an east-west avenue. Within this group was a pair of columns, one of which is shown here (plate 171). It is encircled by a relief carving of a dragon in clouds and is pierced by a flat cloud. The column's surface is carved in a low relief that makes it look as though it had been flat and was then rolled into a cylinder. However, its piercing cloud element introduces a surprising third sculptural dimension. This column provides a highly distinctive image, using elements similar to the Temple of Heaven gateway motif (plate 181). It is only one of the imperial symbols at T'ien-an-men which mingle with Communist iconography such as slogans and giant poster photographs of Chairman Mao.

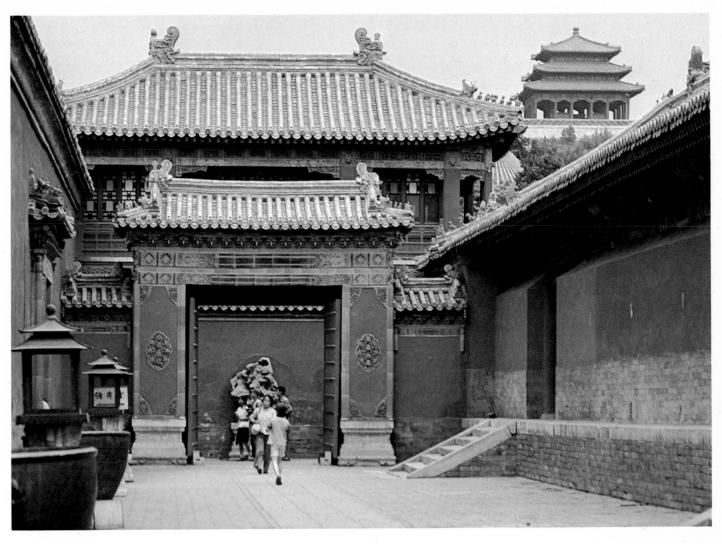

190. Gateway at the north end of the corridor between the Three Rear Palaces (Hou-san-kung) and the Six Western Palaces (Hsi-liu-kung), Imperial Palace, Peking. Ming dynasty (1368–1644), with renovations of the Ch'ing and People's Republic. The walls of the Imperial Palace were painted reddish purple, believed to be the color of the North Star, and therefore auspicious, and the roofs were covered with yellow tiles, the color associated with the emperor.

As we leave T'ien-an-men Square proceeding northward toward the Imperial Palace, we enter the central arch of T'ien-an-men gateway, one of the five openings through the Gate of Heavenly Peace. Previously, only the emperor passed through the central gate. Proceeding along a straight roadway that goes through three more gateways, we pass the area where the imperial guard was once quartered, now a public park. We approach the great Wu-men, Gate of the Midday Sun. The Wu-men bridges the moat (plate 189) to the inner palace city, which covers 250 acres and lies within the greater Imperial City. The palace plan, conceived by Yung-lo in the early fifteenth century, was essentially unchanged by the subsequent Ming and Ch'ing emperors, although they frequently renovated and added buildings. All the Imperial City walls (plate 190) were painted a reddish purple, believed to be the

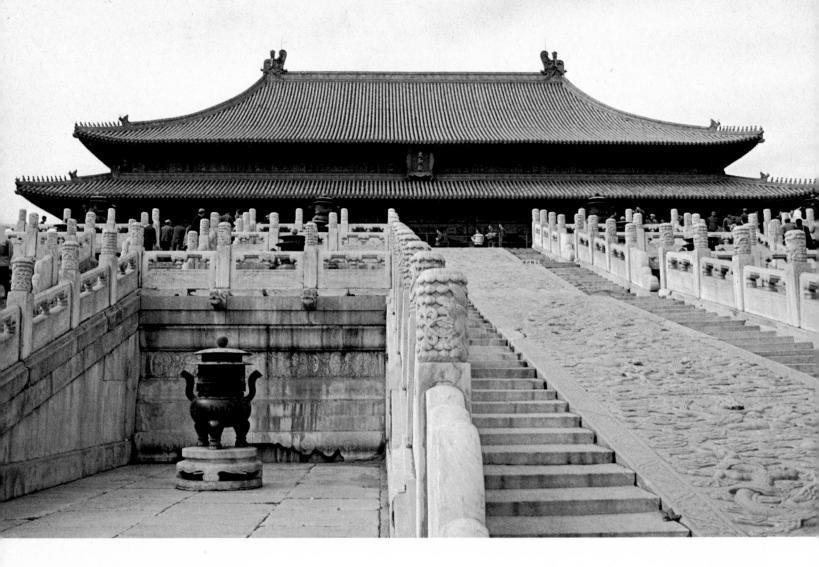

191. Stair terrace of the Hall of Supreme Harmony (T'ai-ho-tien), Imperial Palace, Peking. Ming dynasty (1368–1644), with renovations of the Ch'ing and People's Republic. Marble. The emperor presided over official ceremonies in three great Halls of Harmony at the heart of the Forbidden City. Triple stairways provide access to the ceremonial platform, the base for all the three halls. A panel in the central stairway, carved with clouds and dragons, was the space over which the emperor's chair was carried.

color of the North Star and therefore auspicious. The palace roofs were golden yellow. In the Chinese reckoning, there were five "positions": north, south, east, west, and center; yellow was the color of the center and was selected by the Ming and Ch'ing to be the color for the Son of Heaven—the emperor—who ruled the "Central Realm."

Within the first courtyard, a rectangular space so vast that the scale of a human being is reduced to total insignificance, there are five marble bridges over the River of Golden Water leading to another gate. There is a geometric and axial tyranny throughout the Forbidden City; the courtyard plans are uncompromisingly rectangular, and the gates correspond to the cardinal directions—north, south, east, and west. So strong is the main axis, which runs north-south, that man's impulse to meander or diverge from this awesomely severe orientation is totally subjugated.

At the rear of the next courtyard a great triple-tiered platform stretching north in the shape of an "I" is the base for the Hall of Supreme Harmony (plate 191), the Hall of Perfect

Courtyard of the Hall of Military Prowess (Wu-ying-tien), southwestern section of the Imperial Palace, Peking. Ming dynasty (1368-1644), burned and rebuilt in the Ch'ing, renovations in the People's Republic. During the Ming and Ch'ing, this hall housed the imperial printing presses which produced anthologies of imperial poems, encyclopedias, and collections commissioned by the emperor. It is now used to display some of the archaeological treasures found during the Cultural Revolution.

Harmony behind it, and the Hall of the Preservation of Harmony behind that. This courtyard is even larger than the preceding one, further dwarfing the individual and reinforcing his status as a humble subject of the Son of Heaven. The three Halls of Harmony were part of the original Ming plan. The emperor sat in all three halls on various great occasions such as his birthday, the winter solstice, the New Year, the selection of generals, the reading of the names of scholars who had passed the highest civil-service examinations, the inspection of the annual harvest seed for the next year's planting, and the banquets for the representatives of tributary states or for officials within the imperial government. During times of official celebration, the vast courtyards were filled with legions of men carrying pennants and streamers while orchestras played accompaniment on stone chimes and gilt-bronze bells.

There is a great carved marble slab with dragons and phoenixes in clouds in the center of the triple stairway that ascends the platform to the Harmony halls (plate 191). The emperor was carried over this in his sedan chair. All the

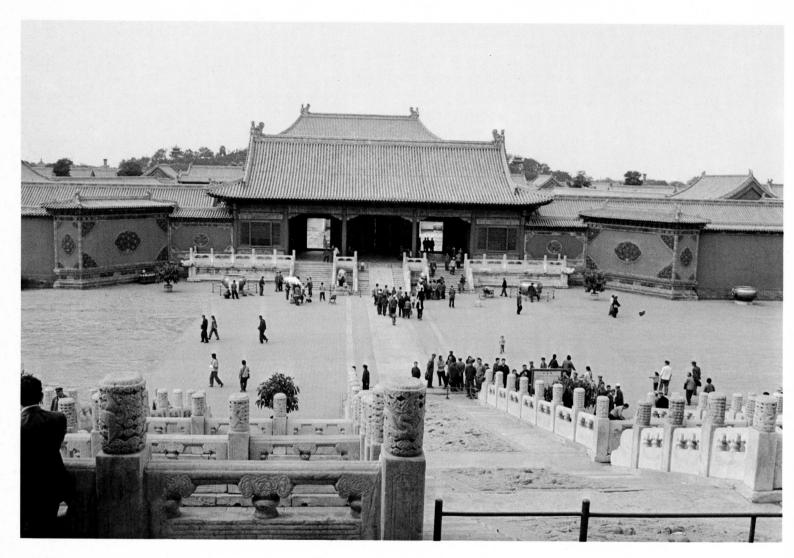

193. Looking south in the corridor between the Three Rear Palaces (Hou-san-kung) and the Six Eastern Palaces (Tung-liu-kung), Imperial Palace, Peking. Ming dynasty (1368–1644), with renovations of the Ch'ing and People's Republic. The residential palaces were built on a north-south axis and surrounded by walls. Long walkways run between the compounds. Gateways open onto these corridors.

Balustrade post with dragon-phoenix-cloud motif, Imperial Palace, Peking. Ming dynasty (1368–1644), with renovations of the Ch'ing and People's Republic. Marble.

Bird-and-flower wall medallion, Imperial Palace, Peking. Ming dynasty (1368–1644), with renovations of the Ch'ing and People's Republic. Plaque and wall, glazed ceramic.

north-south-oriented stairs and other east-west stairs within the pattern of imperial movement had similar carved slabs—spaces which only the emperor could enter. These long marble cloud-and-dragon rectangles look like patterned carpets and are a distinctive imperial motif seen also at other places the emperor visited, such as the Temple of Heaven, the Summer Palace, and the Ming tombs.

The palace and other imperial monuments were also decorated with miles of elaborate marble balustrades such as one finds along the tiered platforms supporting the three Halls of Harmony. The tops of the upright cylindrical posts were carved with the same dragon-phoenix-cloud motif (plate 194).

The vast marble courtyards repeat themselves; all are entered through gates and all have wooden, tile-roofed halls arranged geometrically around the courtyard. Currently they share an austerity which must have been somewhat modified during the imperial period by the perpetual mist of incense that rose from huge censers on the stairs and platforms (plate 192). The aromatic clouds curled around the emperor's buildings and softened their appearance. And on special occasions the human pageantry would, of course, fill up the courtyards. Yet it seems clear that an architectural conception employing such colossal, inhuman spaces walled off from the everyday world and a rigid orientation that assumes such an unyielding hierarchy must reflect how the emperor saw himself in relation to his court and to the people of China. Court protocol was as strict as the architectural design. For a petitioner or an ambassadorial tribute bearer there was no possibility of informal access or conversation. If an emperor wished to be informed of the realities of Chinese life, he had to leave the confines of the Forbidden City. Some emperors had no such desire. The Son of Heaven was not an ordinary mortal; as recipient of the "mandate of heaven" he was the ceremonial head and key power in rigidly organized and categorized institutions. Some Western historians attribute the decline of the Ming dynasty and, indeed, the whole dynastic system to the fact that there was no higher law or institutionalized check on the arbitrary imperial power. Traditional Chinese historians used the stock Confucian explanation that the collapse of the Ming occurred because of the personal failings of various emperors. The emperor's virtue and sense of social responsibility were certainly crucial factors in a successful reign, but no matter how conscientious the emperor was, the Confucian ideal ruler could never have been the Marxian one because of

- 196. Guardians on corner roof tiles, Imperial Palace, Peking. Ming dynasty (1368–1644), with renovations of the Ch'ing and People's Republic. Orange-yellow ceramic.
- 197. Gate of Heavenly Purity (Ch'ien-ch'ing-men), Imperial Palace, Peking. Ming dynasty (1368–1644). The stair descends from the north end of the platform that holds the three great halls of state (Halls of Harmony) to a large courtyard and gateway entrance to the imperial residences located in the northern section of the Forbidden City.

the emperor's class consciousness, class origins, and exploitation of the working people. To Communist historians the collapse of the dynastic system was historically inevitable and was caused by the failures of the system itself, rather than those of the emperor.

The private living quarters of the imperial family, the concubines, and the ever-watchful eunuchs were in the northern section of the walled palace quadrangle (plate 193). Some of the smaller palace courtyards, though hardly cozy, have a more human scale. This is especially true of the concubines' quarters, placed on a north-south axis just west of the main palace. Here the smaller scale allows the charming green-and-yellow ceramic wall plaques of dragons, flora, and fauna and the delightfully tiled roofs to come into focus (plate 195). There is a parade of guardians at each corner of all of the thousands of roofs within the Imperial Palace (plates 196, 198). Their function is to guard the gate or hall from the malevolent spirits who reside in the four diagonal directions—northeast, northwest, southeast, and southwest. Some of the parades include a dragon, nine whimsical feline or birdlike creatures, and an official riding on the back of what appears to be the top half of a giant rooster. Other, more modest groups have only three guardians between the dragon and the mounted official.

There are long narrow walkways between the various sections of the palace (plate 197). These are lined by the ubiquitous reddish-purple walls that enclose each section. Most courtvards are entered from the south through a main gate (plate 200), and many are planted with handsome trees. Directly in front of the gate, the smaller courtyards have wooden screens to protect the occupants from visitors' eyes (plate 199). The rectangular hall at the rear of the courtyard is generally entered from the center. Usually there is a small courtyard and a second hall in back of the first, with a connecting walkway. Since the succession of Ming and Ch'ing emperors who resided in the Forbidden City renovated the apartments that they and their entourages occupied, what we see today is only the shell of the original Ming palace. The apartments that are open for inspection are furnished in the nineteenth-century, late Ch'ing taste. The decoration features an elaborateness reminiscent of its Western equivalent of roughly the same period—Victorian taste (plates 203, 224). In the ceiling of one imperial apartment (plate 201) a marvelously carved golden dragon writhes within a star. Suspended from this golden relief and surrounded by golden fringes is a silver orb that hangs 198. Guardians on corner roof tiles of the hall next to the West Flowery Gate (Hsi-hua-men), Imperial Palace, Peking. Ming dynasty (1368–1644), with renovations of the Ch'ing and People's Republic.

199. Entrance courtyard with screen-gate on left, Ch'eng-ch'ien-kung, northeastern section of the Imperial Palace, Peking. Ming dynasty (1368–1644), with renovations of the Ch'ing and People's Republic. In this complex, which is similar to the Palace of Permanent Peace (plate 200), the screen-gate is closed (left). The small courtyard with trees has a relatively intimate scale and must have been a pleasant place for the women to sit and talk and play games.

200. Entrance to the ceramics exhibition in the Palace of Permanent Peace (Yung-ho-kung), northeastern section of the Imperial Palace, Peking. Ming dynasty (1368-1644), with renovations of the Ch'ing and People's Republic. The sign reads: "Ceramics Hall, latter section." Currently used as an exhibition hall, this small complex used to house women of the court. The main entrance to the courtyard and hall is from the south. In times past, when the gateway was opened for a caller, he would have been confronted by a closed screen-gate which hid the courtyard from curious or unworthy eyes. Here the screen-gate is open.

201. Carved ceiling in an apartment in the Six Western Palaces (Hsi-liukung), northeastern section of the Imperial Palace, Peking. Ming dynasty (1368–1644), with renovations of the Ch'ing and People's Republic. Ceiling, carved wood with paint and gilt; hanging, mirrored ball and golden pendants.

like a crown with long pendants. Couchlike thrones, sometimes called *k'ang*, served for sitting or reclining. Calligraphy and paintings decorated the walls.

The women of the court stayed in their quarters. A force of eunuchs served and oversaw their feminine charges. The women whiled away their days dressing up, playing games, gossiping, and intriguing. The concubine whose son became the heir apparent was afforded all the prerogatives of a full-fledged consort. Occasionally, as in the case of the Empress Dowager Tz'u-hsi (1835–1908), such a woman, supported by faithful eunuchs and trusted officials, attained power through a triumph of court intrigue. But, in general, women played an extremely subservient role.

Especially under the Ming, the unchecked power of the imperial eunuchs was a persistent evil that contributed to the dynasty's disastrous end. Upon the fall of the Mongol dynasty, the scholar-official class had rejoiced at ridding China of the despised foreign rulers, but enlightened government was not necessarily fostered by Chinese rulers. As the Ming dynasty went on, the eunuchs managed to dominate the emperors and officialdom. They created so much factionalism and conflict at court that even the most dedicated literati officials became discouraged and humiliated; sometimes they were even in danger of losing their lives. The literati class, which had

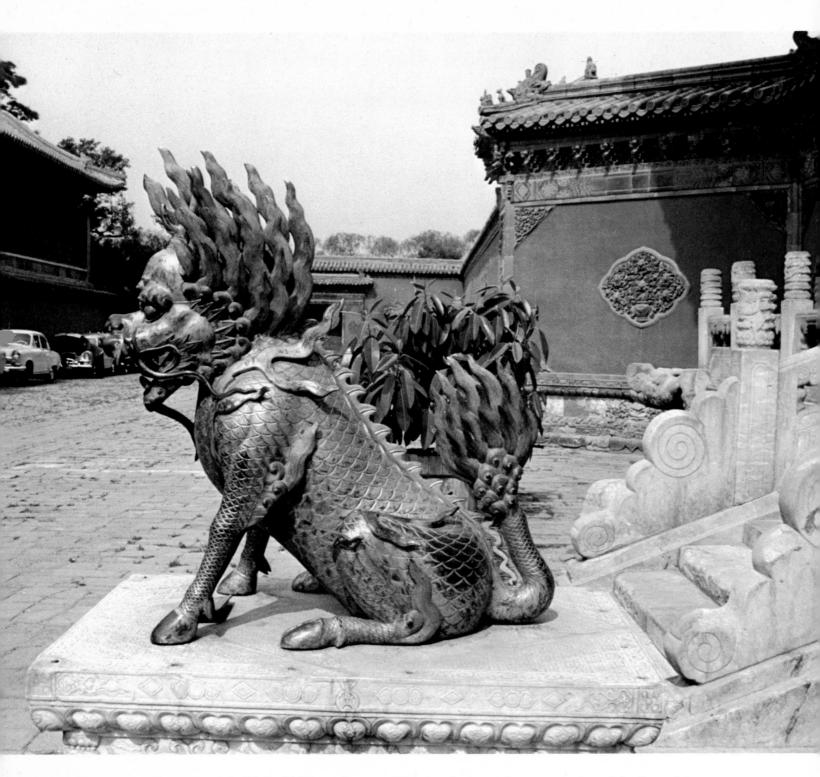

202. Entrance to the Hall of Military Prowess (Wu-ying-tien), southwestern section of the Imperial Palace, Peking. Ming dynasty (1368–1644), burned and rebuilt in the Ch'ing, with renovations in the People's Republic. Sculpture, gilt bronze; stairway, marble; walls, painted plaster with ceramic decoration; tiled roof. Mythical beasts guard the entrance.

emerged victorious in its power struggle with the old noble class in the Sung, was quite helpless to counter the eunuch influence. Eunuchs were companions and friends to young emperors in their formative years, were masters of plots and gossip, and were unencumbered by family obligations. They sublimated their sexual incapacity in a lust for power and extravagance.

In this period the scholars, who were regarded as paragons of Confucian virtue, often chose not to serve in government or else retired early in order to escape the unprincipled schemes at court. While the power elite paid lip service to Confucian morality, it was in fact utterly corrupt.

Literati protest against imperial service was not a phenomenon that began with the Ming. As early as the fifth century, a poet-official named T'ao Ch'ien (also known as T'ao Yüan-ming; d. 427) resigned his official position in protest and retired to private life, commemorating his feelings in a poem, "Going Home."

In a period when official service was especially perilous, such as the Ming, this theme of the courageous official who retires from public life to cultivate his spirit and pursue the fine arts of painting, poetry, and friendship enjoyed great popularity among the literati. Wang Chung-yü, an early Ming artist who was active in the late fourteenth century, painted

his version of the poet T'ao Ch'ien with scroll in hand (plate 204). In his retelling of the story, Wang used as his model an earlier painting on this theme. The figure of the protesting poet, although somewhat haughty, is painted in a sweep of lines more decorative than defiant. His hat, fur cape, and flowing robes fit into a gentle crescent curve. The figure floats in an undefined background, and its elegant lines produce a graceful rhythm rather than emphasize the literary message. Since the message was already well known to the literati audience through paintings on the same subject from the T'ang and Sung periods, the Ming painter could devote himself, if he preferred, to the enjoyment of the abstract, decorative qualities of line.

This painting of T'ao Ch'ien shows why Ming painting is often difficult for the uninitiated Westerner to appreciate fully. It is based on references to classical literature and art that the artist assumes his audience knows. The situation is somewhat analogous to that of a Chinese who has learned English but knows nothing of Western civilization, ancient or modern, and tries to read James Joyce's *Ulysses*. While some words may have a familiar ring, without a thorough grounding in classical and contemporary culture it is quite impossible to understand the meaning. In a similar way, we are ill equipped to approach the subtle antiquarian references and currents so familiar to Wang Chung-yü's audience.

The most revered Yüan painters were all native Chinese. Since most of them had no official connection with the Mongols, their reputations were untouched by the Ming condemnation of the Mongol era, and their work continued to be admired. Ni Tsan (1301–1374) was one of the most influential Yüan artists, among both his contemporaries and succeeding generations. Indeed, were it not for the inscription and signature of the artist, a painting by Wang Fu (1362–1416) in Peking's Palace Collection (plate 205) could well be mistaken for a painting by the Yüan master himself or one of his circle. Wang Fu paraphrased one of Ni Tsan's favorite themes of bamboos, trees, and rocks, painting it in the Yuan master's crisp, dry style. The painting is of superb quality. Because of the graceful arrangement of the composition and the beautifully rendered brushstrokes that define the branches, leaves, and rocks, any connoisseur would cherish it. From the standpoint of originality, however, it is clearly imitative, displaying a cultivation of Ni Tsan's style. Virtually all later Chinese painters, sculptors, architects, and bureaucrats worked within the frame-

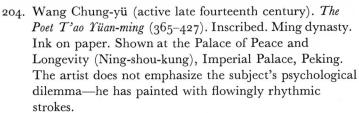

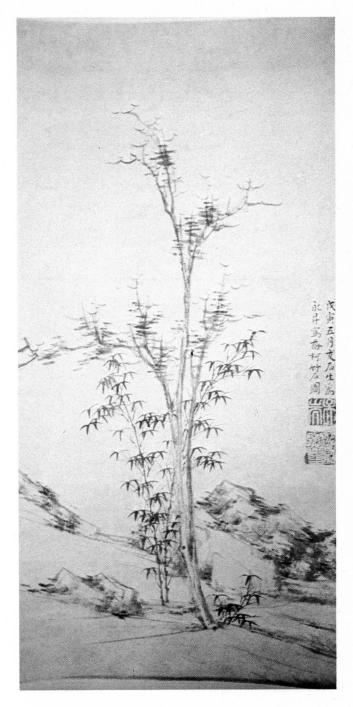

205. Wang Fu (1362–1416). Tall Tree, Bamboo, and Stone. Kiangsu province. Inscription on right margin: "Painted in 1398, when the artist was thirty-six, for a friend, Yung Sheng, signed and dated." Ming dynasty. Ink on paper. Shown at the Palace of Peace and Longevity (Ning-shoukung), Imperial Palace, Peking. To paint the innermost essence of a subject—the hardness and massing of rock, the delicacy and flexibility of bamboo, and the vibrant growth of a tree—was an important goal for a painter.

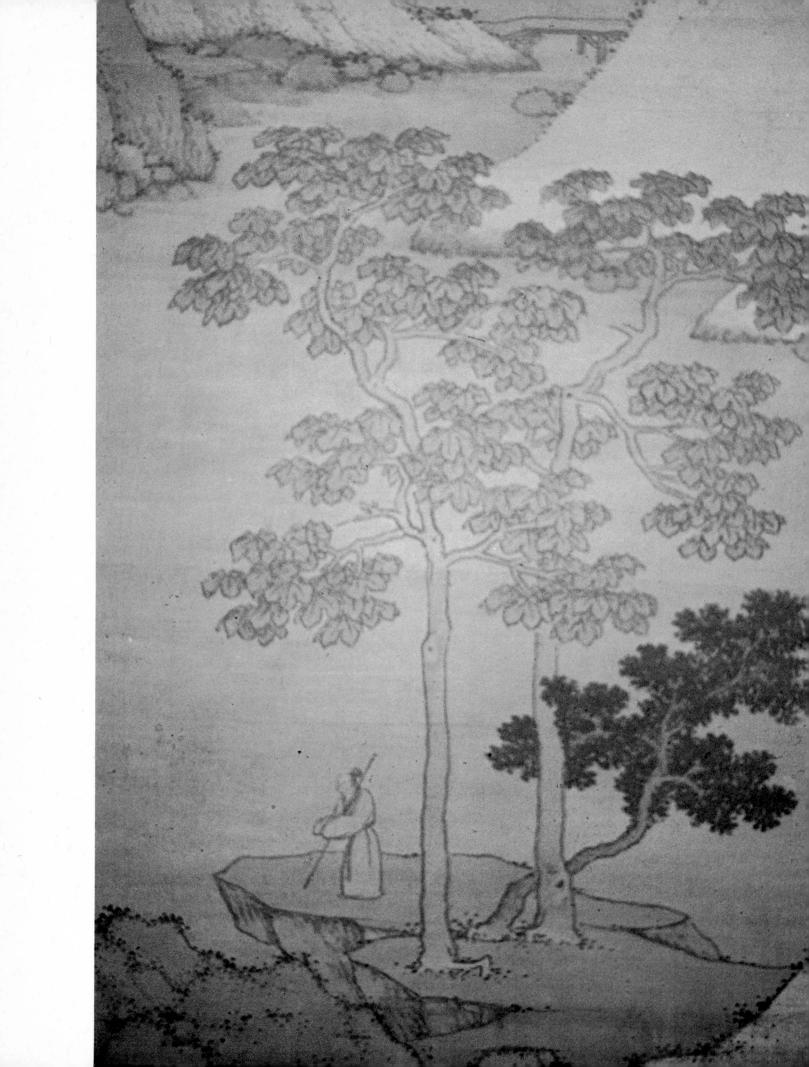

work of the past. In effect, the subject of the art was its own classical past, with new and highly creative stylistic variations. The artist worked with age-old patterns, which he freely reinterpreted.

One of the greatest artists of the Ming, who was also a great admirer of Ni Tsan, was Shen Chou (1427-1509). Remaining in his native city of Soochow, Shen Chou avoided an official career and pursued his art just as Ni Tsan had done. He is considered the founder of the Wu school, so named because Soochow was in the ancient State of Wu. But Ni Tsan's was only one of the older styles of painting that Shen Chou practiced. In Peking's Palace Collection there is a splendid painting (plate 206) executed in the "blue-green landscape" style revived from T'ang times. In a detail of that painting we see a man dressed in long robes and holding a walking stick, standing in a small clearing on a wooded hillside contemplating the true nature of the universe.

Another outstanding painting by Shen Chou in this collection is a self-portrait (plate 207) painted in 1506, when the artist was seventy-nine years old. Portraiture was rare in the Wu school, and this half-length portrait may be unique in Shen's oeuvre. It is in the style of ancestor portraits, which were generally painted by professional artists and not by the literati artists of the Wu school. The artist's inscription states that he was trying to reveal character rather than make an exact likeness. Nevertheless, the painting appears to be a remarkably careful study of advanced age—the facial wrinkles, freckle-like discolorations, even the hair, beard, and eyebrows are clearly those of an old man. The face is very much alive: the lips seem almost ready to utter a phrase, and the intense eyes are piercing. This vitality contrasts with the formal, abstract patterns of the scholar's black hat and pale-brown robe.

Another scholar's portrait, at the opposite end of the stylistic gamut from Shen Chou's self-portrait, is Hsü Wei's Scholar on a Donkey (plate 208). Hsü Wei (1521-1593) was an individualist, aligned with no particular painting school. In keeping with the spirit of literati "amateur" painting, his scholar is painted with rapid calligraphic strokes that outline only the barest essentials of the robe. His dotted eye and hat and the donkey's ears and legs have each been formed with a single stroke. Here the brush was used in a completely calligraphic way. The Chinese have always categorized painting as an offshoot of calligraphy, and Hsü Wei's painting is an excellent example of the close relationship between them.

206. Shen Chou (1427-1509). Landscape (detail), in blue-green T'ang style. Ming dynasty. Ink and colors on silk. Shown at the Palace of Peace and Longevity (Ning-shou-kung), Imperial Palace, Peking. Adapting an ancient style of painting for the background color, Shen Chou created figurations of his own, clear and firm and deceptively simple.

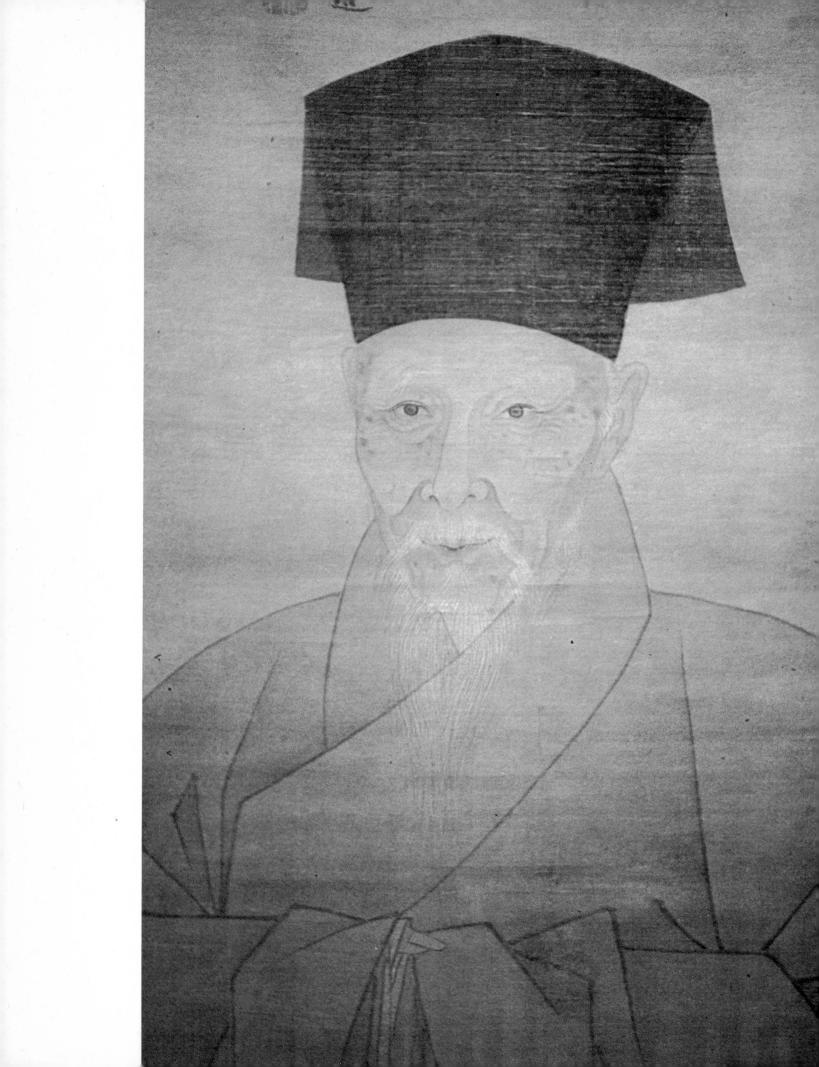

208. Hsü Wei (1521–1593). Scholar on a Donkey (detail). Chekiang province. Inscribed. Ming dynasty. Ink on paper. Shown at the Palace of Peace and Longevity (Ning-shou-kung), Imperial Palace, Peking. The artist has painted the humorous juxtaposition of a dignified scholar and a long-eared donkey with calligraphic skill and economy of line.

of the Artist (detail of lower half). Inscribed in upper half with date, 1506, and comments by the artist. Ming dynasty. Ink and colors on silk. Shown at the Palace of Peace and Longevity (Ning-shou-kung), Imperial Palace, Peking.

In a final example of Ming painting from Peking's Palace Collection we see a picture executed in a professional style which was in vogue at the court. Yu Ch'iu (active c. 1570–1590) painted a subject borrowed from the past, showing the Sui dynasty (581-618) minister Yang Su surrounded by beauties in a garden courtyard (plate 209). The figures are painted in a finely drawn style which was favored by the aristocratic tastemakers. This kind of painting was cultivated in the Sung court also and continued in the Ming period. Most amateur-literati artists rejected the meticulously detailed and highly finished look of professional artists such as Yu Ch'iu, preferring more intuitive and unschooled styles. While both amateur and professional artists practiced a conscious archaism, the amateur artists valued qualities of "naturalness," which were, however, highly intellectualized and contrived, sharing many of the ideals and characteristics of the highly cultivated rusticity of the Japanese "tea taste." Yu Ch'iu's painting, by contrast, has a refinement and artifice quite different from the other paintings we have seen.

Yu Ch'iu's painting of Yang Su provides a wealth of documentary evidence about Ming costuming and furnishing: the design of the ceramic garden seat in the foreground, on which the visiting official sits; Minister Yang's wooden bench with turned-up feet and a matching side table, both covered with brocaded or woven tops; the side-table display of the vase of flowers and an ancient bronze tripod from the minister's collection; the rolled-brocade edging of the table and bench that matches the pattern worn at neck and sleeve by the ladies in their flowing robes; and the pattern of the woven-mat background for the blank screen. The most exotic detail in this painting to Western eyes is the rocky outcropping on the upper right side. This puzzling vision of grotesquely shaped rocks is also found on later Chinese porcelains.

These rock forms were not just a fantasy in the artist's mind. Hollowed out and molded by wind and water over a span of eons, they were collected from the various areas of China and set into Chinese gardens to suggest rugged mountain peaks (plates 210, 214). According to the theory of garden planning, which evolved in ancient times and was fully developed by the Sung, the two most fundamental elements in Chinese gardens were hills or mountains and water. Some writers on the subject of garden theory equate the universal principles of *yin* and *yang* with these elements: *yin* is passive, dark, and moist—that is, water; *yang* is active, bright, and aggressive—the moun-

209. Yu Ch'iu (active c. 1570-1590). The Sui Minister Yang Su (detail). Ming dynasty. Ink on paper. Shown at the Palace of Peace and Longevity (Ning-shou-kung), Imperial Palace, Peking. A minister surrounded by beauties in a garden setting was a favorite subject for court paintings. This theme was adapted for porcelain decoration in the Ch'ing period and exported to the West, where it provided a vision of China for Europeans in the seventeenth and eighteenth centuries.

tain. A harmonious arrangement of mountains and water in a garden could evoke the spirit of universal harmony of vin and yang for the beholder. Of course, gardens also had trees, shrubs, flowers, bridges, and architectural elements. Most important, the arrangement of a garden was quite the opposite in conception of the formal rectilinear courtyard pavilion arrangement of formal palaces and mansions. Chinese gardens, like Japanese ones, are miniature versions of nature's way. The formal geometric gardens of eighteenth-century France are the exact opposites of the Chinese organic adventures, which offer surprise after surprise along the winding pathways that lead one past ever-changing vistas. It is not intended that the viewer be able to comprehend the whole garden from any given point. He must journey past the miniature evocation of mountains, streams, and forests, enjoying each sensation as a traveler would in the countryside. Osvald Sirén in Gardens of China (pp. 3-13) compares the journey through a Chinese garden to the viewer's journey through a Chinese hand-scroll painting of the landscape, which, as it unrolls, has a kind of cinematic effect.

The garden in the Forbidden City has some of the ideal characteristics of such a garden, but, in keeping with the overall rigidity and large scale of the Imperial Palace scheme, it was not planned with the complete freedom of an organic, curvilinear, asymmetrical creation, nor does it contain the intimate surprises found in smaller gardens. The gardens have many rock arrangements. Some are enclosed by marble railings and covered with ivy. Other rockeries are mountainous settings for pavilions; still another is a great rugged wall with a fountain. Yet these gardens are denied a sense of mystery because of the inflexible palace environment. Another treatment of the strangely formed stones may be seen in the northeast corner of the Imperial Palace, in the courtyard outside the private apartments built by the Ch'ing emperor Ch'ienlung (r. 1736-95). Mounted with awesome formality, the stone is displayed as a piece of nature's finest art (plate 210). Although its mannered form can be fully admired, in this setting it is robbed of its potential to evoke a mountain.

If we turn from the dignified gardens of the Imperial Palace to a garden in the old Chinese section of Shanghai, we can see an example of a Ming city garden built in the spirit of fantasy so sought after by the literati. The Yü Yüan, a mandarin's garden (plates 211–219), was built in 1537 by an official and is similar to the kind of garden in Soochow in which Shen

210. Stone outside the Hall of Repose (Yi-ho-hsüan), Imperial Palace, Peking. Ch'ing dynasty (1644–1912), renovated in the People's Republic. Carved by the forces of wind and water over eons of time, this rock, mounted on a base, is shown as a fascinating and artful achievement of nature.

211-15. The Yü Yüan, Shanghai. 1537 (Ming dynasty), restored 1956. Right, the top of the wall undulates like the back of a writhing dragon. Lions stand guard at the gateway. Opposite page: a vase-shaped gate; a garden pavilion made of lacquered wood, with marble table and seats; a two-story pavilion atop a rockery, giving the effect of a mountain retreat; a courtyard enclosed by a roofed gallery with a moon gate at the right. The Yü Yüan consists of a series of enclosed courtyards, each offering new visual delights, with the combination of linear elementsundulating, circular, triangular, and straight-producing extremely lively settings.

Chou and his circle drank wine, composed poetry, played music, created and viewed paintings, played chess, and admired specially cultivated flowers. The Yü Yüan followed the city garden formula; built in the heart of a city, sandwiched between crowded buildings, it was shielded from the activity outside by a high wall. Perhaps it was stocked with exotic birds, whose songs drowned out the street noises of hawkers calling their wares.

Once inside the gate, the visitor is enveloped in a fanciful, contemplative environment. A walk through the first pavilion, made of wood lacquered a rich red-brown, leads to a decorative gallery (plate 213). From this spot one can view the first garden (plate 216), which includes a great rock formation, a small lotus pond, and a covered gallery. The spines of the tiled roof of the gallery and the pavilion turn up at the ends in such a gaily absurd way that they make one laugh aloud. Also, one appreciates that the European creators of chinoiserie were honest men—faithful to the spirit of their models.

A white wall surrounds the garden and provides a perfect backdrop for the baroque rock shapes. The line of black roof tiles on the wall undulates like the back of a great dragon (plate 211). The rockery is not only a mountain with a circuitous path to the summit; it also invites the wanderer into its caverns and grottoes. Then the path leads to a vase-shaped gate (plate 212) through a wall which encloses another section of the garden. Again the wall is a background for fantastic rocks; one fairly restrained arrangement clearly shows the close relationship between Japanese and Chinese gardens. With great economy of elements, a few rocks and a tree suggest a totality of nature. Across the courtyard from this understated group there is the mountainous mass of a second great rockery. A two-story pavilion with humorously curled-up roofs is perched on top of this mountain (plate 214). Other small buildings include a theater.

The path continues through ornamental gates revealing more courtyards with pavilions and lakes, all full of surprises and flights of fancy. The silhouettes of the various elements fairly dance with picturesque exuberance where moon gates, dragon-back walls, and triangular roof lines meet (plate 215). Changes of season are reflected by trees and potted shrubs. In courtyards where there is no water, paving stones are laid in wave patterns.

Just as the gardens have been meticulously restored, so have

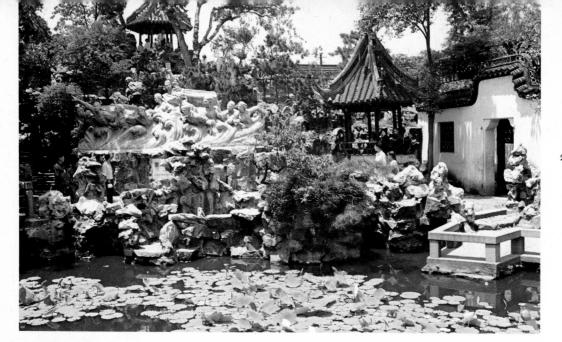

216. Lotus pond and Heroes of the Revolution, Yü Yüan,
Shanghai. Garden, 1537
(Ming dynasty); sculpture,
People's Republic. This piece
of revolutionary sculpture was
added in the recent restoration
of the garden. The figures,
cast in cement colored to
match the rock formations,
represent the rising proletarian
revolutionaries.

217. Interior of a living hall, Yü Yüan, Shanghai. 1537 (Ming dynasty), restored 1956.
Painting in the style of the Peking Academy, ink and color on paper, People's Republic. Although the garde is full of asymmetrical elements, the living halls were designed with the traditional rectangular definitions common to palace and domestic housing.

218. Interior of a reception hall, Yü Yüan, Shanghai. 1537 (Min dynasty), restored 1956. These chairs, made of gnarled elmtree roots, share the fantastic spirit of the garden design.

219. Broken-axis stone bridge over a lotus pond, next to the Yü Yüan, Shanghai. The bridge is a remarkable example of the designer's search for the picturesque through the elaboration of form.

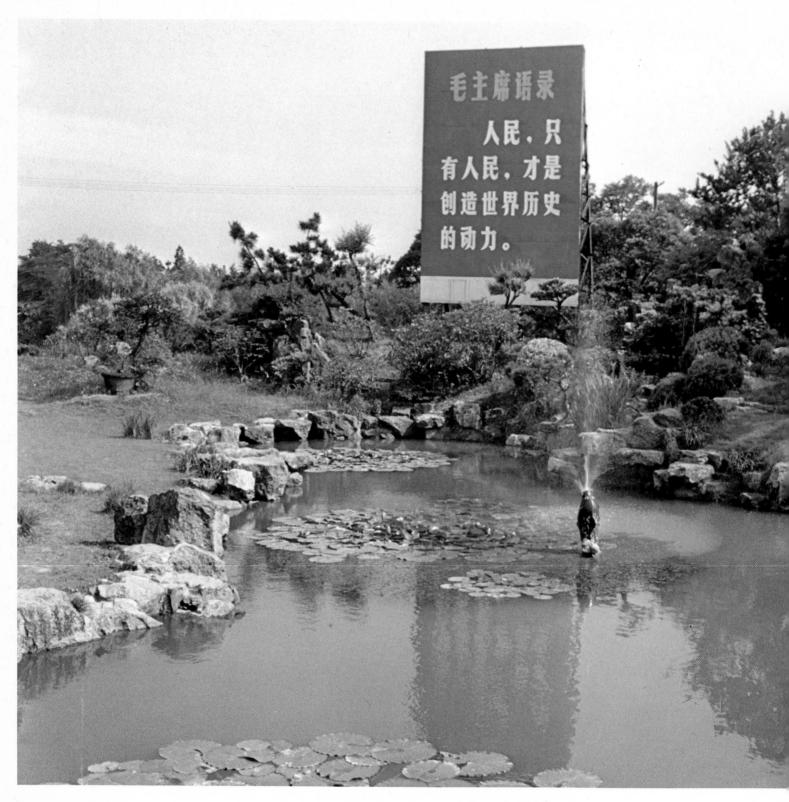

220. Garden of a nursery, Shanghai. Billboard: "It is the people, only the people, who are the moving force in the creation of world history."

221. "Pot landscape." Nursery, Shanghai.

the pavilions been refurbished and fitted out with appropriate furniture. Carved openwork grilles frame room sections hung with landscape paintings (plate 217). Marble and ceramic garden seats are used outdoors; carved mahogany chairs and tables indoors. One pavilion, in which visitors may be offered tea by the cadre in charge of the Yü Yüan, is furnished with chairs made from the gnarled roots of elm trees, whose fantastic forms parallel the grotesque rocks outside (plate 218). The teahouse next door, situated in the middle of a lotus pond, is now a restaurant. Its most picturesque feature is its bridge (plate 219), which, it is said, was built on a broken axis to prevent demons from approaching. Demons, according to Chinese folk literature, cannot turn corners!

A large golden statue of Chairman Mao in the entrance pavilion (plate 32) and cement busts of workers, peasants, and soldiers (plate 216) which grow out of waves at the top of one section of the rockery in the first garden add modern touches. The sculptures in the Socialist Realist style on the rockery express the anger and frustration of the rising masses struggling to break the chains that enslaved them in the old system. Because they are made of harmonizing rock-colored cement, they do not seriously disrupt the overall Ming ambience but provide yet another model of the relative harmony achieved between old and new in the very effective Communist educational policy of displacing the old meaning of the

garden by inserting ideological messages. The garden thus becomes teaching material for the new philosophy.

In the garden of a Shanghai nursery, with a pond and a fountain in a naturalistic landscape setting, a great red bill-board is not integrated nearly so subtly (plate 220). It reminds the contemplative stroller, who may be caught up in wonder at nature's powers, that "it is the people, only the people, who are the moving force in the creation of world history."

This nursery grows many varieties of flowers and shrubs and also cultivates mushrooms. The gardeners clip shrubs into lively topiary shapes and nurture dwarf trees to create "pot landscapes" (plate 221). The concepts of Chinese gardens and pot landscapes were exported from China to Japan along with Ch'an Buddhist ideas (Zen in Japanese) from the tenth to the fifteenth centuries. The Japanese transformed the Chinese garden into a specifically Japanese art form, just as they adapted the practice of Zen to suit their own needs. The Japanese and Chinese, who are so different from each other spiritually, do share the same ideas concerning the underlying form and function of a garden. The garden and the more circumscribed pot landscape are both meant to suggest the totality of nature.

THE CH'ING DYNASTY

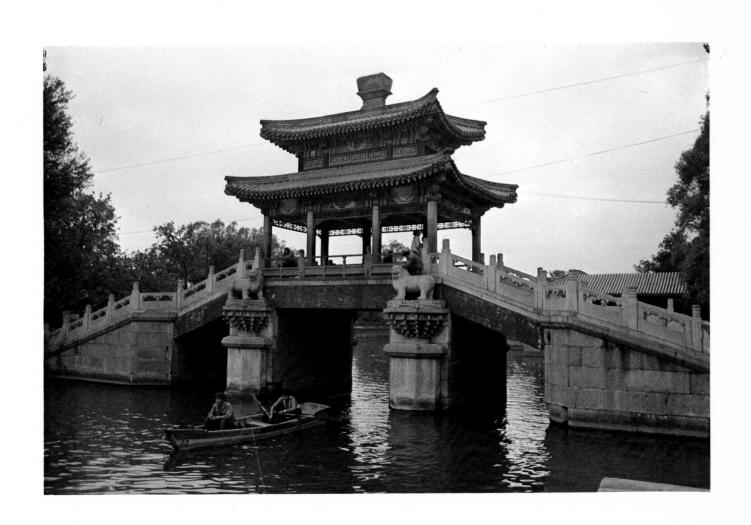

PRECEDING PAGE:

222. Bridge at the Summer Palace (I Ho Yüan), K'un-ming Lake, northeast of Peking. Ch'ing dynasty (1644–1912) and People's Republic. Marble, wood, and tile. Of all the imperial monuments around Peking, none is used with more frequency and joy by the masses of China than the Summer Palace.

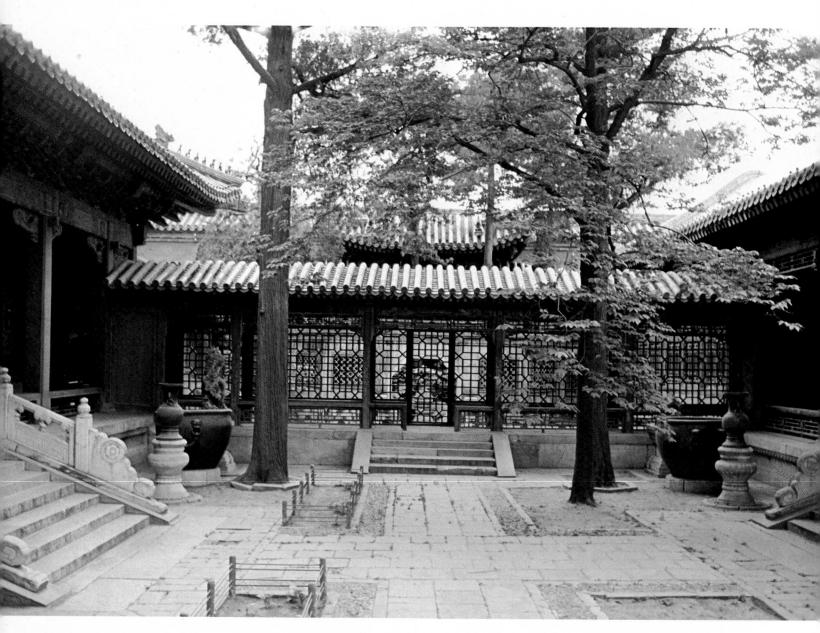

223. Courtyard of the Hall of Repose (Yi-ho-hsüan), northeast corner of the Imperial Palace, Peking. Ch'ing dynasty (1644–1912). Private apartments used by Ch'ien-lung (r. 1736–1795) and the Empress Dowager Tz'u-hsi in the last half of the nineteenth century.

The Ch'ing, or Manchu, dynasty (1644–1912) is best remembered for its careful preservation of Confucian culture. As foreign conquerors of China, members of the Ch'ing elite were more self-consciously traditional than native Chinese leaders had ever been. When the Ch'ing rebuilt and redecorated the Imperial Palace (plates 223, 224) and the Temple of Heaven, for example, the restoration was carried out as an extension and elaboration of Ming forms. Yet both have a distinctive Ch'ing spirit.

In the sixteenth and seventeenth centuries, as the Ming government became increasingly paralyzed by imperial irresponsibility and the excesses of eunuch power, uprisings were led by bandits who developed into regional leaders. The leader who established the most effective power base and became most significant to subsequent Chinese history was a Manchu named Nurhachi (1559–1626), a descendant of the Chin dynasty rulers who had dominated north China from 1115 to 1234. Aided by the official Ming policy of sinicizing the barbarians, Nurhachi organized the Manchu clan society into an effective administrative entity in a modified Chinese style. His bureaucratic government included many Chinese, who worked side by side with Manchu clansmen. While he was consolidating his Manchurian territories, Nurhachi also adapted the Mongolian alphabet to develop a written Manchu language. This facilitated administration and made it possible for the Chinese Classics to be translated into Manchu. Nurhachi thus created a highly sophisticated Confucian bureaucracy which he eventually used to rule China.

In 1644 Peking was attacked by a rebel force from western China and threatened by Manchu forces from the northeast. The Ming general in charge chose to ally himself with the Manchus, who were led by one of Nurhachi's sons. Then the Manchus and the Ming army combined to crush the rebels from the west, and a grandson of Nurhachi was set upon the Chinese throne. The barbarian invaders from the northeast took

the Chinese dynastic name Ch'ing ("Pure") and conducted traditional Chinese-style government with an ease and skill that came from years of practice before their conquest of China.

The situation had some similarities to the Communist "liberation" of China in 1949. By the time Chairman Mao and his forces gained control of the national government, they had already had over two decades of experience in governing large rural areas. This administrative experience offered invaluable preparation for their nationwide tasks, and its mark can still be seen in the political system of the People's Republic. Here the similarities between Communists and Manchus abruptly ends, however, because, once in control of the national government, the Manchus simply strengthened the existing Confucian system, while the Communists abolished the government of Chiang Kai-shek with an awesome finality and created a new system for controlling China.

Throughout the late seventeenth and the eighteenth centuries China enjoyed peace and prosperity. The Ch'ing emperors of that period were conscientious rulers who governed at least as well as the best of their predecessors in previous dynasties. China remained largely aloof from the world behind a cultural and economic wall built on a belief in her own superiority and self-sufficiency. This attitude was well expressed by Emperor Ch'ien-lung in 1793, when he rebuffed Lord Macartney, whom King George III had sent to the Ch'ing court in an effort to persuade the emperor to expand British trade facilities in China. The emperor told Macartney, "Our celestial empire possesses all things in prolific abundance." Despite the fact that Britain presided over a very different type of imperial system from China's, the Son of Heaven in Peking sought to make Macartney's visit conform to the protocol of the hierarchical East Asian system. Thus the British gifts were labeled "tribute," and court officials tried unsuccessfully to make Macartney prostrate himself before the emperor in the tribute bearer's customary kowtow.

Ch'ien-lung's spurning of George III represented a classic example of pride going before a fall. Within half a century the British began to force China to trade on their terms, and the Opium War of 1839–42 inflicted the first of a series of humiliating military defeats on the "Central Realm." By the midnineteenth century China was also suffering grave domestic problems. Swift population growth, natural disasters, official corruption and mismanagement, and economic discontent

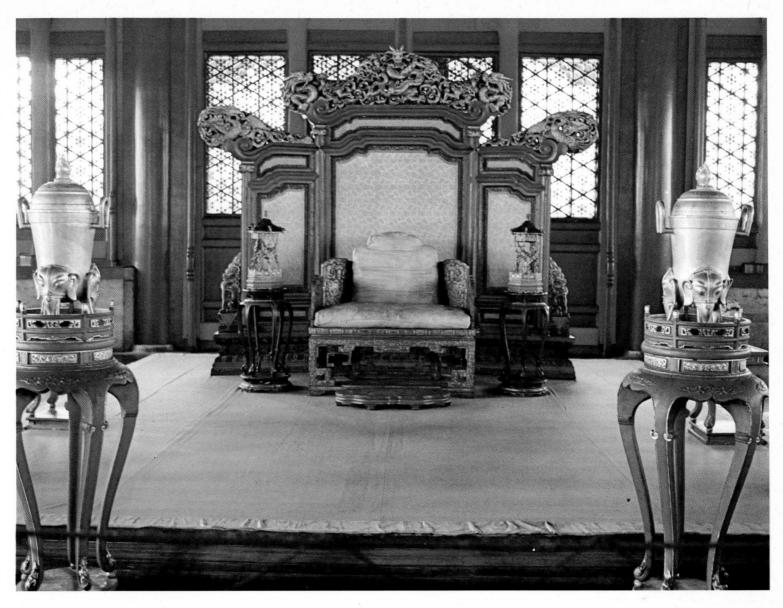

224. Hall with throne, Imperial Palace, Peking. Ming dynasty (1368–1644), with renovations and furnishings of the Ch'ing dynasty (1644–1912), restored in the People's Republic.

Wooden hall with glass windows; lacquered and gilt-wood furniture with brocade upholstery; gilt-bronze urns. This throne room is modestly scaled compared to the elaborately carved high throne in the Hall of Supreme Harmony.

stimulated severe internal upheavals, which came to a climax in the T'aiping Rebellion of 1850–64. Western aid eventually helped the Ch'ing suppress the T'aipings, but not before another round of Sino-Western conflict had culminated in 1860 in a treaty system that granted the major Western nations broad trading privileges and extraterritorial rights.

The 1860 treaty negotiations had been marred by an ugly incident that led to the destruction of Emperor Ch'ien-lung's favorite palace. Despite the fact that a truce had been declared, the Chinese captured the chief British negotiator and his entourage and killed twenty members of his group before releasing him. In retaliation against the emperor, Lord Elgin, leader of the British forces, ordered his men to sack the Summer Palace, Yüan Ming Yüan, which was located about six miles northwest of the Peking city wall. They destroyed more than two hundred buildings. (It was this Lord Elgin's father who removed the marble carvings known by his name from

225. Balustrade at the Summer Palace. Ch'ing dynasty (1644-1912). Marble.

the Parthenon to London, supposedly to assure their preservation.)

The ill-fated Summer Palace had been built by Emperor K'ang-hsi (1661–1722) and enlarged by his grandson, Emperor Ch'ien-lung. Many of the buildings were designed by the Jesuit missionary and court painter Giuseppe Castiglione (1698– 1768), an Italian artist who was among those who introduced the European developments of single-point perspective, chiaroscuro, and oil paints to a small group of interested Chinese court painters. Although, in general, European influence on the Chinese court was far more limited than was the impact of the craze for chinoiserie that swept Europe in the seventeenth and eighteenth centuries, the stone buildings of the Summer Palace were conceived in a somewhat sinicized version of eighteenth-century Italian Baroque forms, with niches, colonnades, pediments, and columns and Ionic and Corinthian capitals. Geometric arrangements featured curving stairways, Neoclassic balustrades, circular pools, and Italianate fountains. These buildings included temples, shrines, libraries, theaters, workshops, farm buildings, and housing for the imperial retinue. One hall was crammed with all kinds of foreign machines, mechanical toys, and clocks that Emperor Ch'ien-lung had received as gifts. Although he was interested in these items as curiosities, he evidently could not imagine their practical application in China—a symptom of Ch'ing failure to understand the necessity of adapting to modern needs in a changing world.

The Yüan Ming Yüan was in the region where summer palaces had been built by reigning monarchs since the Chin dynasty in the twelfth century. Additional pavilions and temples were constructed in the area during the Yüan and Ming. The early Ch'ing emperors continued the practice of building palaces there. Emperor Ch'ien-lung's Summer Palace, Yüan Ming Yüan, was situated in an enormous park, with hills, valleys, pools, ponds, and lakes that provided a variety of picturesque settings for the buildings. From all accounts the palace was as magnificent as it was extensive.

Almost three decades after the sacking by Lord Elgin, a new Summer Palace, I Ho Yüan (plates 222, 224–228), was built on a site nearby, at K'un-ming Lake, at great cost to China's national security. As part of the "self-strengthening" reforms of the 1860s, enlightened Chinese ministers had urged the modernization of the navy, and funds had been collected for that purpose. But the Ch'ing court decided, instead, to cre-

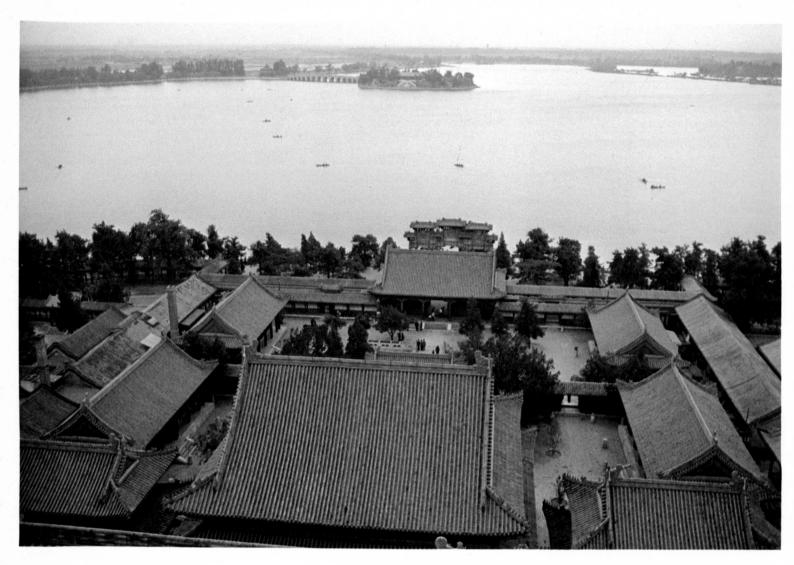

226. Looking south at K'un-ming Lake. Ch'ing dynasty (1644–1912). From the hill overlooking the roofs of the Palace of Orderly Clouds (P'ai-yun-tien), the place where the Empress Dowager T'zu-hsi celebrated her birthdays, one can see the network of islands, causeways, and bridges in the lake.

ate a retirement villa for Tz'u-hsi, the Empress Dowager, and the naval funds were used to build a new Summer Palace. Marine interests were not entirely neglected, however—a marble boat, a pavilion on the water, was constructed at the edge of the lake. This famous marble boat stands as a tragic symbol of the Chinese navy and as an example of the court's lack of commitment to "self-strengthening." While the Summer Palace was being completed to suit the fancy of the Empress Dowager, Japan was enlarging her fleet. When the Sino-Japanese War broke out in 1894, Japan inflicted a disastrous naval defeat on China and forced her to cede Taiwan and pay large indemnities.

The new Summer Palace was opened to the public in 1924 and has served as a popular pleasure garden ever since. The palaces and picturesque views provide interesting sight-seeing,

227. Stage and courtyard, Palace of Virtue and Harmony (Te-ho-yüan), Summer Palace. Ch'ing dynasty (1644–1912), with renovations of the People's Republic. Railing grillwork, metal; gallery, stone and wood. Chinese opera was performed on this platform stage for the Empress Dowager Tz'u-hsi.

228. Aquatic garden in K'un-ming Lake. Balustrade and decorative windows in a covered gallery, Eastern Palaces, Summer Palace. Ch'ing dynasty (1644–1912), with renovations of the People's Republic. From inside the gallery viewers can enjoy the scene through a great variety of window shapes.

229. Stork. Ch'ing dynasty
(1644–1912). Gold, gems, and
pearls. Shown at the Hall of
Happiness and Longevity
(Le-shou-t'ang), Imperial
Palace, Peking. The Empress
Dowager Tz'u-hsi especially
coveted delicate sculptures made
of precious metal and stones.
On her birthday many treasures
like this one were presented
to her.

and K'un-ming Lake is a favorite spot for swimming and boating in the summer and skating in the winter. Huge crowds of vacationing Chinese pour into the previously exclusive imperial hideaway. Compared to the rigid geometric plan of the Forbidden City, the overall layout of the Summer Palace is rambling and informal. Solitary gazebos and palace complexes follow the contours of the shoreline and ascending hills in order to take advantage of lovely vistas. Yet it is interesting to note that individual palace buildings were subjected to the same rigid geometry as that seen in the Forbidden City. Even the yellow-orange tiles in the Forbidden City are found again in the pavilion roofs of the Summer Palace (plate 226). Besides elaborate living quarters, there are facilities for various diversions. Decorated walkways, viewing pavilions, gardens, elegant courtyards, and a stage for theatrical performances (plate 227) indicate some of the imperial recreations. The Empress Dowager watched presentations of Chinese opera from a pavilion across the courtyard from the stage, and it is said that she herself occasionally appeared in these theatricals masked as the Buddhist Goddess of Mercy, Kuan-yin.

Another favorite activity of the Empress Dowager was collecting jewels. At the Summer Palace there is a sumptuous display of birthday presents received by her, including rows of pot landscapes made of jade, garnet, amethyst, lapis, turquoise, and other semiprecious stones. Among the many items at an exhibition of imperial treasure at the Imperial Palace in Peking there is a small golden stork, cloaked in pearls, that carries a jeweled branch in its beak (plate 229).

Evidently the Empress Dowager enjoyed power as much as she did jewelry. Originally the consort of Emperor Hsien-feng, after his death in 1861 she and his brother, Prince Kung, seized power under the nominal reign of her son, the new boyemperor. Histories tell how she dominated her son, and gossip has it that she encouraged the excesses which caused his premature death in 1875 at the age of nineteen. She then successfully connived to have her four-year-old nephew appointed Emperor Kuang-hsü. This was unprecedented, since he was of the same generation as his predecessor and therefore could not properly fulfill the ritual obligations of filial piety that each emperor owed the previous one. The Empress Dowager's bold maneuvering enabled her to continue to dominate the court for another fourteen years until Kuang-hsü's maturity brought about her retirement in 1889.

Japan's stunning defeat of her traditional big brother, Chi-

na, in 1894–95 seemed to signal the impending division of China by the imperialist powers. "Self-strengthening" had proved to be too little and too late. Thus a more radical group of Chinese reformers sought to persuade Kuang-hsü to adopt a program of profound change, comparable to that implemented by Meiji Japan a generation earlier. But most of the reforms of the "Hundred Days" of 1898 were short-lived, for they provoked an ultraconservative reaction in the form of a coup d'etat by the Empress Dowager against her nephew. Thereafter she kept Kuang-hsü a palace prisoner for the last ten years of his life, and it is said that she even forced his favorite concubine to drown herself in a well in the Forbidden City. Mysteriously, he predeceased the Empress Dowager by one day, in 1908. Although contemporary guides show some embarrassment when the subject of concubinage is brought up, the cruel death of Emperor Kuang-hsü's beloved is mentioned crisply as another example of the evils rampant in pre-Communist China.

Only after the failure of the so-called Boxer Rebellion of 1900—actually a war against the foreign powers, in which imperial troops joined forces with a xenophobic mass movement—did the Empress Dowager grudgingly support many of the reforms she had previously frustrated. But even the broad program of political, administrative, legal, fiscal, educational, military, and other changes that was launched during the next decade and that promised eventually to produce a self-governing constitutional monarchy could not save the tottering Manchus. They, and indeed the millennial imperial system, were engulfed by a rising tide of Chinese nationalism that culminated in the revolution of 1911 and the establishment of the Republic of China.

The Ch'ing were great patrons of the arts, including that of ceramics, which came to be well known in the West. Although Sung wares have been preferred by the cognoscenti of the twentieth century, generations of Westerners prized Ch'ing wares.

During the seventeenth century, the ceramics industry was reorganized and was enthusiastically patronized by the court, affluent Chinese, and the foreign market. Although Ch'ing ceramics may lack true originality, they exhibit inventiveness in the handling of materials and glazing, superb execution, elegance, refinement, and charm. If, on the one hand, Ch'ing potters re-created or elaborated on old designs, on the other

230. Shells. Ch'ien-lung (r. 1736–1795), Ch'ing dynasty. Porcelain, enamel glazes. Shown at the Ceramic Exhibition, Imperial Palace, Peking. The potter observed these shells so carefully and crafted them so skillfully that even fishermen could be fooled.

231. Box with cover. Ch'ien-lung (r. 1736–1795), Ch'ing dynasty. Porcelain with lacquer. Shown at the Ceramic Exhibition, Imperial Palace, Peking. The potter plays a joke on the maker of carved lacquer with a deceptive porcelain imitation.

hand their glazed hues introduced intensity, subtlety, and novelty. No form or color seems to have been too difficult for them to make.

Indeed, the remarkable realism they achieved makes many of their objects masterpieces of trompe l'oeil. Several such examples from the eighteenth century are shown in the Imperial Palace's ceramics exhibition. There are some ceramic shells (plate 230) and a circular ceramic box (plate 231) made to look like lacquered wood. The shells look so real that it is hard to believe they are not organic. The ceramic box fools the eve because it looks so convincingly like the kind of carved lacquer that enjoyed great popularity in Ch'ing times. The box is actually painted with lacquer, while the colors of the shells come from overglaze enamels. Two other examples of ceramics masquerading as natural objects are a decorative duck (plate 232) and a leaf dish (plate 233). The feathers and down of the duck, its shiny beak, and webbed feet are all treated with the utmost realism. The incised and sculptured decoration and slick glazes are extremely skillful. The pose has a distinctly ducklike quality. The delicately formed leaf plate, tied with a single flower and some leaves, evokes a pleasantly romantic image. Both duck and leaf are colored with overglaze enamels.

Critics have attacked this kind of technical tour de force, pointing out that trickery, rather than revelation of the innate potential of the material, was its goal. They call these things "kitsch"—stylish objects without artistic value. Yet these ob-

233. Leaf dish. Ch'ien-lung (r. 1736-1795), Ch'ing dynasty. Porcelain with enamel glazes. Shown at the Ceramic Exhibition, Imperial Palace, Peking.

232. Duck. Ch'ien-lung (r. 1736–1795), Ch'ing dynasty. Porcelain with enamel glazes. Shown at the Ceramic Exhibition, Imperial Palace, Peking. No detail of this quacking duck has been overlooked to assure its authenticity in clay.

jects do document China's cultural history and are evidence of a ceramics technology so fully developed that virtually anything could be represented.

The Chinese artist has always had remarkable rapport with the natural world. The Ch'ing potter continued to use animal, vegetable, and mineral objects as his models, regardless of the shift in presentation from abstract decorative to specific descriptive or sculptural forms. He reproduced natural forms for functional decorative objects, including tableware; rests for the head, arm, or wrist; hat racks; head scratchers; hairpins; earrings; cosmetic and scent boxes; incense burners; snuff bottles; palettes; ink rests; water droppers; brush and chopstick holders; chopsticks; scroll mounts; book stands; paperweights; candle snuffers; oil lamps; rice and tea spoons; fish bowls; washbasins; and garden seats. The few examples we can show only hint at the broad range of Ch'ing ceramics production, which includes high-fired, brilliant, monochrome wares of deep intensity, such as the copper reds, cobalt blues, iron-oxide celadon greens, browns, and blacks. Firing at medium temperatures yielded monochrome wares in rich yellows, greens, purples, and turquoises. In addition to these intense hues, the Ch'ing potters developed subtler ones, including the "peachbloom" pinks and "clair-de-lune" pale blues and greens. They were also able to re-create the earlier Sung wares so perfectly that sometimes even connoisseurs cannot distinguish between the two.

The Ch'ing kilns continued to produce prolific amounts of the blue-and-white and enameled wares so popular in the Ming. Some monochrome wares were exported to the West, but the blue-and-white and enameled wares were in the greatest demand. These ceramics, modified in terms of pattern, color, size, and shape to suit the taste of the European market, were decorated with pictures of graceful willow trees, arching bridges, moon-faced maidens, pigtailed mandarins, and pavilions. They transmitted a vision of "Cathay" to the West, and for European scholars who had read the writings of Confucius translated by the Jesuits in seventeenth-century China, the imagery on porcelain was visual documentation of the harmonious society they imagined China to be.

But as the eighteenth century drew to a close, the European vision of an ideal China faded for a number of reasons. When the foreign powers were unsuccessful in obtaining increased trade concessions from China, they became hostile and aggressive. More Europeans went to China seeking the land of their dreams, only to discover that the "land of porcelain" did not exist. Rather, China was full of injustice, poverty, and tyranny. Chinese export porcelains themselves lost some of their uniqueness, because the rapidly expanding European porcelain industry could now supply a reasonable facsimile of the new "essential" household items.

The end of Emperor Ch'ien-lung's rule in 1795 marked the beginning of the decline of the Manchu dynasty. The most creative period of Ch'ing ceramics had ended even earlier. After the mid-eighteenth century there seemed to be no artistic giants to replace the earlier great directors of the imperial kilns. Production continued, of course, but the Chinese potter of the nineteenth and twentieth centuries carried on the norms established before 1750, endlessly remaking the same garden seats, flowerpots, tea sets, vases, bureau sets, figurines, and curios for the court, the Chinese elite, and the export market.

Ch'ing and Communist art forms interestingly mirror the differences between the two regimes. Because the Manchus consciously followed Confucian orthodoxy, their art forms were an extension, a paraphrase, and an elaboration of traditional Ming forms. The Communists, by contrast, imported the foreign style of Soviet Communism and borrowed only selectively from Chinese tradition. They are still struggling to find new and truly revolutionary art forms to express the spirit of their ideology.

THE REPUBLIC OF CHINA

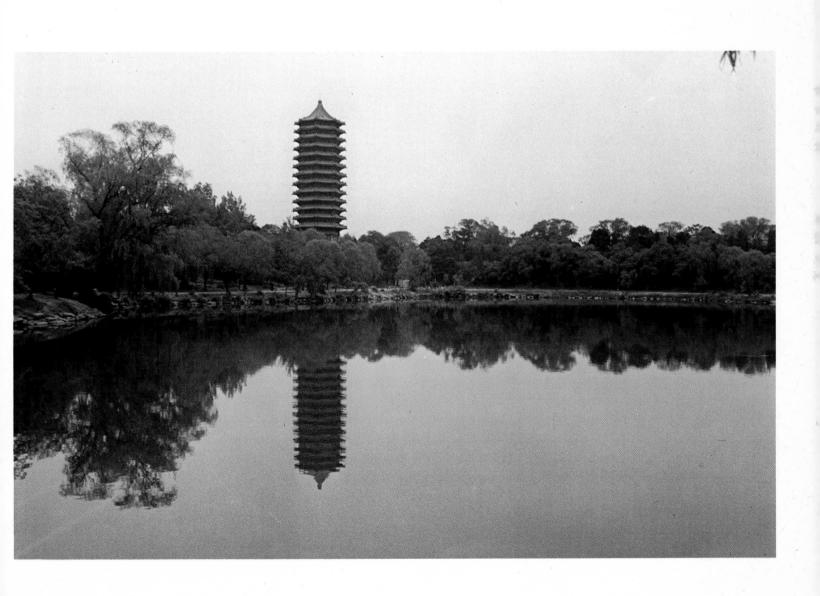

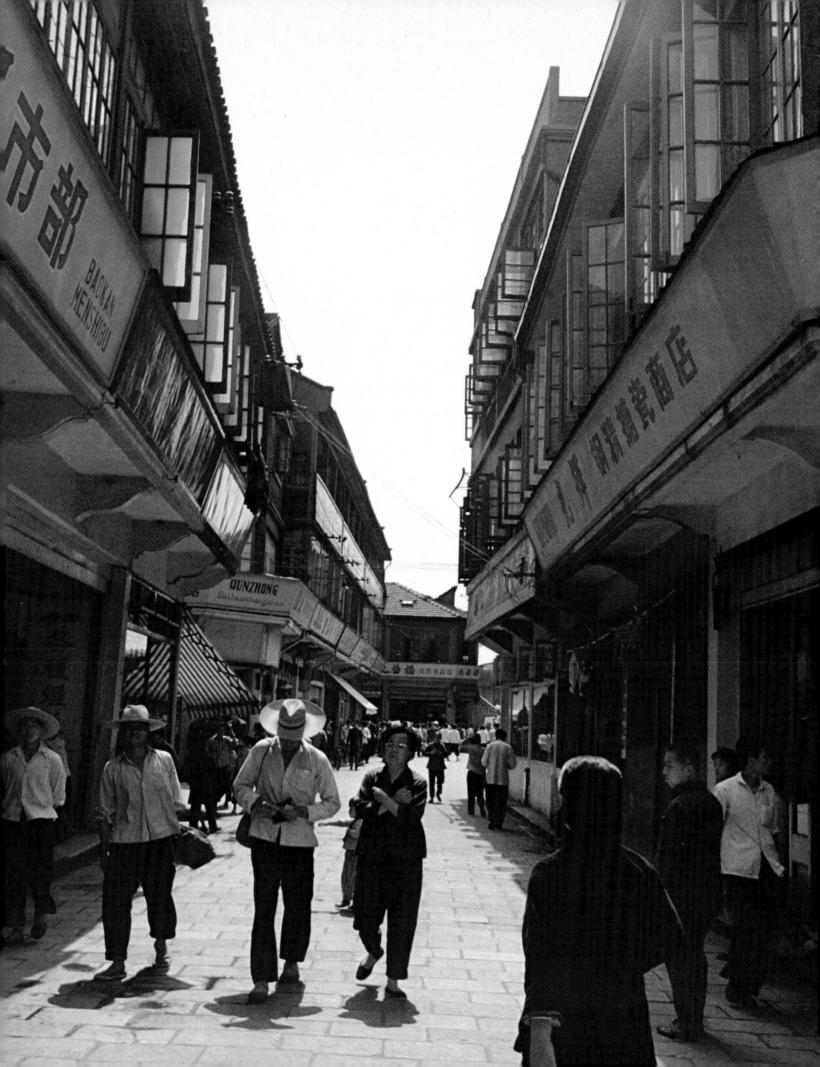

PRECEDING PAGE:

- 234. Henry K. Murphy designed this water-pumping facility cloaked in pagoda-like exterior. Peking University (formerly Yenching University). Republican period (1912–1949).
- 235. Narrow street in the old city of Shanghai.

The revolution of 1911 proved to be as limited as it was nonviolent. On January 1, 1912, the Republic of China was proclaimed and the monarchy toppled soon after. The revolutionaries shared a desire to rid China of foreign control and to establish some kind of parliamentary system based on political parties, and they recognized the need for a strong leader to replace the deposed emperor in maintaining the fragile unity of the country. Beyond that, however, there was little agreement among them. What kind of political ideology should be substituted for the hierarchical, authoritarian ethics of Confucianism? What kind of parliamentary system should succeed imperial rule, once governmental power derived from the Chinese people rather than from the "mandate of heaven"? What public ceremonies should symbolize and sustain the newly proclaimed values and institutions? These and many other fundamental questions had to be answered in detail if China were to create a new order and avert civil war, chaos, and further foreign intervention. All twentieth-century Chinese leaders have had to confront these questions.

Unfortunately for Sun Yat-sen and the other first-generation revolutionaries who attempted to establish a parliamentary democracy, Yüan Shih-k'ai, the experienced military leader and administrator whom they selected to bind the country together, quickly exercised his powers as president to suspend parliamentary activity and install himself as dictator. The politicians lacked the military force to resist, but Yüan lacked the vision necessary to create a new polity, and he gradually revived some of the governmental practices of the Manchus. Just before his death in 1916, he vainly sought to install himself as emperor.

From Yüan's death until the establishment of a national government by Chiang Kai-shek in 1928, China experienced the lowest point in its recent political history. While a succession of governments in Peking continued to represent China abroad and to maintain a facade of parliamentary government

at home, political power in the country actually became more fragmented than ever. Disagreements in the Peking parliament led to the establishment of a rival parliament in Canton, and in both north and south the different contending groups sought to enlist the aid of locally based military leaders known as "warlords." In an effort to expand the areas under their control, these warlords, the real holders of power in their individual regions, alternately struggled against and cooperated with one another and with various politicians in endless and confusing wars and intrigues. Although they experimented with a variety of political institutions in attempting to legitimize their rule, these militarists failed to win the support of the Chinese people, who suffered greatly during this era not only from wars but also from banditry, oppressive taxation, inflation, economic disruptions, decline in public services, and a plenitude of opium.

Adding to China's humiliation, and especially felt by the increasingly nationalistic urban populace, was the expanding foreign interference in China's affairs. Warlordism had disabled the Republic and prevented it from regaining Tibet and Outer Mongolia, which had come under British and Soviet influence, respectively, after the fall of the Manchus. The successive governments in Peking followed the example of Yüan Shih-k'ai and the Manchus by borrowing huge sums abroad on terms that gave foreigners ever greater control over China's administration. Foreign banks were able to make or break governments by granting or denying cooperation. Foreign nationals were not subject to Chinese law. Moreover, in the chaotic conditions of the day, foreign enclaves in port cities and foreign spheres of influence in many parts of China assumed greater and greater importance.

Yet the decline in China's fortunes, the fragmentation of authority, and the impact of foreign ideas were combined with rapid social and economic changes in the cities, creating great political, intellectual, and artistic ferment. Individualism, democracy, egalitarianism, liberalism, populism, feminism, anarchism, nationalism, anti-imperialism, socialism, Marxism-Leninism, and a host of other ideas competed for acceptance among a new generation of politicians, administrators, businessmen, factory workers, teachers, and students, who were searching for an ideology and a political program to replace discredited Confucianism and monarchy. As the 1920s wore on, the reunification of China and the termination of foreign privileges became the dominant themes that united these di-

verse groups. Marxism-Leninism proved attractive to some intellectuals, because it not only offered a comprehensive "scientific" explanation of societal development and of China's backwardness in particular but also presented a specific program of action whereby a small, highly disciplined elite could seize power, as had recently happened in Russia. Yet many others were put off by the Marxist-Leninist call for socializing the means of production and mobilizing the masses of workers and peasants in a class struggle against the landlord and bourgeois classes. Thus, the new revolutionary forces that coalesced in south China—first under Sun Yat-sen and, after Sun's death in 1925, under his military aide, Chiang Kai-shek, and other leaders—reorganized their Nationalist Party (Kuomintang or KMT) under the more inclusive banners of nationalism and anti-imperialism.

Nevertheless, during the mid-1920s the Kuomintang cooperated closely with Soviet Russia; with Moscow's international instrument, the Comintern; and with members of the small Chinese Communist Party (CCP), which had been founded in 1921. After his pleas for help were rejected by the Western powers, Sun turned to Lenin for assistance in creating both a modern army and a political organization capable of seizing power and governing. He sent Chiang Kai-shek to the Soviet Union to study Soviet methods, and Soviet advisers in China helped to restructure the Nationalist Party apparatus along Leninist lines. Although the vague revolutionary ideology which Sun created—the "Three Principles of the People" (nationalism, political democracy, and people's welfare)—differed from Marxism, these advisers also aided Chiang in establishing a military academy for indoctrinating the KMT "party army" in Sun's ideology. By way of illustrating the collaboration of individual Chinese Communists with the KMT, as well as the amazing longevity of China's revolutionary leaders, we should note that half a century ago Chou En-lai served as deputy head of the political-education department of Chiang's military academy and that Mao Tse-tung had even earlier played a modest role in coordinating the efforts of the CCP and KMT party organizations.

Sun Yat-sen's program called for the implementation of his "Three Principles of the People" in three stages: first, military reunification of the country and termination of foreign control; then, political tutelage by a Kuomintang-led state; and finally, after the people were capable of self-government, constitutional democracy. In mid-1926 the Kuomintang army

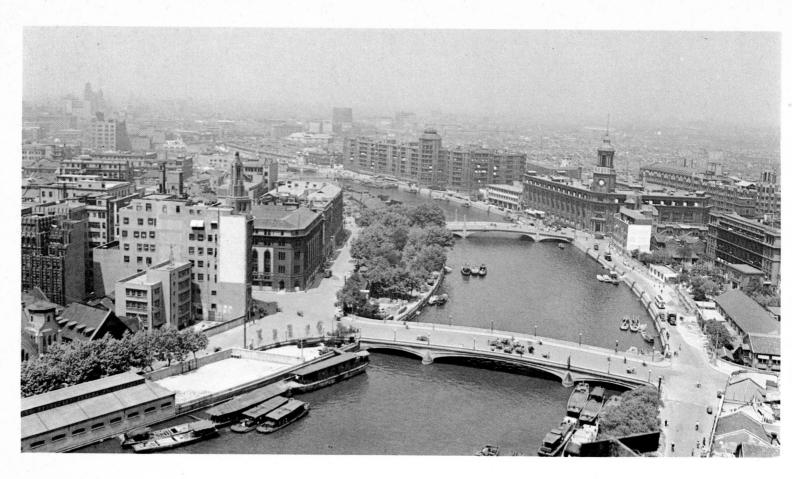

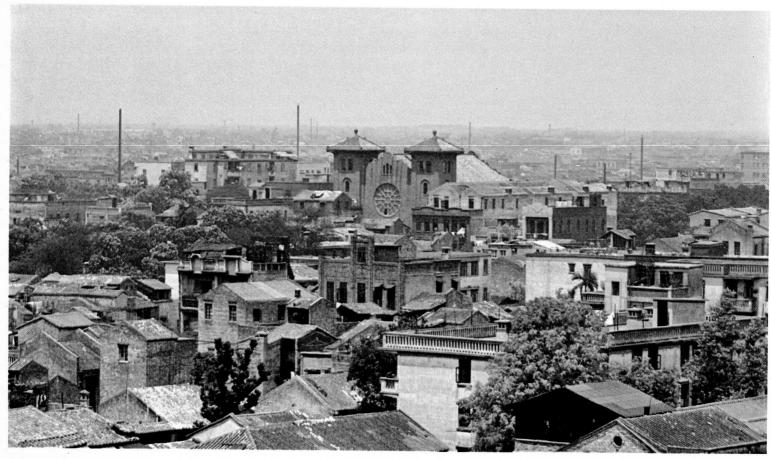

236. View of the Wu-sung (or Soochow) River in Shanghai. Buildings in a variety of foreign styles were built in the Republican period for administrative and domestic purposes in the concession areas of Shanghai.

237. A Christian church in a cityscape of Canton (Kwangchow).

under Chiang Kai-shek initiated stage one by launching from Canton the famous Northern Expedition, which was designed to end the era of warlord rule and to reunify the country. The following summer Chiang, having gained control of central China and Shanghai, and having united the left and right wings of the KMT, purged the Communist elements from its ranks. The CCP leaders who were not killed either went into hiding in the cities or fled to remote rural areas, from which they carried on what became a civil war against the KMT. Having gained the support of the business community by its harsh rejection of social revolution, the KMT established a new central government for China, with its capital at Nanking. In 1928 Chiang brought nominal unity to the country by marching north to take Peking (which he renamed Peiping) and by forging uneasy alliances with the warlords of the north, including the "Young Marshal," Chang Hsüehliang, who had inherited control of Manchuria from his warlord father. Chiang then announced the completion of Sun Yat-sen's first stage and the beginning of the new period of political tutelage.

Despite its continuing concerns about Communist rebellion, Japanese invasion, and warlord defection, from 1928 until Japan unleashed all-out aggression in 1937 the Nanking government, in addition to developing a professional national army, made a great effort to modernize the country and to eliminate the symbols of foreign domination. By adapting Western models to China's circumstances, it sought to implement many of the recently imported social and economic ideas without wholly abandoning Confucian values. Following the precedent set by Japan, it promulgated a European-style, comprehensive set of law codes that went a long way, for example, toward abolishing the worst abuses of the traditional family system and legitimizing the new conceptions of individualism, equality of the sexes, and emancipation of the younger generation. These codes also embodied many Western procedural and substantive protections of the individual against the arbitrary encroachments of the state. Nanking gradually extended the reach of its laws to more and more foreigners as it successfully pressed the lesser powers to surrender their extraterritorial privileges, and it regained control over its tariff schedules and the administration of its customs, salt revenues, and postal system. It coupled with this a series of fiscal and economic measures that unified China's currency and strengthened national finances, and it expanded the transportation system and industrial base. In education, as in legal, social, and economic matters, various reforms were introduced, largely under the influence of Western-trained Chinese.

Western education, science, literature, and thought appeared to dominate China, and Christianity continued to make inroads as Chiang Kai-shek himself became a Methodist. Chiang had converted to Methodism in 1927 in order to persuade Mrs. Charles Soong, matriarch of the formidable Soong family, to permit him to marry her beautiful third daughter, Mei-ling. Mrs. Soong, whose oldest daughter Ching-ling was the widow of Sun Yat-sen and whose Harvard-educated son T.V. was a prominent financier-politician, had been reluctant to approve Mei-ling's marriage to the famous general, not only because he had fathered two sons by a peasant woman and kept many concubines, but also because she regarded him as a heathen. When Chiang agreed to dismiss the concubines and embrace Christianity, marriage to Mei-ling, a politically ambitious graduate of Wellesley College, became possible. The influence of this marriage on Chiang has been aptly summarized by his biographer, Robert Payne (Chiang Kai-shek, p. 137):

He who had always been obstinate became more obstinate; and his intolerance fed on the more intolerant chapters of the Bible. The daily readings under the tutelage of his wife and Christian missionaries had the effect of confirming his belief in his mission, and it seems never to have occurred to him that he was removing himself further and further from an understanding of the real forces that moved the Chinese people. He was to enter the most fateful years of his career armed with a Bible and with a wife who had spent the greater part of her life in America and within the foreign concession in Shanghai.

Strong Western influence, combined with ineffective organization, virtually guaranteed the superficiality of this new phase of the Chinese revolution. Republican reformers were often more familiar with Western conditions than they were with those in their own countryside. They were an urban elite that concentrated on transforming the cities, where Western models had at least some relevance. Having decided to forgo social revolution and mobilization of the peasantry, the new national government allocated too few of its scarce resources to implementing programs for raising agricultural productivity and overcoming rural illiteracy. Moreover, even in the mod-

238. Roofs in Canton (Kwangchow).

ern sector, the effort to carry out political tutelage by gradually putting proclaimed Western democratic principles into practice left much to be desired. Instead of guiding the country toward constitutional self-government, Chiang Kai-shek, who had skillfully maneuvered himself into command of the KMT and the government as well as the army, moved steadily in the direction of establishing a dictatorship that refused to tolerate the growth of genuinely autonomous legal institutions and safeguards of individual liberty similar to those of advanced Western countries.

As an authoritative history puts it: "Despite the end of the monarchy two decades earlier, Chinese politics still required a single power-holder at the top to give final answers, which neither a presidium nor a balance of constitutional powers could supply" (John K. Fairbank, Edwin O. Reischauer, Albert M. Craig, East Asia: Tradition and Transformation, p. 788). Within the areas controlled by his regime, Chiang's power was limited not by the restraints of constitutionalism but by the need to balance his personal bureaucratic machine in the army, party, and government against regional or rival groups.

Because of the unceasing military challenges of the Communists, the Japanese, and the warlords, the influence of the military over the Nanking government became increasingly pronounced, and military expenditures, unchecked by civilian authority, did much to undermine official budgetary reforms. After the fall of Manchuria in 1931, the need to court allies for China's defense against Japan gradually blunted the Nationalists' determination to put an end to the "unequal treaty" privileges still enjoyed by Britain, France, and the United States, for this would have reduced the stake of those powers in the continuing existence of the Republic.

If progress toward reunification and modernization of the country proved to be modest during the decade of the Nanking government, it proved to be impossible after Japan's massive attack on China in 1937. Survival became the overriding concern of the Nationalist government, which was forced to move its capital to Chungking, far up the Yangtze River in the southwestern province of Szechwan, as Japanese forces occupied the vital coastal areas. Wartime pressures increased the regime's conservatism and its militaristic character, runaway inflation decimated the civil service and nourished corruption, and increasing political controls over the universities and suppression of dissent further diminished the intellectuals' support of the KMT. Although Japan's invasion and the Nationalists' retreat to the hinterland gave the regime an opportunity to mobilize the peasantry under the patriotic banner of national resistance, the government concentrated instead on a modest amount of conventional military warfare.

It was the Chinese Communist Party which took full advantage of wartime conditions. In the areas it governed it organized the peasants in the name of resistance to Japan and thereby won their allegiance. In 1937 the Communists and Nationalists had agreed to suspend their civil war in favor of a "united front" against Japan under Chiang Kai-shek; but the veneer of their cooperation soon wore thin, the Nationalists intensified their blockade of the Communists' mountain stronghold in Yenan, and each side sought to emerge from the war in a stronger position for the ultimate contest for power. While waging guerrilla warfare against the Japanese, the Communists expanded their many rural base areas to such an extent that by 1945 they could claim that they governed more than 90 million people.

After the end of World War II, in an attempt to stave off renewal of the Nationalist-Communist civil war, both the United States and the Soviet Union sought to persuade the rivals to agree on a coalition government. These efforts proved unsuccessful. Although the Nationalists had been weakened politically and economically by the anti-Japanese struggle, their possession of vast quantities of American weapons and much larger armies made them confident of their ability to dispose of the Communists by military means. Yet, plagued by poor leadership, inflation, corruption, and jealousies, and lacking an ideology that could revitalize a weary and demoralized people, the Nationalists proved surprisingly vulnerable to the guerrilla warfare strategy that the Communists had perfected against the Japanese. Mao Tse-tung, whose genius lay in perceiving the revolutionary potential of China's million villages and in adapting Marxist-Leninist theory and practice to rural Chinese conditions, mobilized the countryside to surround the cities, gradually forcing them to surrender by cutting off their communications, and thereby acquiring more and more men and equipment for the final decisive battles. By October 1, 1949, the Communists controlled enough of the nation to justify their proclamation of the People's Republic of China, and not long afterward Chiang Kai-shek and a portion of his army, government, and followers fled from the mainland to their present island refuge in Taiwan.

By the end of the Ch'ing dynasty in 1912, a limited number of Western-style structures had been built on Chinese soil. The Summer Palace, Yüan Ming Yüan, remained in ruins, but there were scores of Baroque villas with arcaded verandas and Neoclassical porticoes (plates 239, 240), designed by foreigners in "treaty ports" such as Canton. This architecture is called "colonial-style" because it was the mode generally used abroad by European nations that acquired colonies or spheres of influence from the seventeenth into the nineteenth century. There were also the railroad stations built in the International Railway Style of the late nineteenth and early twentieth centuries—a kind of Victorian stone-and-iron creation. As the foreign powers enlarged their interests in China during the Republican period, more Western-style buildings were erected (plate 236), and high-rise hotels arose along the waterfronts of Canton and Shanghai and near the Forbidden City in Peking. Administrative structures in the foreign-concession areas of the treaty ports, as well as a few Chinese official buildings, reflected the imported architectural vogue with little attempt to adapt Western styles to Chinese form or spirit.

- 239. Mansion on Sha-mien Island, Canton (Kwangchow). Nineteenth century. In 1861 the Chinese were forced to grant Sha-mien Island to Britain and France as concession areas. Both countries built administrative buildings, houses, churches, and clubs on the island, which is separated from the city by a canal and accessible by only two bridges. Handsome colonialstyle villas line the stately main street, a wide avenue laid out like a formal European parkway, and huge shade trees make the river front cool and appealing in the hottest weather. Although it has been many years since European imperialists have inhabited Sha-mien, their former presence lingers on through the architecture and city plan.
- 240. Mansion on Sha-mien Island,
 Canton (Kwangchow).
 Nineteenth century. The facade
 combines Baroque stone
 rustication on the ground floor
 with Neoclassical columns,
 pediments, garlands, and
 wreaths above. The Baroque
 base and protruding balconies
 are characteristic of colonial-style
 architecture.

Considering the influence of Oriental design in Europe from the seventeenth century on, the aggressively foreign character of Western-style buildings in China seems ironic. In the twentieth century there were some modest attempts to synthesize Western and Chinese styles, and it is interesting that the two examples shown here were built by missionaries and philanthropists with a commitment to improve the lot of the Chinese. Their interest in accommodating to the Chinese spirit was far greater than that of foreign commercial firms. Like the Buddhist evangelists of an earlier era, who adapted their forms to make them more acceptable and understandable to the Chinese, some Western educators sought to give their buildings a Chinese identity. Designed by Western architects and combining Western and Chinese materials and techniques, the buildings of Peking University (formerly Yenching University; plates 234, 242, 243) and the Capital Hospital (formerly Peking Union Medical College; plates 244, 245) possess a new spirit.

The Peking University Library is a rectangular building with a tiled roof supported by columns, as in traditional Chinese architecture. However, the columns are set into plastered walls that enclose the interior space in the Western manner. Western windows are screened with Chinese grillwork; decorative bracketing is made as if it supported the Chinese curving roof, which has gable ends and a traditional parade of guardians. Although the plan and details reflect some continuity with traditional Chinese structures, the proportions and scale, as well as the plastered walls that divide interior space from exterior environment, make the building Western, rather than Chinese. In Chinese halls of similar plan, a continuous relationship is maintained between indoors and outdoors by means of screened window-walls. Moreover, the carved-woodand-glass walls of the Chinese hall appear light in comparison with the heaviness of solid plaster in the Western style. Even such an enormous hall as the Hall of the Preservation of Harmony, in the Imperial Palace, appears to be lighter than the smaller University Library. Another building at Peking University, the water-pumping facility, reveals no attempt to synthesize its elements. The mechanism is simply cloaked in a pagoda-like exterior—a charming masquerade.

In a relatively more successful commingling of Chinese and Western styles, the Peking Capital Hospital was built around a U-shaped courtyard. It has brick walls, sweeping green-tiled roofs with parading guardians, and a marble court with balus-

241. Church of England on Sha-mien Island, Canton (Kwangchow).

Nineteenth century. Drawing on an old Christian architectural tradition, this Victorian Gothic church was doubtless as reassuring to the foreigners who worshiped there as it must have been puzzling to the Chinese who saw it.

trades carved somewhat more simply than those of the imperial monuments. Perhaps this hospital complex comes off better than the Peking University Library because the court-yard size, the levels joined by stairs, the sweeping roof lines, and the three blocks of the buildings are related in a unified composition and scale. The plan is congenial to either a Chinese palace or a Western villa with wings.

In the West, each generation in recent centuries has had, to some degree, a romance with Oriental images and ideas. Following the chinoiserie wave of the seventeenth and eighteenth centuries, Chinese and Indian forms were among the elements that made nineteenth-century Victorian "weddingcake" architecture so picturesque. As the Impressionists and Postimpressionists of the last half of the nineteenth century were indebted to Japanese wood-block prints for new artistic resolutions of color, design, and perspective, so the creators of Art Nouveau, a few years later, were inspired by Oriental flower designs in their search for organic forms. In the twentieth century, some of the practitioners of the International Style of architecture employed Chinese and Japanese decorative arts to evoke an exotically elegant ambience. They borrowed such occasional elements from the East as the moon gates used in "1930s modern" and the sweeping roof lines of Frank Lloyd Wright's "Prairie houses" of the first decade of the twentieth century. In addition, modern architects became aware of the Oriental method of interpenetrating interior and exterior spaces. The glass curtain-walls of the modern house articulate this spatial concept. One can only mourn that the People's Republic of China has embraced the foreign formula of Socialist Realism instead of pursuing the spirit of Chinese architecture in the modern idiom.

The art of the Republican period reflects the eclectic search of Chinese intellectuals of the day, who sought the best ways to help China gain a respected place in the world community. During the last years of the nineteenth century and the first two decades of the twentieth, many Chinese went to Japan to learn a variety of disciplines from their progressive, rapidly modernizing neighbor. For Chinese art students, the Tokyo Fine Art School provided an opportunity to study Western painting, and some artists returned to China to teach and paint in the French Beaux-Arts style that they had learned in Japan. Most Chinese artists during this period, however, did not look to Western painting but continued in the tradition of their forebears with ink and paper, paraphrasing older paint-

242. Library, Peking University
(formerly Yenching
University). Republican
period (1912–1949). Designed
by Henry K. Murphy.

243. Reading room in the Library, Peking University. Portrait and "Thought" of Chairman Mao, People's Republic.

244. View across the courtyard, Capital Hospital (formerly Peking Union Medical College), Peking. Republican period (1912–1949).

ings or attempting to find new expressions in the old medium. Disaffection with Japan, culminating in the May 4th Movement of 1919, directed the student flow toward Europe. Would-be artists went to Paris, where they led bohemian lives in Montmartre and were caught up in the many currents of European art, and some of them re-created a bohemian environment when they returned to Shanghai. Imperial patronage was a thing of the past, and the returned artists were alienated from the new officialdom. A small group carried on an isolated pursuit of "art for art's sake," following European models, but this movement was an intellectual and spiritual escape that hardly left a mark on Chinese art.

While painters groped for new ways to express themselves, Chinese writers succeeded in effecting a literary revolution. Hu Shih, who had been a Chinese graduate student in America, spearheaded the cause. In an article published in 1917 in a Chinese literary magazine, he called for a direct vernacular style of writing to replace the highly illusionistic, arcane writ-

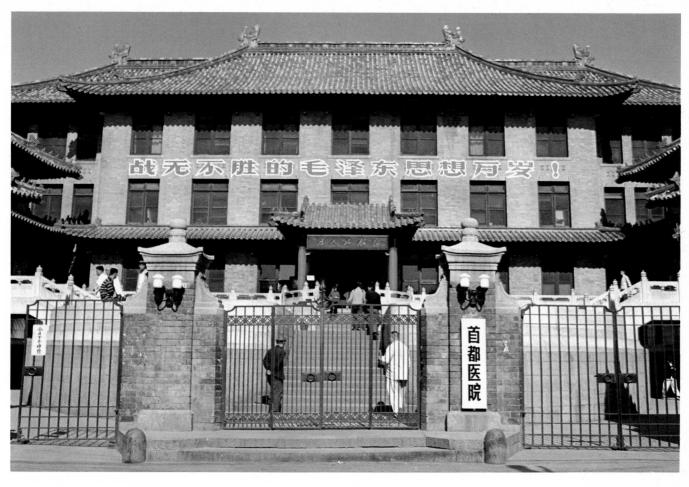

245. Capital Hospital, Peking.
Signs: top, "Long live the
unconquerable thought of Mao
Tse-tung"; over door, "Serve
the people"; gate, "Capital
Hospital."

ten language of the classically educated Confucian scholar. How could China modernize if even literate Chinese could not communicate in an understandable written language?

Lu Hsün (plate 246) was the literary giant of the 1920s. Writing in the new vernacular style, with sardonic wit and factual accuracy, he exposed the injustices of Chinese society and gave full expression to his disgust with the seemingly hopeless quagmire that the social system had become. He was celebrated by all literary and political reformers. However, by 1929, after Chiang Kai-shek's Nationalist Party had failed to end the oppression of the old society, Lu Hsün became confirmed in his Marxian beliefs. He had already created the short stories on which his fame rests. Thereafter, until his death in 1936, he wrote only Communist polemics and translations of Soviet literary theory. Following the Soviet example, he, like Mao Tse-tung, promoted the use of the arts as a political vehicle. He especially emphasized the political value of literature and of wood-block prints, both of which could be

246. Portrait of Lu Hsün, in the Socialist Realism style.
People's Republic. Oil on canvas. Shown at the Peking Art Exhibition Center in the People's Art Exhibition Commemorating the Thirtieth Anniversary of Chairman Mao's Yenan "Talks on Art and Literature," 1972.

cheaply produced for mass dissemination. However, even though the Communists made Lu Hsün a revolutionary hero, they specifically excluded his style as a model for revolutionary writing. There is no place in their mass-directed propaganda for subtle satire or sarcasm. Rather, they use large and positive imagery that lacks the gray shadings of life's irony. The Communist's stock-in-trade in art and literature is based on parables of oppression and class struggle that end with victory for the Communist cause. The legacy of Chinese art, ancient and modern, native and foreign, was to be molded into the image in which People's China wants to see herself.

CONTEMPORARY CHINA

PRECEDING PAGE:

- 247. Peking girl cools off with a popsicle. There are approximately as many children under ten in China as there are people in the Soviet Union. Chinese children are as attractive and charming as those of any country, yet China's burgeoning population—rapidly approaching a billion—is one of the factors in Soviet anxieties about a "Yellow Peril."
- 248. Peking boy. In youth lie the hopes of China's leaders—and their fears. Will young people become worthy revolutionary successors to Chairman Mao? Or will they become "revisionists" and succumb to what Maoists call the "sugar-coated bullets of the bourgeoisie"?

"We are a developing country." The visitor to China often hears these words. To the uninitiated, they may seem a boast, a simple assertion of China's continuing progress. Actually, however, they reflect traditional Chinese modesty, euphemistically expressing the poverty and backwardness that confront "People's China" even after twenty-five years of revolutionary rule. Rather than merely a slogan designed to identify China with the "Third World" countries of Asia, Africa, and Latin America instead of with the two "super powers" and the other industrialized nations, the statement represents a fact of Chinese life—perhaps the most important fact that anyone seeking to understand China should keep in mind.

Despite her ancient civilization, the China over which Mao Tse-tung and his followers seized power in 1949 shared most of the problems of the other underdeveloped countries of the world. Over 80 percent of the population was engaged in agriculture. Farming was undercapitalized, land ownership rather highly concentrated, and the bulk of the peasantry very poor. The industrial base was small; highways, railroads, and other means of communication were minimal; schools, sanitary facilities, and hospitals were limited. The government bureaucracy was swollen. Illiteracy was high, the people lacked a common spoken language, regional differences were marked, and national minorities had been imperfectly integrated into the dominant society. Although much the same could be said about many other countries, China, because of her population—the world's largest—and her vast land mass, suffered this syndrome of underdevelopment on an extraordinary scale. Moreover, nature has often been cruel to China. Floods, droughts, pests, and other disasters have regularly exacted their toll. In addition, by 1949 man-made calamities had left the country in unusually bad straits. Decades of civil war and foreign invasion had wrought unimaginable devastation and had been followed by astronomic inflation, widespread unemployment, disrupted trade, deterioration in

public works, and endemic corruption. Hunger, disease, crime, prostitution, and opium had become the hallmarks of a largely demoralized population.

Even though the Chinese people had lived together in the same territory for thousands of years and shared a common culture, written language, and political tradition, many observers wondered whether any government could reunify the country, transform it into a modern nation, and make China a strong and respected member of the international community. This is the task that the Chinese Communist regime set for itself. Its ideology, organization, strategy, and tactics have all been designed to meet this challenge.

Looking at the busy yet seemingly relaxed people in both city and countryside, the visitor to China in recent years has found it difficult to escape a static view of Chinese society. Can these be the same people who witnessed the process of replacing the Kuomintang-landlord-bourgeois elite and semi-Confucian value system with a Communist Party, government, and ideology? Do they remember the Party-led mass movements of the early 1950s against counterrevolutionaries, landlords, bureaucrats, businessmen, and intellectuals? What had they thought of "Socialist transformation" of industry, commerce, and agriculture in the mid-1950s? How had they fared in the nationwide mobilization of manpower that was the Great Leap Forward and in the economic depression that followed? What role had they played in the turmoil of the Great Proletarian Cultural Revolution? It is even more difficult to keep in mind that the people one sees and meets continue to be engaged in the dynamic revolutionary process that began to gather momentum at the end of the nineteenth century and moved into high gear with the establishment of the People's Republic in 1949.

Economic Reconstruction and Political Consolidation (1949-52)

The events of the past twenty-five years in China must seem bewildering to many Chinese as well as to the "China-watcher." Viewed from the present, they can be said to have occurred in roughly five stages. The period 1949–52 was a time of economic reconstruction and consolidation of political control. The Party, which had previously ruled widely dispersed, largely rural "liberated areas," had to make the transition to governing the entire nation, including the complex, sophisticated urban centers. A new state apparatus was created to carry out the Party's bidding, along with a network of nongovernmental local groups and mass organizations designed to enable the central Party and government authorities in Peking to extend their rule down to each household and individual. Disloyal and corrupt officials were weeded out, and large numbers of new young cadres were selected, indoctrinated, and trained for the many technical tasks required by government. Inflation was curbed, political enemies were suppressed, and land was taken away from the landlords and rich peasants and distributed to the poorer peasants. The economic and educational systems and the media were reorganized under Party domination.

In theory, the new government was a coalition in which the Communists cooperated with a group of "minor democratic parties," whose liberal leaders were given prominent posts. This was in line with the "united front" strategy that the Party had been practicing since 1936 in its efforts to enlist the broadest possible support—in the short run against Japan and in the long run against the Kuomintang. In accordance with this strategy, in 1940 Mao Tse-tung had enunciated his call for a "new democracy" that would eliminate the most glaring inequities of Chinese society and create a strong reformist coalition, while postponing the eventual socialization of agriculture, industry, and commerce, which was central to the Communist program but frightening to many non-Communists whose support the Party required. In mid-1949, on the eve of attaining nationwide power, Mao superimposed upon the "new democracy" the theory of a "people's democratic dictatorship," pledged to permit democracy for "the people" defined as all those who supported the Communist-led government—but to root out the reactionaries who opposed it. The implications of this theory gradually became clear after a relatively tranquil first year, in which the People's Republic was genuinely welcomed by most liberal intellectuals and even some progressive businessmen, as well as by other patriotic groups who had become alienated from Chiang Kai-shek and were eager to see a strong, united China emerge from decades of chaos and humiliation.

From 1950 to 1952, as the land reform was carried out in newly liberated areas and as the Party proceeded relentlessly to crush all sources of political opposition and to rid society of criminal elements which plagued public order, the new democracy gave way to class struggle. Amid the increasing tension generated by the Korean conflict, wave after wave of government-inspired mass movements—such as the "three anti" move-

ment instigated to eradicate official corruption, waste, and bureaucratism, and the "five anti" movement aimed against bribery, tax evasion, fraud, theft of state economic secrets, and theft of other state property—struck against China's old elite in every walk of life. Public "struggle meetings" and "mass trials" were convened by ad hoc "people's tribunals" before hordes of onlookers, who were mobilized to "speak bitterness" against and condemn their former oppressors. These thinly veiled kangaroo courts dispensed their own form of justice under Party guidance. They sentenced hundreds of thousands of "class enemies" to death. Many more were sent to long terms of "reform through labor," and millions suffered lesser sanctions combined with the "thought reform" to which virtually the entire country was subjected. During this period the regular courts also played a role, although it was not until 1953 that they were sufficiently purged of holdovers from the Nationalist government to inspire Party confidence. In addition, military control commissions continued to function and to administer punishments in large areas of the country. In many kinds of cases the civilian police also had unfettered power to investigate, detain, prosecute, and convict, and it conducted large-scale roundups of thieves, gamblers, opium addicts, pimps, prostitutes, vagrants, and other dregs of the old society, subjecting them to "noncriminal" reform measures in the course of long confinement.

In short, the army, the police, and the regular and irregular courts implemented the directive of Chairman Mao to serve as instruments for oppressing the hostile classes and for inflicting "legalized" violence or lesser sanctions on all those who were deemed "reactionaries" or "bad elements." The justification for such harsh programs had been stated by Mao in his famous 1927 "Report of an Investigation into the Peasant Movement in Hunan":

Revolution is not the same as inviting people to dinner or writing an essay, or painting a picture, or doing fancy needlework; it cannot be anything so refined, so calm and gentle, or so mild, kind, courteous, restrained and magnanimous. A revolution is an uprising, an act of violence whereby one class overthrows another. To put it bluntly, it was necessary to bring about a brief reign of terror in every rural area; otherwise one could never suppress the activities of the counterrevolutionaries in the countryside or overthrow the authority of the gentry. To right a wrong it is necessary to exceed the proper limits, and the wrong cannot be righted without the

249, 250. Right: Boulevard in Sian. Only about 20 percent of China's population lives in urban areas. Below: Fields of wheat and vegetables against the background of a terraced hillside in western Honan province. There is an awesome quality about north China's seemingly endless plains.

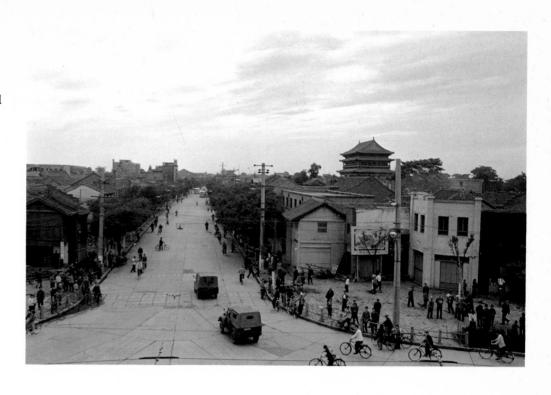

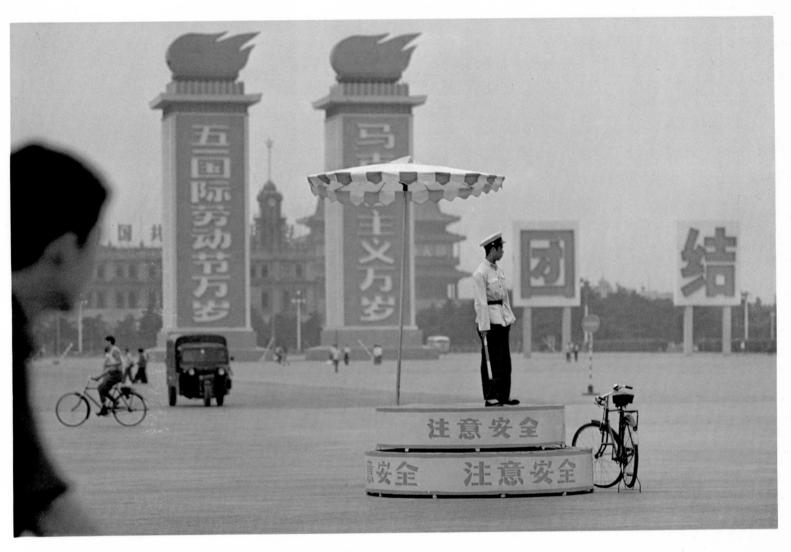

251, 252. Left: Old man resting in the shade of a gateway at the Temple of Heaven complex (T'ien T'an), Peking. Above: Traffic policeman in T'ien-an-men Square, Peking. This square is the political nerve center of the country, where the principal political demonstrations take place.

53-55. Far left: Young woman in the Canton (Kwangchow) Railway Station. The single braid, fashionable for Chinese girls before "Liberation," has been replaced by pigtails. Left: Two young visitors to Peking eve the camera with some suspicion while touring the Forbidden City. Today's revolutionary youth, schooled in the history of foreign exploitation of their motherland, are understandably cautious in their reactions to the increasing numbers of visitors from abroad. Below: Summer Palace visitors rest on a stone bench. This group displays the range of costumes to be seen in China

today.

proper limits being exceeded. (Selected Works of Mao Tse-tung, p. 27.)

Yet it would be inaccurate to depict these early years as a nightmare for the masses. For the bulk of the people "liberation," as the advent of the new regime was called, did live up to its name. For tens of millions of peasant families, land reform meant not only freedom from economic exploitation by the landlord-gentry class but also freedom from the political, social, and psychological domination of that class.

Some inkling of the process by which the landless and landpoor stood up against their oppressors can be garnered from the following account, by the chairman of a village peasants' association, of the last in a series of "struggle meetings" conducted against the village's richest landlord:

When the final struggle began, Ching-ho was faced not only with those hundred accusations but with many many more. Old women who had never spoken in public before stood up to accuse him. Even Li Mao's wife—a woman so pitiable she hardly dared look anyone in the face—shook her fist before his nose and cried out, "Once I went to glean wheat on your land. But you cursed me and drove me away. Why did you curse and beat me? And why did you seize the wheat I had gleaned?" Altogether over 180 opinions were raised. Ching-ho had no answer to any of them. He stood there with his head bowed. We asked him whether the accusations were false or true. He said they were all true. When the committee of our Association met to figure up what he owed, it came to 400 bags of milled grain, not coarse millet.

That evening all the people went to Ching-ho's courtyard to help take over his property. It was very cold that night, so we built bonfires and the flames shot up toward the stars. It was very beautiful. We went in to register his grain and altogether found but 200 bags of unmilled millet—only a quarter of what he owed us. Right then and there we decided to call another meeting. People all said he must have a lot of silver dollars—they thought of the wine plant, and the pigs he raised on the distillers' grains, and the North Temple Society and the Confucius Association.

We called him out of the house and asked him what he intended to do, since the grain was not nearly enough. He said, "I have land and house."

"But all this is not enough," shouted the people. So then

we began to beat him. Finally he said, "I have 40 silver dollars under the k'ang." We went in and dug it up. The money stirred up everyone. We beat him again. He told us where to find another hundred after that. But no one believed that this was the end of his hoard. We beat him again and several militiamen began to heat an iron bar in one of the fires. Then Ching-ho admitted that he had hid 110 silver dollars in militiaman Man-hsi's uncle's home. . . .

Altogether we got \$500 from Ching-ho that night. By that time the sun was already rising in the eastern sky. We were all tired and hungry, especially the militiamen who had called the people to the meeting, kept guard on Ching-ho's house, and taken an active part in beating Ching-ho and digging for the money. So we decided to eat all the things that Ching-ho had prepared to pass the New Year—a whole crock of dumplings stuffed with pork and peppers and other delicacies. He even had shrimp.

All said, "In the past we never lived through a happy New Year because he always asked for his rent and interest then and cleaned our houses bare. This time we'll eat what we like," and everyone ate his fill and didn't even notice the cold. (William Hinton, Fanshen, pp. 137–38.)

Peasants, workers, officials, educators, and others also began to enjoy more economic security than they had previously known. The Marriage Law of 1950, which provided for the equality of the sexes to an even greater degree than did the progressive Nationalist Family Law, was put into effect in a way that the Nationalist law had never been, as the Party sought to free women who felt victimized by the traditional arranged marriages and to prevent such marriages in the future. Although efforts to implement the law's divorce provisions in the early years produced a considerable amount of social upheaval and many murders and suicides, they did much to liberate women from male domination. The new regime also freed young people from the constraints of the Confucian deference to age and offered even to teenagers of proper ideological persuasion unusual opportunities for upward mobility and service to the country. The common people also benefited from the restoration of domestic order, from greater honesty and efficiency in government, and from broader access to education and health care for themselves and their children. The regime's vigorous moves to control and gradually take over Western trading and industrial interests were highly popular, although an intensely nationalistic people could not have been

happy about certain economic concessions that the Soviet Union exacted in return for its "fraternal" assistance.

The Transition to Socialism (1953-57) By the end of 1952, economic reconstruction and political consolidation had been achieved, and, with the aid of Soviet experts, equipment, and loans, China's new leaders were ready to launch their First Five-Year Plan (1953–57). It was designed along lines previously followed by the USSR and emphasized the growth of heavy industry, calling for an ordered and planned society in which economic development would take place within the context of a "Socialist transformation" that would transfer ownership of the means of production from private to public hands.

Specifically, agriculture was to be collectivized. In addition to satisfying ideological preferences and strengthening political control over the peasants, collectivization was supposed to increase total agricultural output by a more efficient use of land, labor, draft animals, and irrigation facilities. It was also desired to prevent rural surpluses from being consumed in the countryside and would place them under the control of Party cadres, who were to turn them into forced savings at the disposition of the state. This would enable the regime to obtain the capital necessary for the desired development of heavy industry and to feed the burgeoning urban population. Collectivization would also ease the Party's immediate concern about the serious inequalities that continued to exist among the peasants, for, despite land reform, the poor peasants and former landless laborers had been left with less land and capital and fewer farm tools and draft animals than the rich and middle peasants, who tended to have the additional advantages of greater literacy and management experience. The Party also hoped that in the long run the success of collectivization, together with other aspects of socialism, would provide individual peasants with greater work incentives than a system of private landowning could offer.

Collectivization was to be carried out gradually, in order to avoid the painful and disruptive consequences of Stalin's excesses in expropriating land in the Soviet Union. The initial stage was marked by the formation of many "mutual-aid teams." Perhaps four to ten neighboring households, while retaining private ownership of all their assets, pooled their labor, draft animals, and equipment to work the land belonging to each. At first these teams operated temporarily, during the

busiest farming seasons, just as neighbors had often done in China before, but later they became permanent. Experiments with agricultural producers' cooperatives soon got under way. The "lower-level" or "semi-Socialist" version involved perhaps fifty families, who contributed their land as well as draft animals and tools in exchange for shares of stock in the cooperative, which generally reflected the amount of capital resources contributed. The return allocated to each household on the crops cooperatively raised was based on the amount of stock it owned as well as the labor its members had performed.

But by mid-1955 only half of China's more than 110 million peasant households had formed mutual-aid teams, and only a small percentage were in lower-level cooperatives. On July 31, 1955, Chairman Mao issued a call for a nationwide acceleration of the cooperativization movement that brought it to a sudden, frenzied climax. Within the next eighteen months, 88 percent of peasant households progressed to "higher-level" cooperatives that usually encompassed an entire village of perhaps 100 to 300 families, while almost all the remaining peasants entered lower-level cooperatives. This was a tremendous organizational achievement, and, given the nature of the higher-level cooperatives, it was extraordinary. The crucial difference between the lower and higher stages was that in the latter the peasants were compensated entirely on the basis of their labor. No longer did their income reflect their capital contribution to the cooperative. Although the cooperative generally purchased the peasants' draft animals and farm tools, albeit at prices often regarded as unsatisfactory by the former owners, it paid nothing at all for the land, which the peasants "voluntarily" contributed.

The extent to which peasants actually parted with their land voluntarily is, of course, open to serious question in a society where intense group pressures are backed by an efficient coercive apparatus. Few peasants could forget the violence and stigmatization that had been inflicted on landlords and some rich peasants and other opponents of Party policy during the land-reform campaign. Indeed, just prior to the "high tide of collectivization" in 1955, the Party launched a fierce campaign against "hidden counterrevolutionaries" in order to minimize opposition to Socialist transformation. Moreover, economic pressures manipulated by the state made it difficult for the more well-to-do peasants to continue to work their farms successfully outside the cooperatives, even if they could withstand the psychological and social pressures mobilized against them. The majority of peasants, especially the poorer

256, 257. Right: Agricultural display case with milk, eggs, and grains at the Shanghai Exhibition Hall. Below: A neighborhood grocery store in the basement of an apartment block in the East District of Peking.

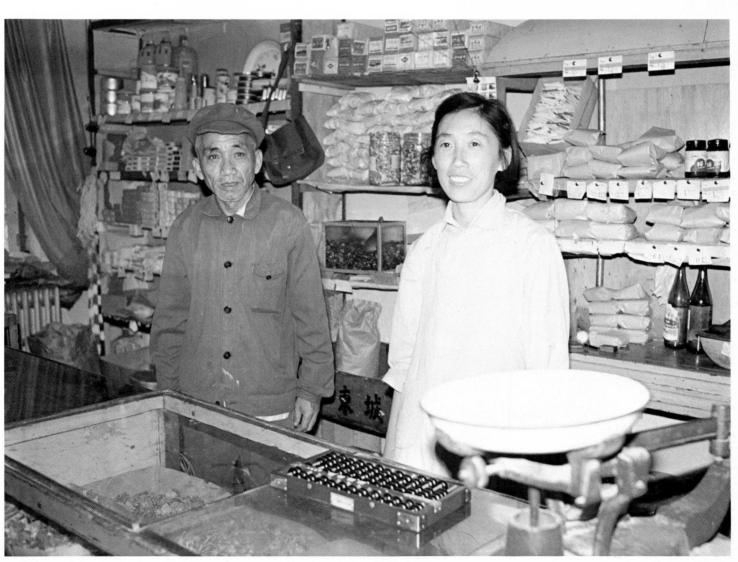

258, 259. Left: Peasant tending ducks at a commune the countryside outsi Shanghai. Right: An elderly shopper holdi a basket of yegetable in the People's Market, Peking.

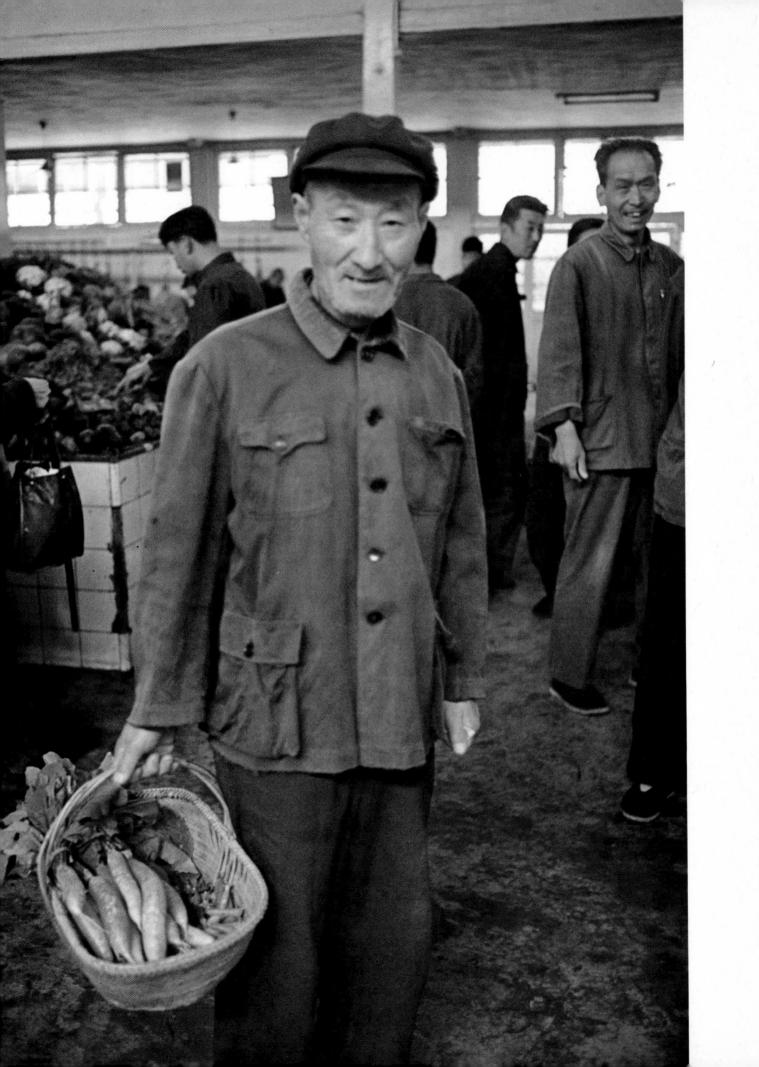

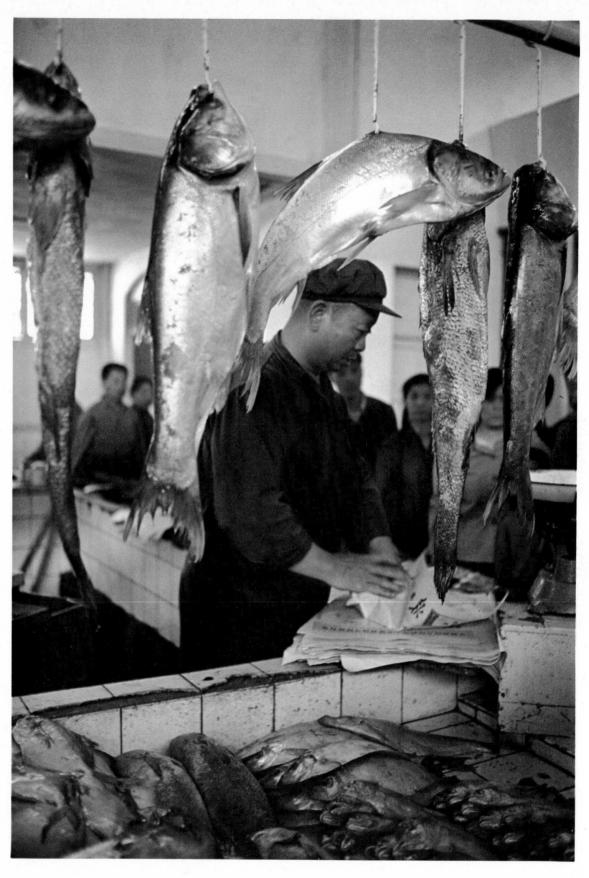

260. Fish counter in the People's Market, Peking. Fresh fish, poultry, and meat are sold at the appetizingly clean market.

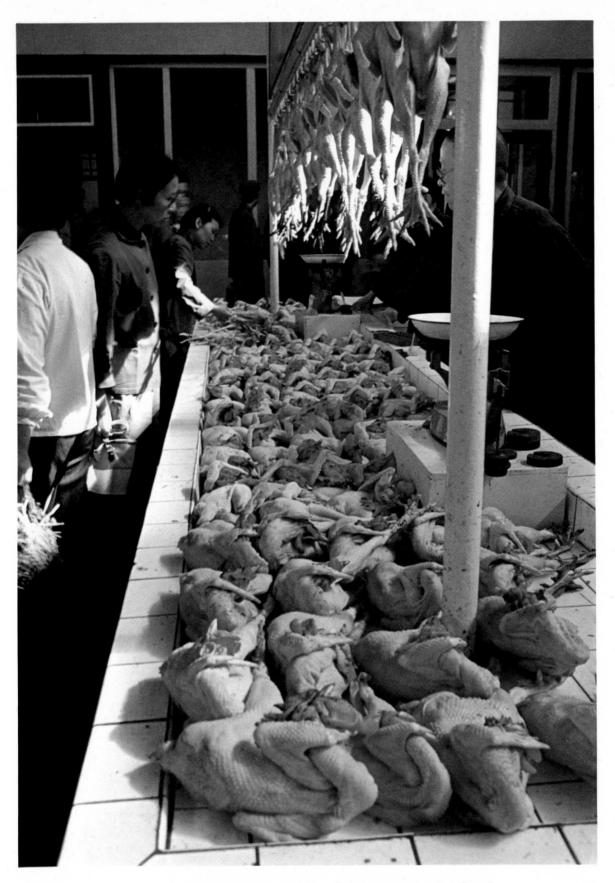

261. Chickens on sale at the People's Market, Peking. This large market is a favorite showplace for foreign visitors. Neighborhood markets are much smaller and are stocked with a more limited choice of foods.

ones who had more immediately to gain by joining the cooperatives, proved responsive to the Party's enormous effort through "persuasion-education" and patriotic appeals to make them take action that was promised to be in the immediate interest of the state and in their own future self-interest. In any event, once Chairman Mao issued the call for intensification of the cooperative movement, developments exceeded all expectations, and the collectivization of agriculture was achieved with far less violence and disruption than had accompanied it in the Soviet Union. The Chinese leaders' intimate familiarity with peasant conditions, their grass-roots Party organization, and their study of the Soviet experience paid rich dividends.

One Party cadre described the process of persuading the reluctant to join the cooperatives as follows:

In general, one can say that those whose land was not good were for the idea; and that those who had good land down in the valley and a lot of manpower were against it. My neighbour, Chao Teh-pa, for example, got up during the discussion and said: "I don't want to go up the hill and toil on the hill fields. I have good, fertile land down here in the valley, and this agricultural co-operative won't pay me. I can manage by myself." Well, we reckoned out properly how many days' work he would get in an agricultural cooperative and how much his fields in the valley gave him as it was. We proved to him that large-scale farming and joint effort was much more rational, and that, in actual fact, he would gain by joining the agricultural co-operative. "I'll hire people," he replied. We told him that would become rather difficult. There would be no day labourers or farmhands to be had, once we had formed our collective. They would prefer to work for themselves in an agricultural co-operative than for anyone farming on his own. In the end we proved to him that he would get much more corn and more cash for his work if he joined the agricultural co-operative.

"That isn't of any significance," he replied. "It may well be that I should earn more. But if I am to choose between earning more and having to climb up the hill and toil there, or earn less and only have to cultivate my own fields down in the valley, then I prefer to earn less and not have to clamber about up on the hill." After that, we had a serious talk with him. "You want to hire people to work for you. That's exploitation. Why do you want to become rich

on other people's work? Why should only you become rich? You are not going to get anyone to exploit. Choose how you want things to be. Do you want to be rich alone, or do you want us all to be well-off together? Do you want to be a decent person or not? Think about it." He thought about it and joined. (Jan Myrdal, Report from a Chinese Village, pp. 160–161.)

In the cities also the period of private ownership of the means of production promised by the "new democracy" proved to be short-lived. Socialist transformation of industry, commerce, banking, and even handicrafts was basically achieved by the end of 1956. Virtually all enterprises of any significance became publicly owned. By value of output the state became sole owner of roughly two-thirds of China's industry, and most of the rest, except for 2 percent owned by cooperatives, was converted to joint state-private ownership. A joint state-private company, despite its title, was tantamount to a wholly state-owned enterprise except for the fact that the state committed itself to pay the former owners a fixed amount of interest, usually 5 percent for a certain number of years, on the value of the capital and inventory of the enterprise as assessed at the time of takeover.

As in the case of agriculture, although public ownership of industry and commerce had been gradually expanding, Socialist transformation of these aspects of the economy did not move into full swing until Chairman Mao personally called for a radical acceleration, this time on October 29, 1955. Again, a process that had originally been scheduled for completion over a period of years was concluded in a matter of months. The Party was actually more successful in mobilizing businessmen to surrender their property to the public domain than it had been with the wealthier peasants. The Party's willingness to pay was a relatively minor reason for this success. Businessmen were aware that their property was unlikely to be appraised at its true value and that the fixed interest would provide them with only partial compensation. They also knew that they would be under political pressure not to accept the interest payments or not to spend most of the interest received, and that, in any event, there would be little they could buy with the money.

As in the countryside, before the sudden final drive for Socialist transformation in the cities there was a long period of intensive ideological preparation, in which businessmen attended lectures and participated in small "study" groups that

explained the desirability of Socialization and committed them to the cause. The state also used to good advantage its power to manipulate sources of supply, prices, taxes, employees, and other factors, leaving businessmen in no doubt about the harassment and anxiety they would suffer if they sought to continue private operation. Moreover, the regime had made clear that it would want the continuing services of able and loyal former capitalists in the complex task of running the economy, so that those who were cooperative could contemplate some responsible and remunerative role for themselves in the future. Finally, the Party warned that businessmen who proved uncooperative would be dealt with according to law. In these circumstances one can understand why, after the Party announced that transformation could be achieved virtually overnight, thousands of "patriotic capitalists" hastened to petition the state for the privilege of converting their companies to joint state-private enterprises. Private enterprise was eliminated in the urban sector, except for a few handicraft workers and some small family stores, street stalls, and peddlers.

The transition to Socialism was marked by structural changes not only in the economy but also in government. The new emphasis on planning and the Soviet model for industrialization was thought to require a reorganization that would create greater centralized control, predictability, regularization, and legitimacy for the regime. The year 1953-54 witnessed Soviet-style elections of local People's Congresses; they in turn elected higher-level congresses, which endorsed a single slate of Party nominees as delegates to a National People's Congress (NPC). The NPC then adopted a Constitution to replace the Common Program that had been a temporary charter of government. Under this Constitution, the NPC was to be the supreme organ of state power. In addition to its legislative and other decision-making powers, it was to choose the Chairman of the People's Republic and the heads of the Supreme People's Court and the Supreme People's Procuracy, and, upon the Chairman's recommendation, the Premier of the State Council. But, because it was composed of well over a thousand delegates and was scheduled to meet only in infrequent and brief sessions, it was obviously not expected to exercise effective power, and its Standing Committee was empowered to wield considerable authority. The principal executive body of government, however, was to be the State Council, composed of the Premier, Vice-Premiers, and heads of ministries, commissions, and specialized agencies that presided over the economy, national defense, and other spheres. Above the State Council and under the direct control of the Chairman of the Republic were two policy-planning organs: the Supreme State Conference, composed of the Chairman and Vice-Chairman of the Republic, the Premier, the Chairman of the NPC's Standing Committee and other principal officials, and the National Defense Council, composed of the country's major military leaders. Apart from outlining the functions and powers of the principal national and local institutions of government, the Constitution, which bore the marks of strong Soviet influence, also guaranteed freedom of speech, assembly, and religion, and other freedoms from arbitrary government action.

Of course, this centralized governmental structure was dominated by the Communist Party, whose top leadership also occupied the highest posts of government and was thus able to operate the levers of power as well as set the guiding policies. Responding to pressures for reorganization and regularization that were felt during this period, the Party itself enacted a new Party Constitution at the Eighth Party Congress in 1956.

Having decided to follow the Soviet political and economic model, China's leaders also decided to develop a Soviet-style legal system. The 1954 Constitution was accompanied by a series of laws that established a framework for the orderly administration of justice. With the aid of Soviet experts, criminal and civil codes were drafted; a few Chinese textbooks and law journals were published; law schools were revamped to train judges, prosecutors, and "people's lawyers" in the principles of "Socialist legality"; collectives of lawyers began to function; and, although individual judges were to serve at the pleasure of the legislative or executive agencies, in theory the courts were to be independent in administering justice. Experiments were conducted with public trials, defense counsel, and other protections of personal liberty, to the bewilderment of many Chinese Communist officials unaccustomed to legal formalities.

The campaign against "hidden counterrevolutionaries" and the pressures of Socialist transformation almost swamped the budding legal system in 1955, but shortly after Khrushchev initiated de-Stalinization in early 1956, an emphasis on legality reappeared in China as part of a general relaxation and readjustment designed to win back the support of officials, intellectuals, businessmen, and others who had been alienated by the drastic upheavals. To be sure, the Party continued

to control the courts and to impose sanctions on certain antisocial elements through agencies other than the courts. But professional legal considerations began to influence judicial decision making, and the Party resorted to "non-courts" less frequently and less arbitrarily than in the past. In the spring of 1957 it appeared that China would continue to develop her legal system in a direction similar to that being followed by the USSR, which had recently launched a series of law reforms to demonstrate both to its own people and to the world its stability and its respect for human rights.

The Party's popularity had been heavily eroded by the manner in which it had tried to modernize the country, and the moderate policies of 1956–57 reflected an attempt to reduce the disaffection. In the countryside the size of the private plots that cooperatives had set aside for individual peasant households to grow their own produce was increased, and rural markets were reopened so that peasants could add to their income by selling their vegetables, hogs, homemade handicrafts, and other spare-time products. In the factories, material incentives were increased to reward ambitious workers. The measures, it was hoped, would increase production. As part of the general relaxation, teachers, writers, technicians, and other intellectuals enjoyed somewhat greater freedom.

Party leaders believed that much of the discontent was traceable to the growing separation of administrative officials from the people they governed. Therefore the Party initiated a campaign to "rectify" the "working style" of the cadres, calling on intellectuals and businessmen to criticize official arrogance, bureaucratism, and "commandism." The purpose of this campaign to "let a hundred flowers bloom, let a hundred schools of thought contend," as it was called, was not only to reform the cadres but also to provide an outlet for the frustrations and resentments pent up within the most articulate segment of the elite of the old society, thereby reducing the risk that China might suffer a violent outburst similar to those that had occurred in Hungary and Poland in the wake of de-Stalinization.

Fearful of punishment if they genuinely criticized the cadres, for a long time intellectuals and businessmen resisted the appeals to "bloom and contend." But they finally became convinced of Party sincerity, and, for six weeks from the end of April to June 8, 1957, a torrent of criticism attacked not only the cadres but also the Party policies they administered.

One major theme centered upon claims that the Party had set itself up as a new exploiting class whose members lorded it over the rest of the people like "local emperors" and "plain-clothes police." At the same time, the Party was charged with committing frequent violations of "Socialist legality," and critics called for a commission to review the sanctions meted out against the innocent in past mass movements. They also asked why the much-mentioned but never-published proposal for a criminal code had not been enacted; as one comment put it, "one hears the sound of footsteps on the stairs without seeing anyone coming down." Another theme revealed the resentments that experts in many fields felt at having non-specialists from the Party dictate decisions on professional matters. "The Party committee controls everything, yet knows nothing" was a common complaint.

Journalists were bitter because newspapers could not act independently but were mere "gramophones" or "bulletin boards" for transmitting orders from upper to lower levels. Reporters bemoaned the fact that they were often regarded as spies and that their papers were dreary and dull. Teachers claimed that they were not trusted, that they were expected to attend so many political meetings that they could not do their work, and that they had to slavishly copy the Soviet Union. Professors said that the Party had adopted "Kuomintang methods of controlling intellectuals," that universities had become "beehives of doctrinairism," that "[t]he place is absolutely littered with feudal princes and stinking charlatans," and that "[w]hile we want to set up an institution of higher learning, they, on the other hand, want to run a department store."

Writers lamented the impossibility of being creative while churning out simplistic stereotypes for mass political appeal. Literary critics chafed under a mesh of rules and regulations. As one wrote:

One cannot be rude, one cannot ridicule, one cannot use smart phrases; one must pay attention to authorities, to the famous writers, the new forces, the leading personnel, the old gentlemen, unity. One must consider the editor's plans, the opinions circulating in current Soviet magazines, and your own retreat in the event of future policy changes. With that many "pay attentions" and "considerations" in one's head, one's personal intentions get smaller and smaller. (Roderick MacFarquhar, ed., *The Hundred Flowers*, p. 183.)

Artists whose work failed to win Party approval told how they had lost their jobs. Businessmen questioned the adequacy

262-65. Below: Cornfields against a rugged mountain background northwest of Peking on the road to the Great Wall. Every inch of arable land is cultivated in an effort that has made the country's burgeoning population self-sufficient in food despite recurring droughts and floods. Opposite page: China is only on the verge of mechanization.

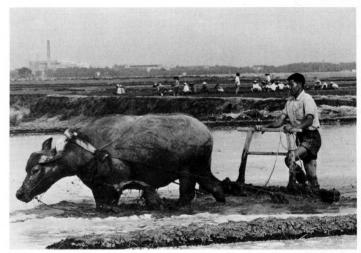

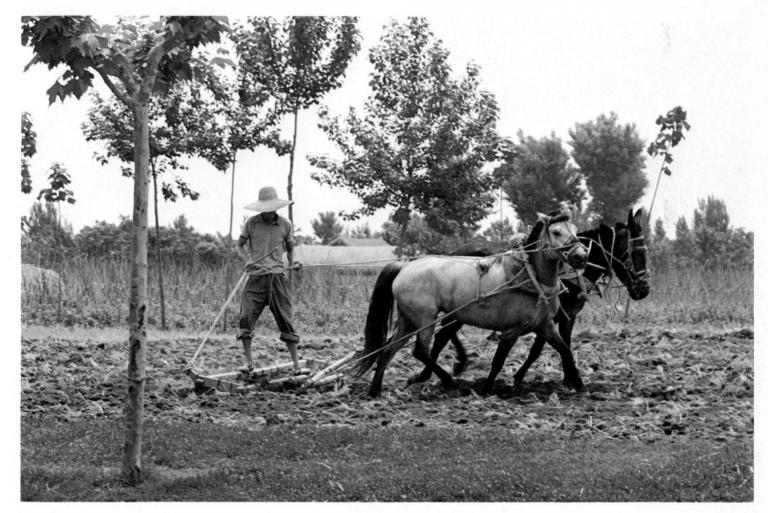

266-69. Left, above: Wheat fields against a background of terraced hillsides in western Honan province between Loyang and Sian; below: a peasant drags a cart loaded with straw at harvest time. Right and below: Sian hotel employees help with the harvest by drying wheat in the hotel parking lot.

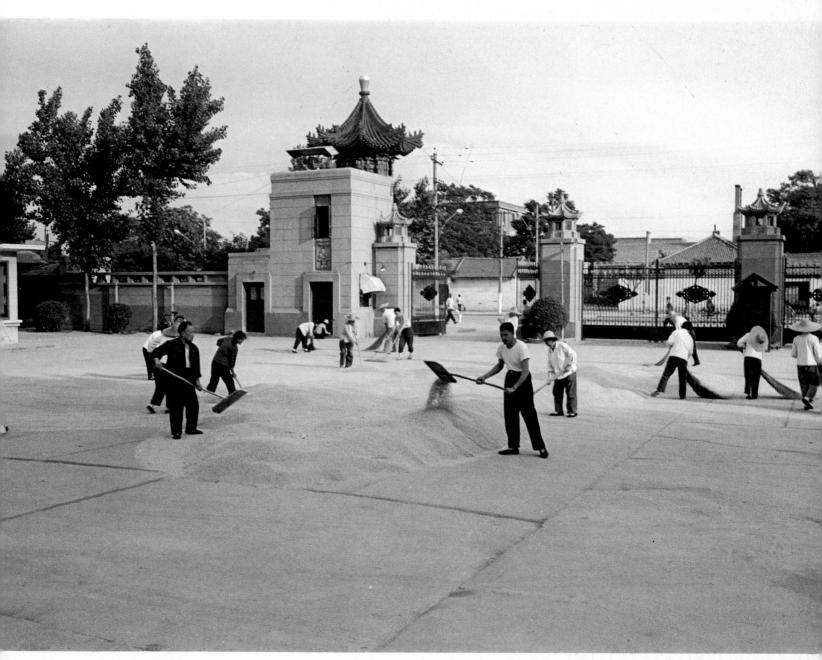

270-72. Left: An old woman, whose feet were bound in childhood, toddles down a street in Loyang with the wheat she has just gleaned. Right: A little boy sits in the straw munching on a sweet bun. Below: Traditional peasant house, hung with garlic, at a Shanghai commune.

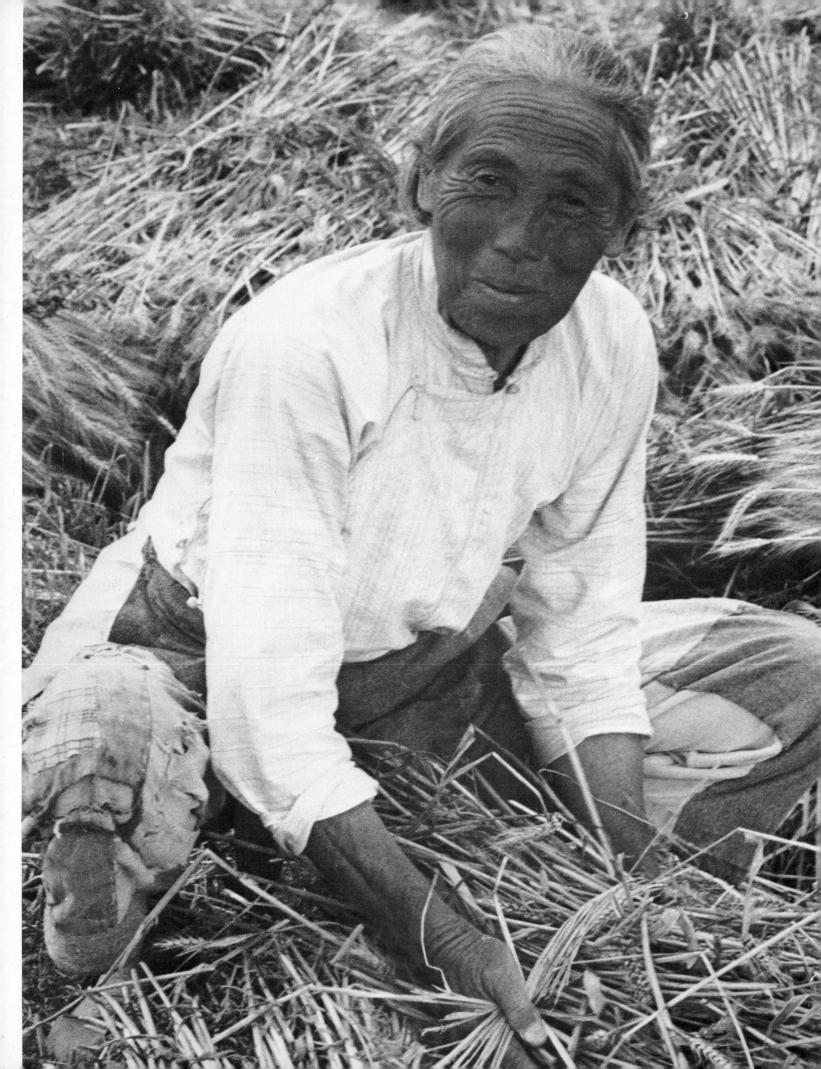

of the "fixed-interest" compensation paid for "Socialist transformation," the need to take orders from unskilled cadres, and the Party's lack of confidence in them. The nepotism of leading cadres was also frequently mentioned. One Shanghai industrialist stated:

There is a saying in the Shanghai China Shipbuilding Factory, "For every Lo-han [A Buddhist monk who has passed the stage of novice] there is a Kuan-yin" [Buddhist goddess of mercy], meaning that all the wives of the Party cadres in the factory have got jobs in the factory. (Roderick MacFarquhar, ed., *The Hundred Flowers*, p. 206.)

The scope of these attacks exceeded anything Party leaders had expected and made it clear that the old elite was not committed to the existing system but desired drastic democratic and organizational reforms that would end the Party's monopoly of power and fundamentally alter China's political and economic structure.

After a brief period of stunned inaction, the Party leaders responded with an "anti-rightist" movement that savagely struck back at their critics, including many inside the Party, and radically transformed China's political climate. The era of moderation was over, and once again discipline and mass mobilization became the order of the day.

The Attempted Transition to Communism and Its Aftermath (1957-62)

273. Woman harvesting wheat at a

Shanghai commune.

While the "anti-rightist" campaign got under way in the cities, the Party concentrated the main thrust of a somewhat milder "Socialist education" campaign in the countryside. This was designed to counteract the adverse effects of the period of leniency on cooperativization. Some peasant families had taken advantage of the relaxation to leave their cooperatives. Many more had spent too much time away from collective duties while farming their private plots or producing commodities for sale in the local markets. In the lexicon of the Party, the peasants were demonstrating their "spontaneous tendencies toward capitalism." The remedy, it was thought, lay in a strong dose of indoctrination regarding the necessity of Socialist transformation, combined with a renewal of pressures such as those created by restricting the size of the private plots and the peasants' access to rural markets and by reemphasizing punitive measures.

The Party's new hard line had profound implications for

the evolving system of administering justice along de-Stalinized Soviet lines. Many Party leaders had never felt comfortable about importing the formal Soviet judicial model, which to them was essentially a Western product. As a result of the "hundred flowers" debacle, they came to fear that implementation of this system would unduly limit the power of the Party and hamper "Socialist construction." Therefore, during 1957-58, while in the USSR de-Stalinization was culminating in a series of reforms that brought Soviet law closer to Western systems, in China principles of Western justice such as the independence of the judiciary from political domination and the right of the accused to a fair public trial were systematically denounced. In both theory and practice, the Party openly assumed control over individual court decisions as well as judicial policies. Moreover, the role of the courts was sharply reduced by a system of severe, police-imposed "administrative" sanctions that required no judicial approval. The most notorious of these was "rehabilitation through labor," which was used to resettle thousands of "rightists," "anti-Socialist reactionaries," and others in harsh labor camps. As Party authorities liked to put it, the reorganized coercive apparatus became "a single fist, attacking the enemy even more forcefully."

This renewed stress on indoctrination and discipline prepared the masses for another all-out effort to modernize the country, one that would challenge both nature and human nature. China's Second Five-Year Plan (1958–62), while continuing to emphasize heavy industry, called for increasing agricultural production. Party leaders had been disappointed in the economic progress of the rural sector following collectivization. The failure to generate larger agricultural surpluses was an important constraint on industrialization. Yet the leadership continued to be reluctant to allocate scarce state investment funds away from industry and into the rural sector, hoping that cooperatives would use their own funds to make improvements. Beyond that, its solution was to brighten agricultural prospects by applying massive amounts of labor in lieu of capital to the variety of tasks—such as irrigation, land reclamation, fertilizer collection, and tool manufacture that had to be accomplished to enhance production. Moreover, in order to overcome the inefficiencies of bureaucratic overcentralization and to provide added technically qualified leadership for the mobilization of labor in the countryside, the regime shifted economic decision-making authority to lower

levels and accelerated the "downward transfer" (hsia-hsiang) of administrative cadres to rural areas.

At the beginning of 1958 the measures taken to increase grain production appeared to be yielding results, and this encouraged Chairman Mao to believe that the time was ripe for a "Great Leap Forward" throughout the economy. Mao's optimism derived from the international as well as the domestic situation. In late 1957, after China's Soviet "big brother" successfully launched both an intercontinental ballistic missile and Sputnik, its first artificial satellite, Mao proclaimed, "The East Wind is prevailing over the West Wind." Not long afterward, the People's Republic sought to take advantage of the favorable climate to mobilize the nation for the "liberation" of Taiwan, the only significant territory controlled by the preceding government that Peking had failed to bring under its rule. The wartime atmosphere created by this campaign provided an ideal environment for enlisting the people in heroic efforts to increase production for the sake of national unification.

By the spring of 1958, however, repeated upward revisions by authorities in the capital had raised production goals beyond what was humanly possible. Cadres on the "production front" were well aware of the increasing unreality of these targets, but few dared speak out. Some Party leaders and local officials did seek to moderate Mao's utopian expectations, but their efforts were in vain.

In midsummer of 1958, as the Taiwan crisis approached its climax, the Party called for a nationwide campaign to build small-scale steel furnaces in every locality. This plan, together with the massive water-conservation projects already under way and other activities such as the construction of small factories and workshops in every township, required a vast mobilization of labor far beyond the capacities of individual cooperatives.

In early August Chairman Mao urged all of China to follow the example of Honan province by organizing "people's communes," which were formed by merging many agricultural cooperatives with the local government; the handicraft, supply-and-marketing, and credit cooperatives; and other local groups such as the Communist Youth League and the Women's Association. By the end of the year, over 99 percent of the peasants joined the communes, which the Party termed the best form for the transition to Communism. Amid intense excitement and ever-escalating production goals that made

those of the spring seem modest, the *People's Daily* announced that even octogenarians would live to see Communism.

The original commune was a large unit containing perhaps twenty-five to thirty thousand people, or even seventy thousand. Its subunits were the production brigades, often corresponding to the former higher-level producers' cooperatives, and, below them, the production teams, often corresponding to the lower-level cooperatives. An aggregation of this size under unified management facilitated the mobilization of labor forces required for water conservation, steel smelting, and other large-scale projects cleared by the Party. But so many other aspects of the commune soon proved unsuitable that the institution underwent successive and significant modifications during the next few years before attaining the form we know today.

The vision of the commune presented to the peasants offered what its proponents hoped would be sufficient incentives to sustain the enormous demands that were being made on them. Women, whose labor was needed on the farms to replace that of the men who were being assigned to construction projects, were released from many domestic chores by the institution of mess halls, where the entire family was to eat food prepared by full-time cooks, and nurseries, where younger children were to be left all day. "Happiness homes" were to care for aged members of the family. Moreover, the approach of Communism was to be heralded by the free, equal, and ample distribution of basic foods—this to soften the blow dealt peasants by the abolition of private plots. Tractors were to begin to replace physical labor. The gap between city and country people was to be narrowed by commune management of new small-scale industrial enterprises and by the introduction of technology in the countryside. People were to become both "red and expert," technically skilled as well as politically enlightened. Thus, it was thought, the communes would fulfill the Great Leap Forward slogan of "more, faster, better, and cheaper" and bring about the needed increase in agricultural production.

But Mao's hopes for the commune were as romantic as his hopes for the Great Leap generally. Although communization and the Leap were not designed to shatter the fabric of the Chinese family, as some foreign critics alleged, they made more severe inroads on peasant domestic life than any previous Communist innovations had done. Because production teams had to provide their commune with a quota of male labor to be assigned to construction projects that were often

carried out in distant places, family members were frequently separated for long periods. The local labor shortage created by the absence of these men increased the burdens of those left behind, especially as higher levels passed down increasingly unrealistic production targets. With virtually every waking hour devoted to work, there was no time for private life. The requirement that meals be taken in mess halls in the company of perhaps thirty to fifty other families was a further infringement on privacy and widely disliked.

If these changes had been accompanied by an improvement in the peasant's economic position, they might have been more acceptable. As it was, however, communization sharply worsened his economic situation at the same time that it infringed on his family life and made the most extreme work demands that the People's Republic had ever imposed. Peasants were pressed to donate "voluntarily" to the collective much of their remaining personal property. Farming tools and privately raised pigs and chickens had to be turned over to the team: and pots, pans, utensils, plates, tables, and chairs had to be given to the mess hall. Private plots also had to be surrendered, depriving peasants of the opportunity to eat or sell home-grown produce, and other profitable sideline occupations were prohibited to prevent the diversion of energies from the common interest. Furthermore, peasants had to strip their homes of all kinds of metal objects and contribute them to the scrap-metal drive that was to provide material for the new local steel smelters and other industrial enterprises. Even scarce cash savings were often collected in order to establish a fund for the purchase of tractors.

The new organization also virtually dismantled the individual work incentives that had been built into the cooperatives. When a commune absorbed a number of higher-level cooperatives, it tended to take their land, equipment, and animals and redistribute them throughout the commune, in effect confiscating some of the assets of the more prosperous cooperatives to the benefit of the poorer ones. Moreover, because the commune itself was made the accounting unit whose success or failure determined what segment of production would be allocated to peasant remuneration and other benefits, it became much more difficult for peasant families to see the relationship between their effort and their reward. Even if they and all their neighbors toiled heroically, their benefits would still depend on whether thousands of other families worked with equal vigor and skill. To make matters worse, the communes seemed to be deemphasizing the work-point system

by which, according to one formula or another, the cooperative had implemented the Socialist principle of "to each according to his work." To the extent that the compensation of commune members was not to vary significantly with the degree of their productivity but was to reflect the Communist principle of "to each according to his need," the hardworking and competent would receive no greater economic advantage than the lazy and inept.

Peasant dissatisfactions were also increased by the many mistakes in planning, coordination, and decision making that accompanied the Leap and communization. Hasty and illconsidered efforts to expand agricultural production often proved disastrous. Just as the Party challenged human nature by mobilizing people to work beyond the limits of endurance and without material incentives, so too did it challenge nature by attempting to grow crops with seeds suited to another climate and by resorting to planting techniques that the soil could not sustain. And cadres, caught between unrealistic goals set by higher authorities on the one hand and diminishing peasant productivity and morale on the other, submitted false reports of overfulfilled quotas to their superiors, thereby reinforcing the unreality and stimulating further mismanagement. Urban areas also suffered from tremendous waste and dislocation as a result of the faulty planning, excessive decentralization, poor record keeping, absurd targets, false reporting by cadres, and squandering of energies that marked the frenzy of the Leap. The "backyard furnaces" that absorbed vast quantities of manpower and raw material but produced unusable steel came to symbolize this era.

By late 1958 the evidence of chaos throughout the nation was so great that leaders such as Liu Shao-ch'i, who had been unable to curb Mao's plans in the spring of the year, were finally able to moderate them and put him on the defensive. It is probably more than coincidental that Mao at that point decided to turn over his responsibilities as head of state to Liu and concentrate on providing policy guidance as Chairman of the Party. In any event, the Party began to address itself to the worst excesses of the commune and the Leap. Peasants were assured, for example, that they would receive adequate time for sleeping and eating, that their houses, clothes, furniture, and savings would not be taken away, that the quality of the mess halls would improve, and that their labor would continue to be compensated on the basis of Socialist rather than Communist principles. As 1959 unfolded, the Party also initiated the process of transferring responsibility for activities

and financial accounting from the commune to the brigades and the teams, it again allowed peasants to grow subsidiary crops and sell them in rural markets, and it put an end to the small-scale furnaces.

The situation was destined to get much worse, however. Unusually bad weather in 1959 exacerbated China's manmade difficulties and contributed to a poor harvest. Rations fell as sharply as grain production. An attempt was made to revive the Great Leap Forward in a more moderate way, but it failed to stem what was rapidly becoming a major economic depression. The years 1959-61 proved to be extremely difficult for China. Food shortages, malnutrition, and disease were widespread. Public morale dropped disastrously. Not only did peasant enthusiasm for collective labor fall off sharply, but also many peasants and rural cadres succumbed to petty corruption. They helped themselves to harvested produce and collective funds and violated public order in other ways that included development of a flourishing black market and illegal entry into the cities. The impressive progress that new China had made during its first decade in inculcating respect for the public interest in a notoriously privately oriented people was seriously threatened.

Although the Party tried to put the best possible face on it, by 1960 the Great Leap Forward was plainly a failure, at least in terms of its immediate consequences. Even the greatest mobilization of human energy in history could not overcome the intractable facts of life. Modernization could not be attained overnight, nor could human nature be ignored, even after a decade of thought reform. The long-run consequences of the Leap, of course, may be quite beneficial to China's modernization, for it did much to shake the hold of tradition by introducing a still rural, economically backward people to technology, stirring their capacity for innovation and raising their expectations. Yet this must have been small consolation for the Party leaders, and particularly Mao, who were faced with their gravest challenge since the early days of the Party's nationwide rule. In 1949 both the cadres and the masses had been energetic and hopeful. By contrast, they were now tired and jaded. Moreover, in 1949 the People's Republic had enjoyed the support of the Soviet Union; now Sino-Soviet tensions were severe. Finally, the Chinese leadership itself, which had long been regarded as extraordinarily cohesive, was torn with dissension.

The most urgent need was to feed the people and restore production. This the Party undertook to do by going far to meet the demands of the peasants and workers and to adapt the commune to the existing situation. A new program emerged, according to which the Party at long last gave agriculture its due by allocating state investment funds to it. Most communes were reduced in size, and the Party gradually completed decentralization within the communes, transferring many operating powers to the teams and making them not only planning units but also accounting units for purposes of calculating and distributing peasant earnings.

The Party also made other concessions to the "petty capitalistic" instincts of the peasants. It fully revived what came to be known as the "three freedoms"—to farm private plots, to engage in private sideline production, and to sell the fruits of this noncollective labor in rural markets. It also ordered that the peasants be compensated for the metal items they had been forced to contribute for scrap metal. Pots, pans, chairs, small farm implements, and other private property they had surrendered to the commune at the height of the Leap were to be returned or, if that was not possible, to be paid for. Although the compensation was seldom regarded as adequate, this recognition of "bourgeois legal rights" illustrates how anxious the Communist regime was to assuage the peasants' sense of injustice.

Also, as so often happens in China after extreme Party policies have proved unpopular, the Party sought to deflect the resentment of the masses by blaming the extremism on the basic-level cadres rather than on the policies they carried out. The peasants' severe criticism of the "commandism" of these hapless scapegoats provided a convenient safety valve for social grievances, and 1961–62, like 1956–57, became a period of general political and economic relaxation following a period of mass mobilization and tension.

In the industrial sector, also, the Party restored material incentives for individual effort, while reintroducing planning, regular production modes, and reliable supply systems. By 1962 all these organizational changes and concessions to individualism began to bring about an increase in production.

The Background of the Cultural Revolution (1962-65)

Now the Party was faced with deciding how far it could safely go in making concessions to individualism and how long these concessions could last without undermining the Socialist foundations of the state and the march toward Communism. Within the Central Committee of the Party there were sharp divisions of opinion. Occasionally criticism of Mao's utopian mobilizational strategy even appeared in the press, albeit in such subtle and veiled forms that only the cognoscenti appreciated the significance of the historical or theoretical discussions or literary vehicles in which the attacks appeared. One such attack, which became famous when it was denounced at the start of the Cultural Revolution, was the play which Wu Han, a historian and deputy mayor of Peking, published concerning Hai Jui, a brave official of the Ming dynasty who had not been afraid to tell the emperor of the suffering of the peasants. The play, as insiders knew and as the Maoists later conceded, was an allegory in praise of Marshal P'eng Tehuai's unsuccessful but damaging criticism of the Chairman at a Party conference in 1959.

By the time of P'eng's attack, Mao had yielded control over day-to-day governmental decision making to Liu Shao-ch'i, who became chief of the state while Mao retained chairmanship of the Party. It was Liu and a number of other high Party and government leaders who initiated the less ideological, more pragmatic policies that restored China's economy and political stability in the wake of the Great Leap Forward. By 1962, however, Mao was convinced that the pragmatists had gone too far in catering to the private, selfish orientation of the masses and in insulating the demoralized basic-level officials from further criticism. In September he persuaded a majority of the Party's Central Committee to launch a "Socialist education movement" designed to renew the faith of the masses and the cadres in the Socialist system, put an end to the "three freedoms" to pursue private interests, reemphasize class struggle and individual self-sacrifice for the collective good, and again resort to social mobilization as the means of modernization.

The pragmatists within the leadership, concerned that a new mass campaign might undo their efforts to restore production and stability, quietly did their best to limit the scope of the Socialist education movement while publicly espousing its slogans. Because they controlled both the Party and government machinery, this strategy of "waving the red flag to fight the red flag," as the Maoists called it, proved quite effective. Mao sought to counter it in 1963 by placing the People's Liberation Army (PLA), rather than the Party or government, in charge of political indoctrination. Marshal Lin Piao, who during the darkest days of 1960–61 had renewed the PLA's faith in the regime by an intensive thought-reform campaign that focused on the works of Chairman Mao,

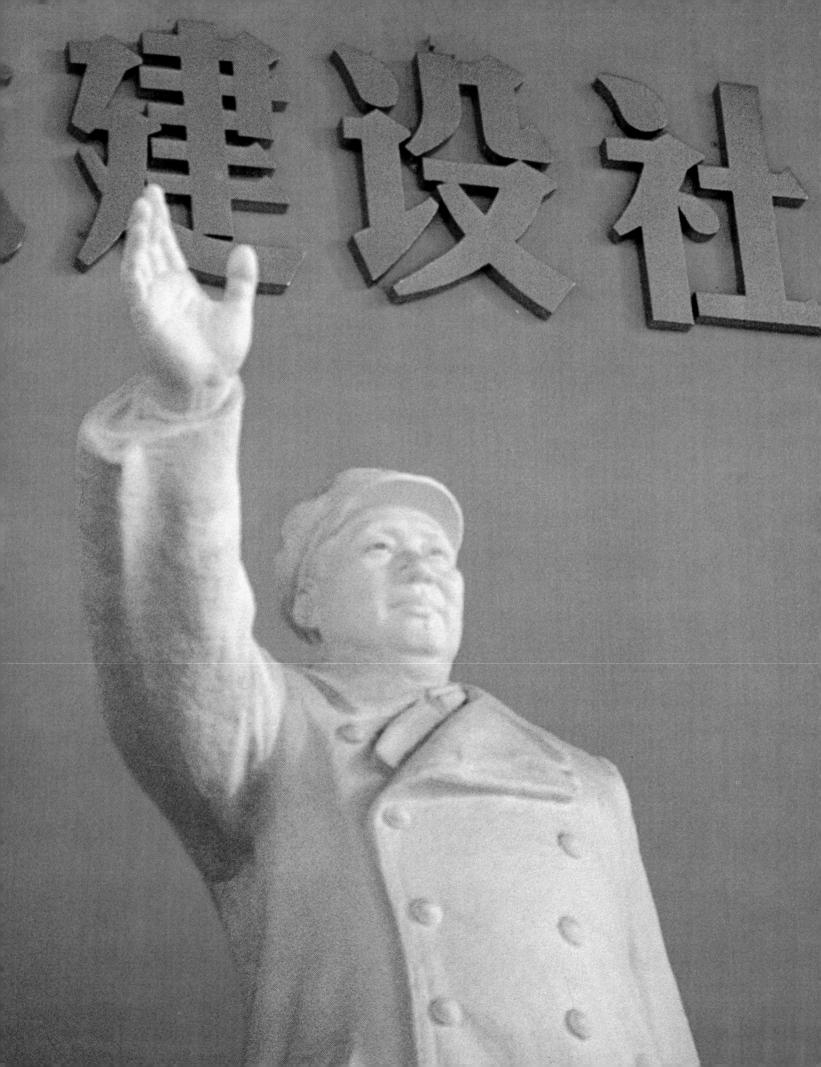

274-76. Chairman Mao and his "Thought" are ubiquitous in contemporary China. Every instrument of what is called "persuasion-education" is mobilized to break the hold of tradition and to indoctrinate the populace in the Party's revolutionary ideology. Left: Detail of a giant sculpture of the Chairman in the Shanghai Exhibition Hall (see plate 298). Right: Signboard in the Park of the Martyrs of the Canton Commune Uprising (1927), Canton (Kwangchow). It says: "Every member of the Communist Party must understand this truth—'Political power comes out of the barrel of a gun.' Mao Tse-tung." Below: Young Mao Teaches the Peasants to Be Revolutionaries. Sculpture in the Peasant Movement Institute, Canton.

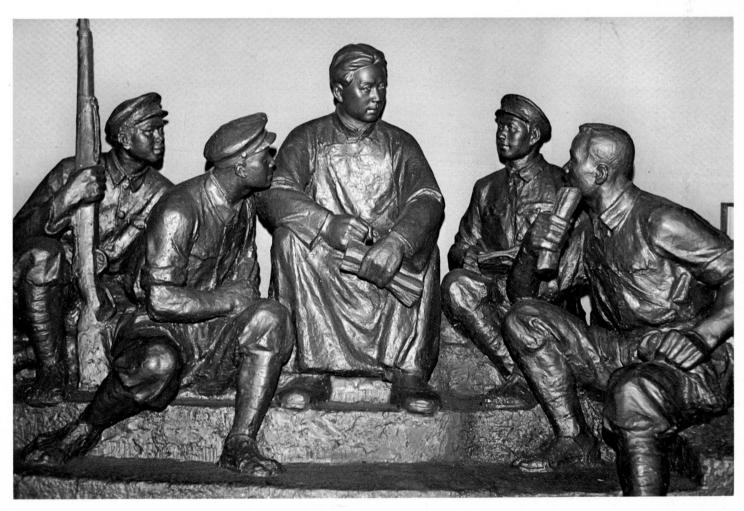

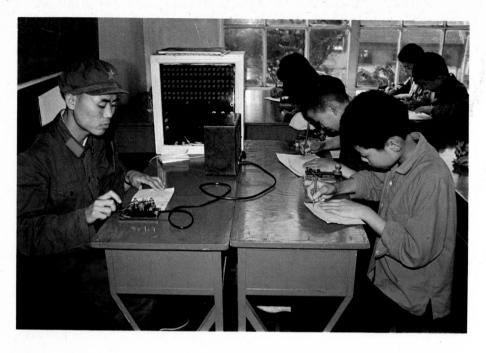

277-80.

Left, above: A soldier instructs students in code at a Shanghai "children's palace." Man soldiers teach special skills to politically favored youngsters at these urban after-school institutions. Center: "Students" at the East District "May 7th Cadre School," outside Peking, dance and sing a tribute to sunshine and Chairman Mao. A product of the Cultur Revolution, these "schools" were established so that officials, teachers, and other governme employees whose ordinary work insulates the from contact with the laboring masses could spend from three months to more than a year combining intensive study of the Communist classics with farm labor. Below: During a bre the "students" sit in the sparsely furnished dormitory which they built for themselves. This group was studying a Chinese translation of nineteenth-century German Marxist philosophy. Most Chinese participate in one kind of study group or another, reading and discussing the basic ideas of Marxism-Leninis Maoism and their application to daily life. Right: Cadre musicians play a variety of Chinese and Western instruments to accompa the singing and dancing that invariably greet visitors to a "May 7th Cadre School." Weekl performances are given, not only to heighten morale and patriotism but also to teach the cadres currently approved songs and dances.

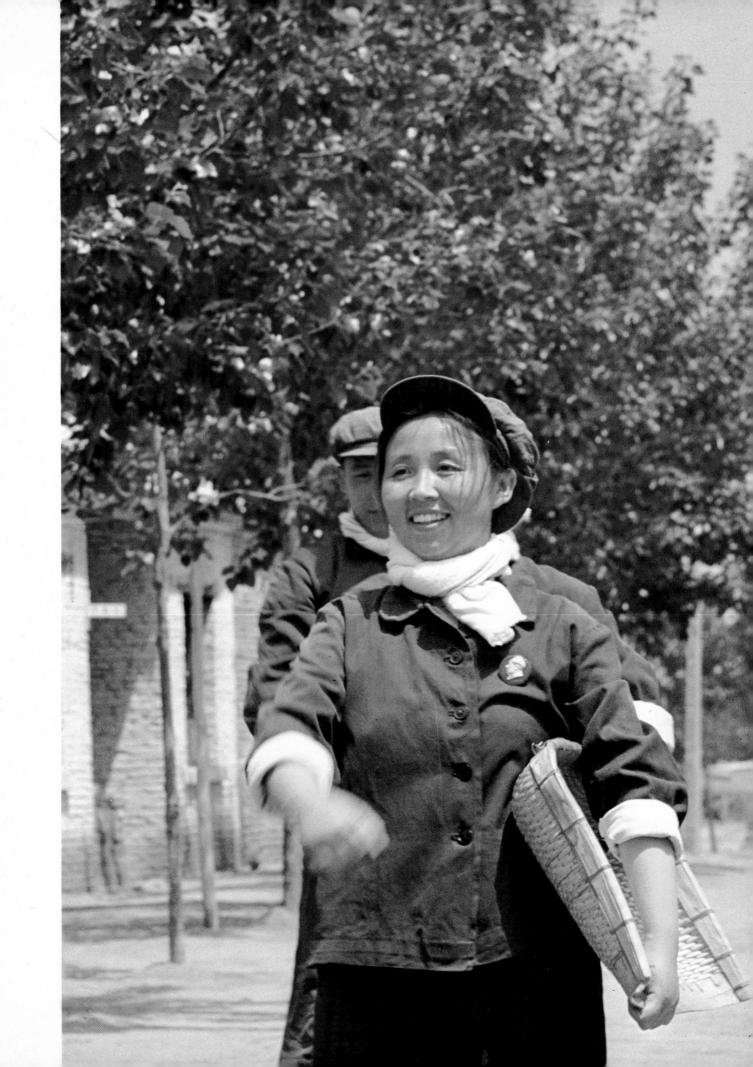

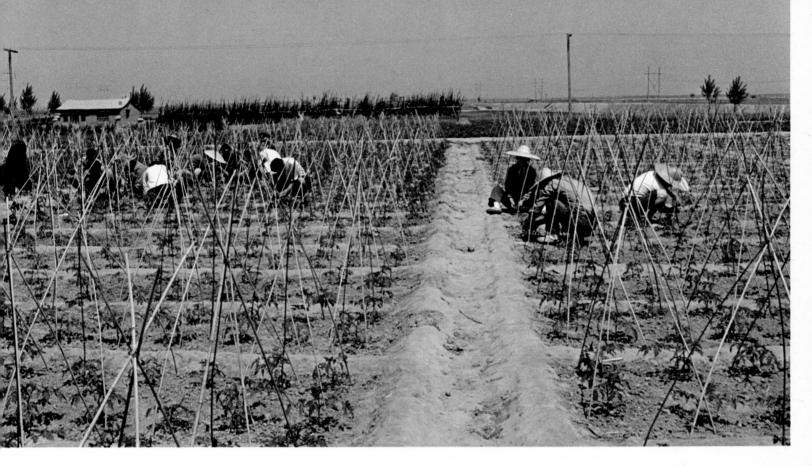

281, 282. Left: A harvest song-and-dance entertainment at a "May 7th Cadre School." The "students" sing of the virtues of learning from the peasants. In early experiments, cadres who were sent from the cities lived in the villages with peasant families and worked with them, but this produced a variety of social and economic dislocations, mostly because of the persisting cultural gap between urban and rural people. Now the cadres build their own accommodations and cultivate their own fields, consulting the peasants from time to time. Above: Tending tomato plants. Here "students," heirs to the traditional bureaucratic disdain for manual laborers, learn to appreciate the rigors and satisfactions of peasant life.

283. At a Shanghai "children's palace," Young Pioneers, eight to fourteen years old, learn to use rifles to shoot down enemy airplanes.

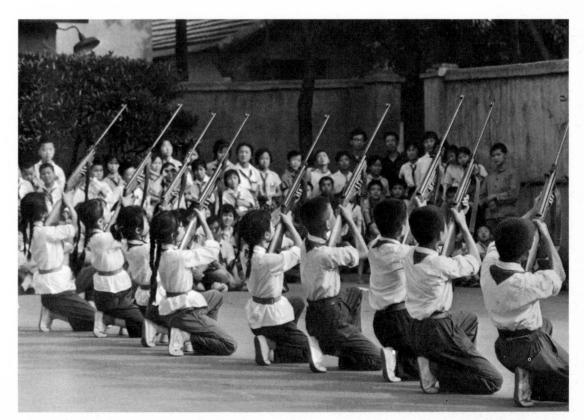

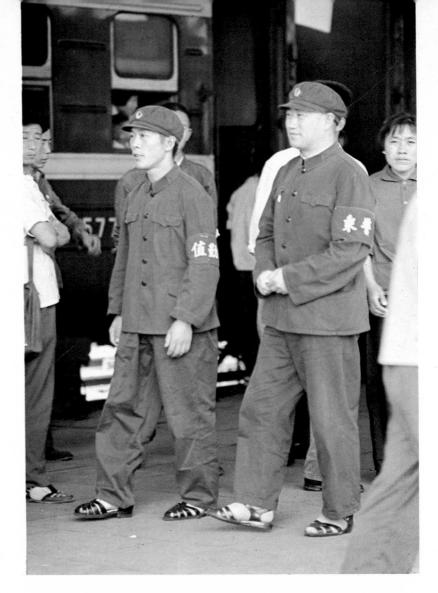

284–86. Left: Soldier carrying surveying equipment down a Peking street. Uniforms are much in evidence in China's cities. Right: Railroad police oversee platform activity at the station in T'ang-shan, an industrial city east of Peking. Below: Red Guards at Middle School 26, Peking, sing and clap to the accompaniment of the school band.

287. Soldier dragging a vegetable cart to market in Loyang, Honan province. Members of the People's Liberation Army frequently participate in civilian jobs, both rural and urban, as part of the military's effort to "serve the people" and stabilize the country in the post-Cultural Revolution period.

now attempted to refurbish the Chairman's tarnished image throughout the nation by a similar effort. Mao also initiated a "four clean-ups" campaign that was designed to mobilize lower and middle peasants to cooperate with former and present PLA members in attacking peasants and cadres who wanted to pursue the "capitalist path."

The year 1964 witnessed an intensification of the struggle between what, in oversimplified yet convenient terms, we may continue to call, on the one hand, the pragmatists, bureaucrats, or conservatives and, on the other, the ideologues, Maoists, or radicals. Despite a nationwide "learn from the PLA" campaign by the ideologues, the pragmatists continued to have considerable success in resisting the unfolding of another all-out mass movement. This led Lin Piao and certain other Maoist military leaders to join with other ideologues in a new stage of the "four clean-ups" that began the following year, attacking supposed bourgeois elements within the Party who were resisting the class struggle.

Of course, the pragmatists were not really "capitalist roaders," as the ideologues were beginning to call them by the fall of 1965. Like the ideologues, they were devoted Communists. They differed from their rivals neither in goals nor in principles so much as in emphasis, timing, techniques, and approach. Yet fifteen years of experience had demonstrated the implications for modernizing China of the "struggle between the two lines." In the economic sphere the pragmatists stressed conventional planning, organization, professional management, discipline, rules and regulations, technical skills, and material incentives. The ideologues emphasized ideological indoctrination, Promethean mobilization of the spontaneous energies of the masses, charismatic leadership, and moral incentives. They believed that it would not be possible to make any significant long-run economic gains without first transforming the political consciousness of the Chinese people. The pragmatists, by contrast, thought that swifter material progress would facilitate the transformation of consciousness, which in any event could not be attained in apocalyptic leaps.

These differing approaches were reflected in other important areas. In military strategy, to the distress of many professional commanders, Mao and his "close comrade-in-arms" Lin Piao, influenced by their victories over the Japanese and the Kuomintang, continued to emphasize guerrilla rather than conventional warfare; passive rather than active defense; egalitarian rather than hierarchical relations between officers and men; ideological purity rather than technical skills; army

participation in agriculture, industry, education, police, and other civilian functions rather than confinement to customary military concerns; and the training of a vast militia rather than concentration exclusively on the armed forces. They tended to play down the role of modern weapons; Mao had even called the atomic bomb a "paper tiger." By 1965 major military figures, led by Army Chief of Staff Lo Jui-ch'ing and backed by Liu Shao-ch'i and other pragmatic leaders, had come to differ with Mao on military matters. They were particularly disturbed by the Sino-Soviet rift, which denied China access to Soviet aid for military modernization. They strongly urged a settlement that would enable China to regain Soviet military aid and the security of the USSR's nuclear umbrella, thereby permitting China to make a military response to American intervention in Vietnam. This would also have had the more than incidental effect of precluding Mao from continuing to use the PLA as an instrument of domestic political purification in his struggle to regain control over the pragmatists. Understandably in these circumstances, Mao opposed both reconciliation with Moscow and direct military involvement in Vietnam.

Educational policy was also a major area of dispute. Mao called it "a matter of life and death for our Party and our country." As he characterized it:

The question of training successors for the revolutionary cause of the proletariat is one of whether or not there will be people who can carry on the Marxist-Leninist revolutionary cause started by the older generation of proletarian revolutionaries, whether or not our descendants will continue to march along the correct road laid down by Marxism-Leninism or, in other words, whether or not we can successfully prevent the emergence of Khrushchevite revisionism in China. ("On Khrushchev's Phoney Communism and Its Historical Lessons for the World," *Red Flag*, July 14, 1964.)

Who should receive higher education? For what purposes? By what means? Here, as elsewhere, the "two lines" differed. The pragmatists tended to support the view that education should go to those academically best prepared for it. They maintained that education, while not ignoring political indoctrination, should, nevertheless, feature serious academic subjects and technical training in order to produce the many kinds of specialists required by an industrializing society. As Vice-Premier Ch'en Yi had said during the relaxation of

1961: "Who wants to fly with a pilot who is ideologically pure but cannot manage the controls?" The Maoists, however, maintained that education, while not ignoring academic subjects, should strive to create new Communist men and women who would be closely integrated with the toiling classes rather than members of an elite that stood above them. In their view, devices such as entrance examinations and course examinations overemphasized the academic and gave undue advantage to the children of Party members, cadres, intellectuals, and the former landlord and bourgeois classes. The Maoists wanted to recruit most students from worker, peasant, and soldier origins; give them relatively brief, largely practical academic training; and return them to the masses to serve the people.

By 1965 the problems of education and employment had become very sensitive, because educational and job opportunities had become more limited as a result of the depression that followed the Great Leap. Disillusionment and anxiety were particularly widespread among urban youth, many of whom were not eager to respond to the Party's call to join their politically advanced comrades in moving to the country-side to develop the motherland. Chairman Mao had become increasingly preoccupied with what he perceived to be the softness and revisionism of the new generation. He clung to the notion of permanently altering human nature by replacing selfish and materialistic tendencies with selfless and altruistic ones, kindling in the population at large the collective spirit that had prevailed in the Red Army during the struggles against the Japanese and the Kuomintang.

Indeed, the Maoists sought to change the definition of happiness for China's youth. Over and over they preached that happiness does not consist of remaining with one's family in comfortable urban living quarters, eating and dressing well, obtaining higher education, working in a bureaucratic job, marrying when one wishes, having as many children as one desires, and enjoying urban entertainments. Rather, happiness is abandoning parents and education for a Spartan life of manual labor, transforming some rural wasteland in the company of like-minded patriotic youth, postponing marriage for many years, limiting the number of children one has, and devoting periods of leisure to mastery of Mao's works. What China's youth needed, Mao told visitors in 1964, was to be toughened in revolutionary struggles similar to those that the older generation had experienced. Indeed, all of China needed a revolution that would transform the existing environment

and values and "touch people to their very souls." This was the background to the Great Proletarian Cultural Revolution that Mao launched in the fall of 1965 in a daring and desperate effort to mobilize the masses to overthrow the "power-holders" within the Party who had been frustrating Mao's plan for "continuous revolution."

The Cultural Revolution (1965-69)

The preliminary phase of what was to become the Cultural Revolution began innocuously enough with another of the series of attempts to eradicate "bourgeois reactionary thinking" in China's art and literature. Mao's wife, Chiang Ch'ing, played an important part in this campaign. He had met her in 1937, when, as the well-known film star Lan P'ing, she, like many patriotic artists, writers, and students, had come to the Communists' mountain stronghold in Yenan to enlist in the revolution. It had been love at first sight. Against the advice of most of his comrades, Mao had divorced his third wife, who had borne him five children—including one born during the Long March—and married the glamorous actress. This episode tarnished Mao's image as the embodiment of revolutionary austerity. There had been nothing shameful in his previous marital history. His first marriage, at age fourteen, to a woman four years his senior, had been foisted upon him by his parents, and he had left her to resume his schooling. His second wife had been executed by the Nationalists in 1930, after bearing him a son who was later killed in the Korean War. Comrade Chiang Ch'ing, as the Chairman's new bride came to be known, remained largely hidden from public view for over a quarter of a century, bearing him two daughters. It was subsequently revealed that she participated in the effort begun in 1964 to revolutionize traditional Peking opera; the following year she became active in transforming other aspects of art and literature.

Because the Party apparatus in Peking, under Mayor P'eng Chen, was controlled by the pragmatists, Chiang Ch'ing persuaded certain radical leaders in Shanghai to publish a criticism of Deputy Mayor Wu Han for his allegorical attacks on Mao. Actually, however, the condemnation of Wu Han had been taking place for weeks during secret meetings of the Standing Committee of the Politburo. It was understood by the pragmatists as a veiled attack on Mayor P'eng Chen, Wu's superior, and perhaps even on higher Party leaders. Interestingly, while the public manifestations of this preliminary

stage of the Cultural Revolution focused on literature and art, behind the scenes the first major leader to be purged was Army Chief of Staff Lo Jui-ch'ing, who was apparently removed from office because of his efforts to involve the PLA in military engagements in Vietnam and the Taiwan Strait, which would have diverted it from any domestic political role.

That Mao intended no ordinary campaign but was determined to use the PLA as a principal weapon in an all-out struggle against the pragmatists became clear to insiders in late February, 1966. By April P'eng Chen and his aides, who had tried to give the impression of complying with Mao's directives while actually maneuvering to counter them, were deposed, and Mao regained command of the capital's propaganda organs. Mao then appointed a small group of confidantes headed by his private secretary, Ch'en Po-ta, and by his wife, Chiang Ch'ing, to constitute a Cultural Revolution Directorate that was to root out the remaining "counterrevolutionary revisionists." Mao sought to show that he had support for his new policy among intellectuals by persuading contemporary China's most famous literary figure, Kuo Mo-jo, to make a dramatic self-criticism before the National People's Congress, declaring that everything he had written should be "burned to ashes, for it has not the slightest value." Then Premier Chou En-lai called for expanding the struggle from art and literature to embrace education and journalism. and in late spring Mao directed Lin Piao to end the domination of "bourgeois intellectuals" over the universities and schools by having the military organize students to rebel against the Party bureaucrats in control.

Peking University became the site of the first academic conflict of the Cultural Revolution, and it was only Mao's personal endorsement that enabled the radicals to triumph over the entrenched Party authorities. His intervention unleashed a torrent of student criticism of the oppressive Party apparatus. A festive atmosphere of genuine elation prevailed. By venting their spleen on administrators and professors, students found release from the pressures of academic and political obligations, job worries, sexual repression, and tensions among the children of different classes. With Mao's blessing in the media and his new slogan "Rebellion Is Justified," the excitement spread to other universities throughout the nation.

For Liu Shao-ch'i and other pragmatic leaders, Mao's challenge represented a grave dilemma. If they opposed the Cultural Revolution, they would be attacked for suppressing the masses. If they allowed it to develop, they would be

attacked by the masses for their past opposition to Mao. Their strategy, as in the past, was to appear to be implementing Mao's campaign while actually striving to control it. This they hoped to accomplish by their management of the Party work teams that were assigned to carry out the cleansing of the universities. Well aware of his opponents' dilemma, Mao waited from early June until mid-July to see how they would cope. This period witnessed a great deal of revolutionary rhetoric, considerable turbulence, and attacks on some sacrificial lambs selected by Party bureaucrats in an effort to demonstrate their ideological fervor, but the hold of the Party machine remained essentially unshaken.

At that point Mao emerged from his Hangchow retreat and captured worldwide attention by taking his now legendary swim in the Yangtze River to symbolize his vigor. The Chairman, who was then seventy-two, reportedly swam for more than an hour in the swift current and strong waves, covering a distance of over nine miles. He then returned to Peking to confront the opposition, while the *People's Daily* drove home the moral: "No one has ever learnt to swim just by standing on the shore and studying one or another aspect of the art of swimming. And the same is true of making revolution. You must take part in actual class struggle, master the laws governing revolution in the storm of class struggle and learn the art of swimming in class struggle" (July 26, 1966).

By early August Mao dissolved the work teams and criticized their operation before a long-overdue plenary session of the Party Central Committee, which he packed with his supporters in an irregular manner. He also demoted Liu Shao-ch'i and other Party Vice-Chairmen and promoted Lin Piao to be sole Vice-Chairman. While attacking the "capitalist roaders" from above, Mao also moved to undermine them from below. He mobilized the radical youth who had been forming Red Guard groups with the assistance of Lin Piao's army units and launched an unprecedented assault on Party organizations at every level.

The "Sixteen-Point Decision" that Mao pushed through the reluctant Central Committee announced "a great revolution" that would wipe out "old ideas, old culture, old customs, and old habits of the exploiting classes." Large numbers of revolutionary youngsters were to serve as the brave vanguard of this movement, arousing the masses to eliminate the influence of "anti-Socialist rightists." Like Communist documents generally, the "Decision" contained some cautionary and ambiguous language that was undoubtedly inserted to ease

the concern of high government leaders such as Premier Chou En-lai, whose support Mao needed, and who feared the consequences of chaos for China's economy and national security. Thus, the document admonished the revolutionaries not to intervene in industrial or agricultural production or to struggle against loyal scientists and technicians or to interfere with the army. The "Decision" also sought to safeguard the majority of Party members, stating that only a small number were so reactionary as to warrant dismissal.

Although the "Decision" urged the revolutionary youth to use persuasion rather than coercion, some of its language was inflammatory, and contemporaneous statements by members of the Cultural Revolution Directorate exhorted the Red Guards not to fear turmoil. Thus, shortly after Mao greeted over a million red-book-waving, slogan-chanting, hysterical Red Guard worshipers in T'ien-an-men Square on August 18 in the first of a series of enormous rallies, China's cities were subjected to the beginning of a reign of terror.

By and large, the principal victims of the first fortnight were not Party bureaucrats but a variety of helpless scapegoats intellectuals; people who had been educated in the West before 1949; former members of the landlord, rich peasant, and bourgeois classes; people who had been branded counterrevolutionaries or "bad elements"; and even some Party members who were no longer in favor. What the pragmatists succeeded in doing during these earliest days was to divert the Red Guards from attacking the Party machinery by offering them harmless targets on which to expend their energies. Declaring war against the old world, the Red Guards sought to revolutionize all of life. They changed the names of streets, restaurants, and stores, and one group even demanded that traffic lights be revolutionized so that red would signal "go" and green "stop." More sinister were the young leftists who vandalized the homes of thousands, wantonly smashing or confiscating traditional Chinese art objects or foreign-made items, shaving the heads of people with Western hairstyles, and destroying Western clothes. Their hooliganism also extended to statues, paintings, and other objects in temples, parks, cemeteries, and other public places. Hundreds of thousands of people were publicly humiliated, intimidated, and forced to withdraw from society, and many thousands were murdered or driven to suicide. One Chinese woman who had lived in Germany during the 1930s compared the beginning of the onslaught to Hitler's infamous Kristallnacht pogrom against the Jews in 1938.

Mao was not fooled by the diversionary tactics of his opponents or by their efforts to suppress or misinterpret his directives or to form their own Red Guard units to counter the Maoists by "waving the red flag to fight the red flag." At the end of August, Lin Piao and other Maoists began to urge the millions of Red Guards who flocked to Peking from all over the country to focus their attacks on the Party organization, and this word was carried from the capital as the exhilarated young rebels traveled widely through the provinces in a "great exchange of revolutionary experiences" that constituted one of the major mass migrations the world has seen. Regional and local power holders defended themselves against the Red Guards by forming worker and, in some cases, peasant units to control them. This frequently led to combat between rival

groups and even between different Maoist units.

By the end of September Chou En-lai and some of the other leaders who shared Mao's enthusiasm for the Cultural Revolution but feared that it was getting out of hand strove to curb its abuses. The Red Guards were disrupting transportation, communications, the building trades, factory output, and government operations, and were even beginning to diminish agricultural production. They were also alienating important sources of Maoist support by their gangster tactics and an extreme class consciousness that excluded from their ranks the children of "feudal" families. But Chou's efforts to rein in the Red Guards yielded before the flames of revolutionary fervor fanned by Mao's wife and other members of the Cultural Revolution Directorate, and Lin Piao, invoking the precedent of the short-lived Paris Commune of 1871, called for "extensive democracy," which would allow the masses to criticize all institutions and leaders. Thus the turmoil intensified during the remainder of 1966. In mid-December the Red Guards were told to revolutionize agriculture by replacing the rural Party power elite with poor peasants under the control of new Cultural Revolution committees. Shortly afterward the Maoists were unleashed on industry. New Year's Day, 1967, found Mao urging the nation to a "general attack" on "monsters and demons anywhere in society."

This led to bloody factional strife virtually all over China as the Maoists sought to seize power from the bureaucrats. The country was exhorted to emulate Shanghai, where a coalition of radical groups had replaced the municipal Party committee. Nevertheless, although the radicals succeeded in toppling certain provincial leaders, in most areas a badly crippled Party machine retained power after violent battles that

seemed to be bringing the country to the brink of civil war. The situation was made even more desperate by the fact that urban workers took advantage of the chaos to manifest their dissatisfaction with economic conditions. A series of dock and railway strikes plagued China's coastal cities, and local officials handed out extra funds to many workers in the hope of placating underpaid apprentices, insecure contract workers, and others who were demonstrating for higher wages and better terms of employment. Yet these "sugar-coated bullets of the bourgeoisie" failed to stem the tide of dissatisfaction, and hundreds of thousands of workers followed the example of the Red Guards by journeying to Peking, ostensibly to present their grievances. Urban life also became more difficult to deal with, because large numbers of former city residents who had been sent to the countryside to work with the peasants had illegally drifted back to the cities during the turbulence and had begun to support themselves through crime and blackmarket activities. And peasants began to help themselves to government and communal supplies and returned to private rather than collective interests.

By the latter part of January it was plain that the Maoists had to bring the situation under control or see China collapse. There was only one possible effective instrument—the People's Liberation Army. Although it had provided organizational and logistic support for the Red Guards, the PLA had subsequently sought to remain neutral in the radicals' struggle to overthrow the Party bureaucrats. Many PLA leaders were seriously worried that the Cultural Revolution would weaken China's national defense by implicating the armed forces and breeding disunity. In late January Mao sought to end the chaos by directing the PLA to enter the struggle on the side of the radicals. Before doing so, however, he purged certain high-ranking officers who opposed military involvement in domestic affairs and assured those who retained command that he would take measures to contain the revolution.

Actually, the PLA had already restored order in certain areas. In doing so, it had generally failed to support the radicals, sometimes suppressing them and sometimes arranging local compromises. But in either event it had played an important political role on the local scene. After Mao ordered it into action, it behaved in a similar way on a nationwide scale, moving vigorously to promote stability, even at the cost of many very bloody clashes against Red Guard units. In February and March of 1967, while Peking propaganda organs were urging Red Guards to behave in an orderly manner and re-

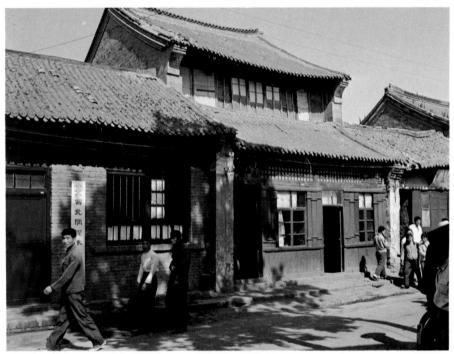

288-90.

Above: A lane of workers' new apartments in the East District of Peking. A family of four or five typically has one or two rooms and may share kitchen and bathroom facilities with the family next door. Center: Traditional wooden houses with tiled roofs line a small lane in the "old city" of Loyang. Below: Traditional housing in Sian. It is of wattle-and-daub construction, with a thatched roof.

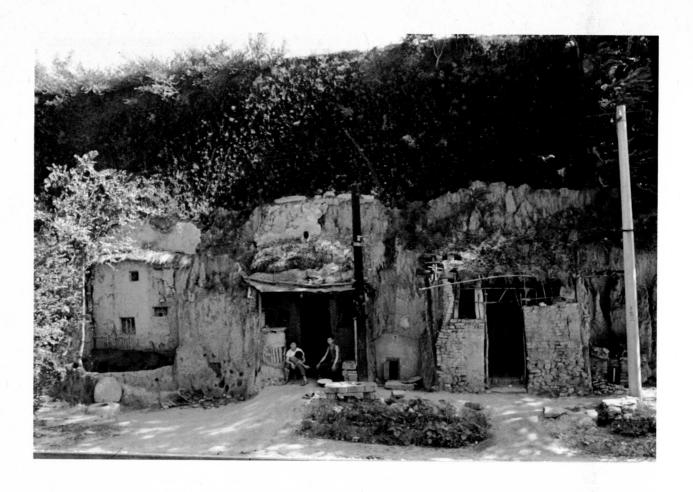

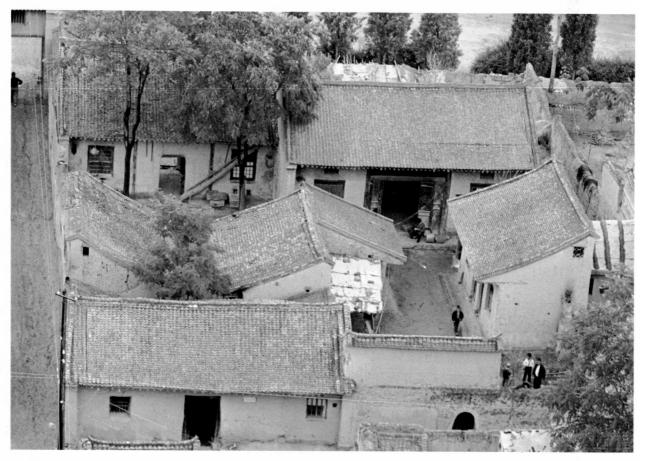

91, 292. Above: Cave dwellings in eastern Shensi province, between Sian and Loyang. For almost a decade during the Sino-Japanese War, Mao Tse-tung and his comrades lived in cave apartments in the hills of Yenan in Shensi. Below: Contemporary courtyard housing in traditional style, near the Great Gander Pagoda on the edge of Sian, Shensi province. China has made considerable progress in housing since 1949 but still has a long way to go to alleviate overcrowding.

spect rather than rebel against officials, the PLA organized military control commissions that took over police powers from the badly divided urban public-security bureaus, formerly the backbone of the dictatorship of the proletariat. It assumed control over schools, universities, factories, mines, and even rural areas. And it began the slow process of rebuilding shattered local and regional government by forging "triple alliances" of officials, radicals, and military men into disciplined "revolutionary committees." Organization of the revolutionary committees proved extremely difficult, since the PLA tried to be faithful to Maoist principles, on the one hand, and to avert anarchy, on the other. Moreover, it was often impossible to distinguish the genuine revolutionaries among the bitterly contending groups.

In the view of the Maoists, military efforts to restore order went too far and threatened to end the Cultural Revolution. Thus, at the end of March, Mao launched a new offensive designed to topple Liu Shao-ch'i and other pragmatist leaders, to complete the purge of their followers among Party and government officials, and to eliminate the restraints which the PLA had imposed on the Red Guards. While again exhorting radical youth that "Rebellion Is Justified," Mao moved to restrict the PLA, leaving it virtually defenseless against the mob if it followed his orders. The result was unparalleled civil conflict throughout the spring of 1967, as youth groups battled each other, as the PLA and workers fought radicals, and as rival military units opposed each other. Many thousands were killed, and the Red Guards, who had been admonished by Mao to emulate the xenophobic "Boxer" mystics of 1900, outraged the world by their attacks on foreigners, diplomats as

well as ordinary nationals.

By the summer of 1967 China seemed to have reverted to the civil war and chaos that had debilitated her during the century prior to Communist rule. The specter of "warlordism" became very real as local military commanders ignored Mao's restrictive edicts, particularly in July, when the Wuhan military command rejected the order of the central authorities to side with the radicals and kidnapped the two prominent emissaries whom Mao had sent from the capital. This Wuhan uprising, which was ended only by Peking's show of overwhelming force, stunned the country and introduced the bloodiest fighting of the Cultural Revolution. Mao and the Cultural Revolution Directorate exhorted the masses to prepare for protracted war against recalcitrant military com-

manders and demanded a purge of the armed forces; this in turn spurred many regional military authorities to fight the Maoists more forcefully than ever. By late August the crisis had become intolerable. Although the world was ill informed about developments in the provinces, events in Peking convinced many that China had gone mad, as a torrent of Red Guard abuses against foreigners culminated in the burning of the British diplomatic mission and extreme Maoists seized power over the Foreign Ministry.

At that point Mao again had to reverse his field in an effort to end the conflict. Characteristically, he condemned the excesses as the work of "ultra-leftists," whom he purged, even though they had actually been following his orders. He commanded the Red Guards to cease attacking officials and to strive for unity, called for rehabilitation of officials who had criticized their mistakes, expressed faith in the PLA as the "chief component of state power," and authorized it to use force in self-defense against offenders. With this fresh mandate the PLA made considerable progress in restoring order and renewed the difficult task of completing the formation of revolutionary committees to replace the shattered Party and government structures. Much to the disillusionment of the Red Guards, the revolutionary committees that were organized during the following six months bore suspicious resemblances to the old structures in substance, if not in form, as the military brought veteran cadres back to power. These new military-bureaucrat coalitions tended to subordinate the "little red generals" who had been idealized during the previous years as Mao's revolutionary successors.

In March, 1968, however, the frustrated revolutionary forces burst forth again with the approval of radical leaders in Peking, who apparently feared that the pendulum had swung too far to the right. This triggered a new round of violence in the capital and savage warfare in a number of provinces, especially in south China. Once again, within a few months Mao and other radical leaders had to abandon support for their followers and solicit military assistance in reasserting central control over chaotic provinces. As Stanley Karnow has written in the leading study of the Cultural Revolution:

By the middle of summer, the trend toward moderation was firmly established and it was publicized by a lexicon of mirror-language phrases. What had formerly been justifiable "rebellion" now became "counterrevolution." Red Guards were now "anarchists" poisoned by "bourgeois factionalism"

and "leftist opportunism." The restoration of law and order by the Army and its auxiliaries was no longer a "reactionary adverse current," but the imposition of "revolutionary discipline" designed to defend the "dictatorship of the proletariat" against its "class enemies." And the rationale for the new line, like the rationale for the exhortations that had launched the Cultural Revolution, would be found in Mao's immense body of doctrine. (Mao and China, pp. 442–43.)

Mao now prepared to bring the Cultural Revolution to a close. He not only explicitly repudiated the Red Guards but also used the PLA to control the universities and schools that had been their base. Moreover, during 1968-69 he carbed the revolutionary potential of the cities by launching the hsiahsiang (down to the countryside) campaign, moving over eight million young urban students to rural areas in the next five years. This enormous achievement, testimony to the continuing potency of the Chinese propaganda and coercive apparatus, substantially reduced urban unemployment and social problems, increased rural technological capacity and public-health resources, and constituted a major step toward Chairman Mao's goal of eliminating the gap between intellectuals and peasants. Yet it was far from popular either with the peasants, who often resented the dislocations caused by the "educated youth," or with the young people, many of whom were already bitter about the course of the Cultural Revolution and the lack of educational and job opportunities in the cities and who dreaded the harsh monotony of their presumably permanent residence in the backward countryside.

In the fall of 1968 Mao moved to consolidate his hold on the battered Party apparatus. He used the vehicle of a Central Committee meeting to strip Liu Shao-ch'i of both his Party and his government offices. Although on several occasions during the previous two years Liu and his wife had admitted various errors under Red Guard pressure, unlike many of their colleagues they had refused to make the abject and exaggerated confessions demanded by the Maoists. After a long delay that reflected the problems Mao was encountering in reuniting the party and the country, the Ninth Party Congress was convened on April 1, 1969.

The Continuing Struggle (1969-74)

The most striking fact about the Ninth Party Congress was its domination by the military, whose representatives filled a large number of the places left vacant by purged members of the previous Central Committee and Politburo. The principal radical leaders who had directed the Cultural Revolution remained at the very top of the Party hierarchy in the Politburo Standing Committee and the Politburo, but few of their followers held places in the Central Committee, which retained many Party bureaucrats. The Party Constitution that this Congress enacted was much less detailed and organizationally precise than its 1956 predecessor, which had sought to regularize Party procedures in the wake of Khrushchev's revelations of Stalin's abuses, and it elevated Mao and his "Thought" to heights that earlier concern about the "cult of personality" had forbidden. In addition to its emphasis on opposing Soviet revisionism and on heightening class struggle, the new document's other distinguishing feature was its designation of Lin Piao as Mao's eventual successor to the Party chairmanship.

But the new elite enshrined by the Ninth Party Congress proved to be an unstable coalition. The radical leaders must have been increasingly unhappy over the moderate policies that emanated from Peking in 1970 and 1971. Law and order became a major preoccupation. Harsh punishments were meted out to many who had acted like hooligans during the Cultural Revolution, including certain leaders of groups that had attacked foreigners and their diplomatic missions. In some cases Red Guards and other offenders were even required to make compensation for their destruction of private property. Ideological slogans began to lose some of their stridency, and the worship of Mao and the little red book of his "quotations," which had risen to extreme proportions in an effort to overcome the legitimacy of his bureaucratic opponents, began to decline. Gradually some of the cadres who had been severely attacked by the radicals returned to reconstituted Party and government units, and mass organizations such as the Communist Youth League, the labor unions, and the Women's Federation, by which the Party had formerly controlled virtually every sphere of life, began a lengthy process of reconstruction.

Economic management reflected this renewed emphasis on stability and regularization. Many of the policies the bureaucrats had used to pull China out of the depression following the Great Leap Forward were restored. Planning, expertise, technical skills, accounting, inventory and quality control, and material incentives such as private plots, sideline production, and free markets again prevailed, despite a brief effort by the ideologues to reverse the tide. China also took steps to enhance her international trading reputation, which had suffered

when the Cultural Revolution prevented her from fulfilling commitments to deliver goods.

By late 1970 it was also apparent that China, which had alienated many countries during the Cultural Revolution, was determined to gain acceptance by the world community. This return to a foreign policy of moderation elicited a warm response abroad, and Peking soon established diplomatic relations with many states that had previously maintained bilateral ties with the Chiang Kai-shek government. Peking also made clear its desire to replace Taipei as the representative of China in the United Nations. It even responded to America's new China policy by dramatically initiating "Ping-Pong diplomacy" in the spring of 1971 and later agreeing to the visit by President Nixon that symbolized the start of a Sino-American détente. The Soviet Union alone among the major powers maintained its hostility. Although the Sino-Soviet armed clashes of early 1969 had given way to negotiations, Peking was preparing for a possible nuclear attack by Moscow, undertaking a massive urban underground air-raid shelter program that demonstrated its concern.

The preeminent spokesman of China's new policy was Premier Chou En-lai, who had labored to support the Cultural Revolution and yet keep it from shattering the country. With Mao's blessing, by autumn, 1971, Chou appeared to have prevailed over those leaders who had earlier joined Mao in pushing the Cultural Revolution to extremes. Ch'en Po-ta, head of the Cultural Revolution Directorate, had dropped from sight amid rumors of disgrace. In late September the world was stunned by increasingly specific stories that Lin Piao himself, designated by the Party Constitution to be Mao's successor, had been killed in a mysterious plane crash while trying to flee to the USSR after an unsuccessful attempt to assassinate Mao. The actual cause of Lin's demise remains uncertain, as is the fate of the high military leaders who disappeared with him, five of whom were members of the Politburo. Also unclear are the reasons for this spectacular and embarrassing turn of events. Among those issues commonly thought to have been involved were the Party's effort to reimpose control over the military, disputes within the armed forces concerning not only political questions but also professional matters such as strategy and weapons development, foreign-policy changes such as the turnabout toward the United States, and the struggle between Lin and Chou En-lai to determine whether Lin would become chief of state as well as Chairman of the Party.

Lin's demise accelerated the prevailing pragmatic trend. While many of Lin's followers were being removed from office, Chou En-lai reinstated increasing numbers of veteran civilian and military cadres who had been humiliated during the Cultural Revolution. That bitter experience made some of them reluctant to participate in the reconstruction of Party and government, yet by the spring of 1973 many skeptical officials were persuaded that a serious attempt to re-create stability was under way. Premier Chou was obviously striving to create a new relationship with military leaders while gradually reducing their influence over both China's politics and economy. At the same time he attempted to reduce the role of the remaining "leftist" leaders without provoking further confrontation.

Renewed pragmatism became all the more essential in economic and social matters when unusually bad weather in 1972 diminished the agricultural harvest and slowed recovery from the disruptions of the Cultural Revolution. In these circumstances the leadership could ill afford to dispense with "reasonable rewards" based on individual worker and peasant productivity. Moreover, it emphasized improvements in the standard of living and a relaxation of domestic tensions.

In the cultural, ideological, and educational spheres, however, the influence of the radicals was far from dead. Although Western music could again be heard on occasion, and several Western orchestras were even allowed to perform in China for the first time since 1949, Madame Mao continued to promote "revolutionary model operas" in lieu of the traditional variety. Ideologically, great effort was expended to convince the Chinese people as well as foreigners that the Cultural Revolution had been a necessary experience that had made important and beneficial changes in national life. The "May 7th Cadre Schools," to which officials, teachers, intellectuals, and others "voluntarily" went for labor and "thought remolding," constituted an important symbol of the continuing tangible impact of the Cultural Revolution.

During 1973 education continued to be the most visible area of struggle between pragmatists and ideologues. When university study resumed in an experimental way in 1970 after a four-year hiatus, a "Cultural Revolution in Education" had begun. Entrance examinations had been abolished, and admission standards had been adjusted to assure that the overwhelming majority of the students would be the children of workers, peasants, and soldiers. Curricular changes had been introduced to carry out Chairman Mao's directive of May 7,

1966, that students "should in addition to their studies learn other things; that is, industrial work, farming, and military affairs. They should also criticize the bourgeoisie. The period of schooling should be shortened." Course examinations had also been abolished.

Gradually, however, the pragmatists made certain inroads in an effort to improve academic quality. For example, in late 1972 reports began to circulate that university course examinations had been reinstituted to test students' knowledge. It was later learned that those who failed to meet minimum standards were being sent back to their units after a few months. As 1973 unfolded, certain radical leaders in both Peking and the provinces openly criticized this concern for quality rather than class background and political standpoint. By midyear some observers interpreted this criticism and the campaign against Confucian thought as veiled attacks not only on the bureaucrats but also on Premier Chou's "centrist" course. Observers impatiently awaited the Tenth Party Congress in order to determine the extent to which Chou could muster support for his policies and personnel changes.

Held in unusual secrecy and brevity in late August of 1973, the Tenth Party Congress of 1,249 delegates superficially appeared to consolidate the power of Chou under Mao's titular leadership. In language reminiscent of Stalin's extravagant attacks on his purged rivals, it posthumously expelled Lin Piao from the Party, denouncing him by name for the first time and labeling him a "bourgeois careerist, conspirator, counterrevolutionary double-dealer, renegade, and traitor." Although the Congress reaffirmed its faith in "Marxism-Leninism-Mao Tse-tung Thought," Chairman Mao played only a symbolic role in its activities, and the new Party Constitution deemphasized the cult of Mao that had been Lin Piao's stockin-trade. The Congress generally endorsed existing policies, but both the personnel changes and the reports delivered reflected the delicate political balancing act that Chou had performed in order to stage the Congress. The appointments to the new 319-member Central Committee, the 25-member Politburo, and the 9-member Politburo Standing Committee that constitutes China's most powerful decision-making body achieved a compromise on representation not only between pragmatists and ideologues but also between civilian and military leaders and between regional and central authorities. The two principal reports, by Chou and by Wang Hung-wen, a Shanghai political cadre in his late thirties who suddenly rose from obscurity to a prominent position among the leadership, suggested the continuing contest between pragmatists and ideologues for the loyalties of a Party that had swollen to 28 million members. Chou denounced Ch'en Po-ta, ousted head of the Cultural Revolution Directorate, in the same vitriolic terms he used for Lin Piao, and warned: "For a long time to come, there will still be two-line struggles within the Party . . . and such struggles will occur ten, twenty, or thirty times." Wang, by contrast, said nothing about Ch'en Po-ta and asserted that struggles like the Cultural Revolution "will have to be carried out many times in the future."

The months following the Tenth Party Congress witnessed a slow intensification of the veiled attacks on pragmatic policies, under the slogan "Go Against the Tide." More than coincidentally, the new Party Constitution states that "all comrades throughout the Communist Party possess the revolutionary spirit of daring to go against the tide," a sentence that was probably inserted as part of the price of radical support, and Wang Hung-wen's report on that document emphasized that "a true Communist must act without selfish concerns and dare to go against the tide, not fearing removal from his post, expulsion from the party, imprisonment, divorce, or the guillotine." Although propaganda media continued to excoriate Lin Piao after the Congress, they branded him a "rightist" rather than a "leftist," linked him to the policies of Liu Shao-ch'i, whom he had helped to depose, and reaffirmed the anti-elitist values that Lin had personified only a few years earlier. Not long afterward, the intensifying attack upon Lin was linked to the campaign against the teachings of Confucius. Lin was condemned for "preaching the rubbish of Confucianism as part of his attempt to restore capitalism to China" and for opposing the "forward-looking approach to social change and the important measures" adopted by the First Chinese Emperor, Ch'in Shih Huang-ti, who in the current Chinese lexicon seems to symbolize Chairman Mao.

As the year 1974 opened, the mystery of Chinese politics deepened. Former Party General Secretary Teng Hsiao-p'ing was restored to the Politburo, despite the fact that he and Liu Shao-ch'i had been purged during the Cultural Revolution as "the two leading power-holders in the Party taking the capitalist road." Mao had charged them with usurping power and treating him "like a dead parent at a funeral," and the Red Guards had pilloried Teng for his obsession with the games of mahjong and bridge. Teng had been so fond of bridge that he had sometimes ordered special planes to fly his favorite partners over a thousand miles to join his game. Nevertheless, this

293. The Chinese are especially proud of their progress in industrialization. Visitors to China are shown many factories, large and small. Here a completed caterpillar-type tractor moves off the assembly line at China's leading tractor factory, in Loyang. The plant was built in 1955 and now produces caterpillar and rubber-wheeled tractors as well as bulldozers. This famous factory and others like it hold the hopes for the mechanization of Chinese agriculture.

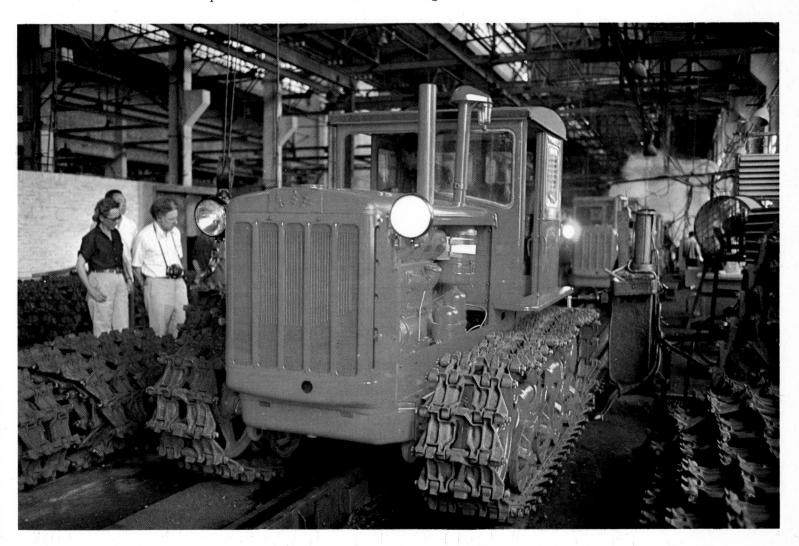

294–96. Left: Making parts in one of the sixteen divisions of the tractor factory at Loyang. Right: Assembly line at the same factory. Below: Skilled women workers at the West District No. 1 Transistor Factory, Peking. Many small workshops and factories in urban residential neighborhoods offer housewives an opportunity to participate in production and to learn practical skills.

297. Neighborhood housewives sewing red neckerchiefs in a basement workshop of an apartment block in Peking's East District.

enormously able organizer was rehabilitated, apparently to assist in the strengthening of the central Party and government organs in Peking.

Further evidence of the centralizing trend came with the dramatic reshuffling of most of the country's regional military commanders. This uprooted them from local power bases where they controlled not only the army but also the Party and government bureaucracies in their areas.

Yet at the same time as these efforts were being made to reinforce Peking's discipline over the country, the radicals were intensifying their campaign against so-called "reactionary tendencies." Educational institutions seemed to be on the verge of fresh upheavals. The *People's Daily* made a national heroine of a twelve-year-old girl who wrote a letter to a local newspaper denouncing the autocratic behavior of her fifthgrade teacher. She had asked rhetorically: "Are we, the youth of Mao Tse-tung's era, to be slaves to the notions of teachers' status that ruled in the old society?"

Shortly afterward, the *People's Daily* turned its guns upon Western cultural giants. Plato, Shakespeare, Beethoven, and

Schubert were among those condemned. For example, the leading Party newspaper wrote that the "Unfinished" Symphony "not only has no title but it also depicts evident class sentiments, having been written in an epoch when Austria, reactionary feudal bastion in the Germanic federation, was exercising cruel oppression and exploitation of peasants and workers" (January 14, 1974). Infinitely to be preferred were the works of Maoist composers which reflected the goodness of new China. There were many signs of a disturbing antiforeign tone that was reminiscent of the early days of the Cultural Revolution. For example, a documentary film on China by the Italian director Antonioni was castigated as a "wild provocation against the Chinese people." And Professor Owen Lattimore, a leading Western expert on inner Asia who had toured China's remote border areas as a guest of Chou En-lai in 1972, was denounced as an "international spy" for having praised Confucius in a book written almost forty years ago.

There were other indications of an almost self-conscious orchestration of the echoes of 1966. Particularly striking was the self-criticism of China's most famous philosopher, Feng Yu-lan. He confessed that he had mistakenly worshiped Confucius for most of his seventy-nine years and defended brainwashing by saying: "People regularly wash their faces and take baths to keep clean. Why shouldn't a person cleanse his mind of filth?"

The pendulum of China's politics, having swung for almost five years in the direction of moderation, seems to be reversing its course once again. Is Mao Tse-tung launching yet another revolutionary onslaught like the Great Leap Forward and the Cultural Revolution? If he is, will Chou En-lai go the way of Liu Shao-ch'i and Lin Piao, or will he again manage to contain the whirlwind? And what will the "struggle between the two lines" do to China, once the elderly Mao and Chou have left the scene? The answers to these questions—whatever they may be—will surely be no more astounding than the events of the past quarter of a century.

After Twenty-Five Years

This summary of the efforts of China's first-generation leaders to modernize their country necessarily focuses on dramatic mass movements, policy clashes, power struggles, personal rivalries, and purges. All this is essential background for understanding contemporary China and the increasing fragility of its leadership as the People's Republic approaches the crucial challenge of transferring power from Chairman Mao and his followers to the next generation. Yet most visitors to China today would agree that an account of the elite's difficulties in evolving the correct "line" for the nation's development offers an incomplete picture of its accomplishments. Indeed, however chaotic events may appear at any given time, in the long view the pendulum nature of China's post-1949 development—apparently embodying the Marxist dialectic of a recurring process by which thesis evokes antithesis to create synthesis—has spurred substantial progress. The strategy of "One Step Backward, Two Steps Forward," as the Leninist slogan goes, has begun to break the hold of millennial tradition.

Economically, despite marked fluctuations in annual output and almost ceaseless tinkering with institutions and policies, the People's Republic has proved quite successful in sustaining development. Between 1957 and 1972 China managed an average annual rate of growth of roughly 5 percent in her gross national product. Industrial production grew at an average annual rate of 8 percent, agriculture at approximately 3

percent, and the service sector at about 4 percent.

With the exception of 1972, China's performance in agriculture, the foundation of her economy and generally the bane of other Communist countries, has been particularly impressive since the basic organizational structure of the commune was finally settled in 1962. By decentralizing a good deal of control over planning and management of labor and crops from the commune to production teams of perhaps a few dozen families, by making each team rather than the vast commune the accounting unit for calculating collective profits and losses, by encouraging teams to become as self-reliant as possible, and by allowing peasant families to farm private plots in their spare time and to sell this produce in rural markets, the regime seems to have found an optimum "mix" between collective and individual incentives. This policy has enhanced production and efficiency, albeit at the price of allowing considerable disparities in income to exist among the peasants, contrary to the PRC's commitment to the principle of eliminating inequalities in income distribution. Yet, whether visiting communes selected by one's hosts, riding through the countryside by train or car, or observing peasants who have come to the city for marketing or recreation, the visitor to China is struck by the fact that the rural people he sees appear to be living above subsistence level. They look healthy

and adequately fed, their clothes are simple but in decent condition, and they are generally quite clean. To most Americans this may not seem such a great achievement, but to those familiar with the desperate poverty, ubiquitous beggars, and disease-ridden homeless of the pre-1949 Chinese countryside, the contrast is vivid.

Perhaps the PRC's most impressive achievement affecting agriculture has been its water-conservation policy. In areas of heavy rainfall, such as the southeast, great progress has been made in controlling floods and reclaiming swamps. The mobilization of manpower made possible by the communes has also been responsible for extensive irrigation projects, which have transformed arid areas such as the plains of north-central China into fertile soil. Thousands of wells have been drilled in water-short areas, more and more pumping stations dot the landscape, and mammoth aqueducts have been built. If Peking undertakes the expensive task of harnessing the rivers of the north for irrigation purposes, further agricultural advances may be made.

As China reaches the limits of boosting crop production through greater use of chemical fertilizer, expansion of cultivable acreage by terracing and other reclamation techniques, and more extensive double and triple cropping, increased use of scientific methods and mechanization of agriculture will become more important. It is unclear to what extent improved seed strains and insecticides and other new scientific inputs can enhance agricultural prospects. What is clear is that China is still a very long way from mechanized farming, as visitors to the countryside cannot fail to note. Draft animals are everywhere, and only occasionally does one see a tractor.

Yet tractors are coming, if only gradually. China's industrial production, which was quite spectacular from 1949 to 1957, slumped during the next decade under the impact of the Great Leap Forward, the sudden withdrawal of Soviet experts, and the Cultural Revolution. By 1973, however, it had become apparent that those events only slowed growth temporarily and that China's long-range accomplishments continued to be impressive. For example, in 1972, which was not a good year, total steel output was 23 million tons, over four times the 1957 figure. Chemical-fertilizer production had increased over thirty times during the same period. The era of foreigners providing "oil for the lamps of China" had plainly ended, as 1972 petroleum output soared to 29 million tons, over sixty times the 1957 figure and more than enough to make China self-sufficient in oil. By early 1974, as the world

energy crisis deepened, Chou En-lai casually claimed that China's annual production of oil had reached 50 million tons. Although the country continues to be short of electricity—even urban homes are dimly lighted—the electric-power industry has burgeoned. It now produces more electricity in a few days than in the entire year 1949. Particularly impressive has been the increase in power supply in rural areas, where electricity consumption has multiplied more than fourfold since 1965. No longer able to rely on the receipt of Soviet weapons, the PRC, through massive budgetary allocations, has become a major producer of nuclear weapons, missiles, and conventional armaments. Substantial gains have also been made in machine tools and certain light industrial products, including some consumer items such as bicycles and cloth made of synthetic fibers.

As in agriculture, more than a decade of experimentation finally resulted in the evolution of an effective organizational structure for industry. Having learned the drawbacks of both extreme centralization and extreme decentralization, the regime finally lodged economic authority in provincial and county planning and control organs. Perhaps the most distinctive feature of China's industrial development is the increasing reliance on thousands of small rural firms that produce goods of many types but principally iron and steel, cement, chemical fertilizer, coal and electricity, and machinery and simple tools. It is true that this development originated in fiascoes such as the "backyard furnace" movement of the Great Leap Forward, but these experiences introduced millions of Chinese peasants to industrial technology. Recent experience with rural factories seems to make economic sense, and these factories are also instrumental in breaking down the barriers that exist between city and countryside. Every commune now has a variety of industrial activities. Another important manufacturing development of which the Chinese are proud is the proliferation of workshops and small factories that housewives have organized according to local initiative in urban areas.

The respectable economic performance by the world's most populous country—now over 800 million people—has kept China's growth in production ahead of her growth in population. The latter, in part reflecting a declining death rate as a result of improved health conditions and the absence of war and famine, remains at about 2 percent per annum, despite a relentless and efficient family-planning campaign that seeks to penetrate the grass roots except in underpopulated areas.

Great progress has been made in reducing the birthrate in the cities, where it has fallen to roughly I percent or even significantly less, as in Shanghai. But the challenge persists in the countryside, where traditional preferences for male children continue to stimulate larger families. Gradually, however, even rural areas should feel the impact of intense educational and social pressure. Especially effective have been the efforts of women cadres who convene group meetings of the women in every neighborhood or work unit so that the group can discuss the importance of birth control and agree on a specific plan for limiting the number of children per family in accordance with maxims such as "one is fine, two is all right, three is too many." The most popular birth-control technique in the cities is the oral pill, while intrauterine devices predominate in the countryside. All contraceptives are issued free or at a nominal charge, and usually women can be sterilized and men vasectomized at no cost. Unwanted pregnancies are commonly terminated by legal abortion. The most effective birth-control technique, of course, is abstinence, and the People's Republic has sought to maximize it by pressuring young people, not always successfully, to postpone marriage until their mid- or late twenties and to refrain from premarital intercourse. Frequent propaganda campaigns warn those who seek early marriage that, wittingly or not, they have fallen "under the evil influence of the counterrevolutionary line of Liu Shao-ch'i and other swindlers." The entire subject of sex is not an easy one for Chinese to discuss with foreigners, and even voluble cadres often become reticent and embarrassed when questions arise.

The long-range increase in per capita production has largely consisted of growth in the producer-goods sector, but statistics since 1963 reveal a modest increase in the per capita availability of consumer goods. Because manufactured consumer products that are dependent on agricultural raw materials have grown at a rather low rate compared to most industrial products, cotton cloth continues to be rationed throughout the nation, as are cooking oils and grain. Occasionally other items in short supply, such as meat, are rationed locally. Large volumes of certain products, such as sewing machines, watches, bicycles, toys, and some liquors and foods, are allocated to the export market. Such items tend to be available on the domestic market only at very high prices or with special permission. Although many Chinese families manage to purchase these products, theirs is certainly not a consumer economy. People use public telephones, which are located in every neighborhood. If they watch television, they do so on sets located in schools, factories, and communes. And they have to shop daily because they lack refrigerators.

Yet, unlike the situation "before liberation," as the Chinese frequently point out, today everyone is assured of the basic necessities of life. The markets in areas one can visit are often heaped high with beautifully displayed vegetables and rather expensive fish and chicken. Although cooking oil has to be carefully husbanded and cotton-cloth allotments permit only about one new outfit a year, grain seems to be amply rationed and inexpensive.

Expense, of course, is a relative matter. By American standards an ordinary industrial worker's salary of perhaps sixty yuan per month (not quite \$30) is infinitesimal. But families usually have more than one breadwinner, there is neither a personal income tax nor a sales tax, rent including utilities is only a few yuan per month, and transportation, education, and medical care are available at nominal cost. Frugality is absolutely necessary to make ends meet, however, for tea may cost three yuan per pound or more, and a pound of pork may be only slightly under one yuan. Nevertheless, many families, encouraged by China's lack of inflation, manage to save money and deposit it in a savings account which earns interest of roughly 2 to 3 percent per year. These savings finance the occasional purchase of a major item such as a bicycle or a sewing machine, which costs perhaps 140 yuan, or a watch that costs at least 100 yuan.

There is little danger that China will seek to emulate the automobile-dominated culture of the United States. Although privately owned bicycles seem to be everywhere, there are no private automobiles. The relatively few cars one sees, some made in China and others abroad, are for government or collective use. In the cities a modest number of taxis is available, but they are expensive. Buses, trucks, and other motor vehicles are also in short supply, as are railroad cars and airplanes. One of the reasons why the People's Republic has increasingly established small factories in rural areas is to minimize the transportation burden of distributing manufactured goods to consumers. Because the Chinese make do as best they can, walking is very much in vogue, people as well as beasts still pull carts in city and countryside, and "carrying water on both shoulders" is not a figure of speech but a familiar sight. China continues to rely on internal transport via rivers and canals and even imports large quantities of foreign grain by ship to relieve the burden of transporting domestic grain from

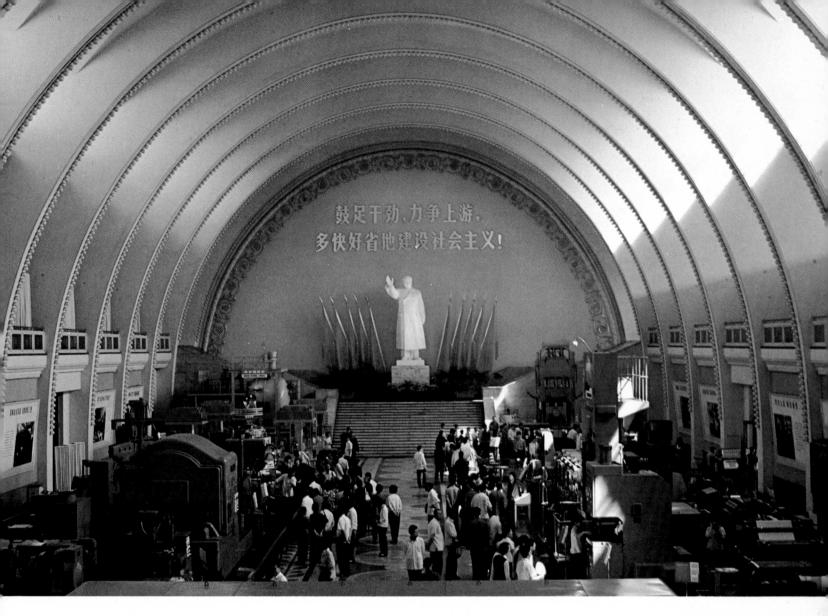

298. Shanghai Exhibition Hall.

Against a red background
featuring red flags, a large
sculpture of Chairman Mao,
and his exhortation to "go all
out, aim high, produce more,
faster, better, and more
economically to build Socialism,"
visitors inspect the machinery
produced in People's China.
In adjoining halls a wide range
of Chinese products is displayed.

the western part of the nation to the populous coastal areas.

Housing is one of the regime's sore points. Everyone now has a roof over his head, and this achievement must not be underestimated. Yet despite serious construction efforts, many families continue to live in crowded conditions. The visitor who strolls into the alleys a few paces from the main thoroughfares of Canton will see conditions that evoke the Middle Ages. Many charming courtyard residences in Peking and other cities have been subdivided among several families. New housing in the cities has often been constructed as part of new factory complexes, the long multiple-entry, four-to-five-story, red-brick buildings resembling public-housing projects in the West. A typical post-1949 building will have four walk-up apartments on each floor of an entry, with a bathroom and kitchen shared by two apartments. A family of four or five may have one or two rooms. Space is at less of a premium in rural

areas. Peasant families, like some city families, often live in individual one-story wattle-and-daub, brick, or cement houses with tiled or thatched roofs. These houses have several rooms and frequently open onto a small courtyard that may be shared with another family. Some of the new housing in communes consists of two-story buildings divided into four to eight individual duplex units. In some places in arid north-central China people still live in caves that have been converted into simple homes. In the cities most houses as well as apartments are owned by the state, which leases them at rents calculated according to floor space. In the countryside private ownership of houses is widespread, although the land on which the houses stand is, of course, collectively owned.

Perhaps new China's most widely acknowledged and least controversial achievement is in medical care. The world is now familiar with, and even beginning to benefit from, China's development of the ancient art of acupuncture in place of chemical anesthesia for certain types of surgery. Visitors never fail to be impressed when, thanks to acupuncture, babies are delivered by cesarean section or tumors are removed while the patient remains awake but free of pain. In recent years progress is said to have been made in aiding the deaf through acupuncture and in perfecting its other, more traditional applications. Chinese media have also given great publicity to the accomplishments of surgeons who have successfully restored severed limbs, and of medical researchers who have succeeded in synthesizing insulin.

Yet China's gains in organizing the delivery of medical services and the spread of preventive public-health measures, though less spectacular than her well-known medical feats, are undoubtedly more important in the long run. Not only do a variety of large and small urban hospitals offer competent treatment for the range of serious human ailments, but city neighborhoods have easily accessible health stations staffed by paramedical personnel who treat emergencies and minor problems, give vaccinations, and dispense advice and contraceptives. Larger factories also offer medical care. More remarkably, this system has been extended to the countryside. Production brigades and some production teams have paramedical personnel, called "barefoot doctors." They operate modest health stations or often clinics that provide outpatient care and sometimes hospitalization, and a commune headquarters generally has a small hospital. Serious cases are often sent to larger, more specialized medical facilities in the county seat or provincial capital.

299–302. The transportation system that the Chinese Communists inherited was extremely inadequate. They have made slow but steady progress in improving the situation, yet human power is still a basic means of moving materials from one place to another.

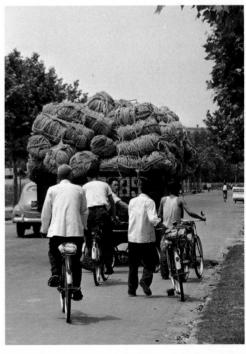

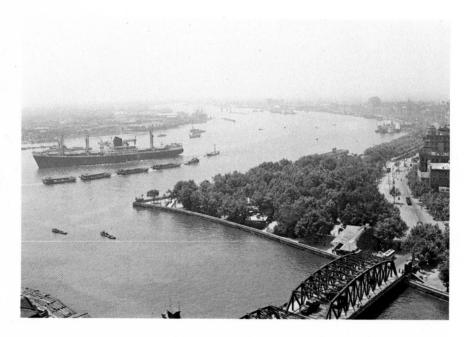

303-5.

Above: Barges on the Wu-sung (Soochow) River in Shanghai. Shanghai is not only China's largest city but also its greatest industrial and commercial center. China's inland waterways are vital parts of the national transportation network and are crowded with all kinds of boats. Center: An oceangoing freighter on the Huang-p'u River in Shanghai. Although now self-sufficient in food production, China continues to import foreign grain into its coastal cities rather than impose too great a strain on its internal transportation system within China. Below: Carrying water cans on a pole continues a time-honored tradition.

Both Western and traditional Chinese medical practices are used, depending on the nature of the problem and, at least in the first instance, on the preference of the patient. Perhaps the most notable aspect of the system is that the cost of medical services is very low, even in Chinese terms. Thus, medical care is now more readily available to the ordinary people of China than ever before. This and endless health-education campaigns and organized attacks on unsanitary conditions, such as the legendary fly-swatting movement of the late 1950s, have made China a healthy place, despite the existence of primitive economic conditions. One notable accomplishment, for example, is the almost complete obliteration of venereal disease, which was made possible by the regime's stern measures, shortly after it assumed nationwide power, to suppress prostitution. The conquest of schistosomiasis, or snail fever, has proved more elusive, but China's doctors and scientists hope to meet this challenge before long and even talk confidently of finding a cure for cancer. The country still has a long way to go in improving the quality of rural medical practice, and it urgently needs to increase the number of its medical schools (fewer than forty in operation). Yet progress to date has been impressive.

The educational accomplishments of the People's Republic present more of a mixed bag. It has made enormous progress in reducing illiteracy in a population where few could read and write prior to 1949. By reducing both the number of Chinese characters used in publishing and the number of strokes in writing the characters, it has facilitated the success of massive adult-education programs. In what may well be the most impressive quantitative expansion of education the world has known, the PRC is approaching its goal of universal primary and lower-middle-school education. Two decades ago only 20 percent of school-age children attended primary school, while now over 80 percent do, despite a massive increase in population. Whereas formerly even an elementary education set a person apart, now most children advance to lower middle school, and their parents need pay only a few yuan per year for tuition and books. In this respect, as in others, change has been slower in remote rural areas, particularly those inhabited by minority nationalities.

Because mothers have been recruited into the labor force, many urban children and some rural ones as well, before they reach kindergarten, spend much of their time first in nurseries and then in nursery schools. Some return home every evening, while others board throughout the week. This prepares them for what is to come, socializing them in a collective atmosphere

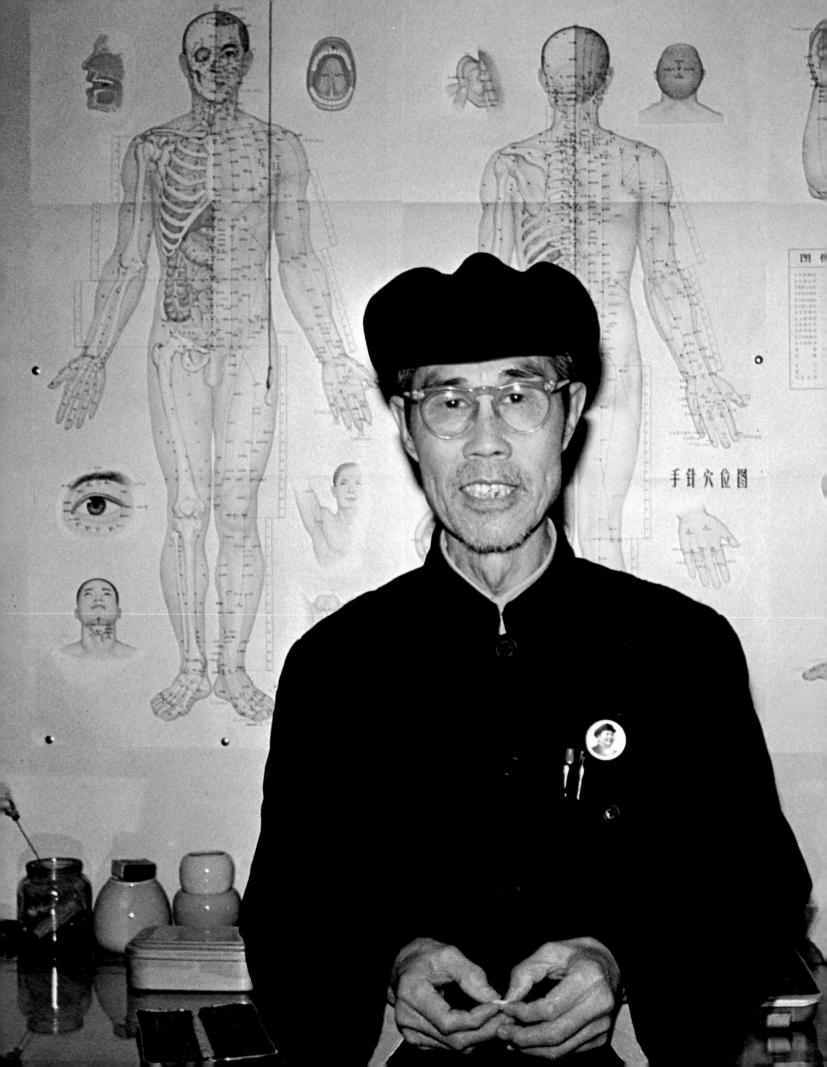

306-8.

Opposite page: Medical worker at a neighborhood clinic in the basement of an apartment block in the Eastern District of Peking. Behind him are the charts that guide his application of acupuncture for the treatment of various ailments. One of new China's outstanding achievements has been the extension of low-cost, competent medical care to the masses. A combination of traditional Chinese and Western medicine is used. Above: Medical worker at a neighborhood clinic applies acupuncture to the leg of a smiling resident. Below: A Young Pioneer learns to find the "pressure points" for acupuncture treatment by practicing on herself. She is attending an acupuncture class at a Shanghai "children's palace."

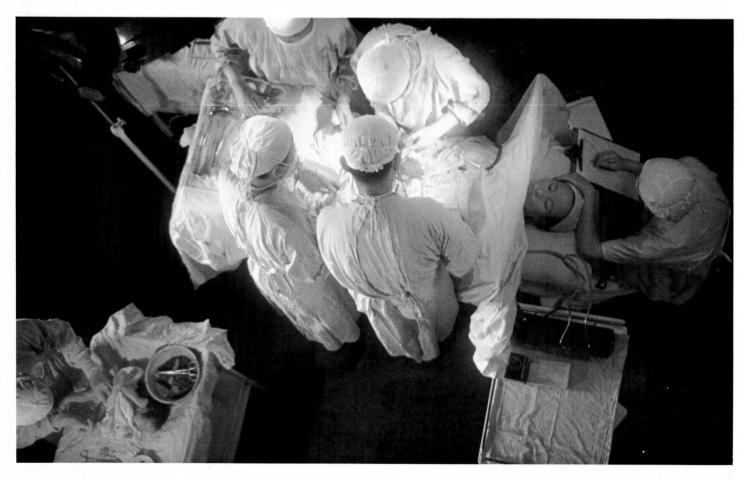

309, 310. Far left: Patient about to undergo surgery to remove a cranial tumor. The operation was successfully performed, with by the staff of Teaching Hospital No. 2, Chung-shan Medical College, Canton (Kwangchow). Left: A doctor points out the cranial tumor being removed by surgery. Drills were used to cranium. A fiberglass plate was inserted to replace the section removed.

the aid of acupuncture anesthesia, cut out the diseased section of the suffused with patriotism, political indoctrination, concern for the welfare of the group, and conformity. This orientation persists through their formal schooling, which emphasizes reading, writing, arithmetic, science, and arts and crafts, as well as political study and group activities that make useful contributions to society. For example, even nine-year-olds march to the fields to help with the harvest, often with festive songs and chatter that give their excursion a holiday air.

Most Chinese children do not go beyond lower middle school. At age sixteen they take up full-time work at farms or factories. Perhaps 20 percent have an opportunity to attend upper middle school, where they continue with math, sciences, and politics and study a foreign language, now increasingly English, and world history. In keeping with Chairman Mao's maxim that education should be combined with labor so that students acquire production as well as book knowledge, students at these schools spend a few months each year in practical work inside and outside their school, applying what they have been taught. Many schools have workshops that manufacture chemicals, for example. Schools also feature a variety of sports and musical drama and dance programs with explicit political themes.

Given the facts that lower-middle-school education has vastly expanded and that education has traditionally constituted the most prestigious ladder to success in China, the limited opportunity for upper-middle-school education has become a point of tension. This seems especially to be the case since the Cultural Revolution, which increased the numbers of workers' and peasants' children attending such schools to the detriment of the children of Party and government cadres, intellectuals, and the former favored classes. Many disappointed parents have had to take extra doses of "thought reform" to reconcile themselves to the early termination of their children's education. That those students who do attend upper middle school usually display a high degree of ideological enthusiasm is hardly surprising. Their selection was importantly influenced by their previous political and moral behavior, and they tend to appreciate not only their present opportunity but also the importance for their postgraduation plans of continuing to be well regarded. More than one foreign visitor has been struck by the uniformity of responses when questioning students about future occupational ambitions. "I will go wherever the Party and Chairman Mao send me" is usually their first answer. However little this may reveal about their true prefer-

◀311. Using acupuncture anesthesia, doctors deliver a baby by cesarean section. The baby is on the table at the left. The mother is being sewn up on the right. This is a frequent occurrence at Teaching Hospital No. 2.

ences, in view of the process by which labor is allocated in China it is at least an accurate prediction.

There are other educational rewards for youngsters who demonstrate a high degree of political consciousness. Urban centers offer "children's palaces" for the extracurricular training of select groups. There, red-neckerchiefed Young Pioneers, the political vanguard of the primary schools, and their elder brothers with red armbands, the Red Guards, now a middle-school honor group, benefit from instruction in applied sciences and a host of performing, manual, and athletic arts. Colorful group dancing, marching, and other exercises with martial overtones are a prominent feature of these programs. Despite the Maoist slogan of "self-reliance," in artistic activities the emphasis is on precise duplication of prescribed models rather than on independent creativity.

While lower levels of education have expanded rapidly and to the satisfaction of the leaders in Peking, higher education has proved to be a continuing headache. The Cultural Revolution put an end to China's efforts to emulate the Soviet model of universities as elite centers where the most academically qualified students learn to become the technical specialists required by industrial society. Liu Shao-ch'i and his followers were willing to tolerate the emergence of a "new class" in China as the price of modernization, but Chairman Mao was not. Yet when universities began to reopen in 1970, after being closed for four years during the successful struggle to overthrow Liu, they encountered serious difficulty in implementing Mao's vision of proletarian education. At first, curricula were sharply reduced in duration by excising "irrelevant" academic subjects and concentrating on practical and applied courses, but by 1973 the curricula were being reexpanded, because the originally planned shorter programs did not afford enough time for teaching the knowledge required. For example, in 1970 Shanghai's two colleges of Western medicine reduced medical training from six years to two, but in 1973 they found it necessary to introduce a three-and-a-halfyear course that placed greater emphasis on the basic sciences. Similarly, students were supposed to be spending half their reduced university programs in manual labor, but, without fanfare, this was gradually reduced to significantly smaller proportions that allowed them more time to study. The requirement that middle-school graduates engage in full-time labor for at least two years before being considered for college admission has also begun to give way; colleges have discovered that students forget so much in the intervening period that it is almost necessary for them to begin again in certain middle-school subjects.

Admissions standards and procedures have become a particular battleground. Mao's insistence on a student body that is largely composed of workers, peasants, and soldiers, who have been recommended by their units on the basis not of their academic quality but their political orthodoxy and hard work, has filled institutions of higher learning with people who are unprepared for advanced study. In some cases this has led to the reimposition of entrance examinations, sometimes euphemistically described as "investigations of cultural knowledge" or "reference materials." That in turn has brought down the wrath of the radicals, who maintain that applicants should be evaluated on the basis of their moral, intellectual, and physical attributes and not on tests of how well they have memorized their middle-school textbooks. Propaganda organs approvingly gave nationwide publicity to a note written on a college-entrance examination by an "educated youth" who for five years had been laboring eighteen hours a day on a rural production team and thus had had no time to prepare for the test. On an otherwise almost blank answer sheet the youth wrote:

To tell the truth, I have no respect for the bookworms who for many years have been taking it easy and have done nothing useful. I dislike them intensely. During the busy summer hoeing time, I just could not abandon my production task and hide myself in a small room to study. That would have been very selfish. If I had done that, I would have been guilty of being unworthy of the revolutionary cause which concerns both the poor and lower-middle peasants and myself, and I would have been condemned by my own revolutionary conscience.

I have one consolation. I have not slowed the work of the collective because of the examination. (*People's Daily*, August 10, 1973.)

A similar debate is raging over the utility and significance of examinations concerning the subject matter of the various college courses. In late 1973, Chinese press dispatches announced that students in the third and last year of the newly revised curriculum at Peking University were not required to take written final examinations. Instead they were permitted to fulfill requirements by lecturing to labor groups or by producing reports describing their experiences during three months

312-14. Right: Toddler in a day-care nursery run by a neighborhood residents' committee in the basement of an apartment block in the Eastern District of Peking. If mothers work and no grandparent is available, infants may be enrolled in nurseries two months after birth. Opposite page, above: Nursery school in Pei-hai Park in Peking. Youngsters board at this school. Parents take them home whenever they have a day off from work; below: An English class at Middle School 26, Peking. English-language lessons are often based on translations of Chairman Mao's "Thought" and Communist Party ideology.

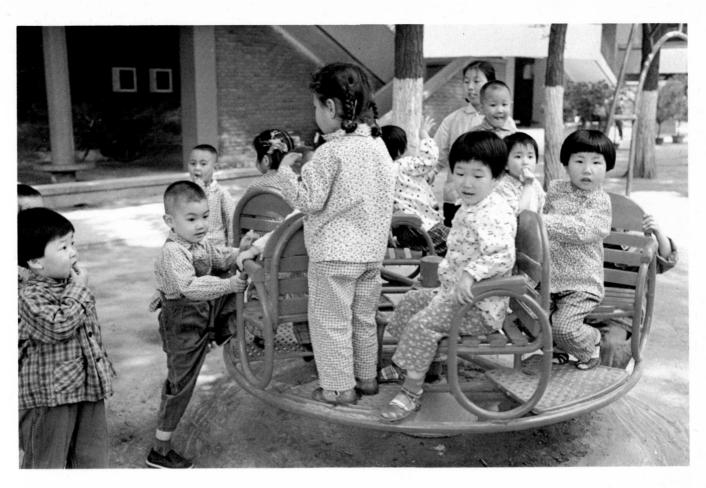

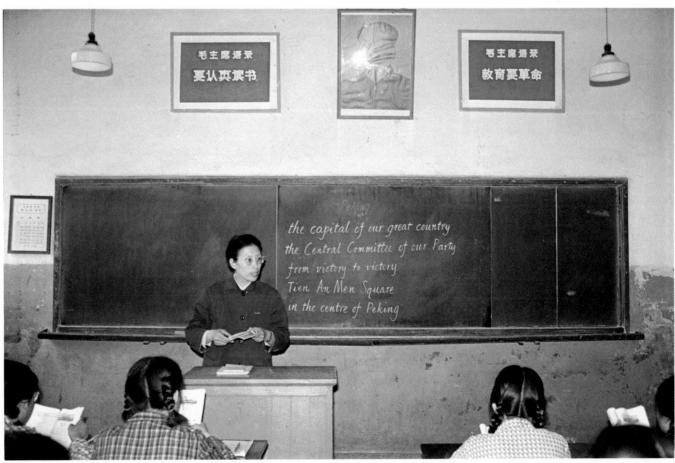

315-18. Left: Jars of calcium chloride manufactured by the students of Middle School 26, Peking, stand outside the schoolyard workshop. Each student is expected to engage in practical labor for two months a year, putting into practice what has been taught in the classroom. Right, above: Young Pioneer learning woodworking at a "children's palace" in Shanghai. Center: Young Pioneers learning how to braid plastic thread into flowers and animals at a Shanghai "children's palace." Paper cutouts are displayed under glass on the table. Standard approved designs for plastic objects and paper cutouts are given to schools and clubs all over China. Below: Experiment under way in the physics laboratory of Peking University.

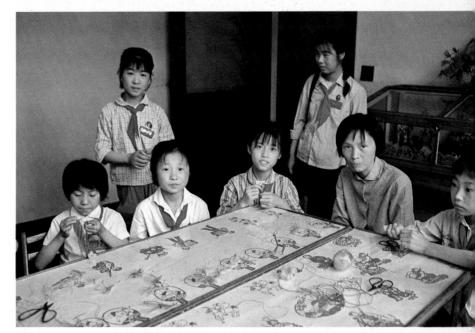

of work on farms or in mines, factories, or research institutions. For example, led by a miner with twelve years' experience, a group of twelve students in economics went to the An-yuan coal mine near Peking and delivered a series of lectures to the miners on aspects of China's political economy. They benefited from the suggestions of the miners both before and after the lectures. When the students completed their stint, the workers commended them for contributing to production and for "helping Socialism triumph over capitalism." A dozen workers who accompanied the students back to Peking told university authorities: "We think these students are up to standard." These new student exercises were praised as better than the old-style examinations based on book learning, because they deal with urgent problems and the research is conducted in actual conditions. Similarly, new texts developed through the cooperation of students and teachers were said to be superior to their predecessors, which had failed to link practice with theory and had been based on foreign ideas, including a Europe-centered view of history that concealed the class struggle.

Higher education is still in a process of transition, as university authorities continue to experiment with ways of reconciling Maoist principles with the need to impart the academic knowledge that their graduates must have if they are to cope with China's problems. Until educators acquire greater experience with current experiments, they seem reluctant to enroll more than a fraction of the number of students taught by their institutions prior to the Cultural Revolution. The fact that there are so few opportunities has, of course, sharpened the controversy over who should receive university education and has undoubtedly spread dissatisfaction among Party elite, cadres, intellectuals, and others who no longer find it possible to assure their children a higher education. It also raises the question of how great a handicap China, which last graduated large numbers of scientists, engineers, doctors, economists, and other specialists in 1966, will suffer from its failure substantially to replenish the supply of experts during the intervening years.

One should not exaggerate the limited nature of recent academic training, of course. It seems probable that a small number of the ablest young science students continued to be trained at research institutes even during the Cultural Revolution, and some important applied scientific research has continued to take place. Yet even if the People's Republic should adopt a policy of relying principally on basic research

done abroad rather than investing heavily in the expensive process of further developing its own, it will need to train many more scientists capable of assimilating and applying the imported data, if only to replace those who are gradually dying off.

Assuming that the leadership can identify China's needs for highly educated personnel and arrange to fill them, one can sympathize with the importance it attaches to creating an educational system that is open to the masses and in close contact with them, and that sends most of its graduates back to "serve the people" in the units that nominated them for advanced learning. Such a system will solidify the egalitarian values from which the People's Republic derives much of its internal cohesion. Moreover, given China's stage of economic development, it will make no sense to "overeducate" large numbers of students to fill positions that do not or should not exist.

Yet the most profound doubts about the PRC's policy for educating scientists and other necessary specialists are precisely those that apply to its entire academic effort and to the nature of the Chinese Communist polity itself—the ideological orthodoxy that precludes individuality, creativity, and free inquiry. At some stage of China's development, the gains that accrue from the singleness of ideology and purpose that has done so much to speed the country's modernization will be outweighed by the costs, even if one confines the calculation to the impact on productivity. As the Soviet Union has discovered in the post-Stalin era, the complex problems of managing a modern economy become increasingly difficult to solve in the absence of freedom to acquire information and exchange ideas.

Whatever the problems of scientific and technological education, they pale in comparison to those that most of the social sciences, the liberal arts, and the fine arts confront today. It is no accident that foreigners usually have easier access to China's scientists than to scholars in other fields, and that scientific journals have made more of a comeback since the Cultural Revolution than have most others. Perhaps experimental university courses in subjects such as history, politics, literature, and philosophy generate more penetrating discussion than visitors discern, perhaps faculty members are engaging in more significant research than the absence of publications suggests, and perhaps prospects for intellectual life are brighter than the domination of the universities by the Party and the military and the stringent control over reading matter throughout

society imply, but at this point one can only remain skeptical.

Religion has been an obvious casualty of the Chinese Communist revolution. In 1949 there were only about 3 million Catholics and I million Protestants in China—less than I percent of the population. This situation contrasted sharply with that in Communist Eastern Europe, where the Church's hold was great. Moreover, China's churches were dominated by foreign missionaries, whom many Chinese patriots, non-Communist and Communist alike, had for decades believed to be political instruments of imperialism. Ideological principles reinforced the Communists' nationalistic hostility to Christianity, which they deemed incompatible with "scientific Marxism." After seizing nationwide power and severing foreign ties with China's Christian institutions, the Communists recognized that the new national churches thus created represented little threat to the government, except perhaps through subversion. Official policy until the Cultural Revolution purported to permit freedom to worship, as well as freedom not to worship, in accordance with the Constitution's guarantee of freedom of religion. Actually, however, explicit ideological opposition to religion, tremendous political and psychological pressures against those engaging in religious activity or revealing religious attitudes, a ban on religious instruction, and close control over the churches' hierarchies contributed to a withering of Christian influence. The Cultural Revolution put an end to all formal Christian worship as the remaining churches came under severe attack by the Red Guards, and only in recent years have a few churches begun to reopen, principally for the benefit of foreigners.

Although Buddhism claimed more adherents in China than in any other country and in earlier centuries exerted enormous influence on Chinese life, its fate has been similar to that of Christianity. Largely in order to win favor with the Buddhists of other Asian countries, the People's Republic spent large sums on the restoration of temples in the 1950s. During periods of relaxation such as 1956-57 and 1961-62, the temples were filled with worshipers, some of them youthful, who ran the risk of being accused of "feudal thinking." In 1963, however, the regime initiated a policy of eliminating religious activity that reached its climax in the sacking of temples during the Cultural Revolution. Since 1972, as part of Peking's resurgent "people's diplomacy," foreign visitors have again been permitted to visit some repaired monasteries and to meet Chinese Buddhist leaders. But there is as yet no evidence that ordinary Chinese are being allowed to worship or that the aging Buddhist monks are training successors. Rather, the monasteries are now being displayed to the masses as historic monuments that demonstrate the building skill and artistic creativity of China's laboring people in centuries past. Thus they serve both domestic and international politics by becoming "object lessons in history" as part of a post-Cultural Revolution revival of respect for traditional culture. Presumably, some Chinese families still practice Buddhist rites discreetly.

Some of the costs of contemporary China's achievements are not apparent to the casual observer. As previously indicated, one works where he is told. If he refuses, he will be "reeducated" and eventually forced to do so. Political dissent is not tolerated. Group social pressure makes it possible to give many individual acts a veneer of "voluntarism." The basis of the entire well-regulated society, however, is a public-security system that unobtrusively extends to every household and work site and that has subjected millions of people to a spectrum of efficient sanctions. This system has cut China off from the world and even from its own past, except on terms approved by the Party. It is the unspoken premise of social action.

Yet the coercive apparatus is not very much in evidence. In the cities one frequently sees soldiers on holiday or taking part in the labor force. But, except for guards at major buildings, airports, and railroad stations, the only visible sign of police control is the traffic cop on duty. Although one of the few smartly attired figures in China, he hardly symbolizes a police state. Trucks, buses, bicyclists, and pedestrians rarely seem to heed his flailing arms or shrill whistle. How, then, do the Chinese do it?

In the cities the "street revolutionary committee" is the primary level of government and is responsible for an area embracing as many as 65,000 people. In addition to cooperating with the public-security station for the area in settling interpersonal disputes and imposing sanctions against persons whose misbehavior is not serious enough to warrant treatment as "criminals," the salaried officials of the street committee lead or coordinate myriad local activities, including schools, medical care, sanitation, welfare, production, service facilities, and propaganda.

Each street committee is assisted by a number of "residents' committees," which are semiofficial organizations of perhaps seven to eighteen locally elected volunteers, who are mostly housewives and retired workers. A single residents' committee may be responsible for an area including several thousand

people. These people are in turn subdivided into small groups of about fifty persons, each group having an elected volunteer leader who is linked to the residents' committee.

Each of the dozen or so patrolmen assigned to a public-security station cooperates with one or more residents' committees in maintaining public order in a given area. Certain members of each committee are assigned the duty of protecting public order, mediating disputes, and generally acting as the eyes and ears of the police in every lane and apartment complex. The Communist Youth League, the women's organization, and other groups of volunteer "activists" also operate in the area. In recent years civilian militia groups, which have long been active in the countryside, have been organized into neighborhood patrols in the cities. This entire apparatus is usually directed by the Party, with the chief of the street committee often serving as first secretary of the Party committee for the area.

This thorough grass-roots network, which also reaches into factories and workshops, helps explain why Shanghai's formal police force is much smaller than that of the world's other major cities. It also helps explain China's progress in curbing crime since 1949. Of course, the People's Republic continues to be troubled not only by espionage and subversion but also by murder, rape, theft, and other conventional criminal activity. In insecure places people are careful to lock their bikes, and the bicycle stores in Canton even chain together the outermost bikes in each rack. Although seldom publicized, the most difficult public-order problems of late are the many "educated youth" who, unreconciled to the enforced resettlement in the countryside accepted by the majority, illegally return to the cities and become drifters.

The government has done much to bring down the crime rate by the vast improvements it has made in social and economic affairs, yet the contribution of the public-security network to this achievement should not be underestimated. Not only is it efficient in detecting interpersonal disputes and antisocial infractions, but it also plays an important role in disposing of them in a variety of ways.

Even though certain members of street and residents' committees are designated to look after mediation and public order, virtually everyone in the official and semiofficial network tends to participate at one time or another. For example, a dispute between tenants over sharing a bathroom or kitchen might be mediated by any residents' committee member, the small-group leader, or the group itself. Chronic quarreling

would be dealt with in a series of discussion and "study" sessions that involve not only street-committee officials, residents' committee members, family, friends, and the parties themselves but also representatives of the factories or other units where the parties are employed.

A petty thief might in the first instance simply receive some private "persuasion-education" or criticism from his small group. But if he failed to reform, he might be censured by a meeting of the entire neighborhood convened by the residents' committee. An especially recalcitrant offender might be made the target of intense verbal abuse at a "struggle meeting," stigmatized as a "bad element," and given one of several possible forms of compulsory labor by the public-security apparatus. The situation is similar in the rural communes. Every production team has people who participate in security and mediation work under the direction of production-brigade and commune personnel, who in turn work with the county public-security bureau and its agents.

An effort is made to reduce the risk of arbitrariness in imposing sanctions, which, although nominally "noncriminal," are recognized as being severe. Before subjecting someone to the humiliation of being censured at a public meeting, for example, it is said that the leaders of a production team or brigade must obtain the approval of commune officials. And prior to stigmatizing a person as a "bad element" or counter-revolutionary, commune leaders are supposed to clear their

proposal with the county public-security bureau.

The role of the judiciary in the sanctioning process is rather small. Most civil disputes never reach the courts. Occasionally, however, if mediation of a divorce case proves ineffective, and if one of the parties is dissatisfied with the decision of the street committee or commune to grant or deny divorce, the dispute may be taken to court. The work of the courts is largely confined to a closed-door review of cases serious enough to be denominated "criminal." Operating under the control of the local Party apparatus, the court has the final say in determining whether the accused is guilty and whether he should be sentenced to prison, to "reform through labor" in a remote labor camp, or to death. Yet it is the public-security force, guided by the Party and, since the Cultural Revolution, by the military, that assumes the major responsibility for criminal cases. It decides whether to charge someone suspected of a serious offense as a criminal or whether to subject him to "noncriminal" sanctions that can include "rehabilitation through labor" in a labor camp. It recommends the appropriate sentence in criminal cases, and it determines whether to announce the sentence at a "mass trial" before a throng of onlookers.

To Westerners, especially to Americans, and even to citizens of the USSR and East European Communist states, perhaps the most striking aspect of the legal system in China today is the virtual absence of practicing lawyers. When questioned in the mid-1960s about whether there were lawyers in China, a Chinese diplomat who had just defected to the West uncomprehendingly replied: "What do you think China is the Soviet Union?" An independent legal profession has little support in Chinese tradition, and the official view today stresses the meddlesome, obstructive, divisive aspects of lawyers, much as China's emperors inveighed against "litigation tricksters." Also quite unusual from our perspective and that of the Soviet bloc is the extremely limited body of published legislation. A frequently ignored Constitution and a handful of vaguely worded laws that were promulgated during the regime's earliest years provide less guidance to the populace than do received notions of right and wrong supplemented by the "Thought" of Chairman Mao and the current Party line enshrined in the *People's Daily*. The "rule of law" has never been held in high regard in China, which today, as in the past, is preoccupied with ethical principles and behavior.

One legal innovation of which Chinese judicial authorities claim to be proud is the suspended death penalty. In many, but far from all, capital cases execution is postponed for two years to allow the convicted criminal an opportunity to demonstrate his capacity for rehabilitation. If he makes satisfactory progress during this period, his sentence will be commuted to life or fifteen years in prison. The Chinese call this a humanitarian measure that is highly successful in stimulating reform and saving lives.

How should one evaluate the contemporary legal system? Plainly, its emphasis on extrajudicial institutions builds on the traditional Chinese preference for local groups to deal with their own affairs and to conserve the resources of the state. But the contemporary system has adapted past practices to revolutionary needs. The grass-roots neighborhood organizations not only provide the parties to a dispute with inexpensive and relatively speedy means of resolving it but also indoctrinate them and the community in Communist moral and legal norms. Similarly, familiar methods of group pressure and social ostracism have become powerful instruments for inculcating the new values.

From the perspective of the regime, the system appears to work well. For individuals it surely has much to commend it in the resolution of civil disputes, although fairness to politically disfavored persons is not always assured. But from the perspective of many educated Chinese, even taking into account the extent to which individual rights have always been subordinated to those of the group and the state in China, the criminal process appears increasingly unsatisfactory in direct proportion to the severity of the sanction imposed. The accused is at the mercy of his accusers, whose guiding maxim is: "Leniency for those who confess; severity for those who resist." No independent authority is allowed to intervene in his defense. The following account of contemporary interrogation techniques is typical:

The judge spoke to me at great length and, in my opinion, his discourse is of capital importance if one wishes to understand penal procedure such as it is practised in China. Moreover, as with all prisoners, foreigners and Chinese alike, it was repeated to me over and over again. I expected to be accused of specific acts: I would have denied or confessed, or would have explained myself according to the circumstances. But such was not the case.

The judge said to me: "If you have been arrested, it is not without reason, for the government acts always in the right. It has observed your anti-revolutionary activity for a long time. It has gathered the witnesses and the accusations necessary. It is, therefore, certain that you are guilty. Two paths lie open to you: either you confess your crimes, whereupon the government will be able to act with extreme clemency toward you, because, although judges previously had to pass sentence in accordance with the former procedure based on the code, we are now able to act with clemency. Or, on the other hand, you refuse to confess, thus resisting the government, in which case the severest of punishments awaits you."

I naturally declared my innocence and asked of what crime I was accused. I received the characteristic reply: "you are not to ask questions. You are to accuse yourself." And this statement subsequently became the basis and the tenor of all the procedure to which I was subjected. . . .

One day, the judge, indicating a thick package of papers, said to me: "I have a pile of accusations against you as high as that." I asked who my accusers were. He then replied: "You do not have to know them. You must simply confess." (André Bonnichon, Law in Communist China, p. 24.)

How the masses of people regard the process is something that is difficult for an outsider to determine, but neither in theory nor in practice have they ever been significantly exposed to the virtues of an adversary rather than an inquisitorial system.

Much the same can be said about the lack of free speech, inquiry, and creativity. Obviously hundreds of thousands of scholars, intellectuals, writers, and artists must be profoundly unhappy about the political and cultural restraints, and the consequent uniformity and mediocrity, that have been imposed on them. And the minority of bourgeois, landlord, official, and other families that enjoyed the benefits of pre-1949 China has also suffered greatly. Yet many from these former privileged classes have adjusted to, and some even welcomed, the revolution as necessary for "the greatest good for the greatest number." The masses, of course, have suffered no similar deprivation and are much less sensitive to the absence of Western individualism and liberal democracy. They undoubtedly place a higher value on the regime's accomplishments in guaranteeing them jobs, food, shelter, clothing, health care, protection against inflation, and freedom from bandits, warlords, and imperialists.

From our distant vantage point it is not easy for Americans, the world's most voracious consumers, to keep in mind the satisfactions that China's much simpler life can hold for the common people today. Although Spartan, it is far from unrelieved drabness. The one day off per week that urban workers receive might be spent visiting relatives or going to a park or zoo, a cultural or historic monument, or a concert, movie, opera, or variety show. Rural people have less frequent access to such diversions, especially during the busy seasons when little time can be spared from agriculture. But mobile film units, entertainment by local groups, and other events break the tedium, and trips to the city can occasionally be made during slack periods. Younger people everywhere are avid sports enthusiasts, and basketball, Ping-Pong, volleyball, and gymnastics are particularly popular. Chinese of all ages like to be spectators at frequently held athletic events.

Work days are busier, of course, but, despite political, neighborhood, and family obligations, there is still time for Chinese chess, card games (mahjong and gambling are prohibited), and gossip. The visitor to China in recent years has found the pace of life more relaxed than in Hong Kong, Japan, or the West. Some people begin the day by practicing a traditional series of slow rhythmic movements called *t'ai-chi-ch'üan*. or by

performing a variety of more martial exercises. Jogging and calisthenics are common. Young couples go for walks in the evening and, despite the Party's puritanical strictures, lovers can occasionally be seen embracing in the shadows in parks or along river banks. In China privacy is a scarce commodity, especially during the searingly hot summers. One popular pursuit for Chinese men at any hour is sitting with a few friends at their favorite wine shop, sipping beer, sweet wine, brandy, or a fiery sorghum distillate, while nibbling assorted cold snacks. There is no "night life" to speak of in the Western sense, and to conserve electricity most people go to bed by ten o'clock and rise by six.

The success of the People's Republic in restoring China's unity and independence has been a major source of satisfaction to all the Chinese people. The theme that "China has stood up" against imperialism and modern revisionism after a "century of humiliation" has continued to elicit the support of the masses. National pride marks all Chinese contacts with foreigners, as a British shipping executive discovered. A Chinese ship en route from Shanghai to Japan was destined to call at Hong Kong. Eager to load freight on the ship, the executive repeatedly cabled Shanghai from Hong Kong asking about space but received no reply. Finally, in desperation, he cabled: "Imperative. Must know today." This drew an immediate response from his Chinese counterpart: "Imperative an imperialist term. Please rephrase." The sense of nationhood is enhanced by instilling pride in China's past as well as her present. To this end many historic monuments have been repaired, and excellent exhibitions of archaeology and traditional art rival displays of contemporary "people's art."

Another major factor contributing to national unification is the progress that has been made in spreading a single spoken language over the entire country. Although local dialects continue to be very much in use, and many older people have failed to learn p'u-t'ung-hua, "the common language," or Mandarin, as Westerners call it, oral communication has been greatly facilitated. And newspapers, theater, radio, television, films, and other media have combined with the expansion of literacy and education to create a new political culture.

China has instilled in its people not only a sense of nationhood but also a sense of national purpose. Today's Chinese preach and practice helping one another to improve skills through informal teaching, criticism, and discussion—all in the name of Socialist construction. Although local affairs are coordinated from above, the Party continues to make "self-

reliance" its motto and enlists the masses in all kinds of activities that range from keeping residential areas spotless to participating in local decision making on various problems. Its skill in communicating the satisfactions of collective effort to "serve the people" and to "defend the motherland" will be important for many years to come because of China's continuing need for massive applications of manpower to compensate for what is lacking in mechanization.

Although there are psychic incentives for everyone to work hard and material incentives for many, morale is also sustained by the fact that no new wealthy classes have been allowed to develop. Unlike other less developed countries, China has sought to achieve rapid economic growth while eliminating inequalities in income distribution. Substantial progress was made in reducing disparities during the 1950s. But the pace was slowed in the 1960s out of deference to economic growth. Some factory and farm workers earn three or four times more than others, and top administrators, scientists, educators, and other leaders may earn even more. Yet China remains committed to the equalization of incomes.

Egalitarianism is also implicit in the measures adopted by the Party to bridge the vast gap between urban and rural life and between intellectual and manual labor: the assignment of educated youth and other city people to life in the country-side; the "May 7th Cadre Schools," at which officials and educators "learn from the peasants" by combining agricultural labor with ideological study for periods of a year or more; the preference given to workers, peasants, and soldiers in education; and the efforts to integrate higher education with production.

Traditionally, the social distance between the educated elite and the ordinary people was enormous. Today in China, except for the privileged treatment given foreign guests, human relations seem gradually to be becoming more egalitarian. The abolition of ranks in the armed forces symbolizes the regime's desire to speed the process. Simplicity in dress and improvement in the masses' standard of living have made it harder to be certain who is a cadre and who a worker, and different classes act more freely and more democratically toward one another than previously. Although it is difficult for foreigners to discern, a social wall undoubtedly persists between Party members and others, and it will be a long time, if ever, before all reflections of status and class distinction are removed from Chinese life. Yet the differences from the "old society" are very evident.

Another very important aspect of egalitarianism is the progress that has been made in the emancipation of women. By fostering a new ethic and by creating facilities such as nurseries and collective dining halls to lighten domestic burdens, the Party has made it possible for women to take part in production and thereby to increase their independence. Today women play important roles in virtually every field, often providing the bulk of the work force in factories, farms, hospitals, schools, offices, and stores. Although they are frequently assigned less remunerative work than men or are paid less for the same work, these differentials are gradually disappearing, and more and more women are assuming managerial responsibilities. Less than perfect equality still seems to prevail between the sexes in the allocation of housework and in family decision making. Chinese cadres, both male and female, seem surprised at the respect with which American men treat the opinions of their wives. Again, however, Party ideological education is slowly making inroads on traditional male chauvinism. Ironically, women continue to be grossly underrepresented in the highest levels of the Party and government. Only two of the twenty-five full and alternate members of the Politburo chosen after the Tenth Party Congress are female, and only seventeen of the 195 full members of the Party Central Committee. The best-known female leaders appear to have reached prominence because of their marriages to principal figures. Again, progress at the basic levels should eventually be reflected at the top, but even the former will take time.

The Chinese family has managed to survive the vast changes of the past quarter century. It remains the basic social unit. With a twinkle in his eye, Premier Chou En-lai occasionally gives visiting Americans the impression that Chinese parents, unlike Americans, no longer have to look after children. Actually, however, Chinese parents still are responsible for the upbringing of their children, and children continue to be responsible for the welfare of aged parents. Indeed, one can argue that on balance the Communist revolution may have strengthened the family as an institution rather than weakened it. Surely some of the traditional sources of family tension have been reduced by curbing the tyranny of husband over wife, of mother-in-law over daughter-in-law, and of parents over children. Although campaigns against arranged marriages and related customs, including expensive dowries, betrothal gifts, and wedding banquets, have been only partially successful, they have to that extent re-

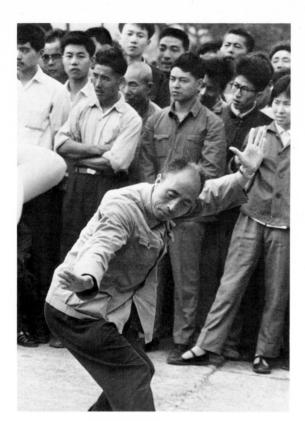

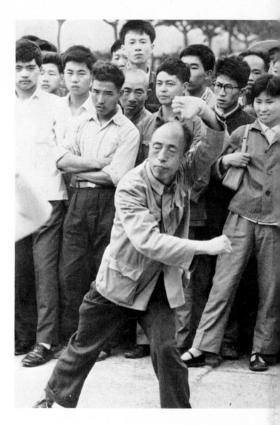

319-21. Left: Early morning crowd watching traditional Chinese sword-dancing exercises. This is a daily occurrence near the Peace Hotel on the Bund in Shanghai. Above: Practicing the traditional Chinese exercise t'ai-chi ch'üan on the Bund before an admiring throng.

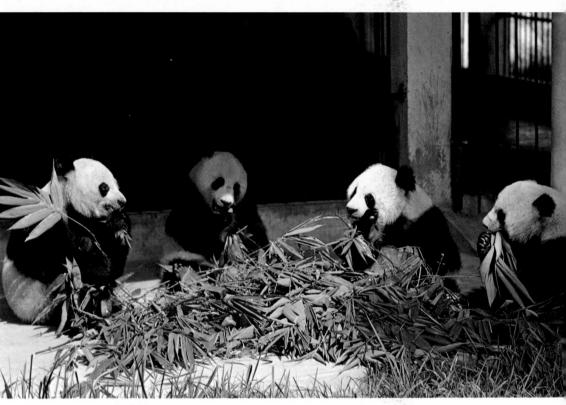

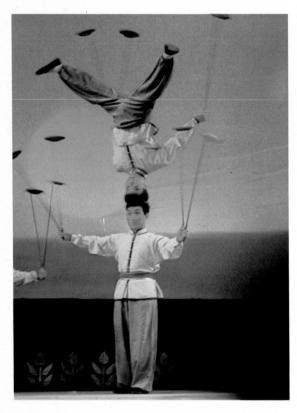

lieved families of a substantial financial burden and the worries associated with it. Also, improvements in the political and economic environment have eliminated many of the anxieties that formerly plagued home life. Natural calamities can still spell hard times for peasant families, but collectivization has given them much greater assurance against complete economic disaster than they have ever had before. Similarly, the Cultural Revolution to the contrary notwithstanding, the regime has enhanced the family's sense of protection against violent intrusions such as the banditry, civil war, and foreign invasion that formerly laid waste many parts of China. In these circumstances, and with a gradual increase in the standard of living, more relaxed, warmer family relations are now possible, at least during periods when no mass movements are taking place.

This is not to say that the vast changes wrought since 1949 have not exposed families to new tensions. Simply adjusting to the often bewildering succession of policies, values, and institutions created by the People's Government has produced considerable strain among family members. Husbands have had particular difficulty in coping with the liberation of women and children. Having both parents employed outside the home has challenged the family in China as well as elsewhere, but grandparents continue to play an important role in child care, often living with their children and grandchildren; and one of the most frequent and touching sights in China is that of an elderly person walking hand in hand with a grandchild. It is especially difficult to maintain close ties in families if, because of the absence of resident grandparents, children board away from home the bulk of the time. Families also reflect current political worries, such as the widespread fear of Soviet aggression, felt even in villages deep in China's interior, and the continuing concern over subversion by counterrevolutionaries.

Divorces are few and far between in contemporary China. The policy of easy divorce that marked the regime's early years and produced a good deal of social disruption soon gave way to a highly conservative policy of maintaining family stability. Visitors to urban street revolutionary committees, for example, are frequently told that there have been only one or two divorces granted in the past year for a population of some fifty or sixty thousand people. Neighborhood mediators, cadres from the street revolutionary committee or rural production brigades, and judges patiently admonish husbands and wives who seek divorce to return home and try harder to

322, 323. Far left: Summer Palace visitors enjoy a picnic lunch on the terrace of an old imperial hall. Left:

Perhaps China's favorite sight, for foreigners and Chinese alike, is a group of pandas munching on bamboo shoots. This scene is breakfast at the Canton (Kwangchow) Zoo.

4, 325. Far left: The Kaifeng Acrobatic
Troupe offers a dazzling display of
coordination. Left: A juggler twirls
a fiery baton. This is one of the
troupe's most spectacular acts.

apply Chairman Mao's maxims to marital misunderstanding.

The Party especially has sought to impose strict standards upon the marital relations of its members. Some former Party members report that Party organizations have occasionally even tried to regulate the number of times a week that husbands and wives engage in sexual intercourse, on the grounds that too infrequent contact may develop tensions which interfere with the spouses' contribution to production and that excessive contact may lead to exhaustion, which is also counterproductive.

The marital problems of the many millions of men and women who are Party and government cadres or members of the armed forces are sometimes complex, because their duties may often require them to travel or to live apart from their families in another part of the country for a time. In these circumstances either or both spouses may become involved with members of the opposite sex. The following "Letter to the Editor," published in the *People's Daily* of July 18, 1956, is illustrative:

Comrade Editor:

I am a soldier on active duty. I now want to make an accusation to you about the unlawful conduct of Hu Chingchou, an officer of the public security department of Chekiang province, who undermined the marriage of a revolutionary soldier.

In October 1954 my wife, Tuan Cheng, was transferred from her job in the armed forces to work in the public relations office of the city of Shen-yang [Mukden]. At that time Hu Ching-chou, who was a cadre in the International Travel Agency in Peking, was also transferred to the same office. During the time that the two worked together, although Hu clearly knew that my wife was married, he nevertheless illicitly fell in "love" with her. Later Hu was transferred to the public security department of Chekiang province, but he still continued to write letters to my wife. In October 1955, even more shamelessly than ever, he proposed a love affair to my wife. In November I completed my studies at a military school, was assigned to work in Shenyang, and discovered their illicit relationship. I reported the matter to the organization, and through the organization they were separately given persuasion-education. According to reason, Hu Ching-chou should have thoroughly reformed and severed his relations with my wife. Yet, on the contrary, he intensified his advances toward my wife and even tried to coerce her to divorce me. Even more intolerable was the fact that on the Chinese New Year of 1956, after I had returned from the public relations office to my military unit, Hu Ching-chou took a plane from Hangchow to Shen-yang and lived with my wife in a hotel for two days. It was only when the organization discovered them on the third day that he was compelled to return to Chekiang. After this the Party organization within the public relations office undertook to educate and deal with my wife (she was a member of the Communist Party). She also had to make a self-examination before a meeting of all the members of the [Party] branch, and she indicated that she was determined to improve relations with me. Nevertheless, Hu Ching-chou continued his involvement with her and would not let her alone. He secretly incited her to divorce me.

Hu Ching-chou is a cadre of a state organ. Yet he knowingly broke the law. He should be punitively restrained by law.

Hsü Yüan-i

(Translated in Jerome Alan Cohen, The Criminal Process in the People's Republic of China, 1949–1963, p. 191.)

As this letter implies, adultery is a crime in China; it occasionally is punished by a sentence of perhaps eighteen months in prison. More often, however, cases are disposed of by informal or administrative sanctions. Every legal system has limits to the resources at its command, and as one former public-security officer has said: "If we had prosecuted all the cases of adultery, we never would have had time for dealing with counterrevolutionaries."

Appraising new China presents complex questions of human values. These questions are sharply raised when one returns from China to the capitalism, individualism, and diversity of Hong Kong. There, under paternalistic British rule, newspapers have news and people are able to speak their minds and go about their business free of the conforming pressures of a revolutionary system. But in Hong Kong the Chinese people still serve an alien master. There the richest live in glamour while the poorest endure revolting housing and health conditions. There one also finds widespread theft and official corruption, fear of violence by "teddy boys," and an educational system that is geared to those with money.

It is easy to condemn the leaders of new China for suppressing political and intellectual freedom. The costs of the Communists' road to modernization have been very high. Yet, in

assessing the progress they have made in organizing, feeding, clothing, and housing almost one-quarter of mankind and restoring national pride and morale, we have to ask whether such freedom is possible at this stage, what its costs might be, and whether the values of Western individualism necessarily outweigh the immediate needs of Chinese society and the other elements of human dignity.

Surely any appraisal should be made in Chinese terms and with a realistic sense of the possibilities, given China's contemporary conditions and her political, social, and economic history.

If we look at the record of the Chiang Kai-shek regime, both before and after 1949, we find, despite all the rhetoric about "free China," that the restraints it has imposed on political and intellectual freedom bear many resemblances to those imposed by the People's Republic. In recent years Taiwan's economic progress has been very impressive. But, beneath a thin democratic veneer, ever-present secret police, suppression of dissent, censorship or exclusion of foreign newspapers, indoctrination, and other trappings of totalitarianism have been familiar features of the Kuomintang alternative for modernizing China.

Generalissimo Chiang and his colleagues lost the confidence of the Chinese people and failed in governing China. Thus far, Chairman Mao and his cohorts have managed to retain the acquiescence of most people and the enthusiasm of many, and, despite grave divisions among the leadership and tremendous problems, are succeeding in governing China. Whether their successors will do as well is an open question.

THE ARTS IN PEOPLE'S CHINA

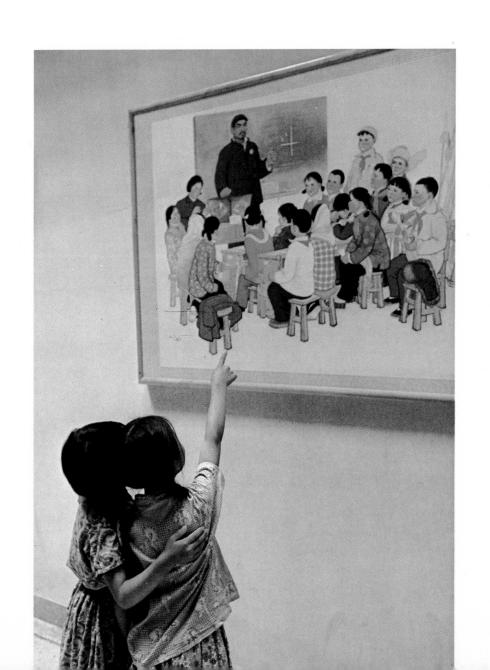

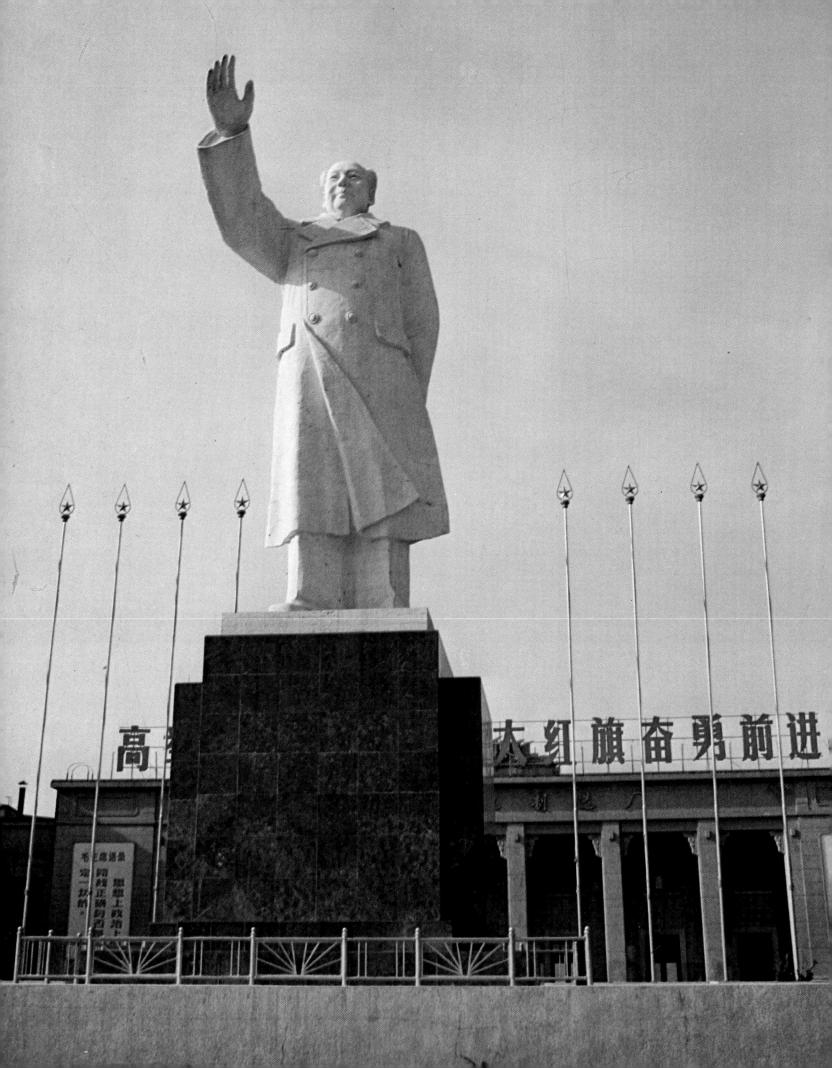

PRECEDING PAGE:

- 326. Young Pioneers look and learn from the paintings in the People's Art Exhibition Commemorating the Thirtieth Anniversary of Chairman Mao's Yenan "Talks on Art and Literature," Peking, 1972.
- ◀327. Giant sculpture of Chairman Mao in front of the tractor factory in Loyang, Honan province. The sculpture stands in a square in front of the great gateway adorned with a Maoist slogan.

THE COLORING OF CHINA is essentially low-keyed and somber, and eyes accustomed to a richer diet soon begin to search hungrily for color in the monotones of the Chinese scene. Apart from the chic traffic police, the most smartly dressed people in China are the soldiers, and their olive-green uniforms, accented with red, make them stand out. The great majority of people wear conservative colors enlivened only by flashes of red in Mao buttons or official armbands. The only color in the drab cityscapes comes from red-and-gold Party signs and poster portraits. The brown and gold of the northern countryside and brown and green of the lush southern landscape are also spotted with these messages. Against this quiet background, the visual imagery of Communist Party designs stands out with an unusual potency enhanced by constant repetition.

Visual communication in China largely consists of a succession of posters of heroes and written admonitions from Chairman Mao. Larger-than-lifesize statues of the great Chairman as a young man or as a mature leader are cast in white plastic and set up in front of factories, exhibitions, or revolutionary monuments (plates 327, 351). His features are photographically realistic, yet his presence is solemn, like that of a Buddha, and the massiveness of the figure suggests superhuman strength. This is, indeed, the messiah of the new Communist order. Poster pictures of Mao outnumber sculptures, but commoner than either are the large billboards carrying quotations from the Chairman's writings—in block-style and cursive calligraphic characters—which punctuate the landscape. His poetry, in his own calligraphy, is frequently reproduced. Signs everywhere—on billboards, fences, roofs, mountainsides, mud walls, and rock faces-exhort the faithful to work harder, conserve water, raise political consciousness, beware of counterrevolutionaries, defeat imperialism, suppress capitalism, and be physically fit. Excerpts from Mao's "Thought"—the term applied to his collective writings—are

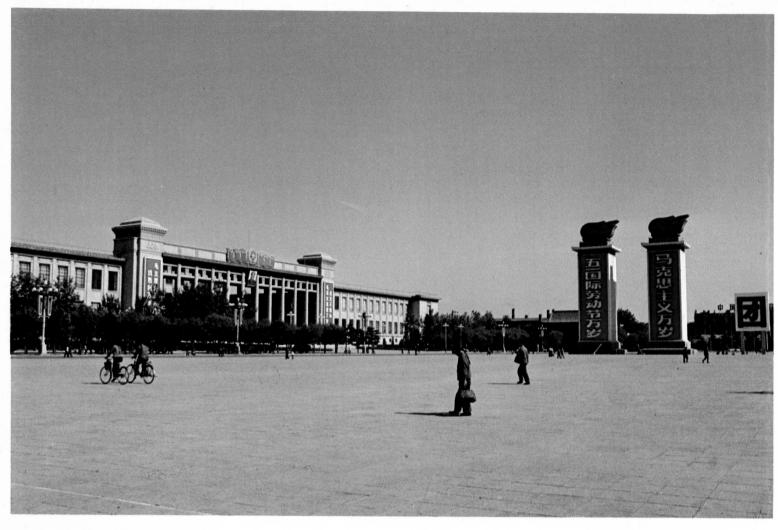

geographic and ceremonial center of Peking. Maoist slogans, red flags and stars, and Mao's picture decorate the Museum of History and of the Revolution on the east side of the square (left). The freestanding columns in the shape of torches spell out: left, "Long Live the Fifty-First International Labor Meeting"; right, "Long Live Marxism."

mixed with Party slogans (plate 328), which most frequently celebrate the longevity of the Chairman and the Chinese Communist Party. These messages are entirely direct; there is no subtlety in the exhortation.

The large forms of Mao are complemented by the jewelry of the masses—Mao buttons (plate 329). As though campaigning for an American political candidate, a large percentage of the people wear such buttons, which are quite varied in design. Most often they have Mao's cameo-cut profile stamped out of gold-colored metal, bonded to a deep-red plastic background, and set on a gold-metal pinback. But they differ in size, color, edging, technique, material, in the architectural facades shown with Mao's face, and in the age at which Mao is depicted.

Chinese imagery reinforces and expands the vision and message of Mao by referring to other heroes of the Communist gospel. Posters or printed textile pictures not only of Mao but also of Marx, Engels, Lenin, and Stalin (the Chinese identify

329. Women ironing red neckerchiess in a housewives' workshop in the basement of an apartment block, Eastern District, Peking. The woman on the left wears a Mao button. The red neckerchies are worn by members of the Young Pioneers.

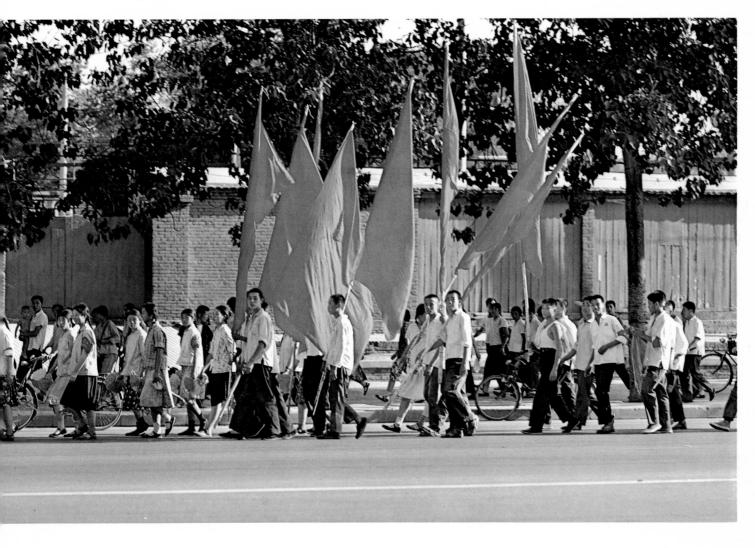

was Infalled

15. 新日本山南京中岛最长州 3.182.11年1日高。

Eltonich Charles show

and a state of the state of the state of

Larrada portugues de desar

Successive Ring of Local

生无产阶级平命等业的 可然接班人

intexte — Chetholi Ashatz 5

京本章 2014年1日1日 東京市 LE A. 新新的工作品的基础

numbers of the second the final of the first field and the last the theory of at-ENGLISHED & SINGSTRUM e upo essa Produceronida hisfolistanis koso struderoj ktorosti novarnije kapajanje

江江北村,江山泉北村中,北村村,民代大厅山 大小二人等对你在八点上第一定提在了的教师是 Blokerale and baker meneral new 時に第一507日本土用の丁上作用地上上計山等中報時 我的一次完全上是《好水下原本》并此版《改造书集、《家 interestinate disciplinative 可沙草煤人工的电话完整的挑剔 花状与蕈大麻的过去 ALANGALEANDA ATTHREE ANT A 在大学中的大学中的大学中的大学中心的

· 在127 14. 全年的人在15. 生命一年二年至15年 自至章,(更有美容,至4艾/应。惟受上人问题的存在至 一、小孩子的年龄科林政士等也,能力学自己时候,克特尔 12. +14594614552 6+41-8-1598-1 etackery-kinded

一批丰学东

业学大庆

a manufactura proportion of the control of the cont

RESERVENTIAL BY WILL K IN FRESH wattherstand washing in 12 few routille where we ce the rough 然此也是我明明是大大大小魔性的人生和不知 FIRST CHARGE WESTER PROPERTY COME TO the artist to be offered assembly the should AND STATE AND AND ASSESSED ASSESSED AND STATE STATE Litt with the tytespool of it pators. 的是 的现在分词 在文本中的教育學學如果文章经历的文 His trust aid it is seed not set a dist 智思是大益性的,这处的原则的发展是是明白的,我 ATTRICK THE CHILD WAS THEFT FAVOR

さらさらるるるる こうしゅうしゅう eleanorate, estudapentino ATE, TRUMPING AND INVOLVED AND 好水好在京上村工人在人工等一个大街车,要在山下中来 grand hardelstanding trails in FIGHTH OF MALKETTS MARKETH Annathratelle totalite

对发展的现在分词不成为对人的对对的发展,我们的对 是配车上的村林内农老江大大主人类为蓝文印的设计 中报 象点从主义社员 正常如此误 子思斯中等 在第一至1月中如村子、村上以下水利等一台 ESTABLISHED SHIPS BUREAU A 大大体的执子中的对对的支撑的支撑的行子子的 于称三年工机中沙伦设施的城市北部的李子居 此此是次年代至此代的同年的配子红使用 起,随得坚强在1天线的进过度在10条约市 的方景工作品以及在新州城下的设施等的 fille.

大夫以如此治此为近年的北"只是不有 社会ではおうないないないからまないますが 图1.000日本 有田田子(秋人村) 朝祖建善在在在北京的大学的大学和新文学的

问题,我思想对能这次的一,使人在人主意 中京是被转标准设了账管证法,但是他 杨昭41年5、6年近晚末期9年时,10日11年 且无是此,用自己的身体提择状态提。 自己的等面的皇帝技术了大大面面的专作并,自 ELLE RECESSION ARTICLES 准上,村成为人工社会计、从来叫茶、阳台水 北京人们走行公园村、西江北省大中省(东京 请我早本祭理中的,是此身体证之力。但 练的看了对同样性养养,我们心里不到是 上作对多的经济股产以及查对成就的是有 性外自以考生保证是对成就的大夫人或者。 在是是此经年生活

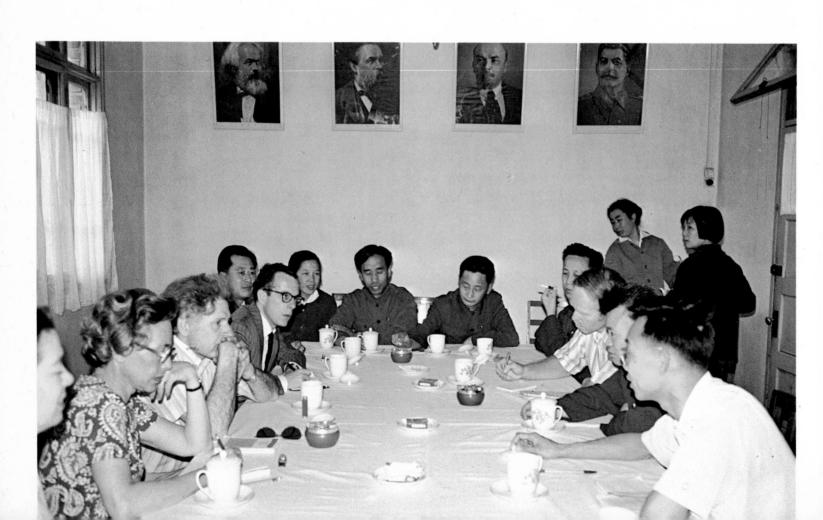

- 331. Wall posters outside a Peking factory. In the illustrated poster, done in the Socialist Realism style, workers are exhorted to study Ta-ch'ing, an oil field in northeast China. This successful industrial complex has been singled out as an example for the rest of China.
- 332. Members of a street-revolutionary committee in the Eastern District, Peking, explain their activities to foreign visitors in a typical meeting room. Colored posters of Marx, Engels, Lenin, and Stalin hang on one wall; a portrait of Mao hangs on the opposite wall (not shown).

him as the man who industrialized Russia) adorn official meeting halls (plate 332). Occasionally Chou En-lai, Enver Hoxha (the Albanian Communist Party Chief), or North Vietnam's Ho Chi Minh join the classic five. Some of the portraits are printed adaptations of photographs. The portraits of Marx and Engels appear to be derived from engravings, and when they are printed on textiles, the mixture of mediums makes for a startling effect. Some of the Mao portraits are based upon heroic-scale paintings in the Socialist Realism style.

Everywhere in China—at factories, communes, and central urban locations—in addition to the ubiquitous wall posters, bulletin boards display posters, newspapers, and photographs (plate 331). The photographs are usually of friendly foreign delegations to China or of Chinese delegations abroad. The most memorable and colorful posters are those advertising revolutionary operas and ballets. These posters, incidentally, are generally the only visual materials besides images of Mao and family photographs that decorate the homes of workers and peasants. The posters feature climactic moments: the White-Haired Girl executing an inspired leap through a snowstorm, or the hero of the Red Lantern gesturing triumphantly, while his eyes bulge defiantly at the enemy. The posters, like some of the portraits, are adapted from photographs, but they are embellished with intense colors and brushed-on highlights. The product is a slick, eye-catching popular art form.

The stories of the operas and ballets are romanticized versions of true stories of the revolution, slanted to emphasize the victory of the righteous cause. In words, music, and body language, they tell stories of suffering and vindication. The old favorite of Chinese performing arts, the opera, has been purged of its prerevolutionary classic features. No longer are the heroes derived from traditional Chinese history, nor are the roles performed in elaborate costumes of silk and jewels or in hard-to-understand language delivered in supremely mannered falsetto voices. Just as traditional opera has been overhauled so as to be almost unrecognizable, so too has the foreign ballet, which was introduced by the White Russians in the 1920s, been adapted by the Chinese. No classical Western ballet remains in the Chinese repertoire. The current operas and ballets are products of the artistic and ideological struggles that culminated in the Great Proletarian Cultural Revolution.

Red Detachment of Women and The White-Haired Girl (plates

333. Classroom performance of *The White-Haired Girl* at Peking's Middle School 26.

334. Sculpture of *The White-Haired Girl.* Shown at the Canton
Museum (Kwangchow Po-wukuan).

334, 335) are two current favorites shown all over China, not only in opera and ballet but also in filmed versions. Both have almost the same basic story—that of a peasant girl who is oppressed and exploited by a landlord. In the one, she runs off into the jungles of Hainan Island to join the Red Detachment of Women, with whom she later returns to kill the evil oppressor; in the other, she escapes to the mountains, where she hides alone for several years and then joins the Communist guerrillas, who, in the end, shoot the landlord. The revolutionary message is artfully and effectively conveyed, eliciting an enthusiastic response from the audience, especially when the heroine downs the villain. The music of Red Detachment of Women is a distinctive combination of dramatic Wagnerian, romantic Rimsky-Korsakov, and patriotic marine band, based mostly on Western harmonies but sung in the typically Chinese nasal style. In the ballet based on the same story, the technically brilliant dancers move to flowing rhythms that climax in jubilant staccatos and create a strange new vocabulary of classic combined with modern ballet that emphasizes dramatically militant operatic stances.

No character is more popular in posters, sculptured images, songs, and spontaneous amateur performances than the graceful yet militant heroine of The White-Haired Girl. According to the story, when she escapes to the mountains and lives "like an animal," her flowing black tresses turn white because of the lack of salt in her diet. Thus her act I image—black braided hair and brilliant red pajamas—undergoes an expressionistic and dramatic transformation in act 2, where she appears with a glamorously flowing white mane artfully set off by a tattered gray chiffon outfit. Her white hair is an explicit expression of the suffering she endured within the Chinese revolutionary struggle, yet she appears to Westerners to be a platinum blonde reminiscent of a host of Hollywood idols. Moreover, in a land of dark-haired people who rarely admire foreign characteristics, it is puzzling to find light hair used as such a romantic symbol.

Little girls can be seen dancing and singing parts from *The White-Haired Girl* for their parents on leisurely Sundays in the park in Peking, on the Bund in Shanghai, and under shade trees near the Pearl River in Canton. They also perform it in schools and "children's palaces" (plate 333). Visitors often waken to the sounds of *The White-Haired Girl* played over loudspeakers near their hotel or piped through the publicaddress system on a train.

This all-pervasive audio-visual imagery is obviously designed

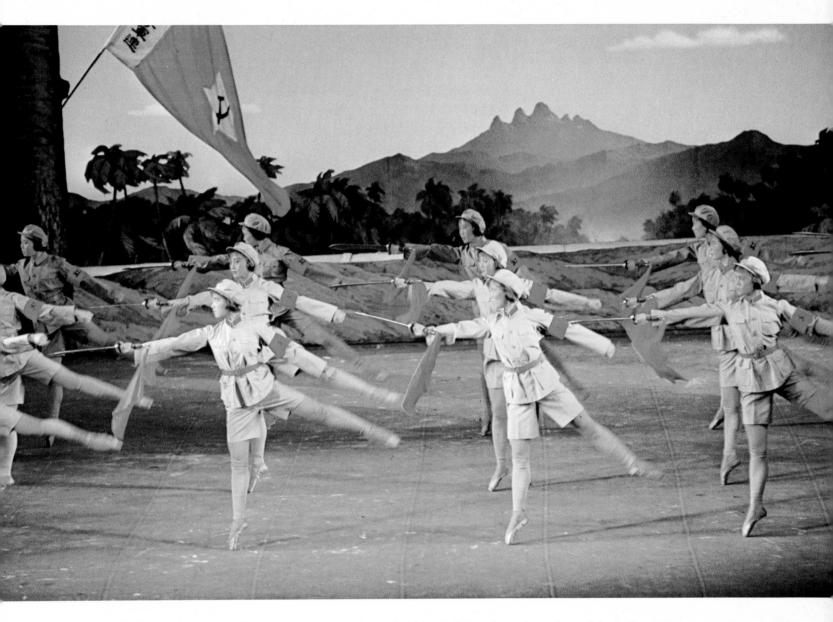

335. Ballet performance of *Red Detachment of Women*, Peking. *Red Detachment* is performed in ballet and opera forms developed during the Cultural Revolution under the guidance of Chiang Ch'ing, wife of Chairman Mao.

to help give cultural unity to a vast country whose different regions have long been separated by distinctive dialects, customs, climates, topographical features, and racial mixtures. Although it is impossible for visitors to evaluate the extent to which the mobilization of the performing arts has helped in accomplishing this task, the medium and the message seem to be reaching and pleasing audiences. While it is true that there are only a handful of approved operas, ballets, and films to choose from in China today, and only a limited amount of music is allowed to be performed, what exists is enthusiastically received.

Prestige Art: What Is Exhibited?

What kind of art is being shown in China's exhibition galleries? How does it compare with the ever-present posters, photographs, and sculptures?

Because the Communist Party controls all aspects of life, it is not surprising that contemporary art reflects the Party view of new China. The fine arts and the popular arts share a uniform subject matter—Chinese Communist political history synthesized into ideology. They depict the struggle and triumph of the revolution and its martyrs and heroes, the liberation of the oppressed classes, the achievements of the developing industrial state, and the spirit of cooperation and support among the masses.

"Serve the people" is the slogan that animates art as well as everything else in China. Art must follow the "mass line," that is, it must appeal to the masses, express their viewpoint, and educate and guide them, so that the peasants, workers, and soldiers as well as the cadres will better understand the demands of patriotism and political consciousness. Art that lacks this content is counterrevolutionary and must be suppressed.

The proper way to "serve the people" and express consciousness of the class struggle is still far from self-evident, however. The Cultural Revolution revealed the intense controversy that continues to surround the relationship between art and politics. Artists who pursued the style of traditional Chinese painting were violently attacked as counterrevolutionary. In an article published in *China Reconstructs*, Vol. XIX, No. 7, July, 1970, entitled "Red Painters Fight with a Brush," the staff reporter says:

The capitalist-roaders in the Union of Chinese Artists

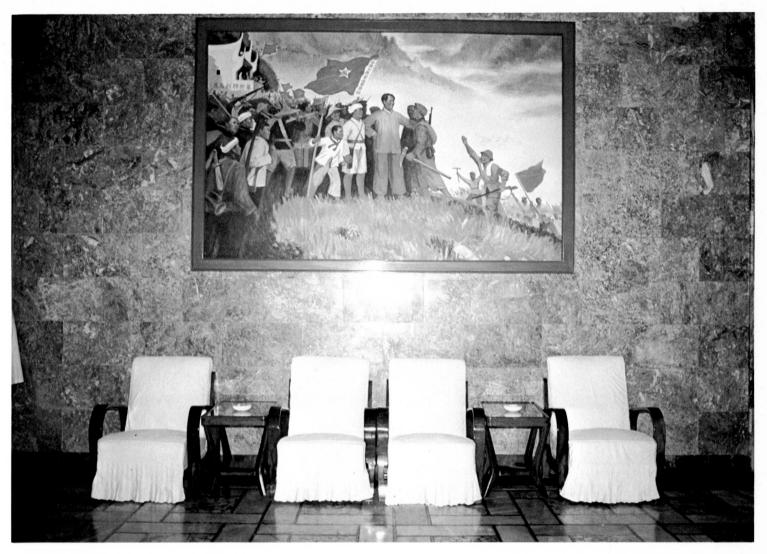

336. An Army of Peasants Welcomes

Mao Tse-tung. Artist unknown.

Oil on canvas. Shown at the

Kwangtung Province State Guest

House. This type of large painting
in the Socialist Realism style is
often executed by a provincial
artistic collective.

and other bourgeois art "authorities" tried to lead the Red painters on to the wrong path. [The reactionary artists said:] "You can express the spirit of workers, peasants, and soldiers without depicting them." [The reactionary artists exhibited] "gems of art" by "master painters." These paintings depicted ancient temples in deserted mountains, faded lotus flowers and withered willows, and feudal scholars and beauties. It was an attempt by the class enemies to corrupt the Red painters and make them draw things that the bourgeois class would like. But the poor and lower-middle peasants saw through the enemies' plot at once.

Chairman Mao has repeatedly called for reeducation of artists; they must live and work side by side with peasants,

337. P'an Chia-chün, an artist in the People's Liberation Army. I Am a Seagull. Oil on canvas. Shown at the 1972 People's Art Exhibition. In this typical Socialist Realism painting, with its large figure, dramatic lighting effects, and romantically brushed-on pigments, the poetic seagull metaphor is applied to the hard work of industrialization.

workers, and soldiers so that they can truly express proletarian viewpoints. At the same time he has called for new artists to rise from among the masses to express their vision. From this idea the "people's art" movement was born. At least at certain times, the leadership has seemed to believe that professional artists can be dispensed with and that the masses can produce all the revolutionary art necessary in their spare time.

The new revolutionary art is required to be completely comprehensible to the masses. No veiled metaphors will educate. Although traditional Chinese painting also conveyed messages, the poetic and philosophical images that it conjured up were filled with subtle allusions from classical Chinese literature and overlaid with centuries of embellishing refinements which only the educated elite could understand. The Confucian scholar-officials were the literati who understood this limited, specialized art form, and they used a series of cultivated, disciplined brushstrokes in both painting and calligraphy to communicate with one another. Today, although new China has made enormous progress in wiping out illiteracy, the new literate Chinese proletarian has not cultivated calligraphy and lacks the technical training to use or appreciate the subtleties of the brushstroke as a means of expression.

Moreover, even if the peasant were master of the brush, the real discontinuity with the past would still cut him off from its traditional message. The only "classics" that the men and women of new China have read are the writings of the Communist pantheon, and the only literature they know is that which has emerged under the sponsorship of the Party. Thus the campaign against old art forms seeks to bury not only the techniques but also the ideas of traditional art. The new art seeks to reach all the people, symbolize the new unity among classes, and provide a common cultural basis.

What media are best suited to the new proletarian art? Some good illustrations are provided by two well-attended exhibitions in Peking in May–June, 1972, that commemorated the thirtieth anniversary of Chairman Mao's Yenan "Talks on Art and Literature." The first was a photography exhibition at the Nationalities' Cultural Palace. Photography is a natural medium for the new art, because in the Chinese view art should accurately communicate visual reality. The central hall of the exhibition was devoted to a giant sculpture of the most important subject—Mao. In the room directly behind were approximately eighty photographs, almost all in black and white, that celebrated his life organizing the Party, fighting the civil war, working with the peasants, swimming the

338. K'ang Tso-t'ien. A Splendid Red Sun Will Shine for Tens of Thousands of Generations. Ink and colors on paper. Shown in the 1972 People's Art Exhibition. Painted in Socialist Realism style, this picture of the classroom in springtime conveys the ideal spirit of learning in the new utopia of Chinese Communist society.

Yangtze—in short, building the revolution, his lifelong cause. All the black-and-white photographs were touched up with color washes.

The vast majority of the other 400 photographs in the exhibition were also in black and white but were not touched up with color. They covered the Long March of the 1930s, the Japanese war, the liberation of China from Chiang Kai-shek, the reincorporation of Tibet, the Korean War, industrialization, the development of agriculture, and the people. These subjects are the same ones found in other contemporary mediums such as oil and ink painting and wood-block printing. Yet photographs of the landscape also form an interesting tie with traditional Chinese painting, for they seek and sometimes capture the same rapturous compositions of soaring mountains shrouded in vaporous mists.

Throughout the photographs, straightforward techniques of photo-journalism were used. Shots of people struggling to win the war or build the state were clear and human. The photo-

graphic medium can be truthful to itself while still achieving the goal of Communist art.

The second exhibition, that of "people's art," demands a conscious suppression of the values and qualities associated with Western art criticism. It is all too easy for the sophisticated foreigner to dismiss these paintings as unoriginal in subject, clichés in execution, and lacking in technical competence. Yet they form a rich body of visual evidence of the achievements and goals of the Chinese revolution, and Westerners must approach them in contemporary Chinese terms. As the Chinese see their paintings, they are original vis à vis traditional Chinese art, blending a new formula—Socialist Realism—with a fresh technique—oil on canvas—in a manner that stirs their hearts. Having only the most limited tradition of Western oil painting or composition, they do not share our standards of evaluation. Visitors to such exhibitions cannot fail to see that this art does communicate to the masses and arouse their enthusiasm.

■339. A Bumper Harvest. Ink and colors on paper. Characters written on the haystacks say "Agriculture should study Ta-chai," a model commune in north-central China. The style of this painting was unique in the 1972 People's Art Exhibition. Different from both traditional Chinese and Socialist Realism styles, the miniature harvest scene is faithfully rendered in a manner reminiscent of the American primitive painter Grandma Moses.

Because of the nature and expectations of the medium, painting provides a far greater challenge in creating "people's art" than does photography. In the first half of the twentieth century some Chinese artists experimented with oil painting, but its use and influence were relatively insignificant compared to traditional Chinese ink painting. In the same period new international compositional formulas were introduced to China. During the long period of Soviet influence on Communist art, from the 1920s until the end of the 1950s, the fullblown compositional formulas of Socialist Realism were imported from the Soviet Union. After 1949 the Chinese Communist Party gave that style the prestige and patronage of the state. Among the professional Chinese artists who have taken up Socialist Realism, many use oils; others use watercolors or gouache. Socialist Realism also dominates the "people's art" cultivated by amateur artists.

In keeping with the spirit of "people's art," most of the exhibition entries were painted by amateur artists, and there were no obvious clues to distinguish their work from the paintings of the professional artists who were included. The painting exhibition opened in an arrangement plan parallel to that of the photographic show, featuring a central hall full of giant portraits of the Chairman among the masses. The central hall was flanked by room after room of canvases depicting groups of workers, peasants, and soldiers.

In addition to the use of oil on canvas, the emphasis was on over-lifesize people in heroic groupings, a convention which is also new to the vast majority of Chinese. The Communist style fits strangely well into the spirit of the "grand-manner" painting of eighteenth-century Europe (plate 336). Both "grand-manner" painting and Socialist Realism share sublime ideals and moralistic themes that are intended to uplift and inspire the viewer (plate 337). Although Western elements, such as single-point perspective, which shows the land-scape diminishing to a single horizon line, and human forms modeled in light and shade had been introduced to China as early as the seventeenth century, they had never reached the mainstream of Chinese art. The deeply toned colors ranging from rather unsubtle pink flesh tones through brilliant red suns were new to the Chinese palette.

The uniform arrangements of the compositions showed that the artists must have used printed models, copybooks, or photographs for inspiration. Judging from these pictures, the Chinese will have to go through a long period of intensive practice and experimentation with oil paint before they achieve mastery of this new medium.

Ink paintings, wood-block prints, and paper cutouts are traditional Chinese mediums which sometimes present the new subject matter with grace, humor, and charm (plates 326, 338). When the Chinese are at home in an old technique, they, like bamboos in the wind, can bend in new directions. When the contemporary artist uses traditional ink and color wash but applies the color with an untraditional intensity, he is generally portraying oversize heroes of agriculture or industry set in a single-point perspective background. He is applying the old medium to the new formula of Socialist Realism, which developed in oil painting. The result is a technically more skillful version of the Communist cliché.

To Western viewers, by far the most appealing paintings in the exhibition were a tiny number that used the age-old formula for Chinese painting: black ink with light color washes, and a bird's-eye view with multiple perspective points in a land-scape that places the approved subject matter on a diminished scale (plate 339). In other words, although the subject is new—a factory among rice paddies, rather than a scholar's retreat—it is depicted by traditional techniques and, in relation to the whole picture, is in scale with traditional views of small man dwarfed by large nature.

The heavy-handed quality of most contemporary woodblock prints conceals the long Chinese tradition of printmaking. It was the Chinese who invented this art form some fifteen hundred years ago, but today, just as Lu Hsün had proposed in the 1930s, ideology and revolutionary achievement dictate the subject and the spirit. The bleak, unmodulated intensity of color and form has no more subtlety than the steel mills, bridges, or dams depicted in these straight-on compositions.

Paper cutouts have a crisp freshness which apparently cannot be dulled by uniform subject matter. While the quality of wood-block prints offers no clue to the antiquity of the medium in China, the paper cutouts do show a remarkable mastery over paper, which is a 2,000-year-old Chinese invention. Perhaps because the nature of the medium precludes full-blown realism, the resulting forms have a compact energy within a style that recalls 1920s Art Deco book illustrations. Their charm, which often verges on being cute, counterbalances the Wagnerian boom of "people's" oil painting.

The subject matter of the paper cutouts exhibited was the same as that of the paintings. In a "red sun rising" cutout, a

340. Peasants, Soldiers, and Children
March to the Fields Together as the
Red Sun Rises (detail). Paper
cutout. Shown at the 1972
Exhibition of People's Art.

merry troop of farmers, soldiers, and children marches into the fields with shovels, lunches, and "little red books" in hand (plate 340). The light-stepping gaiety of the group conveys the joy with which the new Maoist Chinese should approach his tasks. The fish almost jump out of the pond with excitement, and the landscape is alive with artfully swirling clouds. Perhaps the most unusual part of this engaging scene is the shadows of the marchers reflected in the pond.

Cutouts are for sale all over China as inexpensive artistic souvenirs. In these, the subjects are allowed to range beyond the standard contents of "people's art," probably because the medium is considered less worthy of sublime ideological messages. Traditional bird and flower scenes appear along with series of pandas, the new symbol of international friendship. One of the most engaging sequences shows spirited doe-eyed children gracefully diving, skiing, lifting weights, throwing the discus, swinging badminton racquets, playing soccer,

balancing in acrobatic poses, and riding bicycles. These scenes effectively transmit the national message of physical fitness. The miniature heroes move within an ovoid format, amid curving flowers, swirling waves, six-pointed snowflakes, and flying birds.

Most of the paper cutouts are "mass-produced," stacks of paper being cut simultaneously with a knife and hammer, but some are individually cut with scissors. The artists' versatility with a cutting edge is almost as great as that of traditional painters with a brush. Sleek bamboo stalks, coarse bark branches, fluttering leaves, furry pandas, and delicate flowers are all masterfully suggested. This work stands in contrast to the paintings of "people's art," which are destined for public places rather than the home.

Despite the fact that the new, revolutionary Chinese sculp-

■341. Workers, Soldiers, and Peasants Celebrate the Victorious Revolution (detail). Ceramic sculpture. Shown at Canton Museum (Kwangchow Po-wu-kuan). The figures are posed in the militant stances assumed by the actors and dancers in revolutionary operas and ballets. These postures are a uniquely Chinese blend of Socialist Realism and traditional Chinese opera gestures. ture has been a featured subject in Chinese publications and is exhibited in many museums, none was shown in the "people's art" exhibition. This does not mean that this medium is considered too challenging for amateurs participating in the people's art movement. The notion that the revolutionary consciousness of the worker will firmly guide his hand and transcend any technical difficulties is a recurring theme in the development of People's China.

The ceramic sculptures displayed in museums employ the themes of "people's art," representing the martyrs and heroes of stage, screen, and revolutionary literature (plate 341). They continue a 2,000-year-old Chinese tradition of making miniature ceramic sculptures of people. Of course, originally the small figurines were substitutes for human beings sacrificed in ancient burial practices. The ceramics industry continues to produce utilitarian ware for domestic consumption, but even in hotels and restaurants that cater to foreign visitors the crockery, if it is decorated, is undistinguished. Export china continues to be made in the old Ch'ing patterns.

None of the monumental paintings by members of the Peking Academy was included in the exhibition of "people's art." The Peking Academy of Chinese Painting was established in May, 1957, during the movement to "let a hundred flowers bloom," as a center for Chinese-style painters and a school where selected students could train with particular masters. In addition, its members were authorized to "compile a systematic record of Chinese paintings and revive this [old] art," according to an article in People's China ("New Day for Chinese Painting," June 12, 1957, pp. 36-37). Paintings by Peking Academy masters decorate major buildings, including hotels, airports, and the Great Hall of the People, and are frequently published in Chinese magazines for consumption abroad (plates 342, 343). The exclusion of such works from the exhibition may suggest that the ideological struggle is still going on within the Party over the correct line for painting. Or it may simply be that these paintings, which treat contemporary themes in traditional style and are plainly the work of highly trained experts, do not fall within the term "people's art."

Western art teachers and critics, eager to visit the Peking Academy, meet artists, see new work, and exchange views, were, as recently as 1972, put off with the excuse that the Academy had not been reopened since the Cultural Revolution and that all professional artists were still in the countryside being reeducated at "May 7th Cadre Schools." Artists, it

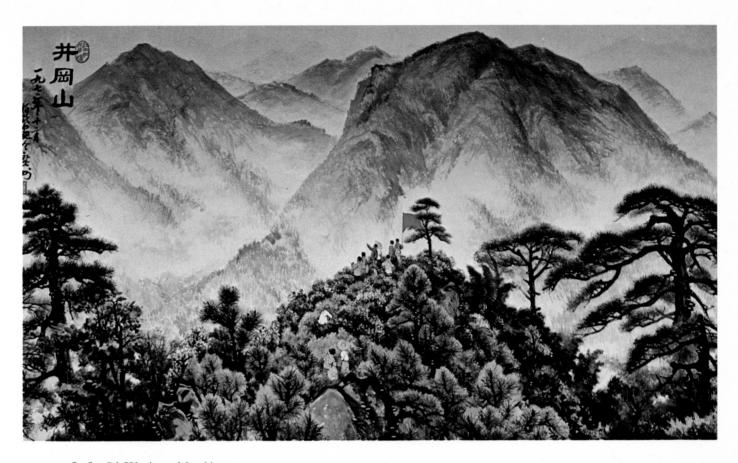

342-44. Left: Li K'e-jan. Marching Through Loushan Pass at Sunset (an episode in the Long March). Ink and colors on paper, in the style of the Peking Academy of Fine Arts. Shown at the Nationalities Hotel (Min-tsu fan-tien), Peking. The multiple perspective points, mountains, trees, and mist all recall traditional Chinese landscape painting. However, the columns of Red Army soldiers and the strong red-orange tone that bathes the scene are innovations of the painters in People's China, and the brushstroke, filled with a new energy, is characteristic of twentieth-century painting in Chinese style. Above and right: Yu Ch'in. Chingkangshan and detail. 1971. Ink and colors on paper. Shown at People's Hotel (Jen-min ta-hsia), Canton (Kwangchow). Located on the border between Hunan and Kiangsi provinces, Chingkangshan is memorialized in Chinese Communist history because Mao Tse-tung and his allies were able to defend it successfully from the pursuing Kuomintang forces in 1927.

seems, require a longer period of reeducation than do many other people. Why is this so? Is it because the visual artist is a natural individualist who cannot subordinate his ideas to the "mass line" of the Party? Is it because the Party line on the arts is still in flux?

A look at traditional-style Chinese painting by contemporary "old masters" illustrates the problem of working out the proper Party line. Despite the fact that they must deal with a new, prescribed subject matter, Peking Academy painters carry on the old tradition of executing huge landscape compositions on paper, in black Chinese ink with color washes. Small groups of Red Army soldiers carrying flags thread their way through sublime Chinese mountain passes, while the red sun bathes the atmosphere in a new-style orange glow. In the iconography of today's Chinese art, the rising red sun is a metaphor of the revolution. This recalls the traditional Chinese association of the appearance of a "new" sun with the advent of a new ruling dynasty to which the "mandate of heaven" has passed. Today the new sun rising illustrates what Marxist "historical inevitability" predicted would occur—the march toward a Communist society. Subjects befitting a "modern industrial nation," such as airplanes and factories, tentatively introduced by a few painters of the Republican era, are now featured attractions. Other favored compositions include Communist idylls such as mountain landscapes with children holding red flags that symbolize the dream in their hearts of a Communist utopia. In keeping with the traditional harmony of man and nature, man and his creations are kept in a modest scale in relation to the vast landscape. The compositional format minimizes the size of the superheroes.

Some changes in technique have occurred in traditional-style painting. Building on the experimentation during the Republican period, Peking Academy artists use more and brighter colors than did their artistic ancestors, and their brush-strokes are charged with newfound vigor (plate 344). The heart of Chinese painting has always been the remarkable versatility of the brushstroke. The variety of moods a Chinese painter can evoke in a single painting—ranging from ethereal melancholy to gargantuan strength—is a source of endless amazement. The shapes and tones of ink suggest soft mists, fragile flowers, sharp pine needles, or the most enduring rock formations. Although practitioners of the traditional style in the People's Republic rarely paint with subtlety and melancholy, the old techniques have not been forgotten.

The overall effect of these changes in both subject and technique makes the new clearly distinguishable from traditional

Chinese art. It is a revitalized vision which might be characterized as a monumental attempt to accommodate both old and new. It would seem, however, that this revitalized art form does not convey the message of the revolution well enough to suit all tastes, and it seems likely that the masses and most cadres prefer the direct inspiration of hard-hitting Socialist Realism. The visual schizophrenia between "people's art" and Peking Academy painting illustrates how difficult it has been to develop the perfect vehicle for the Chinese Communist vision. Traditional-style painting has millennial roots, yet it apparently fails to enjoy the confidence of some Party leaders. While the artists are in the "May 7th" schools, they, in concert with the Party leadership, presumably continue to seek the correct revolutionary road for the visual arts.

Architecture

The forms of Chinese Communist architecture, like those of the pictorial arts, reflect the search for a new expression. Similar tensions between old and new and between domestic and foreign influences are apparent. The Shanghai Exhibition Hall (plate 345), a post-liberation structure formerly called the Palace of Sino-Soviet Friendship, was clearly inspired by the predominant Soviet influence of the 1950s—only the Russian onion dome is absent. Its facade has intertwined and patterned columns, gingerbread turrets, Neoclassic colonnades, and a soaring steeple. Yet the borrowed finery of the exterior does not extend to the interior. The vast, bare semicircular space, reminiscent of an airplane hangar, is devoid of warmth.

As one enters the main hall, the ubiquitous great white figure of Mao stands against a red backdrop, flanked by his golden "Thought" and red flags, overseeing the proud display of new Chinese industry. Some small attempt is made to relate interior to exterior in the entrance hall, where jewel-like, Russian-inspired, colored-glass medallions are set into grillwork inside the arches, but they are too inconsequentially scaled to have any real effect.

When Khrushchev suddenly withdrew the Soviet specialists from China, the building forms of Socialist Realism remained behind as memorials of their presence. Monolithic gray block buildings of concrete, stone, or glazed brick, enhanced by a crown of Chinese characters spelling out patriotic slogans or the "Thought" of Chairman Mao, had become the official style (plate 346).

The ultimate state colossus is the Great Hall of the People in T'ien-an-men Square (plate 348). This showpiece of new

345-47. Above: Shanghai Exhibition Hall (formerly the Palace of Sino-Soviet Friendship). The facade has a mixture of borrowed elements, including Baroque columns, gingerbread turrets, and a churchlike steeple. Opposite page, above: A government building in Peking. The blocky building follows the formula of Socialist Realism architecture. Below: Nationalities' Cultural Palace (Min-tsu wen-hua-kung), Peking. This building includes a theater, cultural center, library, and museum.

proletarian architecture covers over half a million square feet and is said to be larger than the palaces of the Forbidden City. It is a massive monolithic block which gives no hint of its functions; it contains a banquet hall for 5,000 people, a theater that seats 10,000, and countless smaller rooms. It is here that the Communist Party holds its national Party congresses and here that China's leaders wine and dine their guests. The exterior is decorated with Neoclassic columns and cornices. There is none of the flamboyance that marks the Shanghai Exhibition Hall—the grandeur of this edifice lies in its scale. The vast interior spaces climax in mountainous staircases. Perhaps the Chinese designers had in mind the Forbidden City, where vast courtyard approaches make human scale almost meaningless. The awesome ceremonial approach to the Great Hall of the People, through the cavernous entrance space and up the great stairs, leads to a wall decorated with a huge landscape painting done in the "red sun rising" style of the Peking Academy. A bleacher stands in front of the painting, and here official visitors assemble for photographs with whatever high Party leaders are their hosts.

High ceilings and large floor areas are the only symbols of power and glory in a typical Great Hall reception room for small dinners (plate 349). Luncheon starts with tea served in one half of the room, which is simply furnished with upholstered armchairs and small, adjoining, wooden tea tables arranged in a large circle. Later, guests move to a large, round banquet table in the other half of the room. The arrangement and decor of these reception rooms are distinguished from those of reception rooms in stations, hotels, and airports by the fact that the chairs are not pushed flat against the walls and are not slipcovered. The uninspired but comfortable basic International Style chair of the 1930s is standard for important reception areas. Peking Academy paintings decorate the walls.

Not all post-liberation architecture lacks Chinese feeling. The Nationalities' Cultural Palace, which housed the photography exhibition, shows an attempt to recapture the Chinese idiom (plate 347). The typical Socialist horizontal U-block plan is partially covered with a Chinese tiled roof. The central tower is crowned by a blue-green-tiled, square, pagodastyle roof surrounded by four miniature tiled pagoda towers. The gentle slopes of curving "dragon-back" roofs are replete with decorations suggesting the roof-line parade of guardian figures seen on old buildings.

The recently built Peasant Movement Institute (plate 350) in Canton has virtually the same massive U-shaped plan, with

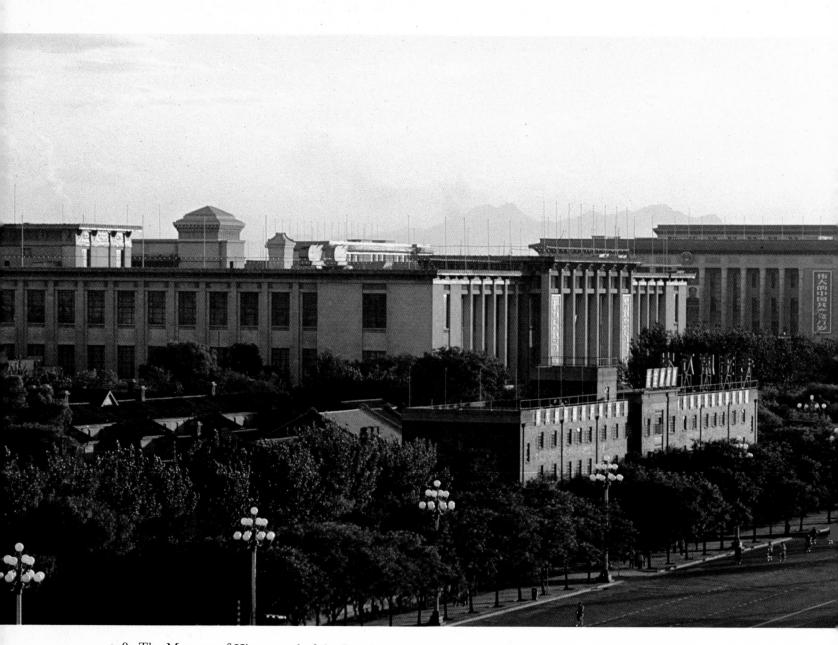

348. The Museum of History and of the Revolution in the foreground; the Great Hall of the People in the background; looking southeast toward T'ien-an-men Square, Peking.

349. A reception and dining room in the Great Hall of the People, Peking. Hosts and guests sit in armchairs, with adjoining tea tables, in a large circle. Interpreters and cadres sit in the rear. The plaster walls are enriched with wooden paneling, grillwork, and paintings in the style of the Peking Academy.

the same central tower, as the Nationalities' Cultural Palace in Peking. In keeping with the spirit of the building, however, the Chinese tiled roof is replaced by a symbol of international Communism—a great red plastic windblown torch. Surrounded by four little torches which rise triumphantly from the tower, this five-pointed roof crown, with four elements arranged around a central one like five dots on a die, is like the arrangement of onion domes on medieval Russian cathedrals, the Buddha figures in esoteric Buddhist sculpture, and the towers of Angkor Wat. It has not come from the main line of Chinese architecture. A series of lamp-post fixtures carries on the five-torch theme and illuminates the huge rectangular park approach.

Next door to this embodiment of contemporary Chinese thought is a carefully restored Confucian temple which housed the original Peasant Movement Institute founded in the 1920s (plate 351). Mao had briefly used this old Ming dynasty (1368–1644) temple as a school for training revolutionary cadres. According to the architectural mode of Ming times,

350-51. Left: Peasant Movement
Institute, Canton (Kwangchow).
In 1926, Mao trained peasants
to be cadres in an old Ming
dynasty temple of Confucius
(foreground roof). In the early
1970s a new building was erected
to train cadres (background
tower with torch). Above:
Sculpture of Mao Tse-tung as a
young man stands in front of the
Peasant Movement Institute.

the wooden rectangular halls with tiled roofs are arranged in a geometric order, one behind another, and enclosed by a rectangular walled walkway. The roof lines dance with decorations of flowers and aquatic and airborne grotesques. The modestly scaled courtyards between the halls provide intimate spaces similar to the courtyards of the concubines' quarters in the Forbidden City.

There is a message in the contrast between these two adjacent complexes that represent the highest thoughts of leadership, traditional and modern. The torch tower of the Peasant Movement Institute can be seen like a beacon rising above the Canton skyline, speaking to the masses of the supreme power of the Communist Party; it is an omnipresent vision and an omniscient eye. The temple of Confucius is an intimately

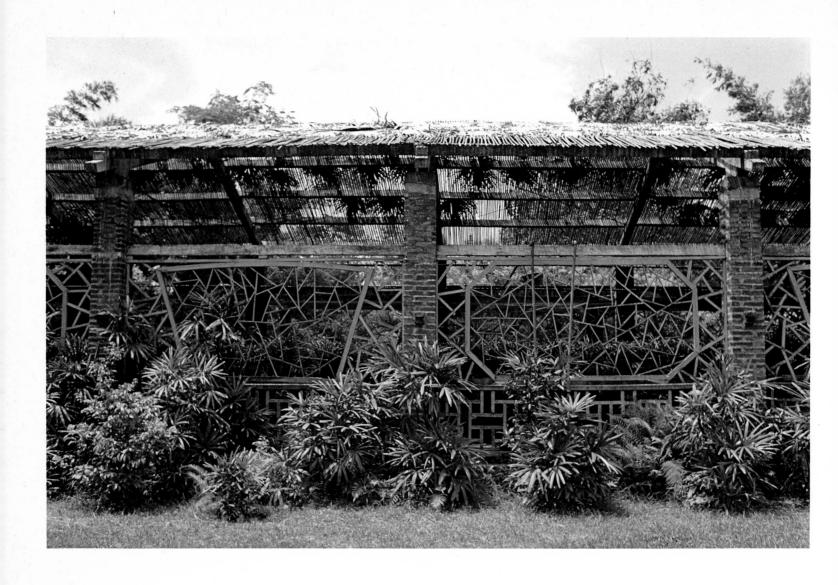

scaled refuge for thoughtful reflection and ceremonial worship.

Of the distinctive elements of traditional Chinese architecture seen in the palaces, temples, and mansions of the past—rectangular wooden halls, tiled roofs, pillars, brackets, and decorated grillwork screens and railings, the sole element persistently to survive in the new ceremonial architecture is the interior grillwork decoration. Only occasionally is a tiled roof used. But the Chinese, in their search for architectural expression, have carried on a dual policy similar to their treatment of painting, by building in both new Socialist and revived traditional styles. The latter are far less in evidence and are used mainly in parks, such as the Park of the Martyrs and the Orchid Garden in Canton (plate 352).

The most significant change in city skylines comes from the new ways of housing people—in blocks of brick or concrete

■352. Pavilion for growing orchids,
Orchid Garden, Canton
(Kwangchow). Bamboo poles
on the roof filter the sun, and
screens in "cracked-ice" design
decorate the sides. In old China
orchid growing was the pastime of
the literati. In People's China
the Party line emphasizes that the
masses may now enjoy orchids
previously reserved for the elite.

that form four- or five-story workers' apartment buildings (plate 288). The traditional city courtyard housing usually had one or two floors and was made of wood and tile for the rich, mud and thatch for the poor. The exteriors of new housing blocks have the same dreary, impersonal image as low-rent urban projects in the United States, but the similarity is diminished by the fact that the Chinese tree-planting program is far more intensively carried out than are well-intentioned American beautification attempts. Also, the Chinese do not seem to be plagued by vandalism to the same extent as we. The interiors of the apartment houses, however, demand a high degree of tolerance and cooperation from the occupants. A family of three or four shares one or two rooms, and that family in turn shares tiny bathroom and kitchen facilities with a neighboring family. Some modern housing has been built on communes, but the traditional conservatism of the peasant is reflected in the persistence of mud-walled courtyard dwellings. There still are many quaint little Chinese villages that appear to have remained unchanged for two thousand years, except for electric power lines and, of course, the revolutionary slogans painted in large characters on their mud walls.

Millions of words have been written since 1949 analyzing and explaining the new Chinese government and its efforts to transform the country. Scholars have recognized a fascinating interplay of continuities and discontinuities. Although they have made great changes in Chinese society, the Communists have recognized that if their system is to operate effectively, it would be unwise to attempt to destroy all traditional aspects of life. In many cases they have filled old needs and expectations in new ways that are distinct from, and yet functionally similar to, the old ones. Their revision of China's imagery is a case in point.

Art forms are visual symbols of both continuity and innovation in People's China. The tamped-earth wall and brick gate of dwellings are ubiquitous in the countryside today and have a timeless quality (plate 353). Traditionally, buildings were enclosed by walls, and the peasant-style housing is so enduring that this sort of complex could have been built in any given year in the last two millenniums. Because a common vocabulary of architectural forms pervaded the old society, the basic similarity between rustic and sophisticated walls and gates is to be expected. The entrance to the Yü Yüan, the Ming dynasty city garden in Shanghai, has a roof that curls up and a gate elaborately embellished with carved-tile designs (plate

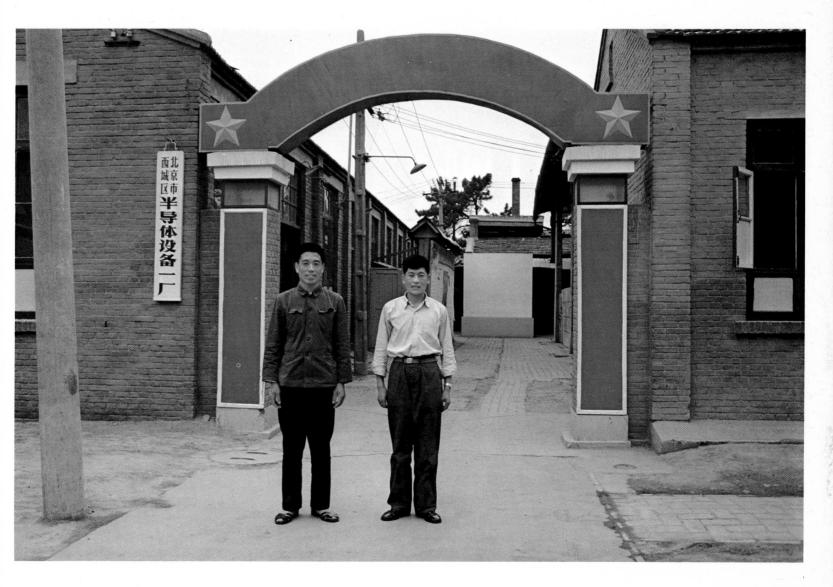

353–56. Opposite page, far left: Wall and gateway of countryside housing near Sian, Shensi province. Pounded earth, brick, and tile. Left: Gateway of the Yü Yüan, Shanghai. 1537 (Ming dynasty), renovated in 1956. Carved brick and tile. Below: Gateway of the Hall of Military Prowess (Wuying-tien), Imperial Palace, Peking. Ming dynasty (1368–1644) with renovations of the Ch'ing dynasty and the People's Republic. Above: Gateway of the West District Transistor Factory No. 1, Peking.

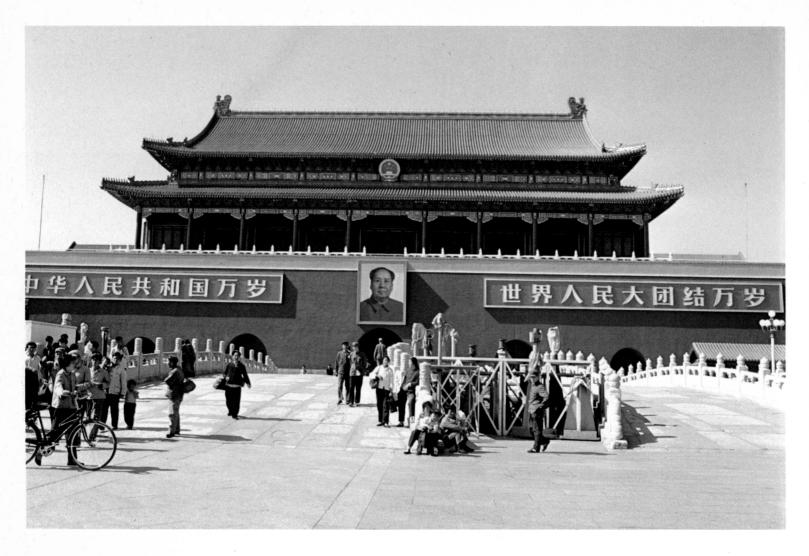

357. Gate of Heavenly Peace (T'ien-an-men), Peking. Ming dynasty (1368–1644), with renovations of the Ch'ing dynasty and the People's Republic. Signs: left, "Long live the People's Republic of China"; right, "Long live the solidarity of the people of the world."

354). Yet the underlying form of the gate is virtually the same as that of its country cousins. Even the gates of the Forbidden City share the form beneath the intricately carved wood and flamboyantly colored tile decoration (plate 355).

In People's China it is striking to the Westerner that so many new structures continue to be defined by walls that perpetuate the traditional notion of enclosure. In addition to preserving many old gateways, China's present leaders have also built many new ones. The new gateway forms are heavy, sturdily built, and decorated with much red and many stars in the international Communist image (plate 356). But the new forms are used to continue the old Chinese idea of enclosing.

The old T'ien-an-men gate, now decorated with Maoist slogans and Chairman Mao's picture, is often used to symbolize the People's Republic (plate 357). It faithfully reflects the Chairman's instruction to "let the past serve the present."

BIBLIOGRAPHY

- Akiyama, Terukazu, Kosei Ando, Saburo Matsubara, Takashi Okazaki, and Takeshi Sekino. *Arts of China: Neolithic Cultures to T'ang Dynasty* (coordinated by Mary Tregear). Tokyo and Palo Alto, Calif.: Kodansha International, 1968.
- —— and Saburo Matsubara. Arts of China: Buddhist Cave Temples. Trans. Alexander C. Soper. Tokyo and Palo Alto, Calif.: Kodansha International, 1969.
- Andersson, J. Gunnar. Children of the Yellow Earth. London: Kegan Paul, Trench, Trubner & Co., 1934.
- Ayers, John. The Baur Collection: Chinese Ceramics, 4 vols. Geneva: Collections Baur, 1972.
- Barnett, A. Doak. Communist China: The Early Years, 1949–55. New York, Washington, and London: Praeger, 1964.
- —. "There Are Warts There Too." New York Times Magazine, April 8, 1973, pp. 36, 37, 100–106.
- de Bary, William Theodore, Wing-tsit Chan, and Burton Watson (compilers). Sources of Chinese Tradition. New York: Columbia University Press, 1960.
- Bennett, Gordon A., and Ronald N. Montaperto. Red Guard. Garden City, N.Y.: Doubleday, 1971.
- Birch, Cyril (compiler and ed.). Anthology of Chinese Literature. New York: Grove Press, 1965.
- Bonnichon, André. Law in Communist China. The Hague: International Commission of Jurists, 1956.
- Bulling, A. "Historical Plays in the Art of the Han Period." *Archives of Asian Art*, XXI. New York: The Asia Society, 1967–68.
- ——. "Hollow Tomb Tiles." *Oriental Art*, XI, no. 1, Spring, 1965.
- Bunker, Emma C., C. Bruce Chatwin, and Ann R. Farkas. "Animal Style" Art from East to West. New York: The Asia Society, 1970.
- Bush, Susan. The Chinese Literati on Painting. Cambridge, Mass.: Harvard University Press, 1971.
- Cahill, James. Chinese Painting. Geneva: Albert Skira, 1960.

- ——. The Art of Southern Sung China. New York: The Asia Society, 1962.
- Campbell, Joseph. The Masks of God: Oriental Mythology. New York: Viking, 1962.
- Carter, Thomas F. (rev. by L. Carrington Goodrich).

 The Invention of Printing in China. New York:
 Ronald Press, 1955.
- Chang, Kwang-chih. The Archaeology of Ancient China. New Haven: Yale University Press, 1968.
- Chao Mei-pa. A Guide to Chinese Music. Hong Kong: Tai Hwa Printing Factory, 1969.
- Ch'en, Jerome. *Mao and the Chinese Revolution*. New York: Oxford University Press, 1965.
- Ch'en, Kenneth K. S. *Buddhism in China*. Princeton, N.J.: Princeton University Press, 1964.
- Chinese Art Treasures. Geneva: Albert Skira, 1961.
- Chinese Cultural Art Treasures. Tapei, Republic of China: The National Palace Museum, 1967.
- Chuka jinmin kyowakoku shutsudo bumbutsu ten (Exhibition of Archaeological Treasures Excavated in the People's Republic of China). Kunio, Fujita and Sumio Kuwabara, eds. Tokyo: Asahi Newspapers Ltd., 1973.
- Clapp, Anne de Coursey. *The Ming Artist and Antiquity* (unpublished Ph.D. thesis). Harvard University, Cambridge, Mass., 1971.
- Cohen, Jerome Alan. The Criminal Process in the People's Republic of China, 1949–1963: An Introduction. Cambridge, Mass.: Harvard University Press, 1968.
- ——. "Notes on Legal Education in China." *Harvard Law School Bulletin*, February, 1973, pp. 18–21.
- ---- and Hungdah Chiu. People's China and International Law. Princeton, N.J.: Princeton University Press, 1974.
- Creel, Herrlee Glessner. *The Birth of China*. New York: Frederick Ungar, 1967.
- Croizier, Ralph C. (ed.). China's Cultural Legacy and Communism. New York: Praeger, 1970.

- Dawson, Raymond. *The Chinese Chameleon*. New York: Oxford University Press, 1967.
- —— (ed.). The Legacy of China. Oxford: Clarendon Press, 1964.
- Donnithorne, Audrey. *China's Economic System*. New York and Washington, D.C.: Praeger, 1967.
- Dubs, Homer H. (trans.). The History of the Former Han Dynasty by Pan Ku, 2 vols. Baltimore: Waverly Press, 1938.
- Eliséeff, Vadime, and M. T. Bobot. Trésors d'Art Chinois. Paris: Petit Palais, 1973.
- Fairbank, John K., Edwin O. Reischauer, and Albert M. Craig. East Asia: Tradition and Transformation. Boston: Houghton Mifflin, 1973.
- Fairbank, Wilma. Adventures in Retrieval. Cambridge, Mass.: Harvard University Press, 1972.
- Feuerwerker, Albert (ed.). History in Communist China. Cambridge, Mass.: MIT Press, 1968.
- Fitzgerald, C. P. China: A Short Cultural History. New York: Praeger, 1961.
- Fourcade, François. Art Treasures of the Peking Museum. New York: Harry N. Abrams, 1965.
- Galston, Arthur W., with Jean S. Savage. Daily Life in People's China. New York: Crowell, 1973.
- Gernet, Jacques. Daily Life in China on the Eve of the Mongol Invasion, 1250–1276. Trans. H. M. Wright. Stanford, Calif.: Stanford University Press, 1970.
- Goldman, Merle. Literary Dissent in Communist China. Cambridge, Mass.: Harvard University Press, 1967.
- Garnet, Marcel. Chinese Civilization. Trans. Kathleen E. Innes and Mabel R. Brailsford. New York: Meridian Books, 1958.
- Grousset, René. Chinese Art & Culture. Trans. Haakon Chevalier. New York: Grove Press, 1961.
- Trans. Anthony Watson-Gandy and Terence Gordon. Berkeley and Los Angeles: University of California Press, 1964.
- Hinton, Harold C. An Introduction to Chinese Politics. New York and Washington, D.C.: Praeger, 1973.
- Hinton, William. Fanshen, A Documentary of Revolution in a Chinese Village. New York and London: Monthly Review Press, 1966.
- ——. Hundred-Day War, The Cultural Revolution at Tsinghua University. New York and London: Monthly Review Press, 1972.
- Historical Relics Unearthed in New China. Peking: Foreign Languages Press, 1972.

- Ho, Ping-ti. The Ladder of Success in Imperial China. New York: Columbia University Press, 1962.
- ----. "The Loess and the Origin of Chinese Agriculture." *American Historical Review*, LXXV, no. 1, 1969.
- —. "The Significance of the Ch'ing Period in Chinese History." The Journal of Asian Studies, XXVI, no. 2. Association for Asian Studies, Inc., 1967.
- Hobson, R. L. The Later Ceramic Wares of China. London: Ernest Benn, 1925.
- Honey, William B. The Ceramic Art of China and Other Countries of the Far East. London: Faber & Faber, 1945.
- Honour, Hugh, Chinoiserie. London: John Murray, 1961.
- Hsia, C. T. A History of Modern Chinese Fiction 1917–1957. New Haven: Yale University Press, 1961.
- Hsia Nai. "Opening an Imperial Tomb." China Reconstructs (Peking), VII, no. 3, March, 1959.
- Hsi-an Pan-p'o [The Neolithic Village at Pan P'o, Sian]. Archaeological Monograph, XIV, ser. D. Peking: Wen-wu Press, 1963.
- Isaacs, Harold R. *Images of Asia*. New York: Capricorn Books, 1962.
- Jenyns, R. Soame. Later Chinese Porcelain. London: Faber & Faber, 1951.
- ——. Ming Pottery and Porcelain. London: Faber & Faber, 1953.
- Johnson, Chalmers A. Peasant Nationalism and Communist Power. Stanford, Calif.: Stanford University Press, 1962.
- Jourdain, Margaret, and R. Soame Jenyns. *Chinese Export Art.* Middlesex: Spring Books, 1967.
- Kaltenmark, Max. Lao Tzu and Taoism. Trans. Roger Greaves. Stanford, Calif.: Stanford University Press, 1969.
- Karnow, Stanley. Mao and China. New York: Viking, 1972.
- Kuo Hsi. An Essay on Landscape Painting. Trans. Shio Sakanashi. London: John Murray, 1959.
- York: American Geographical Society, 1940.
- Lee, Sherman E. A History of Far Eastern Art. New York: Harry N. Abrams, 1964.
- Chinese Landscape Painting. New York: Harper & Row, n.d.
- —— and Wai-Kam Ho. Chinese Art Under the Mongols: The Yüan Dynasty (1279–1368). Cleveland: The

- Cleveland Museum of Art, 1968.
- Legge, James. *The Chinese Classics*, 7 vols. Taipei, Taiwan, 1966.
- Levenson, Joseph R. Confucian China and Its Modern Fate, vol. 3. Berkeley and Los Angeles: University of California Press, 1958, 1964, 1965.
- Li Chi. *The Beginnings of Chinese Civilization*. Seattle: University of Washington Press, 1957.
- Lin Yutang. Imperial Peking. New York: Crown, 1961. Loehr, Max. Chinese Painting After Sung. New Haven:
- Yale Art Gallery Ryerson Lecture, March 2, 1967.

 ——. Relics of Ancient China. New York: The Asia Society, 1965.
- -----. "The Fate of the Ornament in Chinese Art." Archives of Asian Art, XXI. New York: The Asia Society, 1967-68.
- Loewe, Michael. Everyday Life in Early Imperial China. New York: G. P. Putnam's Sons, 1968.
- Loh, Robert, and Humphrey Evans. Escape from Red China. London: Michael Joseph, 1963.
- MacFarquhar, Roderick (ed.). The Hundred Flowers. London: Stevens & Sons, 1960.
- Mahler, Jane Gaston. The Westerners Among the Figurines of the T'ang Dynasty of China. Rome: Istituto Italiano per il Medio ed Estremo Oriente, 1959.
- Malone, Carroll Brown. History of the Peking Summer Palaces Under the Ch'ing Dynasty. Urbana, Ill.: University of Illinois, 1934.
- Mao Tse-tung. Selected Works of Mao Tse-tung, vol. 1. London: Lawrence & Wishart, 1954.
- Miduno, Seiiti (Mizuno, Seiichi), and Toshio (Tosio) Nagahiro. A Study of the Buddhist Cave Temples at Lungmen, Honan. Tokyo: Zauho Press, 1941.
- Mino, Yutaka. *Ceramics in the Liao Dynasty*. New York: China Institute in America, 1973.
- Munro, Eleanor C. Through the Vermilion Gates. New York: Pantheon Books, 1971.
- Myrdal, Jan. Report from a Chinese Village. Trans. Maurice Michael. London: Heinemann, 1965.
- Needham, Joseph (with research assistance of Wang Ling). Science and Civilization in China, 5 vols. Cambridge, England: Cambridge University Press, 1954–1971.
- New Archaeological Finds in China. Peking: Foreign Languages Press, 1972.
- Payne, Robert. Chiang Kai-shek. New York: Weybright and Talley, 1969.

- Perkins, Dwight H. "Looking Inside China: An Economic Reappraisal." *Problems of Communism*, May–June, 1973, pp. 1–13.
- —. Market Control and Planning in Communist China. Cambridge, Mass.: Harvard University Press, 1966.
- Pope, John Alexander. Chinese Porcelains from the Ardebil Shrine. Washington, D.C.: Smithsonian Publication 4231, 1956.
- ——, Rutherford John Gettens, James Cahill, and Noel Barnard. *The Freer Chinese Bronzes*, *I*. Washington, D.C.: Smithsonian Publication 4706, 1967.
- Reichwein, Adolf. China and Europe: Intellectual and Artistic Contacts in the Eighteenth Century. Trans.
 J. C. Powell. New York: Barnes & Noble, 1968.
- Reischauer, Edwin O. Ennin's Travels in T'ang China. New York: Ronald Press, 1955.
- Rice, Edward E. Mao's Way. Berkeley, Los Angeles, and London: University of California Press, 1972.
- Schafer, Edward H. *The Golden Peaches of Samarkand*. Berkeley and Los Angeles: University of California Press, 1963.
- Schram, Stuart. Mao Tse-tung. New York: Simon and Schuster, 1966.
- Schurmann, Franz. *Ideology and Organization in Com*munist China. Berkeley and Los Angeles: University of California Press, 1966.
- Seckel, Dietrich. The Art of Buddhism. Trans. Anne E. Keep. New York: Crown, 1964.
- Sickman, Laurence, and Alexander Soper. The Art and Architecture of China. Baltimore: Penguin Books, 1960.
- —. A History of Early Chinese Art, 4 vols. London: Ernest Benn, 1928.
- ——. The Chinese on the Art of Painting. New York: Schocken Books, 1963.
- ——. The Imperial Palaces of Peking, 3 vols. Paris and Brussels: G. Van Oest, 1926.
- ——. The Walls and Gates of Peking. New York: Orientalia, n.d.
- Sirén, Osvald. Gardens of China. New York: Ronald Press, 1949.
- Sivin, Nathan. Chinese Alchemy: Preliminary Studies. Cambridge, Mass.: Harvard University Press, 1968.
- ——. "The Theoretical Background of Chinese Alchemy," in Joseph Needham, *Science and Civilization in China*, vol. 5, sec. 33. Cambridge, England: Cambridge University Press, 1954–71.
- Snow, Edgar. The Other Side of the River. London: Gollancz, 1963.

- Solomon, Richard. Mao's Revolution and the Chinese Political Culture. Berkeley, Los Angeles, and London: University of California Press, 1971.
- Ssu-ch'iu chih-lu (The Silk Route). Han T'ang chih-wu (Objects from the Han and T'ang). Edited by the Work Group for the Exhibition of Unearthed Archaeological Treasures of the Wei-wu-er Autonomous Regional Museum of Tibet. Peking: Archaeological Treasures Publishing Co., 1972.
- Sullivan, Michael. A Short History of Chinese Art. Berkeley and Los Angeles: University of California Press, 1967.
- Swann, Peter C. Chinese Monumental Art. London: Thames and Hudson, 1963.
- Tang, Peter S. H., and Joan M. Maloney. Communist China: The Domestic Scene, 1949–1967. South Orange, N.J.: Seton Hall University Press, 1967.
- Terrill, Ross. 800,000,000: The Real China. Boston and Toronto: Little, Brown, 1972.
- Treistman, Judith M. *The Prehistory of China*. New York: Doubleday, 1972.
- Tseng Yu-ho Ecke. *Chinese Calligraphy*. Philadelphia: Philadelphia Museum of Art, 1971.
- Tuchman, Barbara W. Stilwell and the American Experience in China, 1911-45. New York: Macmillan, 1971.
- Van Briessen, Fritz. The Way of the Brush. Rutland, Vt.: Charles E. Tuttle, 1962.
- Vogel, Ezra. Canton Under Communism. Cambridge, Mass.: Harvard University Press, 1969.
- Waley, Arthur. An Introduction to the Study of Chinese Painting. London: Ernest Benn, 1958.
- Watson, Burton. Early Chinese Literature. New York: Columbia University Press, 1962.
- —— (trans.). Chinese Rhyme-Prose. New York: Columbia University Press, 1971.

- ——. Su Tung-P'o, Selections from a Sung Dynasty Poet. New York: Columbia University Press, 1965.
- Watson, William. Early Civilization in China. New York: McGraw-Hill, 1966.
- Watt, J. C. Y. A Han Tomb in Lei Cheng Uk. Hong Kong: City Museum and Art Gallery, 1970.
- Welch, Holmes. "Buddhism Since the Cultural Revolution." *The China Quarterly* (London). October–December, 1969.
- -----. "The Buddhists' Return." Far Eastern Economic Review (Hong Kong), vol. 81, no. 28, July 16, 1973.
- Wen-hua to-ko-ming ch'i-chien ch'u-t'u wen-wu (Archaeological Treasures Unearthed During the Period of the Great Proletarian Cultural Revolution). Edited by the Work Group for the Exhibition of Unearthed Archaeological Treasures. Peking: Archaeological Treasures Publishing Co., 1972.
- Whitfield, R. Chang Tse-tuan's Ch'ing-ming Shang-ho t'u (thesis). Princeton, N.J.: Princeton University Microfilms, 1965.
- Willetts, William. *Chinese Art*, 2 vols. Baltimore: Pelican Books, 1958.
- —. "The Treasures of Wan-li: Gold, Jade and Porcelain from the Newly-Discovered Tomb of a Ming Emperor." Supplement to the *Illustrated London News*, Feb. 27, 1960, p. 353.
- Wittfogel, Karl A. Mao Tse-tung: Liberator or Destroyer of the Chinese Peasants? New York: Free Trade Union Committee, American Federation of Labor, 1955.
- Wright, Arthur F. Buddhism in Chinese History. New York: Atheneum, 1965.
- —— and Denis Twitchett (ed.). Confucian Personalities. Stanford, Calif.: Stanford University Press, 1962.
- Wu, Nelson I. Chinese and Indian Architecture. New York: George Braziller, 1963.
- ----. "The Toleration of Eccentrics." Art News, vol. 56, no. 3, May, 1957.

INDEX

Boldface type indicates references to plate numbers.

Acrobats, 87, 151; 74, 149-50,

324-25 Acupuncture, 324; 306-11 Agriculture, 257-65, 268, 277-84, 301-2, 318-19; 26-27, 39, 250, 256, 262-69, 273 Alchemy, 142-44 Altar of Heaven, 177-80; 181 Altars, Ming, 177-80; 178, 181, 184 An Lu-shan, 140-41 Animal forms in art: Ch'ing, 222, 224-25; **229, 232;** Han, 90-91, 94, 99, 101, 103, 171; 75-78, 81, 84-87, 93-95, 174; Ming, 171; 11, 170, 173, 202; PRC, 180; Shang, 59; 47; T'ang, 138-40, 142; 127, 133, 138; Yang-shao, 50-51; 45. See also Dragons; Nature in art Antonioni, Michael, 317 Anyang, 44–45 Apartments, imperial, 193-95; 201, 203 Apsarases, 120; 108 Archaeology, 44–46, 97–99, 173 Architecture: Ch'ing, 219-22; 210, 222-23, 225-28; colonialstyle, 237-39; 239-41; influences on, 219, 237-40; Ming, 176-95, 204, 383-85; 28, 32, 181-203, 211-19, 224, 350, 354-55; PRC, 175-76, 240, 379-90; 180, 328, 345-51, 356; Republican, 237-40; 57-61, 234-45; Sung, 133-35; 124-25; T'ang, 130, 132-33; 120-21; Yüan, 157-58; 154-56

Ballet, 363–66; 333, 335 Balustrades, 191; 194, 225, 228 Bells, bronze, 62; 52 Billboards, 33, 182, 212, 359–60; 31, 220, 275 Birth control, 320–21 Black Horse Hill, 67, 69, 140; 58 Blue-and-white ware: Ch'ing, 165, 226; Ming, 164-66; 165, 168; Yüan, 165-66; 167 Boats, 107-8; 97-98, 102, 303-4 Bodhi trees (pipal), 135; 125 Bodhisattvas, 113, 117, 119-20, 127; 105, 117 Botanical Gardens, Canton, 19 Boxer Rebellion, 223 Bridges, 187-88, 211; 19, 219, Bronze: Chou, 48, 59-60, 62, 99; 48-50, 52, 56; Han, 90-91, 94, 99, 103; 75-81, 85, 94-95; Ming, 11; Shang, 99; 47 Buddha Vairocana, 127; 100, 115, 117 Buddhas: sinicization of, 117, 121-22; Sui, 110; T'ang, 122, 158; 100, 108, 110-11, 113-15, 117-18; Wei, 117, 119, 158; 36, 104-5, 107, 109; Yüan, 158; 155-56 Buddhism, 65, 112-14, 117-19, 122, 127, 158; PRC and, 114, 340-41; T'ang, 121, 129-30. See also Religion Buddhist art. See Buddhas; Cave sculpture Bumper Harvest, A, 339

of Mao, 182, 359; 31
Camels, 138–39; 133
Canton, 121; 237–41
Canton Commune Rising of 1927, 175; memorial tumulus, 180
Canton Fair, 78
Capital Hospital, 239–40; 244–45
Cash, string of, 67; 143
Castiglione, Giuseppe, 219
Cave dwellings, 291

Cadres, 13, 268, 277, 282, 284,

Calligraphy, 103, 149, 201, 368;

308; 5, 22, 280, 349

Cave of Ten Thousand Buddhas, 122; 112-14 Cave sculpture, 112-32; 100, 102 - 19CCP. See Communist Party, Chinese Ceilings, 171, 193; 176, 201 Celadon ware, 161-63; 96, 122, 157-61 Ceramics, 45, 52; Ch'ing, 223-26, 375; Five Dynasties, 158, 160; Han, 87-89, 101-3; 74, 87, 89-93, 98; Lung-shan, 46; 41; PRC, 375; 341; Six Dynasties, 105, 160; 96; Sung, 158, 160-64, 223, 225; 123, 160-63; T'ang, 133, 139-41, 160; 35, 99, 122, 131-36, 157, 159; Yang-shao, 46, 49-52; 40, 45-46; Yüan, 164-66; 145, 164-66. See also Blue-and-white ware; Celadon ware; Chün ware; Porcelain; Three-color ware; Ting ware; Tz'u-chou ware; Yüeh ware Ch'ang-an, 83, 84, 112, 121, 133, 135-36, 140-41. See also Sian Chang Hsüeh-liang, 70, 233 Chang Tse-tuan, 150 Chariots, 91; 77-78 Ch'en Po-ta, 298, 309, 312 Ch'en Yi, 295 Chiang Ch'ing, 297, 298, 301, 310 Chiang Kai-shek, 45, 70-71, 116, 175, 216, 309, 356; and the Republic, 229-37 Ch'ien-lung, Emperor, 204, 216, 219, 226 Children, 327-31, 349, 353; 1-3, 8-9, 11, 25, 30, 247-48, 271, 312-14, 316-17, 330 Children's palaces, 29, 332; 1, 277, 283, 316-17 Chimes, stone, 62; 51 Chin dynasty, 157, 215

Ch'in dynasty, 77-78, 83

Ch'in Shih Huang-ti, Emperor, 77-78, 83, 111, 312 Ch'ing dynasty, 43, 136, 149, 165, 215-16, 222-26 Chingkangshan, 343-44 Ch'ing-ming festival, 149-51; 147-49 Chou dynasty, 43, 56-57, 60-69, 111 Chou En-lai, 10, 39, 298, 300-1, 309-12, 317, 363; and the Republic, 71, 231 Chou-k'ou-tien caves, 44 Christianity, 234, 340 Chu Yüan-chang, 169 Chü-yung-kuan Pass, 157-58; gateway, 154-56 Chün-ware, 163; 162 Churches, 237, 241 Classics, Confucian, 43, 44, 67, 130, 148, 169, 215 Clothing: Han, 140; Ming, 203; 179; PRC, 359; 10, 253, 255; T'ang, 140; 134-35; Wei, 140 Cloud Terrace, 157-58; 154-56 Coins, 65-67, 144; 56, 143 Collectivization, 257-65, 268, Columns. See Pillars Communes, 279-84, 318 Communism, primitive, 52, 55 Communist Party, Chinese (CCP): art and, 366-68; Congresses, 267, 307, 311-12; ideologues vs. pragmatists, 285, 294-300, 310-11; 1949-52, 248-50; 1953-57, 258-65, 267-78; 1958-62, 278, 282-84; 1962-65, 284-97; 1965-69, 297-307; 1969-74, 307-17; Republican period, 231, 233, 236-37 Communist Youth League, 279, 308, 342 Confucianism, 148, 158, 215, 312, 317. See also Classics, Confucian

Constitution of 1954, 114, 266–67

Cooperatives, 258–64, 268, 277, 281–82

Courtiers, 141; 136

Courtyards, 191–93; 199, 223, 227

Cowrie shells, 65; 55

Crime, 342–43, 355

Cuisine, 29–33, 140; 22–23

Cultural Revolution, 10, 18, 39, 114, 181–82, 297–307, 366–67

Cultural Revolution Directorate, 298, 300–1, 305

Cutouts, paper, 65, 372–74; 340

Confucius, 56

Divorce, 353–54
Dragon bones, 58
Dragon-cloud motif, 180, 186, 189–91; 171, 191, 194
Dragon King, 142
Dragons, 72, 91, 99, 142, 220; 59, 77, 83, 127, 138

Earthenware. See Ceramics
Economic development, 318–19, 321–22
Education, 114, 234, 269, 316, 327–40; 277–79, 313–14, 316–18; Cultural Revolution and, 295–96, 298, 310–11, 331–32
Elgin, Lord James, 217, 219
Engels, Friedrich, 360; 332
Essay on Landscape Painting, An (Kuo), 154
Eunuchs, 195–97

Family life, 256, 280-81, 349-55 Feng-hsien Temple, 127; 100, 115-17 Feng Yu-lan, 317 Feudal Society, 56, 78, 173 Five Year Plan: First, 257-78; Second, 278-84 Forbidden City. See Imperial Palace Foreign relations: with Great Britain, 216-17; with Japan, 70-71, 220, 222-23, 236-37; with U.S., 15, 18, 309; 7; with U.S.S.R., 231, 279, 295, 309 Foreigners in T'ang China, 135-38; 131-32 "Forest of Steles, The," 148;

Funerary customs, 52, 57, 60-62,

Funerary objects: Chou, 59–62; 48–50; Han, 87–89, 90–104, 107; 74–94, 98; Shang, 57, 64; 47, 53–54; Six Dynasties, 105; 96; T'ang, 133, 136–40; 35, 99, 122–23, 131–36

Funerary suits, 64, 94–99; 69, 82–83

Furnaces, backyard, 279, 282–83, 320

Furnishings: Ch'ing, 193–95, 219; 203, 224; Ming, 203, 211;

217-18; PRC, 380; 349; Re-

publican, 243

Games. See Sports and games Gardens, 203-4, 212; 19, 228; Ming, 387-90, 204-11; 211-19, 354; PRC, 212, 386; 34, 220-21, 352. See also Rocks Gate of Heavenly Peace, 184-87; 357 Gate of Heavenly Purity, 197 Gate of Military Prowess, 29 Gate of the Midday Sun, 187 Gates: Ming, 177-80, 187, 193; 6, 182, 190, 200, 212, 354-55; PRC, 387-90; 353, 356; Yüan, 157-58; 154-56 Genghis Khan, 155 George III, King, 216 Glass, imported, 142; 141 Glazing, 140, 166 Gold, 142, 222; 138, 229 Government: Ch'in, 77-78; Han, 89; Ming, 169, 195-97, 215; PRC, 248-57, 266-78, 284-97, 307-17; Republic, 229-37; Shang, 56; Sui, 121; Yüan, 157 Great Gander Pagoda, 130-33; 120-21 Great Hall of the People, 184, 375, 379-80; 348-49 Great Leap Forward, 279-83, Great Wall, 75-77, 78, 80; 63-65, 67-68 Guardians, 158, 193; 60, 116-17, 156, 196, 198

Hai Jui, 285
Hall of Eminent Favors, 171–
73; 176–77
Hall of Military Prowess, 192,
202, 355
Hall of Perfect Harmony, 188–
89, 191
Hall of Prayer for Good Har-

vests, 176, 180-81, 184; 187-Hall of the Preservation of Harmony, 189, 191, 239 Hall of Repose, 210, 223 Hall of Supreme Harmony, 188-89, 191; 28, 191 Han dynasty, 64, 83-108, 111 Handles, 99-101; 85, 86 Hangchow, 153, 157 Heroes of the Revolution, 216 Ho Chi Minh, 363 Horses, 90; 35, 75-76, 78 Hot springs resort, 67-72; 57-62 Housing: Neolithic, 48; 42; PRC, 288-92; 323-24, 386-87; 130, 272, 353; Republican, 237; 239-40 Hoxha, Enver. 363 Hsia Nai, 141, 144, 173 Hsia dynasty, 43-45 Hsia-hsiang movement, 279, 307 Hsiang Yü, 83-85 Hsien-feng, Emperor, 222 Hsü Wei, 201; 208 Hsüan-tsang, 130-32 Hu Shih, 242-43 Hua-ch'ing-kung, 67-72; 57-62 Huang-p'u River, 304 Hundred Days of 1898, 223 Hundred flowers period, 268-77,375 Hung-wu, Emperor, 169 Huns, 89-90

I Am a Seagull, 337 I Ho Yüan, 219-22; 222, 225-28, 255, 322 Imperial Academy, 153 Imperial Heavenly Vault, 180; Imperial Palace, 169, 176, 182-84, 187-95, 204, 215; 4, 11, 28-29, 189-203, 223-24, 355 Incense burners, 91-94, 142, 166, 191; 79, 137, 168 Industry, 265-66, 277-84, 301-2, 308-9, 318-20; 293-97, 315 Ink, 103-5 Inkstone case, 103; 94 Instruments, 62, 88; 51-52, 280 Ivory, 66

Jade, 45, 63–64, 94–99; **53–54**, **69, 82–83** Jewelry, 64, 222, 360; **54, 179**, **229** Journalism, 10, 13, 269, 298 Jurchens, 153, 157 Kaifeng, 150, 153; 147-49 Kaifeng Acrobatic Troupe, 324-25 K'ang-hsi, Emperor, 219 K'ang Tso-t'ien, 338 Kao Tsu, Emperor, 83-85, 89 "Killing Three Knights with Two Peaches," 87; 73 Ku Yen-wen, 97 Kuang-hsü, Emperor, 222-23 Kublai Khan, 155-58, 169 K'un-ming Lake, 219, 222; 226 Kung, Prince, 222 Kuo-chieh-t'a Gateway, 157-58; 154-56 Kuo Hsi, 154 Kuo Mo-jo, 55–56, 87, 238, 298 Kuomintang (KMT), 231-36 Kwangtung Province State Guest House, 12, 23

Lakes and ponds, 72, 211; 219, 222; 19, 58, 62, 216, 219, 226, 228 Lamps, 94, 136; 80, 127 Land reform, 249-65, 268, 277 Landscapes: Ming, 198, 201; 153, 205-6; PRC, 378-79; 7, 342-44; Sung, 151-54; 151-52. See also Painting Language, 57-59, 242-43, 327, 347 Lattimore, Owen, 317 Legal system, 267-69, 277-78, 343-46 Lenin, V. I., 231, 360; 332 Li Chi, 43-44 Li K'e-jan, 342 Li Po, 136-38 Li Shou-li, cache of, 141-44; 137-44 Lin Piao, 285, 294, 298-99, 301, 308-12, 317 Literature, 242-44, 269, 285, 297-98. See also Classics, Confucian Liu Pang, 83-85, 89 Liu Shao-ch'i, 282, 285, 295, 312, 317, 321, 332; Cultural Revolution and, 298-99, 305, 307 Liu Sheng, 91, 94, 96, 99; 69 Lo Jui-ch'ing. 295, 298 Lotus Flower Cave, 120; 109 Loyang, 69, 83, 111–12, 114, 121; 289 Lu Hsün, 243-44, 372; 246 Lung-men caves, 112, 114-17, 127, 129-30; 100, 102-19 Lung-shan culture, 46

64-65, 91

Macartney, Lord George, 216 Manchu dynasty. See Ch'ing dynasty Mandate of heaven, 67, 84, 169 Mao Tse-tung, 10, 18, 57, 231, 237; in art, 359-60, 368-69; 243; 1949-52, 248-55; 1953-57, 258, 265; 1958-62, 279-80, 282-83; 1962-65, 284-97; 1965-69, 298-307, 310-11; 1969-74, 309-17; poetry of, 33, 182, 359-60; 31; statues of, 211, 298, 359, 379; 32, 274, 276, 298, 327, 351 Marriage, 354-55 Marx, Karl, 360; 332 Marxism-Leninism, 55-57, 231, 237, 243-44 May 7th Cadre Schools, 310, 348, 375, 379; 7, 22, 278-82 Medicine, 58, 142-44, 324-27; 306-11 Ming dynasty, 136, 150, 165-66, 169-81, 191-98, 203 Ming Huang, Emperor, 140-41 Money. See Cash, string of; Coins; Cowrie shells Mongols. See Yüan dynasty Monsters. See Animal forms in Moon gates, 57, 121, 215 Museum of History and the Revolution, 184: 328, 348 Music, 61-63, 310, 316-17. See also Ballet; Opera Musicians, 87-88; 35, 74, 280 Mutual-aid teams, 257-58 Mythical beasts. See Animal

National People's Congress, 266-67 Nationalities' Cultural Palace, 380; 347 Nature in art, 50-51, 59, 154-55, 225. See also Animal forms in art; Gardens; Lakes and ponds Neo-Confucianism, 148 Neolithic cultures, 45-52 Ni Tsan, 198, 201 Northern Celadon glaze, 163, 159; 161 Nurhachi, 215 Nurseries, horticultural, 212; 37, 220-21 Nursery schools. See Children;

forms in art

Education

Offerings. See Funerary customs; Funerary objects
On the Docks, 30
Opera, 310, 363-66; 30
Opium War of 1839-42, 56, 147, 216
Oracle bones, 57-59
Orchid Garden, 386; 34, 352

Pagodas, 130-33, 135, 239; 119-20, 122, 124, 234 Painting: Che school, 153; Grand-manner style, 371-72; Han, 83-87; 70-71, 73; Ming, 150, 153-54, 197-203; 147-49, 153, 204-9; Peking Academy style, 375-80; 349; PRC, 154-55, 342-44, 366-68, 370-72, 375-79; 246, 336-39, 342; Republican, 240-42; Sung, 149-55: Western influences, 219: Wu school, 201; Yüan, 198. See also Landscapes; Portraits Palace of Orderly Clouds, 226 Palace of Permanent Peace, 200 Palace of Virtue and Harmony, P'an Chia-chün, 337 Pan Ku, 84 Pan-p'o, 45-52; 38, 42-46 Pandas, 14, 323 Park of the Martyrs of the Canton Commune Uprising, 386; 180, 275 Pavilions, 72, 206-11, 220; 57, 213-15, 352

Pearl River, 33, 97 Peasant Movement Institute. 380-85; **350-51** Peking, 13, 157, 169, 176, 215, 233: 6, 15-17 Peking Academy of Chinese Painting, 375-80; 349 Peking man, 44, 176 Peking University, 239, 298, 333-38; 3, 234, 242-43, 318 P'eng Chen, 297, 298 P'eng Te-huai, 285 People's Art Exhibition, 370-72, 375; **326, 337–40** People's art movement, 368-72 People's Liberation Army (PLA), 285, 294, 298, 302-7; 67, 287 People's Market, 2, 13, 24, 259-

People's Republic of China

(PRC), 216, 247-48, 355-56;

1949-52, 237, 248-57; 1953-57,

257-78; 1958-62, 278-84; 1965-

69, 297-307; 1969-74, 9-40, 307-17 Phoenix hat, 175; 179 Photography, 29, 33, 363, 368-70 Pillars, 180-81, 186; 171, 186-87, 328 Pillows, 99, 163-64; 82-83, 163-Pin, Prince of, cache of, 141-44; 137-44 Pin-yang cave, 117-20; 104-5 PLA. See People's Liberation Army Police, 341; 252, 285 Polo, Marco, 157 Porcelain, 160-61; Ch'ing, 165, 223-26; 230-33; Ming, 164, 166; 167-69; Sung, 163-64; 161, 163; Yüan, 165-66; 165-66. See also Ceramics Portraits: Ming, 197-98, 201-3; 204, 207-9; PRC, 359-63; 246. See also Painting Posters, 359-63; 331-32 Pot landscape, 212; 221 Pottery. See Ceramics. PRC. See People's Republic of China Prehistory, 43-52 Prints, wood-block. 372 Production brigades, 280, 283 Production teams, 318 Public security, 305, 341 Radiant King, 126 Recreation, 346-47; 64, 280-81, 319-25 Red Detachment of Women, 363-64; 335 Red Guards, 18, 299-307, 312,

Production teams, 318

Public security, 305, 341

Six

Radiant King, 126

Recreation, 346–47; 64, 280–81, 5le

319–25

Red Detachment of Women, 363–64; 335

Red Guards, 18, 299–307, 312, 332; 286

Red Lantern, 363

Reforms, social, 223, 230, 233– 35, 296–97

Relic box, 133; 123

Religion, 114, 121–22, 234, 340– 41. See also Buddhism; Confucianism; Taoism

Republic of China, 43, 70, 223, 229–37

Residents' committees, 341–42

Revolution of 1911, 43, 223, 5u
229

Revolutionary committees, 305, 306

Rhyton, 142; 142

Rocks, 203-4, 206; 210, 216

Roofs, 21, 101, 238, 289–90; Ch'ing, 222; Ming, 177–80, 193, 196, 198, 206, 383–85, 387; **183, 188, 350;** PRC, 380, 383, 386; Republican, 71–72; **60–61**

Sacred Way, 171; 170, 173, 175 Sakanashi, Shio, 154 Schools. See Children's palaces; Education; May 7th Cadre Schools Schubert, Franz, 317 Screen-gates, 193; 199-200 Sculpture: Han, 171; 174; Ming, 171, 186; 170, 175; PRC, 211, 298, 359, 374-75, 379; 32, 180, 216, 274, 276, 298, 327, 334, 341, 351; T'ang, 136; 126; Yüan, 158; 155-56. See also Animal forms in art; Cave sculpture Sha-mien Island, 8, 239-41 Shang dynasty, 43-45, 55-59, 65,67 Shanghai Exhibition Hall, 379, 380; 298, 345 Shen Chou, 201, 204-6; 206-7 Shōmu, Japanese Emperor, 141 Shōsōin treasure house, 141-42 Sian, 67, 69; 128-30, 249, 290, 292. See also Ch'ang-an Silk Road, 90-91, 138-39 Silver, 142, 144; 137, 139-40, 143-44 Six Dynasties, 116, 160 Sixteen Point Decision, 299-300 Slave Society, 55-57, 78 Sleeve weights, 94; 81 "Snow" (Mao), 182; 31 Socialist Realism, 211, 240, 363, 370-72, 379; 246, 331, 336-38, 345-47 Socialization, 265-66, 277 Soong family, 234 Sports and games, 346-47; 29, 189, 319-21 Ssu-ma Ch'ien, 84 Stalin, Joseph, 360; 332 Steles, 148; 36, 146 Stoneware. See Ceramics Street revolutionary committees, 341-42, 353; 332 Struggle meetings, 250-57 Sui dynasty, 69, 121 Summer Palaces, 217-22 Sun Yat-sen, 229, 231-34 Sung dynasty, 87, 129, 147-55, 158 - 64

Tai Chin, 153; 153

T'ai Tsung, Emperor, 121 T'aiping Rebellion, 217 T'ang dynasty, 69, 112, 115-17, 121-44, 147 T'ao Yüan-ming, 197-98; 204 Taoism, 142-44 Tartars, T'o-pa, 113. See also Wei dynasties Temple of Agriculture, 176 Temple of Great Good Will, 130, 132-33; 121 Temple of Heaven, 176, 180-81, 184; 187-88 Temple of Heaven complex, 176-82, 215; 181-88, 251 Temple of the Six Banyan Trees, 133-35; 124-25 Temples, Ming, 383-85 Temür, 169 Teng Hsiao-p'ing, 312-16 Three-color ware, 139-40; 123, 133-35, 164 Three freedoms, 284, 285 Three Principles of the People, T'ien-an-men Gate, 184-87, 390; 171, 357 T'ien-an-men Square, 184-87, 300, 379; 252, 328, 348

Tiles, painted, 83-87; 70-71, 73 Ting ware, 163; 163 Tomb figures. See Funerary objects Tombs, 101-3, 169-76; **87, 180** Tools, Neolithic, 49; 43-44 Tou Wan, 91, 94, 96, 99, 103 Trade, foreign, 141-42, 216-17, Transportation: Ch'in, 77; Han, 105-8; 78; PRC, 26, 322; 10, 15, 17, 20, 97, 267, 287, 299-305; T'ang, 138-39 Treasures of Chinese Art, 39, 103 Treaties, 217, 236 Tz'u-chou ware, 164; 145, 164 Tz'u-hsi, Empress Dowager, 195, 220-23

Walls, 177–80, 187–88, 206; **128**, 182–83, 190, 195, 198, 211.

Valley of the Thirteen Tombs,

170-75; 170, 172-73, 175-78

182–83, 190, 195, 198, 211. See also Great Wall
Wan-li, Emperor, 46, 166, 173 Wang-ch'eng Park, 111–12 Wang Chung-yü, 197–98; **204** Wang Fu, 198; **205** Wang Hung-wen, 311–12 Warlordism, 230, 233, 236, 305 Warring States period, 65 Water-pumping facility, 239; 234 Weapons, 49, 57, 294–95, 320; 47

Wei dynasties, 112–13, 116–17, 120–21 West District Transistor Fac-

tory No. 1, 356
White-Haired Girl, The, 363-64; 334-35
Women, 52, 195; PRC, 256, 280

Women, 52, 195; PRC, 256, 280, 321, 349, 353; **5, 10, 16, 253, 270, 273, 329;** T'ang, 140; 134–35

Women's Association, 279, 308, 342 Wright, Frank Lloyd, 240 Writing, 57–59, 103–5. See also Calligraphy

Wu Han, 285, 297 Wu-sung River, **236, 303** Wu Ti, Emperor, 89–90, 94 Wuhan uprising, 305 Yang, 203-4 Yang, Minister, 141 Yang Kuei-fei, 70, 140-41 Yang-shao culture, 44, 46-52; 38, 40, 43-46 Yang Su, 203; 209 Yi River, 116; 102 Yin, 203-4 Young Pioneers, 332; 283, 308, 316-17, 326 Yu Ch'in, 343-44 Yu Ch'iu, 203; 209 Yü Yüan, 387-90, 204-11; 32, 211-19, 354 Yüan dynasty, 149, 155-58, 164-66, 169 Yüan Ming Yüan, 217-19, 237 Yüan Shih-k'ai, 229, 230 Yüeh-chih (nomads), 89–90 Yüeh ware, 105, 160-63; 158, Yung-lo, Emperor, 169-70, 176, 187

Zoos, 22; 14, 323

CHRONOLOGY

Neolithic period		
Yang-shao culture	?4000-?2000 в.с.	
Lung-shan culture	?2000-?1200 B.C. (with scattered later survivals)	
* Shang dynasty	?1523-?1027 B.C. (traditional ?1766-1122 B.C.)	
* Chou dynasty	?1027-256 B.C. (traditional -?1122-256 B.C.)	
Western Chou	?1027-770 B.C. (traditional ?1122-770 B.C.)	
Eastern Chou	770-256 в.с.	
Spring and Autumn era	770-481 в.с.	
Warring States era	403-221 B.C.	
Ch'in dynasty	221–206 B.C.	
Han dynasty	206 B.CA.D. 220	
Western Han	206 B.CA.D. 8	
Wang Mang Interregnum	A.D. 9-23	
Eastern Han	A.D. 25–220	
Six Dynasties	220-587	
		Three Kingdoms 222-264/280
Western Chin	265-304	
		Sixteen Kingdoms 304–386
Eastern Chin	317-420	
		Northern Wei (T'o-pa) 386-534
Liu Sung	420-447	
Southern Ch'i	477-502	
Liang	502-577	
		Western Wei 535–557 Eastern Wei 534–550
		Northern Chou 557–581 Northern Ch'i 550–557
Ch'en	557-589	
Sui dynasty	581-618	
T'ang dynasty	618-907	
Ten Kingdoms	907-979	Five Dynasties 907–960
		Liao dynasty (Khitan Tartars) 947-1125
Sung dynasty	960-1279	
Northern Sung	960-1126	
		Chin dynasty (Jurchen Tartars) 1115-1234
Southern Sung	1127-1279	
Yüan dynasty (Mongols)	1260-1368	
Ming dynasty	1368-1644	
Ch'ing dynasty (Manchus)	1644-1912	
Republic	1912-1949	
Kuomintang	1928–1949	
	(in Taiwan,	1949—)
People's Republic	1949—	

^{*} The dating of the Shang dynasty and the Chou invasion have not been indisputably established. Most modern scholars use the dates given first in the chronology and used in the text, rather than the traditional dates shown in parentheses.